D1372806

Authorizing Early Modern European Women

Gendering the Late Medieval and Early Modern World

Series editors: James Daybell (Chair), Victoria E. Burke, Svante Norrhem, and Merry Wiesner-Hanks

This series provides a forum for studies that investigate women, gender, and/ or sexuality in the late medieval and early modern world. The editors invite proposals for book-length studies of an interdisciplinary nature, including, but not exclusively, from the fields of history, literature, art and architectural history, and visual and material culture. Consideration will be given to both monographs and collections of essays. Chronologically, we welcome studies that look at the period between 1400 and 1700, with a focus on any part of the world, as well as comparative and global works. We invite proposals including, but not limited to, the following broad themes: methodologies, theories and meanings of gender; gender, power and political culture; monarchs, courts and power; constructions of femininity and masculinity; gift-giving, diplomacy and the politics of exchange; gender and the politics of early modern archives; gender and architectural spaces (courts, salons, household); consumption and material culture; objects and gendered power; women's writing; gendered patronage and power; gendered activities, behaviours, rituals and fashions.

Authorizing Early Modern European Women

From Biography to Biofiction

Edited by
James Fitzmaurice,
Naomi J. Miller, and
Sara Jayne Steen

Amsterdam University Press

Cover illustration: Judith Leyster, *Self-Portrait*, c.1633. National Gallery of Art, Washington, D.C., Gift of Mr. and Mrs. Robert Woods Bliss

Cover design: Coördesign, Leiden
Lay-out: Crius Group, Hulshout

ISBN	978 94 6372 714 3
e-ISBN	978 90 4855 290 0
DOI	10.5117/9789463727143
NUR	685

Table of Contents

Section I: Fictionalizing Biography

Section II: Materializing Authorship

Section III: Performing Gender

Section IV: Authoring Identity

List of Figures

Acknowledgments

The editors are grateful to our contributors – the excellent scholars, biographers, and authors of biofiction who literally worked through a global pandemic to produce this collection; to Amsterdam University Press's reviewers and the board of the series Gendering the Late Medieval and Early Modern World for their thoughtful responses; to acquisitions editor Erika Gaffney, with whom it is a joy to work; and to colleagues too many to name with whom we have shared enthusiastic conversations about early modern European women and this topic. All have had a role in bringing early modern women creators and their remarkable stories to contemporary audiences.

1. Introduction: Biography, Biofiction, and Gender in the Modern Age

James Fitzmaurice, Naomi J. Miller, and Sara Jayne Steen

Abstract
Focusing attention upon early modern European women as creators and practitioners, the essays in this volume examine women from saints to midwives, visual artists to writers, who authored their own visions and who have in turn been "authored" and "authorized" by modern writers interested in telling their stories in biographies and through fictionalizations. This opening chapter introduces the contemporary scholars and creative writers who are grappling with the challenges of re-creating early modern women from Spain, Flanders, Scotland, England, Italy, the Netherlands, and Mexico (then New Spain); and provides a framework for their assessments from the emerging field of biofiction, or fictionalizations of actual figures.

Keywords: historical fiction, biofiction, gender, early modern women, biography, Michael Lackey

A surge in recent attention to the parameters of biofiction,[1] thanks in large part to the pioneering work of Michael Lackey, has illuminated some of the tensions distinguishing critical reception of novels with that label.[2] Indeed, it's not simply a matter of scholarship. When contemporary journalists respond to a literary genre with reporting that connects the challenges facing contemporary

1 *Biofiction* is a blended term for *biographical fiction* and refers to fictionalizations of actual figures whether on the page or in performance. Biographical films have become popular enough to have their own term, *biopics*.

2 Significant evidence of this surge can be seen in the international conference on *Biofiction as World Literature* in Leuven, September 2021, as well as in the upcoming Bloomsbury series, *Biofiction Studies*, edited by Michael Lackey, Monica Latham, and Lucia Boldrini.

Fitzmaurice, J., N.J. Miller, S.J. Steen (eds.), *Authorizing Early Modern European Women. From Biography to Biofiction*. Amsterdam: Amsterdam University Press, 2022
DOI 10.5117/9789463727143_CH01

novelists with "ripped-from-the-headlines events," their attention to the implications of biofiction has relevance for the general reader as well as the scholar. A case in point: Ron Charles, the Book World Critic for *The Washington Post*, broke a story in which the real lawyer Alan Dershowitz claimed a fictional lawyer had defamed him; Charles insisted that the "implications for novelists are very real." Pointing out that novels that "borrow, embellish, and manipulate the details of well-known people's lives [...] freely mingle fiction and nonfiction," Charles drew a connection to the early modern world, where "the challenge of blending real and invented characters wasn't so theoretical for William Shakespeare," whose powerful queen, Elizabeth I, might have responded definitively to a stage portrayal of her father (Charles).[3]

Focusing on the distinctions between historical and biographical novels, Michael Lackey has argued that whereas "the ideal character of a historical novel," according to Georg Lukács's 1937 definition, is "supposed to symbolically represent [...] the objective social and political forces of the age," biographical novelists "gravitate towards quirky characters that defy their age and function as forward-thinking agents of change" (2017, p. 4). In a nuanced analysis of the strengths of biofiction, Lackey maintains that "for the author of biofiction, of utmost importance is the artist and his or her creative vision and not the historical past or the biographical subject," because such novelists "do not pretend to give readers unadulterated historical or biographical truth" (2019, "Agency Aesthetics," pp. 6–7). Indeed, one of the biographical novelists interviewed by Lackey concludes that "readers don't come to biographical fiction for truth. They come to biographical fiction for possibilities." In Lackey's own words, "biographical novelists use rather than do history" (2019, "Agency Aesthetics," pp. 8, 15).

At the same time, while we celebrate the growing body of scholarship about biofiction that treats female figures, and considers contemporary novelists such as Emma Donoghue and Margaret Atwood, it is important to note a more reductive creative trend that compounds the unevenness of attention to early modern women as subjects, let alone as creators in their own right. Many existing novels about Renaissance women picture them in relation to powerful men – as lovers, mistresses, wives, or daughters – "legitimating" attention to these women by positioning them in direct relation to already canonical or culturally powerful men.[4] Popular examples

3 For another journalist's take, arguing that a "new kind of historical fiction has evolved to show us that the past is no longer merely prologue but [the] story itself," see Megan O'Grady.

4 Lackey acknowledges that biographical novelists frequently take "liberties with the biographical subject in order to project their own creative vision" (2016, p. 7).

include the wives of Henry VIII and invented characterizations of the "Dark Lady" believed to be Shakespeare's muse.[5]

By contrast to this trend, the essays in *Authorizing Early Modern European Women* focus attention upon early modern women as creators and practitioners. The volume sheds light upon women who authored their own visions, whether individually or communally, and who have in turn been "authored" and "authorized" by modern writers interested in shedding light on their stories. While the #MeToo attention to women's voices might suggest a healthy market in popular culture for representations of the struggles and triumphs of earlier women, the varied range of twenty-first-century fictionalizations suggests a more complicated interrelation between celebrating women and perpetuating popular stereotypes, which includes suppressing historical facts in the effort to entertain.

The essays gathered here explore these intersections with regard to the lives and works of early modern women across western Europe. The geographical exception is the Mexican poet and nun Sor Juana Inés de la Cruz, included because she is considered the last great writer of the Spanish Baroque, and colonial Mexico (Nueva España / New Spain) was then part of the Spanish monarchy. The essays are grouped by theme, rather than by genre, chronology, or person, in order to draw out related conceptual topics: *Fictionalizing Biography, Materializing Authorship, Performing Gender,* and *Authoring Identity.* We hope that readers will find connections within and across thematic categories.

The essays in the first section, *Fictionalizing Biography,* directly address challenges associated with modern fictionalizations. The opening pair of essays examine novels that fictionalize the Spanish saint Teresa of Ávila and the Flemish painter Levina Teerlinc, emphasizing the women's significance in their own era while reflecting twenty-first century concerns with gender. In the initial piece, "*Sister Teresa*," Bárbara Mujica explains the ways in which she dealt with the issue of fictionalizing a saint, such as drawing on Teresa's letters and inventing a fictional nun as foil, in order to remain respectful of Teresa's status as a saint and still create a vibrant, exciting novel with sexual tension and current questions about gender and spirituality. Catherine Padmore, in "Portrait of an Unknown Woman," explores Levina Teerlinc's

5 One of the most lauded recent biographical novelists, Hilary Mantel, can be said to perpetuate this pattern in her treatment of Anne Boleyn in relation to powerful men who surround her, from Thomas Cromwell to Henry VIII, whose lives are the primary focus of the novel (*Bring Up the Bodies,* 2012). For analysis of biofiction about Aemilia Lanyer, represented as Shakespeare's Dark Lady, see the essays in this volume by Susanne Woods and Hailey Bachrach.

life and artistic legacy and analyzes the ways Teerlinc is imagined in five novels – often as a supporting character or in relation to male miniaturist Nicholas Hilliard – and how at the same time the "lost" Teerlinc is being made visible again through works that affirm female agency and signify ongoing concern about gender inequities among artists.

By contrast, in "An Interview with Dominic Smith, Author of *The Last Painting of Sara de Vos*," Frima Fox Hofrichter, a consultant to Smith, speaks with the novelist about his fictional Dutch painter Sara de Vos, her name drawn from a guild painter for whom no works survive and her character modeled on the actual Judith Leyster. Hofrichter explores with Smith the methods he used to capture the seventeenth century and juxtapose it so strikingly with the twenty-first.

The final pair of essays in this section reflect on myths that have been extended in recent biofictions. Susanne Woods, in "Lanyer," considers modern fictionalizations of poet Aemilia Lanyer, including two plays and three novels that perpetuate the myth of Lanyer as Shakespeare's Dark Lady, despite the absence of any historical evidence, because such myth-making both responds to and feeds popular assumptions about women deemed interesting when situated in (sexual) relation to famous men. Woods asks whether it matters when writers base their fiction on an earlier fiction that is so pervasive as to seem historical fact. Similarly, in "Archival Bodies, Novel Interpretations, and the Burden of Margaret Cavendish," Marina Leslie examines myths perpetuated by both scholars and novelists when records are incomplete and inconsistent. She focuses on two novels that incorporate the discredited characterization of Cavendish as "Mad Madge" and suggests how scholars and novelists alike "read" and reproduce Cavendish.

The second section, *Materializing Authorship*, attends to early modern women who themselves materialized their lives through a range of Renaissance artforms. In the opening essay, "Bess of Hardwick," Susan Frye explores Bess's embroidered room-sized hangings featuring mytho-historical women as autobiography in textiles. Frye argues that modern biographers and novelists have re-created Bess in stereotypically gendered ways, overlooking both her artistry and her own questioning of gender roles. In "The Queen as Artist," Sarah Gristwood treats modern representations of Mary Queen of Scots and Elizabeth I, two queens who were practitioners of their own arts as well as rulers of their respective realms, finding spaces for self-expression in writings and needlework. The essay queries to what degree those later fictions, whether on page or screen, were prefigured or contradicted by their own versions of their stories.

The desire to materialize one's life story through narratives can be identified as well in the plays, poetry, and prose produced by Mary Sidney Herbert and her goddaughter Mary (Sidney) Wroth, whose lives and stories are currently available to modern audiences largely through biographies, while biofiction about these figures has recently appeared or is under way. Complementing one another in their attention to these two women, the following two essays consider how biofiction can and must differ from biography, particularly in instances that address early modern women creators. In "'Very Secret Kept'," Marion Wynne-Davies explores the difficulties faced by literary biographers, focusing on an analysis of two key aspects of literary biography in Margaret P. Hannay's works: verifiable facts and the imaginative recreation of events. In "Imagining Shakespeare's Sisters," Naomi J. Miller introduces her debut novel about Mary Sidney Herbert, *Imperfect Alchemist,* as an example of how biofiction can differ from biography in imagining and making visible both individual convictions and strategies of authorship that worked to challenge and transform popular assumptions about gender in another era. In the final essay, "Anne Boleyn, Musician," Linda Phyllis Austern examines the close interplay among history, biography, fiction, the performing arts, and material culture in characterizing Anne Boleyn not primarily as the wife of a powerful man, but as a reputedly skilled musician and composer.

Biofiction on the topic of early modern women rulers has a long history in film and on stage, as Sarah Gristwood notes. One thinks of Glenda Jackson in the BBC 2 *Elizabeth R* (1971) and Bette Davis in *The Private Lives of Elizabeth and Essex* (1939). Stage history is even longer and includes *Mary Stuart*, a play by Friedrich Schiller that was first performed in Weimar in 1800. Mary's story as found in Schiller's play went on to be reworked into an opera by Gaetano Donizetti in 1835. However, the early modern women treated in the third section of this volume, *Performing Gender*, are only now coming into their own on screen and stage. In "Artemisia Gentileschi Speaks to the Twenty-First Century," Sheila T. Cavanagh considers dramatic formats that have ranged from a one-woman show to full production tours and, during the pandemic, electronic Zoom scenes, in three productions circa 2020, exploring how these productions translate Artemisia's creations and painful personal story into powerful contemporary theater.

The next two essays reflect approaches to performing early modern women and gender. Hailey Bachrach, in "Beyond the Record," analyzes the stage play *Emilia*, whose popularity with audiences at the Globe Theater and London's West End arose in part from its identification (again) of Aemilia

Lanyer as Shakespeare's Dark Lady. Bachrach deals with the tensions that arise when a playwright constructs a strong secular feminist biofiction that "erases" the early modern religious feminism of its subject, as well as the feminist scholarship that brought her to attention. Bachrach goes on to take the measure of social media response.

The one-woman-show format served Karen Eterovich well as she projected the fiery passion of Aphra Behn for nearly two decades, starting in the mid-1990s. James Fitzmaurice, in "Writing, Acting, and the Notion of Truth," considers the degree to which Eterovich's monologue rings true, is "on the nose," in relation to Behn's letters on which it is based. In Fitzmaurice's 2017 play on Margaret Cavendish, his student actor, Emilie Philpott, dealt with the demands of truthful depiction in contrast to dramatic surprise, when she "jumped the shark." Fitzmaurice explores whether a fully truthful play or screenplay is always as effective as one that is "just a bit slant."

In the final essay in this section, "Jesusa Rodríguez's Sor Juana Inés de la Cruz," Emilie L. Bergmann treats two audacious and successful plays performed over decades in which playwright, actor, and activist Rodríguez portrays colonial Mexican nun and poet Sor Juana as a feminist intellectual. One play is contemporary political satire, and the second a one-woman performance of Sor Juana's complex *Primero sueño*, a poem that Rodríguez hopes to make accessible to all Mexicans. If performance-based biofiction of the lives of early modern women writers is only a recent phenomenon, it is certainly plentiful.

Section four, *Authoring Identity,* ranges across media to consider early modern women practitioners of poetry, painting, autobiography, and midwifery, from the courtesan poet Veronica Franco and the visual artists Sofonisba Anguissola and Artemisia Gentileschi, to letter writer and royal claimant Lady Arbella Stuart, and two seventeenth-century midwives, Jane Sharp and Sarah Stone. It explores how these early modern women created identities through their works and how biographers and biofiction authors have employed (or failed to employ) the works to re-create the subjects for modern audiences. In the opening essay, "From Hollywood Film to Musical Theater," Margaret F. Rosenthal considers how Veronica Franco's literary works have been reduced for popular consumption, as a screenplay that attempted to draw attention to Franco's courageous advocacy for women's equality and autonomy became a film focused on a love story privileging male power.

By contrast, Julia Dabbs in "The Role of Art in Recent Biofiction on Sofonisba Anguissola" analyzes two novels in which authors bring Anguissola's

artworks, their creation and her processes, into the novels as key elements of plot and character. Since both novelists make illustrations available through print or electronic media, Dabbs, in a Renaissance *paragone*, or debate, compares the use of image and word in the art of re-creating an artist's identity. In "'I am Artemisia,'" Stephanie Russo similarly explores female creativity and identity, in this case in a young adult novel for the #MeToo generation, suggesting that Artemisia's first-person narration and talent for capturing the trauma of rape in paint can act as a conduit for the history of women's suffering at the hands of men and reassure young women about the potential for recovery. In "The Lady Arbella Stuart, a 'Rare *Phoenix*',", Sara Jayne Steen explores the relationship of biography and fiction in selected re-creations of the Lady Arbella across the centuries, noting how an author's era influences the presentation of Arbella's character and identity (particularly at times when women's roles are undergoing reassessment) and considering the evolution and intersection of biography and biofiction as fields.

Arriving full circle from the growing but still too often missing attention to biofiction about women that spurred the creation of this volume, the final essay, "*The Gossips' Choice*," is authored by Sara Read, a novelist who drew on the published writings of midwife Jane Sharp and the case notes of the otherwise-unknown Bristol midwife Sarah Stone to create an invented (but historically compelling) character for modern audiences. This essay supports the critical framework for the volume as a whole, expanding on Lackey's definition to make the case that biofiction's protagonists need not be named after discrete historical figures to be significant.

Viewing diverse authorial strategies across its thematic sections, the volume offers readers an opportunity to consider how modern creators of biography and biofiction about women face cultural challenges in exploding stereotypes, while celebrating early modern women creators who forged their own opportunities for materializing authorship, performing gender, and authoring identity. Given Michael Lackey's observation that biographical novelists take liberties with the biographical subject in order to project their own creative vision, it becomes all the more notable to consider those biofiction authors who offer what might be termed a three-dimensionalized treatment of early modern women as creators that incorporates the modern writer's vision as well as the vision embodied in the early modern woman's own creations. Exceptional in their modern attention to early modern women as creators, then, the authors and their subjects surveyed in this volume exemplify an array of biofictional practices for the modern age.

Works Cited

Charles, Ron. "Alan Dershowitz Claims a Fictional Lawyer Defamed Him." *The Washington Post*, 6 August 2020. https://www.washingtonpost.com/entertainment/books/alan-dershowitz-claims-the-good-wife-defamed-him-the-implications-for-fiction-writers-are-very-real/2020/08/05/703e7106-d699-11ea-aff6-220dd3a14741_story.html. Accessed 9 September 2020.

Lackey, Michael. "Locating and Defining the Bio in Biofiction." *a/b: Auto/Biography Studies*, vol. 31, no. 1, 2016, pp. 2–10. Subsequently published as the volume introduction to *Biofictional Histories, Mutations and Forms*, edited by Michael Lackey. New York: Routledge, 2019.

Lackey, Michael. "Biofiction – Its Origins, Natures, and Evolutions." *American Book Review*, vol. 39, no. 1, 2017, pp. 3–4.

Lackey, Michael. "Introduction: The Agency Aesthetics of Biofiction in the Age of Postmodern Confusion." *Conversations with Biographical Novelists: Truthful Fictions Across the Globe*, edited by Michael Lackey. New York: Bloomsbury, 2019, pp. 1–21.

O'Grady, Megan. "Why Are We Living in a Golden Age of Historical Fiction?" *New York Times Style Magazine*, 7 May 2019. https://www.nytimes.com/2019/05/07/t-magazine/historical-fiction-books.html. Accessed 9 September 2020.

About the Authors

James Fitzmaurice is emeritus professor of English at Northern Arizona University and honorary research fellow at the University of Sheffield. He has published a great deal on Margaret Cavendish, and his screenplays have been selected for or won prizes at many film festivals.

Naomi J. Miller is Professor of English and the Study of Women and Gender at Smith College. She has published award-winning books on early modern women and gender, and teaches courses on Shakespeare and his female contemporaries. *Imperfect Alchemist* (Allison & Busby, 2020) launches a series of novels called *Shakespeare's Sisters*.

Sara Jayne Steen has authored and edited five volumes largely on early modern women and theater, including *The Letters of Lady Arbella Stuart*, and has received awards for teaching and scholarship. She was faculty member, chair, and dean at Montana State University and is president emerita of Plymouth State University.

Section I

Fictionalizing Biography

2. *Sister Teresa*: Fictionalizing a Saint

Bárbara Mujica

Abstract

Tension between fact and fiction is at the crux of any biographical novel. When I wrote *Sister Teresa*, based on the life of the sixteenth-century saint Teresa of Ávila, I conducted extensive research on her life and the minutiae of everyday life in sixteenth-century Spain. Yet, although biographical fiction must necessarily draw on fact, the author must sift through fact to ascertain what is relevant to the portrayal of a deeper dramatic truth. Rather than an accurate representation of their subject's life, bio-novelists seek to convey the essence of the subject's personality, which may require them to modify facts. Rather than feign objectivity, I invented an unabashedly opinionated narrative voice for *Sister Teresa* – an unreliable narrator named Sister Angélica.

Keywords: Teresa of Ávila (de Jesús), biographical fiction, unreliable narrator, historical fiction, Discalced Carmelites, early modern Spanish women

When I wrote my biographical novel *Sister Teresa,* based on the life of the sixteenth-century saint Teresa of Ávila, I wanted to be respectful of the millions of people who venerate her. I didn't want to besmirch her reputation, yet I was anxious to create a vivid, exciting character and a saleable book. My previous novel, *Frida,* based on the life of Frida Kahlo, had been a bestseller. However, Kahlo was a sexual and social rebel, so turning her into a colorful character was relatively easy. In the case of Teresa, I had to humanize the saint and also build into the plot the adventure, romance, sexual tension, and mystery that a novel requires.

What drew me to Teresa was her spiritual message. At the beginning of *Las Moradas* ("The Interior Castle") she invites us to "consider our soul to be like a castle made entirely out of a diamond or of very clear crystal, in

Fitzmaurice, J., N.J. Miller, S.J. Steen (eds.), *Authorizing Early Modern European Women. From Biography to Biofiction.* Amsterdam: Amsterdam University Press, 2022

DOI 10.5117/9789463727143_CH02

which there are many rooms, just as in heaven there are many dwelling places" (1980, p. 283). By moving inward, through the different chambers, we eventually reach the innermost room, where God resides. For Teresa, finding God was not a matter of rituals and prayers mechanically performed, but of moving deeper into oneself, toward one's own spiritual core.

In 1562, Teresa formed a new religious order, the Discalced Carmelites, which fostered cultivation of the inner life. Teresa describes her spiritual journey in her treatises, but these were written at the behest of spiritual directors, who censored them and even rewrote passages. Her letters provide more insight into her personality, and my interest in her epistolary writing led me to embark on a scholarly study, later published as *Teresa de Ávila, Lettered Woman*. At the same time, I commenced writing my novel, *Sister Teresa*.

Teresa's letters reveal a strong-willed, temperamental woman, who was deeply spiritual, yet practical and shrewd. She could be very funny, but her humor could be biting. Once she teased her close friend Jerónimo Gracián about his lack of riding skill: "It would be good if they tied you to the saddle so that you couldn't fall" (2001, October 1575, p. 235). Although she was usually tactful when writing to powerful men, if she was angry with a nun, she made no attempt to hide it.[1]

Although a scholarly study and a work of fiction both emerged from the same research, the processes for producing them were different. A scholarly work attempts to unearth and interpret facts. The author seeks objectivity, even though we know that one's interpretation of historical material is always colored by the current zeitgeist and one's personal biases. Fiction, in contrast, seeks to entice and engage the reader through the communicative force of fantasy (Vargas Llosa, p. 10). In analyzing Teresa's letters for *Lettered Woman,* I looked for themes, historical context, language usage, choice of correspondents, and methods of self-representation. I sought factual answers to specific questions: How many letters did Teresa actually write? What percentage of her letters were addressed to which recipient? Although some of this research proved useful for the novel, fiction requires more in-depth knowledge of everyday life. In order to write a segment in *Lettered Woman* on Teresa's correspondence with Doña Luisa de la Cerda, it was not necessary for me to know what kind of farthingale Doña Luisa wore. However, to create a well-rounded fictional portrait of Doña Luisa for *Sister Teresa*, I had to learn about the clothing, eating habits, leisure activities, and even the bathroom practices of the

1 See my *Teresa de Ávila, Lettered Woman*, pp. 170–172.

Spanish aristocracy. In addition to reading cultural studies and early chronicles, I studied portraits, costumes, and royal menus. To bring the nuns to life, I had to learn about the daily routine in a sixteenth-century Spanish convent.

The tension between truth and invention permeates any kind of historical fiction. Thomas Mallon insists that an author must not alter historical fact: "historical events happened one way and one way only" (p. 61). In fact, fiction writers must aspire to even broader knowledge of the past than historians, so that "in rendering speech and behavior and even the brand names on the breakfast table" they can "give a more palpable picture of [...] the way we lived then" (p. 62). Yet, argues Daniel Kehlmann, the obsession with historical accuracy is ultimately fruitless. Kehlmann contends that the historical novel does not really exist, for novelists always view the past from the standpoint of the present. Because novelists are products of their own historical time and place, they can never emulate convincingly the speech and mindset of characters from another period and culture (2007). The best authors can do is try to remain faithful to the perspective of their characters, avoiding anachronistic concepts (Kehlmann, 2020). Exhaustive descriptions of items that to us are exotic, but to our characters are commonplace, only highlight the artificiality of the narrative.

Although much of this discussion is applicable to the biographical novel, historical and biographical fiction are not the same thing. While the historical novel focuses on the events of a particular time period, biofiction seeks to portray a person. Georg Lukács's highly influential 1937 study, *The Historical Novel*, defines the genre as a literary form that portrays the social, economic, and ideological tensions that shape a period and lead to determinative events. Lukács rejected the biographical novel because its "excessive focus on the psychological subject's interiority necessarily distorts and misinterprets the objective proportions of history" (Lackey, 2017, p. 1).

Today, this focus on the subject's psychic reality is precisely the attraction of biofiction. David Lodge has called the novel "the supreme form of art for representing consciousness because it can go into the heads of characters" (p. 120). Although bio-novelists cannot know what their subjects were thinking at any particular moment, they "can use the clues that are available" (Lodge, p. 120). Teresa's sizable epistolary corpus provides ample clues about what she thought about myriad subjects, from bad confessors to the dangers of sarsaparilla water. Joanna Scott has called the biographical novel a form of portraiture (p. 102). The bio-novelist seeks to paint the psychological landscape of the subject, and, in so doing, argues Michael Lackey, transforms the subject into a symbol, or myth, that conveys a universal truth (2017,

p. 236). Consequently, the struggles of the character speak to others on a highly personal level. Kehlmann says that as a German[2] who once lived in Mexico, he felt an intimate connection with the explorer Alexander von Humboldt, one of the protagonists of his novel *Die Vermessung der Welt* ("Measuring the World"), whose awe before the "otherness" of Latin America permeates the story (2006). Thus, the more personal and intimate the portrait, the more universal it becomes.

In recent years, postmodernism has called into question the very notion of historical truth, and this blurring of the boundary between fact and fiction is what has made biographical fiction possible, according to Lackey (2014, p. 2). Defenders of postmodernism see history as a construct reflecting the biases of historians, who use the same interpretative devices as novelists. In order to create truthful portraits, bio-novelists alter facts, says Lackey, and this is permissible, "so long as the writer remains true to certain symbolic truths" (2016, p. 15). And yet, biographical fiction must necessarily draw on fact even though fact will always be filtered through the mind of the author. In other words, there is no such thing as pure fact or pure fiction. Furthermore, although novelists use fact, they must always winnow it, mold it, and sift out what is irrelevant in order to capture "dramatic truth" (Lackey, 2016, p. 7). If biofiction is not history, it is also not biography. While biographers seek to create accurate representations of their subjects' lives, bio-novelists seek to convey the essence of their subjects' personalities, which may require them to modify or twist facts.

Long before the advent of postmodernism, philosophers argued that it is impossible fully to know the inner reality of another human being, or even our own; we can only know outer manifestations. Because bio-novelists must inevitably come to terms with their inability to see the world through their protagonists' eyes, they must seek ways to compensate. My own solution was to build subjectivity into the structure of my novel. In approaching Teresa de Ávila, I asked myself: What would it be like to know this woman who went into trances, saw visions, and heard locutions? What would it be like to be sitting at the table next to someone who claimed to levitate? Would you be afraid she might finish her supper up among the rafters? I realized that I could never really delve into Teresa's mind; I would always be a subjective observer of her words and actions.[3] However, the same would be true of a person living in her own time – say, a fellow nun who shared her Catholic beliefs, yet remained skeptical of her more

2 Kehlmann was born in Munich in 1975, and holds both German and Austrian nationality.
3 On building subjectivity into biofiction, please see my article, "Going for the Subjective."

implausible claims. We know from Teresa's own autobiographical writing that diverse opinions existed about her visions and locutions. I needed a vehicle to voice these distinct perspectives about Teresa, a subjective narrator to serve as her foil.

As an early modern scholar, I turned for guidance to Cervantes. In *Don Quijote*, an unreliable narrator throws into question the very notion of accessibility to truth by claiming to base his narrative on several conflicting sources, thereby forcing the reader to doubt the veracity of the text. Although Don Quijote is fictional, Cervantes writes as though his protagonist were a real person, whose life had been documented – that is, as if it were a work of biofiction. What Cervantes drives home is that subjectivity is unavoidable in biographical fiction. Rather than feign objectivity, I decided to invent an unabashedly opinionated narrative voice for *Sister Teresa,* an unreliable narrator who would provide me with an alternative perspective, one that is clearly not the protagonist's. The introduction of a fictional narrator, Sister Angélica, provided me with the freedom to interpret my material with no pretense to objectivity.

Angélica is very different from Teresa. While Teresa is rich and beautiful, Angélica is poor and plain. She is also smart, perceptive, and completely down-to-earth. When Teresa has visions and ecstasies, Angélica grapples with how to react. Because Teresa's flights of mysticism are so alien to her, Angélica often loses patience. Angélica loves Teresa as a mentor, friend, and spiritual sister, but watches her raptures and mortifications with a degree of cynicism. She is intimate enough with Teresa to observe and narrate her life story, yet distant enough to provide a personal commentary that, at times, conflicts radically with Teresa's own perceptions.

Hannah Kent, who has written bio-novels about murderesses, says that in her works she aims to address stereotypes. Her objective is not to revamp her subjects as misunderstood innocents, but to unearth the ambiguities in their personalities and thereby to call into question the notion of a single truth – that is, to open up "the possibility of heterogeneous or multiple 'truths'" about a subject (p. 108). In writing about a saint, I faced the same kinds of preconceived notions about my protagonist as did Kent. Angélica provides insight into Teresa's ambiguities by constantly offering alternative and contrasting perspectives. As an unreliable narrator, Angélica makes us doubt not only Teresa's perceptions, but also her own. Angélica is not always certain she sees things clearly or remembers things correctly, which adds layers of uncertainty to the narrative. When several nuns claim to have seen Teresa levitate, Angélica, without denying that levitation is possible, maintains that she has never witnessed it. When workmen insist that Teresa

has miraculously resuscitated a dead child, Angélica tells the story in such a way that a rational explanation is conceivable.

Angélica's skepticism does not diminish Teresa's greatness, but simply shows that there is more than one way to understand certain phenomena. Stephen Greenblatt explains that historical fiction "offers the dream of full access, access to what went on behind closed doors, off the record, in private." Novels do not merely recount what happened; they fill in the blanks. Did the nuns of Incarnation actually huddle to discuss Teresa's claim that the Virgin appeared to her? I can't know for sure, but, based on my reading, I imagine that they did.

Another of Angélica's functions is to provide the sexual tension that this novel about nuns needed. Teresa herself mentions sex directly only in a letter to her brother Lorenzo, who complains of feeling aroused during intense prayer. Teresa is sympathetic, but denies having such feelings herself (2001, 17 January 1577, p. 475).[4] Based on Teresa's vague mention in *El libro de la vida* ("The Book of Her Life") of her relationship with a male cousin before she entered the convent, Antonio T. de Nicolás and Victoria Lincoln assert that she "was not a virgin" when she took vows (Nicolás, p. xiv; Lincoln, p. 15). However, the reference is too equivocal to justify such a conclusion. Scholars and artists have been especially intrigued by the erotic imagery Teresa uses to describe her visions – in particular, the *Transverberation*, in which an angel pierces her heart with a flaming arrow, causing pain so great that it made her moan (1987, *Life* 30: pp. 13, 252). *The Ecstasy of Saint Teresa*, Bernini's famous statue, depicts the Saint in a kind of orgasmic stupor, mouth agape, eyes closed, her habit draped sensuously around her, while an angel stands over her with his spear pointing at her body. This image influenced several modern filmmakers. Nigel Wingrove's 1989 *Visions of Ecstasy* shows Teresa first in a lesbian encounter and then with her legs straddled around Jesus, and in his iconoclastic film *Teresa, el cuerpo de Cristo* (2007), Ray Loriga reduces Teresa's mystical experiences to mere sexual fantasies. Rather than sexualize Teresa, I decided to make Angélica the focus of a novelistic erotic adventure. Unattractive and clumsy, Angélica is nevertheless a woman of strong carnal appetites. When the handsome friar Braulio begins to woo her, she easily falls prey to his wiles. Convent chronicles contain numerous examples of seduction and deceit, so Angélica's tale of an affair with a friar who rapes her when she tries to end the relationship is perfectly plausible.

Angélica also served to highlight Teresa's Jewish background. For centuries, the myth prevailed that Teresa was from an aristocratic, "old

4 For a discussion of this letter, see Mujica, *Teresa de Ávila, Lettered Woman*, p. 136.

Christian" family – that is, one "unstained" by Semitic blood. However, in 1986, Teófanes Egido published documentation proving that both her father and grandfather were *conversos*, Jewish converts to Catholicism. The historical Teresa never wrote about her Jewish ancestry, and some scholars believe that she actually knew nothing about it. Many *conversos* were so sensitive about their lineage that they kept it secret, even from their own children – unsurprisingly, as *conversos* were prime targets of the Inquisition. In *Sister Teresa*, Angélica hears gossip about Teresa's Jewish roots, yet the two women never speak openly about it. However, Braulio, who has also heard the gossip, threatens to expose Teresa's Jewish identity if Angélica doesn't submit to his demands. The whispers about Teresa's *converso* lineage serve to build suspense, for the threat of persecution hovers over the narrative.

One of the key challenges in writing a story set in the past is language. How to write dialogue when the colloquialisms of sixteenth-century Spanish present challenges even to specialists? Some authors attempt to convey the "otherness" of the past by writing in a reconstituted version of period language (Erica Jong, in *Fanny*; and Geraldine Brooks, in *Year of Wonders*), but the result seems artificial and forced. As usual, I looked to Cervantes for a solution.

The fictional narrator of the first part of *Don Quijote* (1605) claims as his main source a manuscript written in Arabic. The text is suspect not only because Moors are reputedly dishonest, but also because the narrator must read it in translation. This requires an additional layer of interpretation, which distances it still further from the truth. In *Sister Teresa*, I placed a fictional author in a similar situation. The novel begins: "I found this manuscript in Dijon, in a tiny antiquarian's shop" (p. 5). The manuscript turns out to be Sister Angélica's spiritual diary, which recounts Teresa's story. The fictional author decides to translate it into modern (rather than archaic) English because "Sister Angélica wrote as she spoke, in a colloquial Spanish that would have been easily accessible to readers of her time" (p. 8). The age-old ploy of the found manuscript enabled me to justify my linguistic choices and to enhance the inherent subjectivity of the account.

A few years after *Sister Teresa* was published, The Actor's Studio, in Los Angeles, adapted it for the stage. Then, in 2017, the novel was published in Spanish. Both the stage adaptation and the translation involved new fictionalizations of Teresa, for, whether we are praying, writing, adapting, or translating, in order to access her message, we must necessarily pass her through the filter of our own imaginations.

Works Cited

Brooks, Geraldine. *Year of Wonders: A Novel of the Plague.* New York: Viking, 2001.

Cervantes, Miguel de. *Don Quijote de la Mancha I*, edited by John Jay Allen. Madrid: Cáteddra, 2000.

Egido, Teófanes. *El linaje judeoconverso de santa Teresa.* Madrid: Espiritualidad, 1986.

Greenblatt, Stephen. "How It Must Have Been." Review of *Wolf Hall*, by Hilary Mantel. *New York Review of Books*, 5 November 2009. https://www.nybooks.com/articles/2009/11/05/how-it-must-have-been/. Accessed 30 July 2020.

Jong, Erica. *Fanny: Being the True History of the Adventures of Fanny Hackabout-Jones, a Novel.* New York: Norton, 2003.

Kehlmann, Daniel. *Die Vermessung der Welt.* Reinbek: Rowohlt, 2005.

Kehlmann, Daniel. "Ich wollte schreiben wie ein verrückt gewordener Historiker." *Frankfurter Allgemeine Faz.Net*, 9 February 2006. https://www.faz.net/aktuell/feuilleton/buecher/bucherfolg-ich-wollte-schreiben-wie-ein-verrueckt-gewordener-historiker-1304944.html. Accessed 4 June 2020.

Kehlmann, Daniel. "Out of this World." *Guardian*, 21 April 2007. https://www.theguardian.com/books/2007/apr/21/featuresreviews.guardianreview30. Accessed 5 June 2020.

Kehlmann, Daniel. "Interview with Zadie Smith." *92Y*, 27 February 2020. https://www.92y.org/archives/daniel-kehlmann-zadie-smith. Accessed 4 June 2020.

Kent, Hannah. "Fictions of Women." Hannah Kent, interviewed by Kelly Gardiner. *Conversations with Biographical Novelists: Truthful Fictions Across the Globe*, edited by Michael Lackey. New York and London: Bloomsbury, 2019, pp. 105–118.

Lackey, Michael, ed. *Truthful Fictions: Conversations with American Biographical Novelists.* London: Bloomsbury, 2014.

Lackey, Michael. *The American Biographical Novel.* New York and London: Bloomsbury, 2016.

Lackey, Michael, ed. *Biographical Fiction: A Reader.* New York and London: Bloomsbury, 2017.

Lackey, Michael, ed. *Conversations with Biographical Novelists: Truthful Fictions Across the Globe.* New York and London: Bloomsbury, 2019.

Lincoln, Victoria. *Teresa, A Woman: A Biography of Teresa of Avila.* Albany: State University of New York Press, 1984.

Lodge, David. "The Bionovel as a Hybrid Genre." David Lodge, interviewed by Bethany Lane. *Conversations with Biographical Novelists: Truthful Fictions Across the Globe*, edited by Michael Lackey. New York and London: Bloomsbury, 2019, pp. 119–129.

Mallon, Thomas. "The Historical Novelist's Burden of Truth." *In Fact: Essays on Writers and Writing.* New York: Knopf/ Doubleday, 2012. Reprinted in *Biographical Fiction: A Reader*, edited by Michael Lackey. New York and London: Bloomsbury, 2017, pp. 60–63.

Mujica, Bárbara. *Sister Teresa.* New York: Overlook, 2007. Paperback: New York: Penguin, 2008. Spanish Edition: Santiago, Chile: Cuarto Propio, 2017.

Mujica, Bárbara. *Teresa de Avila, Lettered Woman.* Nashville: Vanderbilt University Press, 2009.

Mujica, Bárbara. "Going for the Subjective: One Way to Write Biographical Fiction." *A/B: Auto/Biography Studies*, vol. 31, no. 1, 2016, pp. 11–20. doi.org/10.1080/089 89575.2015.1083217.

Nicolás, Antonio T. "Introduction." *Teresa, a Woman: A Biography of Teresa of Avila,* by Victoria Lincoln. Albany: State University of New York Press, 1984, pp. xi–xxi.

Scott, Joanna. "On Hoaxes, Humbugs, and Fictional Portraiture." *a/b Auto/Biography Studies* vol. 31, no. 1, 2016, pp. 27–32. doi:10.1080/08989575.2015.1083239.

Teresa de Ávila (de Jesús). *The Collected Works of Teresa de Ávila* (3 vols). Translated by Kieran Kavanaugh, O.C.D. and Otilio Rodríguez, O.C.D., Washington, D.C.: Institute of Carmelite Studies, 1976–1985; vol. 1 (1976, revised ed. 1987); vol. 2 (1980).

Teresa de Ávila (de Jesús). *Epistolario.* Edited by Luis Rodríguez Martínez and Teófanes Egido. Madrid: Espiritualidad, 1984.

Teresa de Ávila (de Jesús). *The Collected Letters of Teresa of Ávila* (2 vols). Translated by Kieran Kavanaugh, O.C.D., Washington, D.C.: Institute of Carmelite Studies, 2001–2007; vol. 1 (2001).

Vargas Llosa, Mario. *La verdad de las mentiras.* Barcelona: Seix Barral, 1990.

About the Author

Bárbara Mujica, professor of Spanish literature at Georgetown University, is a novelist, short-story writer, and essayist. Her novels include *I Am Venus, Frida, Sister Teresa*, and *Miss del Río*. Her latest scholarly books are *Women Religious and Epistolary Exchange in the Carmelite Reform* (2020) and *Collateral Damage: Women Write about War* (2021).

3. Portrait of an Unknown Woman: Fictional Representations of Levina Teerlinc, Tudor Paintrix

Catherine Padmore

Abstract

The Flemish artist Levina Teerlinc (1510/20–1576) was appointed royal paintrix to the court of Henry VIII in 1546 and continued painting miniatures for the Tudor heirs until her death three decades later. Despite Teerlinc's high profile during her lifetime, her reputation diminished in later centuries. Recent years have seen a sharp rise in scholarly interest in Teerlinc's artistic legacy, as well as an increased fictional presence. Working from the same limited sources, five novels deploy very different versions of "Levina Teerlinc" for distinct purposes. As with other biographical novels of women artists, these shore up the artist's role in public memory, making visible another apparently "lost" or "forgotten" female antecedent while simultaneously reflecting contemporary concerns with continued gender inequities.

Keywords: Levina Teerlinc, biofiction, biographical fiction, early modern women, artist fictions, women artists

Introduction

In 1983, reviewing an English exhibition of Tudor miniatures, art historian Graham Reynolds wrote scathingly and sarcastically about attributions to the Flemish painter Levina Teerlinc: "No doubt for some time after this exhibition we shall see the name Levina Teerlinc used, as here, as a synonym for 'any English miniature painted between 1540 and 1570 and not obviously by Hornebolte, Holbein or Hilliard'" (1983, p. 310). For him, "[T]he chimerical

Fitzmaurice, J., N.J. Miller, S.J. Steen (eds.), *Authorizing Early Modern European Women. From Biography to Biofiction.* Amsterdam: Amsterdam University Press, 2022
DOI 10.5117/9789463727143_CH03

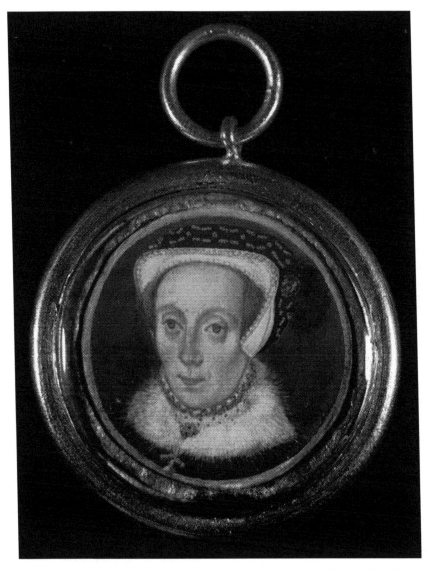

Figure 3.1. *Portrait Miniature of an Unknown Woman*, c. 1560, watercolor on vellum, attributed to Levina Teerlinc (c. 1510/20–1576). © Victoria and Albert Museum, London.

'Levina Teerlinc' so pervades this exhibition that four of the Hilliards are said, without a shred of justification, to be copied from originals by her" (1983, p. 309). In Reynolds's formulation, Teerlinc is a two-fold "chimera": she is the creature formed from many parts (an amalgam of contemporary but as yet unidentified artists), as well as representing "an unfounded conception" ("Chimera").

Here I focus on another aspect of the definition: Teerlinc as an "unreal creature of the imagination," as she is rendered by contemporary fiction writers. To analyze the varied cultural work done in these novels by versions of "Levina Teerlinc," I look first at how she is represented in her own and later times, to chart the changing nature of her reputation, before investigating recent fictional works. In these she is deployed in both small and more significant ways, performing diverse narrative functions. Examining how Teerlinc has been represented in her lifetime, as well as her afterlives in the writings of art historians and fiction writers, provides an opportunity to consider the written trajectory of one artist over centuries, while locating her in wider debates about how women artists are rendered in past and present writings about art.

In her lifetime

The written signifier "Levina Teerlinc" (in its various spellings) appears in the Bruges archives in 1545, when the Flemish artist and her husband, George Teerlinc of Blankenberghe, travel there to finalize affairs after the death of his father (Weale, 1865, p. 147; Weale, 1864–1865, pp. 307–308; Weale, 1906, p. 278). The next archival records for her are English ones – accounts of payments made to her by various Tudor monarchs. The first is from November 1546, when she was awarded a yearly wage of £40: "Mrs. Levyna Terling, paintrix, to have a fee of 40 l. a year from the Annunciation of Our Lady last past during your Majesty's pleasure" (Gairdner and Brodie, p. 227; Auerbach, p. 51). Elizabeth I made the annuity lifelong in October 1559, and back-paid arrears (Auerbach, pp. 103–104; Public Records Office, p. 41). To contextualize this yearly amount, Teerlinc received more than either of the esteemed painters Hans Holbein and Lucas Horenbolte, who preceded her at the English court. Holbein's annual wage was £30 (Auerbach, p. 50). Horenbolte was on a monthly salary of 55s 6d, or just under £34 a year (Auerbach, p. 50). Nicholas Hilliard, a painter whose name retains a great deal more cachet in our time, seems to have worked for the queen from the early 1570s, yet he only received an annuity of £40 in August 1599 (Blakiston, p. 188), when he was in his fifties. This was the same amount as Teerlinc received but by then it would have been much reduced in real-world value.

The surviving archives show Teerlinc giving works regularly as new year gifts to royalty. In 1556 she gave Queen Mary a "smale picture of the Trynite" (Town, p. 172). In Elizabeth's time Teerlinc is listed as one of the Queen's gentlewomen, giving paintings and receiving gifts in all ten extant New

Year's Gift Rolls up to her death (Lawson, passim). Her paintings are often noted as "with the Quene" (Lawson, p. 192), used to indicate those gifts "that caught the Queen's eye" (Lawson, p. 19). Such measures of esteem are well-noted in studies of Teerlinc; what is less remarked upon is her place within the court hierarchy as figured in the meticulously ordered accounts, where the gifts to Teerlinc are substantially smaller than those received by many other gentlewomen. Auerbach notes Teerlinc's dual social position as both painter and gentlewoman (p. 104); the gift records may reflect this tension. Despite this caveat, surviving documents demonstrate Teerlinc was highly valued and highly paid, and that she occupied a respected position in court life across the reigns of four Tudor monarchs.

Beyond England, Teerlinc's reputation traveled widely. Her contemporary, Italian Lodovico Guicciardini (1521–1589), named her in his *Description of the Low Countries* (originally 1567), as one of only four "living female artists" included: "The first is Laevina, the daughter of Mr. Simon Bruges, who, like her father, is excellent in miniature; so that Henry VIII also invited her to his court, with high rewards, where she was afterwards splendidly married, and continued in high favour with Mary, and is now in equal esteem with Elizabeth" (pp. 20–21). Despite the erroneous details of Teerlinc's marriage, this account emphasizes the link to her esteemed father, Simon Bening (1483–1561), whom Thomas Kren describes as "the last great Flemish illumina-tor" (p. 448). Another contemporary, Giorgio Vasari (1511–1574), the Italian painter and writer, mentions her in the 1568 edition of his influential *Lives*, with the entry echoing Guicciardini's (Vere, p. 269). Sutherland Harris and Nochlin note that Teerlinc's "fame was still part of the oral tradition when Guicciardini published his account of Flanders almost twenty years after her departure for London" (p. 26), placing her in the category of "international celebrities" (p. 42) and demonstrating that through her working life, Teerlinc's reputation traveled far beyond England's borders.

What was written after

Art historian Roy Strong asserts that Teerlinc's renown faded after her death: "Almost more than any other Tudor artist [...], she was to disappear into total oblivion, so much so that not even a garbled memory of her name remained by the reign of Charles I" (1981, p. 45). Certainly she is not men-tioned by Hilliard in his *A Treatise Concerning the Arte of Limning*, in which he name-checks male artists who influenced him, including Hans Holbein and Albrecht Dürer (Thornton and Cain, pp. 49–53). Hilliard famously

mentions women painters in general, but only to note their particular kind of quicksilver white (Thornton and Cain, p. 71). Instructional manuals that come after quote his recipes and techniques, branded carefully as belonging to "Old Master Hilliard" (Murrell, p. 60).

But Strong's assertion of "total oblivion" (1981, p. 45) is not strictly true. Between the seventeenth and the nineteenth centuries, Teerlinc is a notable presence in key texts about art and artists, in England and abroad. Often these paraphrase Vasari or Guicciardini, complete with the error about Teerlinc's marriage, but many also unearth archival accounts to develop an increased understanding of her life and contribution. Key authors include Antonius Sanderus (1641–1644, vol. 1, p. 210), Horace Walpole (1762, p. 102), John Nichols (vol. 1, p. 249), Bruges artist and chronicler Pieter Le Doulx (1795, p. 218), Octave Delepierre (1840, p. 44), John Gough Nichols (1863, pp. 21–22, 30, 39–40), W. H. James Weale (1864–1865, pp. 307–308; 1865, p. 147; 1906, p. 278), John Bradley (1891, p. 375), and Joseph Destrée (1895, pp. 18–25). During this period Teerlinc comes to be considered in the context of a recovered history of female artists: Elizabeth Ellet's *Women Artists in All Ages and Countries* (pp. 57–58), which Langer calls "the first systematic history, by an American woman, of the lives of women artists and their accomplishments" (p. 58); and Ellen C. Clayton's *English Female Artists* (pp. 5–12). These accounts demonstrate that, contra Strong, Teerlinc was not relegated to "total oblivion" (1981, p. 45), but instead recurs at frequent intervals, in different contexts and put to different uses, and regaining critical mass as the centuries pass.

In the twentieth century

Awareness of Teerlinc increases in the years after 1900, a trend aptly mapped by Google NGram, an analytical function tracking the frequency of certain terms in works harvested by Google Books. The curve for "Levina Teerlinc" shows steep peaks in the term's frequency since then. Continuing the project begun by Ellet and Clayton in the nineteenth century, more recent commentators have sought greater recognition for Teerlinc's position and work. A number of exhibitions developed in H. Diane Russell's "informational" (p. 469) spirit featured Teerlinc, drawing attention to her as an individual – a testimony to her having existed and worked – but also to the wider historical treatment of female artists. Teerlinc was featured in Ann Sutherland Harris and Linda Nochlin's *Women Artists: 1550–1950* (1976), and in Judy Chicago's "Dinner Party" installation (1979). A significant exhibition of Tudor art in the

early 1980s ascribed a number of key works to Teerlinc: *Artists of the Tudor Court: The Portrait Miniature Rediscovered 1520–1620* (Strong and Murrell, 1983). On the millennium's cusp, she was included in a Belgian exhibition of women artists: *A Chacun sa Grâce: Femmes Artistes en Belgique et Aux Pays-Bas 1500–1950* (Van der Stighelen and Westen).

Debates in this period focus on Teerlinc's "role in the development of the portrait miniature in sixteenth-century England" (Sutherland Harris and Nochlin, p. 104): attempting to identify her works and ascertain if she trained Nicholas Hilliard. Uncertainty defines both these debates, which have been so intense during the twentieth century and into the present that it is impossible to do more than outline them here.[1] In 1929 Basil Long was "doubtful if there exists a single miniature which can be certainly attached to this artist" (p. 432). Decades later Katherine Coombs made a similar observation: "[T]here is no consensus that these miniatures are by one hand and that Teerlinc's name can be attached to them" (p. 24). While some artists' *oeuvres* can be confidently asserted, Teerlinc's is harder to firm up.

Fictions of Teerlinc

Structural obstacles to scholarly certainty open up space for speculation, for writing into the gaps, and a number of writers have leaped to fill these lacunae in Teerlinc's story. In our current century five novels featuring this artist appeared within a decade, and this number is striking in itself: Karen Harper, *The Fyre Mirror* (2005); Grace Cavendish (pseudonym for Patricia Finney), *The Lady Grace Mysteries: Feud* (2005/2008); Melanie Taylor, *The Truth of the Line* (2013); along with Elizabeth Fremantle's *Queen's Gambit* (2013) and *Sisters of Treason* (2014).[2] Fremantle notes explicitly that the "unclaimed space in [Teerlinc's] biography" gave her "a good deal [...] to work with" (Ágústsdóttir). In these renderings, Reynolds's "chimerical 'Levina Teerlinc'" (1983, p. 309) morphs into new forms. She is a central point-of-view character in only one of these novels, appearing elsewhere as a supporting player with varying degrees of narrative importance. To line these representations up offers a parallax vision of the different ways

1 See Coombs and Derbyshire, Goldring (pp. 74–77), James (pp. 287–333), Reynolds (1982), Reynolds (1983), Reynolds (2011), Strong (1981), Strong (1983/1984, pp. 54–64), Strong and Murrell (pp. 52–57) and Tittler (pp. 126–127).

2 A sixth novel, Carolly Erickson's *The Favored Queen* (2011), features "Lavinia Terling," but the named character bears no resemblance to Teerlinc's biography and so the novel has not been discussed here.

authors put such a figure to work.[3] Elsewhere I have written about how
the various characteristics of the Tudor paintrix have been deployed by
novelists, including her migrant status, clear vision and ability to move
between worlds (Padmore). Here the varied approaches demonstrate other
ways this artist figure can be put to use, while exhibiting a shared interest
in questions of representation and female agency.

Most works in this set can be described as biofictions, conforming to
Michael Lackey's definition of this genre as "literature that names its pro-
tagonist after an actual biographical figure" (p. 3). Only one is a biofiction
of Teerlinc: in most others she is a supporting figure to another historical
protagonist. None of the novels analyzed here could be described as a
Künstlerroman, which generally deals with the "development, formation
or special problems of the artist" (Stewart, p. 7). This is a departure from
female artist novels of the seventies and eighties that mapped this struggle;[4]
they do not make "problematic old oppositions between procreativity and
creativity, romantic passion and artistic desire" (Jones, p. 17).

Karen Harper's *Fyre Mirror* (2005) is one of a series of historical detective
novels with Queen Elizabeth as a third-person point-of-view character. The
novel is set in 1565, two years after the draft proclamation controlling how
Elizabeth was to be represented: "Everyone was painting or drawing her, and
she hated most of the results" (p. 5). Elizabeth has employed three artists
to craft "an official portrait of her to be sanctioned, copied, and distributed
in the realm" (p. 5), which must "speak of her serene power and control to
friend and foe alike" (pp. 7–8). "Lavina Teerlinc" is one of these, "who usually
painted miniatures of court personages" (p. 9). She is "blonde, big-boned"
and "the queen's only female artist" (p. 16) who had been "reared in the
Netherlands" (p. 17) but had "been at court off and on for years" (p. 19). At
Nonsuch the three artists begin to craft portraits, but things are derailed
when one of the painters dies in a tent fire (p. 25) and Lavina's portrait goes
up in flames (p. 104). Elizabeth and her "Privy Plot Council" (p. 28) of "covert
detectors" (p. 41) work furiously to uncover the murderer and the motive.
Lavina is a small player in this, a slightly ludicrous character whose work
is not always up to scratch. During a sitting, Elizabeth chastises Lavina,
saying: "you always make me look whey-faced. It may not matter as much
in a tiny, closed locket around someone's neck, but life-sized, I can't abide
it" (p. 9). Elsewhere, she is reported as believing that Teerlinc "painted faces

3 See, for example, Bethany Layne's recent work on the proliferation of fictional engagements
with Henry James.
4 See, for example, studies by Stewart, Huf, and Jones.

too puffy and pasty" (p. 158). While Teerlinc's work and reputation are not celebrated here, the novel's interest in the queen's control of her image, and the impact of this on public perception, is compelling. Emphasizing this interest is the recurring trope of the mirror, on which the plot pivots, with its concerns about how we see ourselves and others, and questions of accuracy in perception.

In *The Lady Grace Mysteries: Feud* (2005/2008), Patricia Finney writes as Grace Cavendish, a fictional member of Elizabeth's Maids of Honour who recounts the story's events in her "daybooke" (p. 3). Like Harper's novel, *Feud* is one of a detective series, this time aimed at younger readers, with Grace as Elizabeth's "most privy Lady Pursuivant" (p. 64). Coincidentally this novel is also set at Nonsuch in 1565, with Elizabeth undertaking the furious production of her image using five painters at once, due to an encounter with a poor-quality image (p. 18): "And ever since the Queen saw a portrait of herself which, as she put it, made her look 'like a half-witted strumpet from the South Bank,' she has insisted that all must come from the palace and be approved by her" (p. 18). The process is supervised by "Mistress Teerlinc," who is "a kind, plump lady with a Netherlander accent" (pp. 16–17). Teerlinc has "been a gentlewoman at Court since Her Majesty was a princess, and so must be terribly old" (p. 17). Here she "is the Head Limner at Court and has a pension from the Queen, so all the other limners are very jealous of her, especially as she is a woman. Because of her position she has very little time for painting, so she mainly does beautiful, tiny portraits and pictures on vellum stuck to playing cards" (p. 22). As part of this role she instructs a young "Nick Hilliard" (p. 19). The material culture of painting is vital to the plot – orpiment, an arsenic-based yellow paint, is missing from the colors storage and Grace suspects it is the poison used to make her friend ill (p. 76). Hilliard is another small character, who is struggling with painting in large until he is convinced of the worth of his small paintings (pp. 148–153), eventually representing the "Queen, to the life, looking out of the frame with such command it was as if she was truly there" (p. 191). The Queen realizes Hilliard's work is better than Teerlinc's (p. 192), appointing him as her "official Royal Miniaturist" (p. 193). Once again, the queen's control over her image is a central trope. Teerlinc is part of the machinery of this, but her own work is secondary to overseeing the productions of others.

Teerlinc's role in Melanie Taylor's *The Truth of the Line* (2013) is similar: she is positioned as a bridge between Hilliard and Elizabeth. Taylor, an English fiction writer and art historian, takes her title from a phrase in Hilliard's manuscript treatise, and the novel is written mostly from his perspective. At its heart is the mystery behind the phrase "Attici Amoris Ergo" in Hilliard's

Unknown Man Clasping a Hand from a Cloud (1588) miniature, for which the
novel proposes "an alternative interpretation to [...] traditional readings"
(p. 338). Teerlinc plays a short but significant role in this work, teaching
Hilliard his skills (especially the symbolic language of painting and *impresa*),
supporting him as the Queen's choice to develop the Phoenix and Pelican
portraits (pp. 45–86), before dying early on in the narrative (p. 90). She is
his "beloved teacher" (p. 2), who introduces him to the Queen as someone
who "can paint as well as she" (p. 4). Taylor's Teerlinc hopes that "Nicholas
would be better skilled than his teacher" (p. 9), and eventually is "satisfied
that Nicholas was ready to take his place at Court as her successor" (p. 30).
This line of succession is important to Taylor, who states: "Without Levina
Teerlinc it is unlikely England's first great home grown artist would have
ever come to the queen's notice" (2017). As well as weighing into debates
about Teerlinc's role in transmitting skills to Hilliard, this novel engages
with questions of attribution more than those described so far, ascribing to
her the Plea Rolls (p. 37) and a 1573 treatise on limning, which she publishes
anonymously: "Because I am a woman and a member of the Court, the Queen
would be most displeased if I were seen to be involved in a commercial
venture" (p. 39). The novel also works closely with elements from Hilliard's
treatise, linking Teerlinc to the quicksilver white he described there (p. 27).
While Teerlinc plays a substantial role in this work, she is still a functional
character whose role is to nurture and enable the development of Hilliard.

Two novels by Elizabeth Fremantle feature Teerlinc. In *Queen's Gambit*
(2013), the painter plays a very small but evocative part. She appears late
in the story, visiting the pregnant Katherine Parr with Jane Grey, having
"arrived recently to paint a likeness of Jane for the King" (p. 432). In this
one-paragraph cameo, the artist "often sits sketching them all going about
their quiet business" and has "a gift for capturing things" (p. 432). Her func-
tion here seems to be a world-building one: to add a sense of time and place
to this quiet moment in the narrative before the birth of Katherine Parr's
child and her subsequent death. Teerlinc's role is extended in Fremantle's
next novel, *Sisters of Treason* (2014), where she is given a full third of the
narration, with the rest occupied by Katherine and Mary Grey. Her role
in the novel is protector of the Grey sisters after their mother's death and
witness to the time's atrocities. Fremantle places Teerlinc at the center of the
action – the novel opens with her holding Jane Grey's hands at execution,
guiding her to the block (pp. 5, 8). Her friendship with the Greys results in
her sending materials to John Foxe in Geneva: first Jane's letter to her sister,
copied from her Greek New Testament (p. 72); later accounts and images of
the "seemingly endless catalogue of horror" (p. 125) under Mary Tudor, "for

all to see what monstrous acts are rife" (p. 96). Her role, in this novel, is "to find truth in the detail," to "render not only what can be seen but also what is hidden" (pp. 63–64). Ways of seeing are vitally important in this work: she sees the "truth" of Mary Grey's crooked body (p. 130) and acknowledges that she "dares not show the Queen [Mary] as she truly is" (p. 127). Her insight takes on visionary qualities at times: after Jane Grey's execution Teerlinc imagines Mary's reaction, understanding then that "the killing has only just begun" (p. 3). Mary Grey states that Teerlinc has "borne witness to it all," which she considers "the role of a painter" (p. 448).

In this novel Teerlinc sees herself as a common painter (p. 40), making miniatures that are both personal and political but also readying masques (p. 183). Her relationship with Hilliard is central to the plot but it differs from other representations. She instructs him but he betrays her, copying her limning of Katherine Grey and circulating it to swell the reformed cause (p. 386). Of all the novels, Fremantle's is most interested in the impact of the artist's gender. She remembers the reactions of the "goodwives of Bruges" to her son's early birth: "A few whispered that was what happened when a woman sought to do a man's work. Spending too much time amongst painters' materials had poisoned her womb, they said; and women like her could not birth healthy infants" (p. 38). While painting Cardinal Pole, she wonders if the man's silence is because he "doesn't like being painted by a woman" (p. 61). Fremantle's version of Teerlinc thinks Hilliard is the better limner: "He will be remembered for his work. And perhaps I will not" (p. 447), which speaks metafictively to contemporary reevaluations of Teerlinc's *oeuvre* and an interest in marginalized female figures.

These fiction writers make the chimerical "Levina Teerlinc" perform multiple narrative functions: her art practice or materials move the plot forward; she provides a means to explore an aspect of the Tudor court not yet written about; and her presence prompts reflections on the artist's role in public memory and the relationship between gender and representation.

Conclusion

Examining Teerlinc's written afterlives in this way, across the centuries, in art writings and fiction, allows readers to consider the moment of enunciation of each representation. For Julia Dabbs: "The life stories of early modern women artists are products of their historical contexts, just as we readers are informed by ours" (p. 7). How these life stories are deployed in later years likewise speaks of the moment of re-use, its preoccupations and

prejudices. Teerlinc's treatment follows a pattern familiar to many other female artists of the time: praised during their lifetime then forgotten, later to be rediscovered and championed. While not panegyrics, these novels recognize and shore up some aspects of the artist's role in public memory, making visible another apparently "lost" or "forgotten" female antecedent to broad audiences. They reinscribe the importance of Teerlinc, both in her moment and in our contemporary imagination, even with a mixed sense of her influence and artistic worth.

More broadly, the novels are predominantly female-focused and, barring Taylor's, have a female protagonist, affirming female voice and agency through point-of-view choices. Some of the novels function on another level as well, reflecting contemporary concerns with continued gender inequities when considering or highlighting the question of the artist's standing in present times. This flickering double vision, between past and present, takes on heightened significance in the female artist novel given the emphasis on ways of seeing and modes of representation.

Beyond this batch of novels, Teerlinc continues to have a powerful presence on the internet, with Louisa Woodville's blog a recent example (2020). She is often framed as a kind of discovery: Teysko notes her surprise on learning a key Tudor painter was a woman and elevates Teerlinc to superhero status on her "Kick@ss Tudor Women" site (2019). Similarly, *The Huffington Post's* list of "The Revolutionary Women Artists of the 15th Through 19th Centuries" (Frank) included Teerlinc because: "Basically, she invented miniatures, royal miniatures to be exact, and that's pretty badass." Teerlinc's archival traces might allow us to think of her in many ways, but "kick@ss" and "badass" aren't the first descriptors to come to mind. A fiction too far, perhaps. Her celebration as trailblazing heroine reveals much, though, of current desires to reclaim and celebrate lesser-known female figures. Throughout these afterlives, however, the signifier "Levina Teerlinc" remains a chimera – a creature of many parts, but also a mere wild fancy in fiction, whose afterlives continue to shape-shift depending on the needs of the present.

Acknowledgments

This research has been supported by La Trobe University and Ghent University. Grateful thanks to Gert Beulens; Elke Gilson; Koenraad Jonckheere; Frederica van Dam; Vanessa Paumens; Katie Coombs; Edward Town; Charlotte Bolland and Alex Shapley; Jan d'Hondt; Anna Welch; Katlijne Van der Stighelen; Joris Heyder; and Kelly Gardiner.

Works Cited

Ágústsdóttir, Ingibjörg. "Interview with Elizabeth Fremantle." 5 February 2016. https://uni.hi.is/ingibjoa/2016/02/05/interview-with-elizabeth-fremantle/. Accessed 2 May 2018.

Auerbach, Erna. *Tudor Artists: A Study of Painters in the Royal Service and of Portraiture on Illuminated Documents from the Accession of Henry VIII to the Death of Elizabeth I.* London: University of London / The Athlone Press, 1954.

Blakiston, Noel. "Nicholas Hilliard: Some Unpublished Documents." *The Burlington Magazine for Connoisseurs*, vol. 89, no. 532, 1947, pp. 187–189.

Bradley, John William. *The Life and Works of Giorgio Giulio Clovio, Miniaturist. With Notices of his Contemporaries and of the Art of Book Decoration in the Sixteenth Century.* London: Bernard Quaritch, 1891.

"Chimera | Chimaera, n." *OED Online.* Oxford University Press. Accessed 20 June 2020.

Clayton, Ellen C. *English Female Artists, in Two Volumes.* London: Tinsley Brothers, 1876; vol. 1.

Coombs, Katherine. *The Portrait Miniature in England.* London: V&A Publications, 1998.

Coombs, Katherine, and Alan Derbyshire. "Nicholas Hilliard's Workshop Practice Reconsidered." *Painting in Britain 1500–1630: Production, Influences and Patronage*, edited by Tarnya Cooper, Aviva Burnstock, Maurice Howard, and Edward Town. Oxford: Oxford University Press, 2015, pp. 240–251.

Dabbs, Julia K. *Life Stories of Women Artists 1550–1800: An Anthology.* Farnham, UK: Ashgate, 2009.

Delepierre, Octave. *Galerie d'artistes Brugeois, ou Biographie Concise des Peintres, Sculpteurs et Graveurs Célébres de Bruges.* Bruges: Vandecasteele-Werbrouck, 1840.

Destrée, Joseph. *Les Heures de Notre Dame Dites de Hennessy Étude Sur un Manuscrit de la Bibliothèque Royale de Belgique.* Brussels: E. Lyon-Claesen, 1895.

Le Doulx, Pieter. *Levens der konst-schilders, konstenaers en konstenaerressen.* MS, Bruges, Stadsarchief and Stadsbiblioteek, Archief Academie voor Schone Kunsten, 1795.

Ellet, Elizabeth. *Women Artists in All Ages and Countries.* New York: Harper & Brothers, 1859.

Erickson, Carolly. *The Favored Queen: A Novel of Henry VIII's Third Wife.* New York: St. Martin's Griffin, 2011.

Finney, Patricia (writing as Grace Cavendish). *The Lady Grace Mysteries: Feud.* 2005. London: Red Fox (Random House Children's Publishers), 2008.

Frank, Priscilla. "These are the Revolutionary Women Artists of the 15th Through 19th Centuries." *The Huffington Post*, 23 March 2015, updated 7 December 2017. https://www.huffingtonpost.com.au/entry/women-artists-_n_6904390. Accessed 20 December 2018.

Fremantle, Elizabeth. *Queen's Gambit*. London: Michael Joseph, 2013.

Fremantle, Elizabeth. *Sisters of Treason*. London: Michael Joseph, 2014.

Gairdner, James, and R. H. Brodie, eds. "Henry VIII: November 1546, 21–30." *Letters and Papers, Foreign and Domestic, Henry VIII, Vol. 21 Part 2, September 1546–January 1547*. London: His Majesty's Stationery Office, 1910, pp. 203–248. *British History Online*. http://www.british-history.ac.uk/letters-papers-hen8/vol21/no2/pp203-248. Accessed 4 May 2018.

Goldring, Elizabeth. *Nicholas Hilliard: Life of an Artist*. New Haven: Yale University Press, 2019.

Guicciardini, Lodovico. *Guicciardini's Account of the Ancient Flemish School of Painting. Translated from his Description of the Netherlands, Published in Italian at Antwerp, 1567*. With a preface, by the translator. London: Printed for I. Herbert, 1795.

Harper, Karen. *The Fyre Mirror: An Elizabeth I Mystery*. New York: St. Martin's Paperbacks, 2005.

Huf, Linda. *A Portrait of the Artist as a Young Woman: The Writer as Heroine in American Literature*. New York: Frederick Ungar Publishing Co., 1983.

James, Susan. *The Feminine Dynamic in English Art, 1485–1603: Women as Consumers, Patrons and Painters*. Farnham, UK: Ashgate, 2009.

Jones, Suzanne W. "Introduction." *Writing the Woman Artist: Essays on Poetics, Politics and Portraiture*, edited by Suzanne W. Jones. Philadelphia: University of Pennsylvania Press, 1991, pp. 1–20.

Kren, Thomas. "New Directions in Manuscript Painting, circa 1510–1561." *Illuminating the Renaissance: The Triumph of Flemish Manuscript Painting in Europe*, edited by Thomas Kren and Scot McKendrik. Los Angeles: The J. Paul Getty Museum, 2003, pp. 411–516.

Lackey, Michael. "Locating and Defining the Bio in Biofiction." *a/b: Auto/Biography Studies*, vol. 31, no. 1, 2016, pp. 2–10.

Langer, Sandra L. "Women Artists in All Ages and Countries by Elizabeth Fries Lummis Ellet." *Woman's Art Journal*, vol. 1, no. 2, Autumn/Winter 1980, pp. 55–58.

Lawson, Jane A., ed. *The Elizabethan New Year's Gift Exchanges 1559–1603*. Oxford: Oxford University Press, 2013.

Layne, Bethany. *Henry James in Contemporary Fiction: The Real Thing*. Palgrave Macmillan, 2020.

Long, Basil. *British Miniaturists*. London: Geoffrey Bles, 1929.

Murrell, Jim. *"The Way Howe to Lymne": Tudor Miniatures Observed*. London: Victoria and Albert Museum, 1983.

Nichols, John. *John Nichols's The Progresses and Public Processions of Queen Elizabeth I: A New Edition of the Early Modern Sources* (5 vols), edited by Elizabeth Goldring, Faith Eales, Elizabeth Clarke, Jayne Elisabeth Archer, Gabriel Heaton, and Sarah Knight. Oxford: Oxford University Press, 2014; vol. 1.

Nichols, John Gough. "Notices of the Contemporaries and Successors of Holbein. Addressed to Augustus W. Franks, Esq. Director." *Archaeologia*, vol. 39, no. 1, 1 January 1863, pp. 19–46.

Padmore, Catherine. *"The Tudor Paintrix in Recent Fictions." Recovering History Through Fact and Fiction: Forgotten Lives*, edited by Dallas John Baker, Donna Lee Brien and Nike Sulway. Newcastle upon Tyne, UK: Cambridge Scholars Publishing, 2017, pp. 158–170.

Public Records Office. *Calendar of the Patent Rolls Preserved in the Public Record Office: Elizabeth, Vol. 1, 1558–1560*. London: His Majesty's Stationery Office, 1939.

Reynolds, Graham. "The English Miniature: Conjecture and Fact." *Apollo*, vol. 115, no. 244, 1982, pp. 507–508.

Reynolds, Graham. "The English Miniature of the Renaissance: A 'Rediscovery' Examined." *Apollo*, vol. 118, no. 260, 1983, pp. 308–311.

Reynolds, Graham. "New Light on Nicholas Hilliard." *British Art Journal*, vol. 12, no. 2, September 2011, pp. 19–21.

Russell, H. Diane. "Art History." *Signs*, vol. 5, no. 3, Spring 1980, pp. 468–481.

Sanderus, Antonius. *Flandria Illustrata, Sive Descriptio Comitatus Istius Per Totum Terrarum Orbem Celeberrimi, Iii Tomis Absoluta. Coloniae Agrippinae: sumptibus Cornelii ab Egmondt et sociorum* (2 vols). Cologne, 1641–1644; vol. 1 (1641). Ghent University's digitized copy: archive.ugent.be: EEB84A32-D219-11DF-9DFE-FEF978F64438. Accessed 26 April 2021.

Stewart, Grace. *A New Mythos: The Novel of the Artist as Heroine*. 1979; Montreal: Eden Press Women's Publications, 1981.

Van der Stighelen, Katlijne, and Mirjam Westen. *A Chacun sa Grâce: Femmes Artistes en Belgique et Aux Pays-Bas 1500–1950*. Ghent: Ludion/Flammarion, 1999. The exhibit was shown in Antwerp in 1999–2000 and in Arnhem in 2000.

Strong, Roy. "From Manuscript to Miniature." *The English Miniature*, edited by John Murdoch, Jim Murrell, Patrick J. Noon, and Roy Strong. New Haven: Yale University Press, 1981, pp. 25–84.

Strong, Roy. *The English Renaissance Miniature*. Revised edition. 1983. London: Thames and Hudson, 1984.

Strong, Roy and V. J. Murrell. *Artists of the Tudor Court: The Portrait Miniature Rediscovered 1520–1620*. London: Victoria and Albert Museum, 1983.

Sutherland Harris, Ann, and Linda Nochlin. *Women Artists 1550–1950*. 1976. Los Angeles County Museum of Art, Alfred A Knopf, 1978. The exhibit was shown in a number of US galleries in 1976–1977.

Taylor, Melanie V. *The Truth of the Line*. MadeGlobal Publishing, 2013.

Taylor, Melanie V. "Portrait Miniature: Is This Levina Teerlinc?" 18 October 2017. https://melanievtaylor.co.uk/2017/10/18/is-this-levina-teerlinc/. Accessed 1 May 2018.

Teysko, Heather. "Kick@ss Tudor Women Day 5: Levina Teerlinc." 2019. https://www.englandcast.com/levinateerlinc/. Accessed 2 June 2020.

Thornton, R. K. R., and T. G. S. Cain, eds. *Nicholas Hilliard: The Arte of Limning*. 1981; Manchester: Carcanet Press, Manchester, 1992.

Tittler, Robert. "The 'Feminine Dynamic' in Tudor Art: A Reassessment." *British Art Journal*, vol. 17, no. 1, Spring 2016, pp. 123–130.

Town, Edward. *A Biographical Dictionary of London Painters, 1547–1625*, vol. 76. London: The Walpole Society, 2014.

Vere, Gaston du C. De, trans. *Lives of the Most Eminent Painters, Sculptors & Architects by Giorgio Vasari* (10 vols). London: Philip Lee Warner, 1912–1915; vol. 9. 1550/1568 (1915).

Walpole, Horace. *Anecdotes of Painting in England: With Some Account of the Principal Artists and Incidental Notes on Other Arts* (4 vols). Based on manuscript materials of George Vertue. London, 1762–1771; vol. 1 (by Thomas Farmer, 1762).

Weale, W. H. James. "Documents inédits sur les enlumineurs de Bruges." *Le Beffroi*, vol. 2, 1864–1865, pp. 298–320.

Weale, W. H. James. "Levina Bynnynch, or Teerlinc." *Notes and Queries*, vol. 8, no. 190, August 1865, p. 147.

Weale, W. H. James. "Livina Teerlinc, Miniaturist." *The Burlington Magazine for Connoisseurs*, vol. 9, no. 40, 1906, p. 278.

Woodville, Louisa. "Levina Teerlinc, Illuminator at the Tudor Court." *ArtHerstory*. 12 May 2020. https://artherstory.net/levina-teerlinc/. Accessed 20 June 2020.

About the Author

Catherine Padmore is Head of the Department of Creative Arts and English, La Trobe University, Australia. She teaches writing and literary studies, with creative and critical research interests in historical and biographical fictions.

4. An Interview with Dominic Smith, Author of *The Last Painting of Sara de Vos:* Capturing the Seventeenth Century

Frima Fox Hofrichter

Abstract

Dominic Smith created a vivid picture of a woman artist, her life and times, in seventeenth-century Holland, in his much-praised historical novel *The Last Painting of Sara de Vos*. Interviewed by Frima Fox Hofrichter, a consultant for Smith, and an expert on an actual seventeenth-century Dutch woman artist, Judith Leyster, Smith discusses his method and research. His storyline has three avenues: the seventeenth-century artist and her milieu, the art historian who specializes on that woman artist, and a twenty-first-century collector. Knitted within are their personal lives – and the question of forgery. Smith and Hofrichter discuss his inspiration for the novel in Judith Leyster and how his contacts and travel influenced the novel's authentic flavor.

Keywords: seventeenth-century women artists, the Golden Age, Dominic Smith, historical fiction, Judith Leyster, forgery

The subject of this interview, Dominic Smith, is the author of *The Last Painting of Sara de Vos* and other novels, most recently *The Electric Hotel*. He was interviewed by Frima Fox Hofrichter, author of *Judith Leyster, A Woman Painter in Holland's Golden Age* and articles on Leyster and other women artists of the seventeenth century. Hofrichter was a consultant to Smith on his novel.

The interview took place over several days in March 2020.

Fitzmaurice, J., N.J. Miller, S.J. Steen (eds.), *Authorizing Early Modern European Women. From Biography to Biofiction*. Amsterdam: Amsterdam University Press, 2022
DOI 10.5117/9789463727143_CH04

FFH: Dominic, it's a pleasure to interview you.

I think most readers have been struck by the authentic nature of the time and place you provided for your characters, who each seem vividly believable. My questions are to explore how you did this.

So . . .

You have written several novels of historical fiction, but they are set in the nineteenth or twentieth century in France, America, and even the South Seas. But none involves art, painting, or art history.

What drew you to this subject?

DS: I'm often drawn to visual culture in my work. *The Mercury Visions of Louis Daguerre* reimagines the life and work of the inventor of modern photography (the daguerreotype), *The Electric Hotel* explores the vanishing medium of silent film, and *Bright and Distant Shores* looks at the phenomenon of nineteenth-century museum collecting voyages. So, in a way, the world of painting, art history, and the Golden Age is an extension of this fascination with visual / physical art forms. But more specifically, with *The Last Painting of Sara de Vos*, I became intrigued by the fact that we know so little about the women painters of the Golden Age. Judith Leyster was of particular interest, especially given that her work was falsely attributed to Frans Hals for so long after her death. I'm drawn to these kinds of gaps and silences in history.

FFH: You have two main female protagonists – Sara de Vos, the seventeenth-century painter, and Ellie Shipley, the twenty- / twenty-first-century art historian.

What is your real relationship with artists, art historians, and the art world in general?

DS: Before writing this book, my exposure to the art world was mainly through visits to museums. But the more I started to work with this material, the more I felt that I needed to probe the methods and materials and mindsets of artists, art historians, and restoration experts. To better understand the life of women artists in seventeenth-century Holland, I was lucky enough to find you, Frima, as an expert willing to be interviewed. Similarly, I interviewed Stephen Gritt, who at the time was the head of restoration for the National Gallery of Canada. To better understand painters, I mostly read books on painting technique and biographies of famous painters through time. I also read extensively about the world of collectors and art auctions.

FFH: Why did you set your story 400 years ago – in the seventeenth century? And in The Netherlands?

DS: I wanted to show the history of a single painting through time, and the Golden Age, especially in Holland, has always been of interest to me. I love the atmosphere in Dutch seventeenth-century paintings, whether it's an Avercamp ice scene or a genre scene in a tavern or a landscape or floral still life. I also knew I wanted a connection between a modern-day art historian and a woman painter of a previous century. Then I discovered the story of these women, like Judith Leyster, who had been members of the Guild of St. Luke, the main painters' guild, and that very little of their work has survived. So the idea of an art historian who has devoted her career to one of these "lost" women painters emerged. These threads came together when I invented the painting "At the Edge of a Wood" that was painted during a period of grief in the seventeenth century, and that has been in one wealthy family for hundreds of years. Fiction writing is often a set of associations that build over time. One choice results in many doors opening and others closing.

FFH: Have you been to The Netherlands?

DS: I lived for a year in Amsterdam in 1999/2000 and became enthralled with Dutch culture and art. I have fond memories of spending afternoons in the Rijksmuseum and discovering hidden, medieval courtyards around the city center.

FFH: Actually, The Netherlands – Haarlem and Amsterdam – are the key settings for only one of the protagonists, Sara, but Ellie lives in Brooklyn and then there are events in Australia.
What is your relationship to or experience with these other places?

DS: I grew up in Australia to an American father and Australian mother. I've lived in the US, more or less, since 1989. I have friends who live in Brooklyn and have always felt like it was a place I wanted to explore in my fiction. It has such a rich history; I also needed a place for Ellie to live in the late 1950s that was decidedly unglamorous. I wanted a place where she could be seen as living "on the margins" of the art and academic worlds.

FFH: The forgery of Sara's seventeenth-century painting is an important part of the story. How did you learn about pigments and the technical side of painting?

DS: Stephen Gritt was the one that taught me about lead-tin yellow, this fascinating yellow of the Golden Age that disappeared for a long time. I learned the technical side of painting all from books and archival resources – textbooks on painting technique but also memoirs and reflections about the lives and works of artists.

FFH: Who taught you how to paint a forgery?!!

DS: One of the stranger moments in writing the book was reaching out to Ken Perenyi, a known forger who'd written a fascinating memoir about his exploits (*Caveat Emptor*). I fashioned some of the forgery methods used by Ellie in the novel on Ken's approach. I emailed him a list of the things Ellie does to the forgery and asked if he would be willing to "authenticate" my methods. To my surprise, he wrote back and validated the forgery techniques. Apart from books and looking at known forgeries in museums and galleries, that was my first contact with this world. Only a novelist could have an email exchange about the authentication of a forgery of a fictional painting!

FFH: Wow! That in itself is a great story!
Much of the seventeenth-century story is similar to the real-life story of Judith Leyster (1609–1660). Did you model Sara after her or other early modern women artists?

DS: Sara is absolutely modeled on some of what we know about Judith Leyster's life, and your own book on Leyster was an essential resource for developing that understanding. Sara van Baalbergen, who may have been the very first woman to be admitted to a painters' guild in Holland (and whose work has not survived) was Sara's namesake. In a lot of ways, Sara de Vos is a fusion of historical elements, inventions, and biographies.

FFH: Is there a particular painting by Judith Leyster that inspired you?

DS: Leyster's *Self-Portrait* (Fig. 4.1) is so powerful, I think, the way it feels like we've wandered into her studio one afternoon and she's turned to take us in with this warm gaze. That was an early image that galvanized the novel, and it is alluded to at the end of the book. I remember standing in front of Leyster's self-portrait at the National Gallery of Art in Washington, D.C. and marveling at the idea that this was her masterpiece, the painting she probably submitted to join the Guild of St. Luke. It was a moment of reaching back through history, and that time felt very immediate.

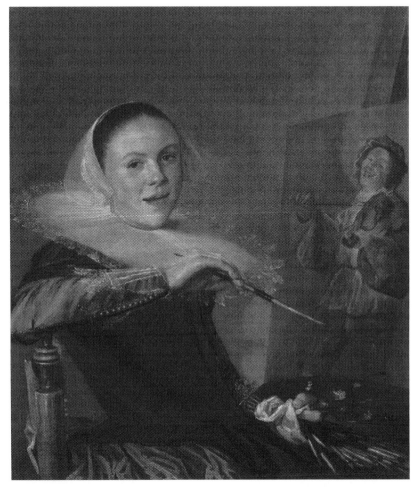

Figure 4.1. Judith Leyster, *Self-Portrait*, c. 1633. National Gallery of Art, Washington, D.C., Gift of Mr. and Mrs. Robert Woods Bliss.

FFH: And it is that sense of immediacy that shows through your writing and the characters you created.

FFH: The inability to have children comes up with two of the women. And the third woman, Ellie, doesn't have any children either. Why?

DS: The book explores "barrenness" on some level, both in terms of having children but also in terms of creative expression. Ellie is a character who has given all of her life to her work and she's never quite felt drawn to the idea of having a child, especially given her ambivalence about her own

childhood. (She's also someone who turned her back on her own painting and creativity.) Marty and Rachel desperately want to have a child but have been unable; this feels a bit like a wound between them. Sara de Vos, of course, loses a child, and it's her grief that adorns the wall above Marty and Rachel's bed. I wanted to explore the different ways children – wanting them, having them, losing them – shape these different sets of characters.

FFH: Would children of any of these women have somehow distracted from the narrative of your story?

DS: I don't think it's a question of whether it would have distracted from the narrative. In fact, the childlessness is a central part of the narrative, and it's woven throughout the book thematically. With a child, even a grown one, Ellie might not have returned to live in exile on an island in Australia in 2000. With children, Marty and Rachel might not have had their particular malaise. And, of course, losing a child for Sara de Vos is the domino that falls and begins the entire book. The idea of children haunts these characters on some level.

FFH: I think you painted (sorry for the pun) a difficult life for anyone in the seventeenth century. How did you learn about it? What did you read or what sources did you use?

DS: I read a lot of histories about the seventeenth century in The Netherlands, but the most useful one was *Daily Life in Rembrandt's Holland* by Paul Zumthor. A lot of what I'm after in my research is the nouns – what did people eat, what did they wear, how did they get around? History books often gloss over such things, so you need either primary sources or books that focus on the stuff of everyday life.

FFH: I know that you have taught writing to both college undergraduate and graduate students. Did you involve them in any way while you were writing this?

DS: For the past decade, I've taught in the Warren Wilson College MFA Program for Writers, in Swannanoa, North Carolina, a low-residency program where students and faculty come together twice a year for a ten-day residency. I like this program a lot because it's about supporting aspiring writers in this lifelong apprenticeship. That said, it's very different from meeting with students in a classroom, where the conversation can be a little more

free-ranging. I've also taught undergraduates at Rice University, Southern Methodist University, and the University of Texas at Austin. In those more traditional settings, I have often given students writing prompts related to a piece of art or history, though not during the time that I was writing this book.

FFH: I think this is a common question to writers of fiction, but do you personally know anyone like the people in your book?
DS: Not really, but there are always elements of people the writer knows in the work. For example, my late father was fascinated by real estate and always looked in realtor windows no matter where he was in the world. That's a habit I gave to the older Marty de Groot. These are the ways that people I know are likely to be reflected in characters who are largely invented. Small habits of mind or speech or action.

FFH: Thank you so much, Dominic, for this interview and for allowing us through your novel to enter the lives of these characters and for capturing the seventeenth century so vividly.

DS: Frima, thank you so much for your interest in my work, and for your time and contributions during the writing of my novel!

Works Cited

Hofrichter, Frima Fox. *Judith Leyster, A Woman Painter in Hollands's Golden Age.* Doornspijk, NL: Davaco Publishers, 1989.

Perenyi, Ken. *Caveat Emptor, The Secret Life of an American Forger.* New York: Pegasus Books, 2012.

Smith, Dominic. *The Last Painting of Sara de Vos.* New York: Sara Crichton Books / Farrar, Strauss and Giroux, 2016.

Zumthor, Paul. *Daily Life in Rembrandt's Holland,* translated by Simon Watson Taylor. New York: Macmillan, 1963.

About the interviewer and novelist

Frima Fox Hofrichter is a feminist art historian and Professor at Pratt Institute. She has written on women artists, and authored the catalogue raisonné on Judith Leyster and the Baroque and Rococo sections of *Janson's History of Art* and *Gender and Art of the 17th Century* for Oxford Bibliographies.

Dominic Smith grew up in Sydney, Australia and now lives in Seattle, Washington. He is the author of five novels, including *The Last Painting of Sara de Vos*, which was a *New York Times* Bestseller and a *New York Times Book Review Editors' Choice*.

5. Lanyer: The Dark Lady and the Shades of Fiction

Susanne Woods

Abstract

This essay considers the work of three novelists and two playwrights who use information from the life of the poet Aemilia Lanyer to create a fictionalized Emilia, in each case contending with the historian A. L. Rowse's claim that she was the "Dark Lady" of Shakespeare's sonnets. The essay emphasizes the use of darkness as a trope for exotic difference, sexuality, and disguise. It considers whether Rowse's founding fiction is a satisfactory basis for these further biofictions, or merely an inescapable one, and contrasts them with Lanyer's own poetry.

Keywords: Aemilia Lanyer, Dark Lady, fiction, darkness, biofiction

"The poet [...] nothing affirms, and therefore never lieth," says Sir Philip Sidney in his *Apology for Poetry* (p. 123). The five fiction writers (synonymous with "poets" for Sidney) that I present later in this essay, though they purport to figure the actual poet Aemilia Bassano Lanyer, should therefore be granted considerable leeway by the fact-oriented biographer and editor, as I hope I do. But there is a shade of fiction pretending to be fact that is an inevitable prelude to any fictionalizing of Lanyer: A. L. Rowse's belief that she was "the Dark Lady" of Shakespeare's sonnets.

We know rather more about Aemilia Lanyer than we do about most women of the minor gentry in her time. In addition to church records and information from two lawsuits, her several visits to the astrologer and diarist Simon Forman in the 1590s led him to record details of her background and life, including her affair with the Queen's cousin, Henry Carey, Lord Hunsdon, Elizabeth's Lord Chamberlain. Lanyer visited the popular astrologer to seek information about her miscarriages, and about whether her husband, on an

Fitzmaurice, J., N.J. Miller, S.J. Steen (eds.), *Authorizing Early Modern European Women. From Biography to Biofiction.* Amsterdam: Amsterdam University Press, 2022
DOI 10.5117/9789463727143_CH05

Ireland foray with the Earl of Essex, would be knighted, allowing her to rise in class and become a lady. These facts, and the lineage and family circumstances she reported which conform to public records, provide useful additions to what we know from those records and the self-presentation she later makes in her book of poems. Forman's obvious attraction to her, however, along with his frequent efforts to seduce ("halek") his clients, blur the portrait. He apparently tried his best, reporting at least two attempts that may have involved some fondling, "yet she would not halek" (Woods, p. 26). Reports of these efforts, somewhat confoundingly, seemed to spark Rowse's portrayal of Lanyer as a loose woman ready to hop into bed with Shakespeare.

That the historian Rowse was dabbling in fiction became clear to most scholars early on.[1] He consistently misread, misunderstood, or simply ignored those features of Lanyer's life that interfered with his narrative, deciding, for example, that Lanyer was "dark," because he misread Forman's comment that she had been "very brave [finely dressed, showy] in youth" as "very brown in youth." From this misreading he assumed that Lanyer's complexion suited Shakespeare's references to the woman whose eyes "are nothing like the sun," and whose hair is like "dark wires" instead of the golden wires of the pale Petrarchan beauty (Sonnet 130). Rowse silently emended this mistake in the introduction to the edition he called *The Poems of Shakespeare's Dark Lady* (1979) but kept the assumption that she was "dark."

Beyond Rowse's speculations, here are the basic facts with which a biofiction writer might contend: Aemilia Bassano was born in London in 1569, the daughter of a court musician, and died there in 1645. In the late 1580s and early 1590s she was the mistress of the much older Henry Carey, Lord Hunsdon and spent time in court in the early 1590s. She was married to court musician Alfonso Lanyer in October 1592 and had one child, named Henry, probably the Lord Chamberlain's son, who lived to adulthood and became a court musician. She published a book of poems in 1610–1611, ran a school for girls from 1617–1619, and lived with her son's wife and two children until and after his death in 1633.

Despite Rowse's insistence, we have no proof of Lanyer's coloring. Forman's only comment on Lanyer's appearance was that she had a "mole at her throat or near it" (Woods, p. 25). Her parents were Baptiste Bassano, of the famous Italian-born Bassano consort of court musicians, and Margaret Johnson, as

1 The current scholarly consensus is that Rowse was making things up. The facts and analyses that follow here are taken from Woods, Chapter 1, and pp. 90–98; and David Bevington. Others, notably Roger Prior, have tried to resurrect Rowse's case, based largely on reading Lanyer into Shakespeare's plays, a technique that amounts to using fiction to establish a fiction.

pale English a name as one could imagine. The one known portrait that is plausibly of Lanyer shows a woman of reddish-brown hair and green eyes. It is attributed to "Mark Gerards" (Marcus Gheeraerts the Younger) and appears paired with a painting of Lord Hunsdon, both works dated 1592. He is identified but she is not, and the timing suggests that Hunsdon may have had it painted when her pregnancy forced him to hand her over to an appropriate marriage with Alfonso Lanyer. Both paintings currently reside at Berkeley Castle, Gloucestershire, where at the time of my visit the Berkeley family (Hunsdon's descendants) displayed "Henry Cary, Lord Hunsdon" in their picture gallery, but showed me the "unknown woman in black" in their private apartments (Woods, pp. 17–18). They professed no idea whom she might have been.

Beyond a few facts, what we also know is that Aemilia Lanyer, by current consensus, "is a hugely important figure in the history of women's poetry" (Wilcox, 2014, p. 46).[2] Unfortunately, a Shakespeare connection, no matter how tangential and unproven, is simply too delicious for writers to let go. It seems so much more inviting to situate a character's interest through association with genius than, as perhaps an alternative approach, to place this pioneer woman poet into a tradition which she did not immediately spark. So even modern women biofiction writers have fallen for Rowse's fiction of Lanyer, in contexts where they can also imagine their own versions of the greatest poet in the English language.

Rowse declares Lanyer a dark seductress who had an affair with Shake-speare. Each of the five avowedly fictional stories assumes the same. While Rowse indulged in salacious speculation about Lanyer's promiscuity, the five versions I examine here deal more consciously with issues of gender and race, including cliches about the exotic, seductive foreigner. As Kim Hall points out, "tropes of disorder, racial otherness, and unruly sexuality" were "positioned very early to be interchangeable" in early modern England (p. 25).[3] To varying degrees, the fictions that depend on Rowse's founding fiction implicitly or explicitly acknowledge that interchangeability.

Three novels, Mary Sharratt's *The Dark Lady's Mask*, Sandra Newman's *The Heavens*, and Grace Tiffany's *Paint: A Novel About Shakespeare's Dark Lady*, grapple differently with race and sexuality, and stray variously from historical plausibility, but project relatively little of what we might think of

2 "Lanyer did not do what was expected of her [...]. She published and claimed her own work without much conventional female modesty, but with a sense of divine authorization and wrote in genres that she newly created or extended by her use of them" (Wilcox, 2007, p. 249).

3 See also Joyce MacDonald: "race and culture have been seen as strongly inhering in skin color, and [...] ideas about race were seen as underwriting larger theses about cultural identity" (p. 21).

as a feminist or proto-feminist anger. Two plays, on the other hand, focus in different ways on Lanyer's primary identity as a poet and her outrage at being ignored: Rachel Eugster's *Whose Aemilia?*, a one-act experimental play performed in Ottawa in 2015, and Morgan Lloyd Malcolm's *Emilia*, produced to good reviews on the London stage in 2019. For clarity, in what follows I will refer to the historical Aemilia Lanyer as "Aemilia," and the biofiction versions as "Emilia." All five of these authors contend with the assumption of Aemilia's "darkness," and each creates an Emilia who negotiates, differently and to a greater or lesser degree, with society's associations among darkness, the exotic, and the sexually tempting. Each fiction deals with the shade of Emilia, as shadow, as ghost, as something that entices or perhaps entices the inspiration of others, most notably Shakespeare.

Mary Sharratt's *The Dark Lady's Mask: A Novel of Shakespeare's Muse* makes good use of what we know about Aemilia in creating her own definitely dark, definitely Jewish, Emilia. She uses the known details of Aemilia's life to craft a fast-moving story about Emilia's chance encounter with Will Shakespeare, which leads her to introduce him to Lord Hunsdon, which in turn gives the actor and his company the Lord Chamberlain's important patronage. Sharratt's Emilia is also the co-author of several comedies, written with Will as they both escape the London plague by taking a trip to Venice to stay with the painter Jacopo Bassano, presumed to be Emilia's uncle. As in Malcolm's play, Will is the father of Emilia's daughter Odillia, whom the real Aemilia sadly lost when the child was ten months old.

Sharratt's Emilia is a wild child unable truly to fit into the fair English model. The "mask" of the title refers first of all to the Christian face that hides the Jewish practices of her father and uncles, safe even from the caring Protestant neighbors that include the writer Anne Locke and her brother Stephen Vaughan (p. 36). It also refers to her escapades riding horses in male drag, to her secretive work with Will Shakespeare, and other postures this Emilia either chooses or is forced to take through her life. The key mask, however, is one of Englishness belied by her appearance: "she didn't look the least bit English. Even in the depths of winter, her skin remained olive in tone [...]. [Her] eyes were as black as ink with amber flecks swimming inside them. Her hair, even in high summer when exposed to the full flood of sunlight, remained dark with only a few auburn lights" (p. 53). This ability to "stand out" attracts a very chivalrous and kindly Lord Hunsdon, who tells her that she "shall be the exotic flower of [Queen Elizabeth's] court, a dark Italian rose amongst the English lilies" (p. 78).

Sharratt's Emilia is definitely Shakespeare's "dark lady," though one he harshly abandons, and semi-publicly repudiates through the portraits

of Jessica and especially Shylock in *Merchant of Venice* and the "Emilia" character in *Othello*. Emilia attributes these portraits to her personal power: "Did [Will] view their secret arrangement to evenly divide the profits of the comedies they had written together as the pound of flesh he was forced to sacrifice lest she step out of the shadows? [...] he simply couldn't banish her. His wife might be left behind in Stratford with her daughters but he had no power over [Emilia][...]. And so he used his plays to purge himself of her, his gadfly, his dark Muse" (p. 299).

As a novel, Sharratt's is basically a kind-hearted book. Her Emilia is empowered by her darkness; she may be in the shadows of Shakespeare's success, but she also liberates his genius in this version and, in the end, is his privately acknowledged "muse." Even as she weaves her own story, Sharratt is exceptionally well versed in the facts of Aemilia's life and provides an epilogue acknowledging the liberties she takes: "there is no historical evidence to prove that Aemilia Bassano Lanier was the Dark Lady of Shakespeare's sonnet [...] [and] most academics dismissed [Rowse's] theory." Nonetheless, "as a novelist [she] could not resist the allure of the Dark Lady mythos" (p. 394). This dark lady, however, is very much her own person, and to the extent that she is of a darker shade than her English neighbors, her darkness contours and enlightens herself and those whom she celebrates in her poetry. This Emilia carries multiple cultures – English, Italian, Jewish, and, through a connection she eventually acknowledges with her husband, "Alfonse," French ("his eyes, as dark as her own," p. 291). This is biofiction exulting in complexity, bringing to life a woman-affirming portrait of a multicultural pioneer. Nonetheless, her crowning achievement is to be affirmed as Shakespeare's "eternal Muse" (p. 388).

Newman's *The Heavens* is an altogether different sort of book, in which Emilia's life, entered increasingly through the dreams of a twenty-first century young New York woman of Persian descent named Kate, becomes a vehicle for a tale of time travel magic. As Kate sleeps, she falls into the early 1590s and some of the known facts of Aemilia's life and becomes Newman's fictional Emilia, exploring with a kind of double vision what "the heavens" have purposed for her to accomplish (p. 15). During her forays into the 1590s Emilia encounters a down-at-the-heels actor she calls "sad Will," gives him access over the course of time to both the Lord Chamberlain and to the Earl of Southampton, and eventually leads him to tremendous success. Each time she wakes as Kate, the world has changed slightly from what it was before, and not for the better. At her first return New York is celebrating the 2000 election of an eco-friendly president named Chen and a great drop in carbon emissions, but no one has heard of William Shakespeare. Next

time, New York is celebrating the election of Al Gore, and a few people have maybe heard of a poet named Shakespeare. By the end, George W. Bush is president, and as the ultimate iteration of Kate's world degenerates from a green new deal to one where Kate's boyfriend, Ben, celebrates a new job with carbon-spouting Exxon, William Shakespeare is famed as the world's greatest poet / playwright (p. 177).

The book crams a number of themes together – the "butterfly effect" of Kate's apparent dreaming herself back in time (p. 12), some vague sense that she is supposed to save the world from the recurring vision of a devastated city (p. 228), "sad Will's" confession, that he, too, dreams back in time – that there are a community of these time travelers, a "fact" which propels the book to its finale in twenty-first-century America (pp. 181, 230). But Newman's Emilia Lanier never lives to write her poems. Her entire purpose is to enable the greatness of Shakespeare, and perhaps of Kate (pp. 213, 238–239).

Newman's Emilia is therefore very much Rowse's Emilia minus the poems. She is dark, Italian-Jewish, a courtesan who uses her sexual favors for personal advancement, while also sometimes helping others (notably a gay Earl of Southampton). She is a shadow-ghost of Kate's twenty-first-century dreaming imagination and the Dark Lady who propels Shakespeare's fame. She sacrifices her own potential for fame to Shakespeare and Kate. She is a device surrounded by images of darkness, a "Lady Israel" in the shadows of an Elizabethan firelight (pp. 145–146). She calls her time with Will "a pattern, black and white" that is meant to reveal his greatness (p. 177). The insistent apocalyptic visions (e.g. pp. 177, 215–216, 228) suggest that Kate cannot save the world, but she will at least have an effect on her time (pp. 253, 257). In the end Emilia's death (p. 241) allows a future for Kate that is unquestionably brighter than her darkest premonitions, but the only successful writer is Shakespeare. This is biofiction that eliminates the most powerful element of the biography it seeks to exploit: its character's own living art.

Tiffany's *Paint* strays farthest from historical fact, not only about Lanyer but also about the court of Elizabeth more generally, including the actual lives of Henry Carey, Lord Hunsdon and his wife, Anne Morgan, who bore him thirteen children. Tiffany portrays her instead as a jealous and barren second wife of a Lord Hunsdon who in turn is portrayed first as Emilia's rapist. Only after Emilia learns the tricks of concubinage from a much-fictionalized Lady Penelope Rich does he also become her patron (p. 20), though she continues to despise him. Aemilia's older sister Angela[4] becomes

4 Angela was married to Joseph Holland by the time Aemilia was seven years old, and had a son, Philip Holland, by the time Aemilia was eighteen (Woods, pp. 7, 15).

Emilia's younger sister, Angelica, in danger of exploitation by Hunsdon (p. 117). Ultimately Emilia murders him (pp. 121–122). The plot depends on the completely fictional Anne Morgan kidnapping Emilia's baby son (she was told that he died) and raising him as Morgan's own, only to offer an apologetic and melodramatic late in life meeting for mother and son (pp. 263–266). From the book's beginning, Tiffany has Emilia Bassano already present in Elizabeth's court at the time of her encounters with Hunsdon and, inevitably, Shakespeare. She is referred to as "Lady Emilia" throughout the book (even by Henry Wriothesley, p. 108), and consorts as an equal with characters well above Aemilia's actual station in life, such as Lady Rich. Alfonso is portrayed as a drunken brute, later a reformed husband, who is also stereotypically gay (pp. 54, 137, 160), and Shakespeare as a "wit" whose conversation is loaded with bad puns and word play (pp. 34, 57, 71 and *passim*). Ben Jonson is a cousin who eventually encourages Emilia's poetry writing even as he steals the idea for a country house poem from reading her "Cooke-ham" (pp. 183, 187–188).

Despite this wildly unhistorical narrative, Tiffany picks up on one possible (even probable) fact: that Lanyer may have been as pale as her mother.[5] From this, her Emilia decides to create her own fiction: a dark lady, Italian-Jewish, who speaks little English (pp. 49, 72). She uses "paint" to darken her fair hair and skin and even her eyes, in order to meet the erotic fantasies of the men around her (pp. 3, 30–31, 77). Tiffany, or at least her Emilia, accepts Rowse's racially charged position that what power she possesses is primarily sexual and emanates from her darkness – a shading that seeks both to entice and hide her from the men she attracts and variously despises: "to his Petrarch, it was not difficult for Emilia to play the beautiful Laura" (p. 26).[6] Tiffany also follows Rowse in giving Emilia a short affair with Simon Forman, and makes him the father of Odillia (pp. 136–138). There are historical inconsistencies and linguistic infelicities too many to mention, but at least this Emilia is a writer.[7]

Rachel Eugster's one-act *Whose Aemilia?* stays closest to historical fact and makes good use of the controversy Rowse has provoked, while her

5 Probable because no one mentions Lanyer's coloring. In order to assume she is "dark," you first have to assume that she is the "dark lady."

6 Presumably Tiffany did not know or did not care that Petrarch's Italian Laura is depicted as fair and blue eyed, which was why Shakespeare's Sonnet 130 makes a point of rejecting the Petrarchan stereotype. See the history of English translations in Roche, for instance Samuel Daniel's translation of P297 that begins "Faire is my love, and cruell as she's faire; / Her browshades frownes, although her eyes are sunny" (p. 133).

7 The portrayal of Elizabeth's court in this novel is consistently counterfactual. See, for example, Tracy Borman, p. 294 ff.

Emilia leaves the question of color, Jewish heritage, and even a relationship with Shakespeare in limbo. A character named "History" awakens the literal shade of a long-dead Emilia to let her know she is being talked about. The ghost assumes that her poetry is finally being given some attention, only to be told that no, she is instead being hailed as Shakespeare's Dark Lady, which annoys and frustrates her – "Why does that man keep intruding? This is *my* story!" (p. 7). The play focuses on Emilia's longing to be recognized as a poet, as she moves through a series of encounters with the ghost of Shakespeare and the voices of Rowse and other commentators. Although she never fully denies the Dark Lady charge, this Emilia dismisses these issues as not relevant to the accomplishments of women. She notes that all those critics and commentators who appear to salivate over the Dark Lady theory are men: "It's not deliberate. They just can't resist the image of a tempestuous temptress, inspiring a man to ever greater heights. They want it to be true because they want it for themselves" (p. 30). This Emilia recites some of Aemilia's most notable lines of poetry, and is grateful to note that those commentators who focus on her poetry are all women. The play ends with a hope for a better recognition to come, not yet here. Emilia asks History, "And in this time to come to which you have awakened me, are women fully recognized throughout the world as equal to men?" to which History replies, "not entirely" (p. 31). This is biofiction that keeps the historical veracities hanging, while at the same time it insists on a serious feminist message: whatever else may be true of Aemilia's life, this Emilia wants "my story" to be about her own authority.

Morgan Lloyd Malcolm's play *Emilia*, like Eugster's shorter play and Sharratt's novel, makes Emilia's identity as a poet central, and also makes use of some of Aemilia's own language, particularly the dedication "To the Vertuous Reader," with its defense of women against the ignominies of men. Lloyd Malcolm also assumes the Shakespeare connection, but even more than the other authors resolves it into a feminist fury. The play makes gender and color its explicit topics by its casting as well as its language and structure. The cast is the obverse of Shakespeare's time – all female, including the male parts. The character of Emilia is played by three actors, all "dark," representing three stages of Emilia's life, with Emilia3 also serving as an ongoing commentator. Structurally, Lloyd Malcolm uses and alters features of Aemilia's life, sometimes reordering or changing them to serve the dramatic arc of the play. In her version, for example, Alfonso's death (p. 73) comes before the publication of Emilia's poems (pp. 80–81) which comes after her creation of a "school" (p. 67), which instead of a place for

"the children of divers persons of worth and understanding"[8] is a Bankside effort to teach lower class women to read and to give them voices. It is these women, newly literate, that help form a protective rank around Emilia when she is threatened by drunks: "Pretty little Moor. Where you from then, eh? You know you'd be a lot prettier if you smiled [...]. WHERE ARE YOU FROM, YOU MISERABLE COW?" (p. 75). The emancipation of these women is one of the messages of the play, as they become emblematic of the voices of women, insistent even through shouts of "COW" or, worse, accusations of witchcraft. Threats of silencing and death, set against the story of Philomela and Procne, give the publication of Emilia's poems, and the play, their mythic reach.

As in Sharratt and Newman's novels, Lloyd Morgan's Shakespeare steals poetry from Emilia, infuriating her. But at the end of the play Lloyd Morgan's ghostly Shakespeare acknowledges an Emilia who is finally having her moment, though as in Eugster's play, a moment that remains incomplete. In Eugster's version the ending is sad. In Lloyd Malcolm's it is full of fury. All five of the works noted here are shaded in multiple ways: from the simple "paint" in Tiffany's yarn, to the secretive "masked" world of Sharratt's Emilia, to the dream world of Newman's time travel, to the ghosts in both plays, there is an aura of shadow in all of them. Each, variously, connects a dark Emilia to seduction, but also to a subversive power. Except in Newman's novel, in which Emilia appears to sacrifice herself to serve Shakespeare's fame, that power emerges through her book of poems.

Lanyer's resurrection as a poet of note has relied on the attention of literary scholars who were already in the process of re-evaluating a woman's literary tradition in early modern English.[9] Among her contemporaries, such as the Countess of Pembroke, Lady Mary Wroth, Elizabeth Melville, and Elizabeth Cary, Lanyer's explicit arguments in favor of women's virtue and authority have arguably made her the most popular and apparently accessible to a modern sensibility. If this serious literary attention has sparked the curiosity that leads modern writers to want to tell more of her story than is available on the record, or even distort that story for their own artistic purposes, that seems fair game. After all, a biofiction writer, whether novelist or playwright or poet, can do what she wishes with the material at hand. It's churlish to demand of modern writers what we would never demand (for example) of Shakespeare's use of his historical sources, or those sources themselves – a partisan Thomas More or a Roman patriot

8 Cited from a court case in Woods (p. 33).
9 For Lanyer, it began with Barbara K. Lewalski's 1985 essay.

Plutarch. All historical fiction and biofiction must make choices beyond what is known, although some poets (again using Sidney's word for those who write fiction) take great pains to let their narrations include to the extent possible what is considered known fact. But what if biofiction writers found their major premise on a probable fiction that pretends to be historical fact? Does it matter?

The October 2019 *PMLA* featured a "theories and methodologies" section on "Poetics of Fact, Politics of Fact." Although references to the then-occupant of the White House were largely implicit after a first mention, this was certainly a time when any solid foundation for what constitutes fact had been regularly and ever more substantially eroded in political discourse. It made sense for the keeper of modern language poetics to raise this up as a theoretical problem, as well as a practical one. In any narration, not necessarily avowedly fictional ones, how you situate facts in a narrative affects how you interpret them, and, as the first two essays in the *PMLA* section noted, hence their relation to truth.[10]

Rowse's interpolation of a supposed fact into the biography of Aemilia Lanyer casts a different kind of shade on the biofictions that authors might derive from her story: it blocks or at least shadows the authority of the woman whose claim to fame is an unusual and gifted volume of poems. Lanyer's poems themselves, in the dedications and especially in the "Description of Cooke-ham," offer her vision of female authority, framed by her version of her own life. Inevitably, even as modern authors seek (in most cases) to honor the historical figure, they are forced to situate the "fact" of her relationship with Shakespeare into their narratives, and inevitably that falsification distorts the truth of any narrative that could be called biofiction.

So I think it does matter that even biofiction writers who are women choose or feel forced to grapple with the Dark Lady story, a founding fiction that pretends to be fact, offered not by a fiction writer but by a male historian.[11] The truth therefore denied is not so much the more probable facts of a real life as it is the significance of that life, and by extension, the importance of a woman writer in her own right. Eugster's ghostly Lanyer comes closest to making this point, but even that play needs the presence of Shakespeare to create the work's dramatic conflict. If we forget about

10 See Colleen Gleeney Boggs and Chenxi Tang; and Peter Brooks: "The facts on the ground may not themselves be malleable, but once they are narrativized – as they must be if they are to be intelligible – their shape may prove protean" (Brooks, p. 1120).

11 Specifically, A.L. Rowse was a gay male historian whose interest seemed more in Forman than Lanyer.

the shadow of the Dark Lady, there are multiple alternate "what ifs" that might extend from what we do know about Lanyer: what if she served as Lady Anne Clifford's music tutor, and helped give her the tools to become the formidable landowner and force for northern England that she would eventually become?[12] What if she educated young women of means for two years, 1617–1619, and (as Lloyd Malcolm posits for her Bankside women) had an important and potentially dramatic effect on their lives? How might they have gathered around her as she faced a lawsuit from her landlord (Woods, pp. 32–33)?

Any historical fiction or biofiction will necessarily shade the facts, but history at least pretends to deal in fact, narrated as closely as possible to resemble truth. To base a fiction on a fiction, especially one that exploits the gender and racial stereotypes of a culture, is problematic, though the temptation is perhaps inevitable. One might make a case that these then become historical fictions rather than biofictions. That is, if biofiction starts with known facts to create fictions that seek to imagine an inner character, it should not have a distracting counterfactual presence at its center. A feigned Shakespeare connection will inevitably overshadow everything else about Lanyer. Historical fiction, more broadly, might tell a tale that touches on elements of recorded history, but be more interested in story than character. If that is so, then Sharratt, Eugster, and Lloyd Malcolm are at least attempting true biofiction as they seek to honor an actual woman writer, while Newman and Tiffany are writing historical fiction that happens to use some historical names. For all five, however, Rowse's founding fiction creates the proverbial elephant in the room, in this case wearing a doublet and hose, who keeps shading a true biofiction of Lanyer.

Works Cited

Bevington, David. "A. L. Rowse's Dark Lady." *Aemilia Lanyer: Gender, Genre and the Canon*, edited by Marshall Grossman. Lexington: University of Kentucky Press, 1998, pp. 10–28.

Boggs, Colleen Glenney, and Chenxi Tang. "Introduction to 'Poetics of Fact, Politics of Fact'." *PMLA*, vol. 134, no. 5, October 2019, pp. 1109–1114.

Borman, Tracy. *The Private Lives of the Tudors*. New York: Grove Press, 2016.

Brooks, Peter. "The Facts on the Ground." *PMLA*, vol. 134, no. 5, October 2019, pp. 1115–1120.

12 See Lewalski's 1993 essay on Clifford.

Eugster, Rachel. *Whose Aemilia?* Performed Ottawa Fringe Festival, 18–28 June 2015; copy available from rachel.eugster@gmail.com.

Hall, Kim. *Things of Darkness: Economies of Race and Gender in Early Modern England.* Ithaca: Cornell University Press, 1996.

Lanyer, Aemilia. *Salve Deus Rex Judaeorum.* London: by Valentine Simmes for Richard Bonian, 1611.

Lanyer, Aemilia. *The Poems of Aemilia Lanyer: Salve Deus Rex Judaeorum,* edited by Susanne Woods. New York: Oxford University Press, 1993.

Lewalski, Barbara K. "Of God and Good Women: The Poems of Aemilia Lanyer." *Silent but for the Word,* edited by Margaret P. Hannay. Kent, OH: Kent State University Press, 1985, pp. 203–224.

Lewalski, Barbara K. "Claiming a Patrimony and Constructing a Self: Anne Clifford and Her *Diary.*" *Writing Women in Jacobean England.* Cambridge, MA: Harvard University Press, 1993, pp. 125–151.

Lloyd Malcolm, Morgan. *Emilia.* London, Oberon, 2018. Performed London, The Globe and Vaudeville Theatres, August 2018 and March 2019.

MacDonald, Joyce. *Women and Race in Early Modern Texts.* Cambridge: Cambridge University Press, 2002.

Newman, Sandra. *The Heavens.* New York: Grove Press, 2019.

"Poetics of Fact, Politics of Fact." *PMLA,* vol. 134, no. 5, October 2019, pp. 1109–1172.

Prior, Roger. "Was Emilia Bassano the Dark Lady of Shakespeare's Sonnets?" *The Bassanos: Venetian Musicians and Instrument Makers in England, 1531–1665,* by David Lasocki and Roger Prior. Aldershot, UK: Scolar Press, 1995, pp. 114–139.

Roche, Thomas P., Jr. ed. *Petrarch in English.* New York: Penguin Classics, 2005.

Rowse, A. L. *Simon Forman: Sex and Society in Shakespeare's Age.* London: Weidenfeld & Nicolson, 1974.

Sharratt, Mary. *The Dark Lady's Mask.* New York: Houghton Mifflin Harcourt, 2016.

Sidney, Sir Philip. *An Apology for Poetry* (1595), edited by Geoffrey Shepherd. London: Thomas Nelson and Sons, 1965.

Tiffany, Grace. *Paint: A Novel About Shakespeare's Dark Lady.* Tempe, AZ: Bagwyn Books, 2013.

Wilcox, Helen. "Lanyer and the Poetry of Land and Devotion." *Early Modern English Poetry: A Critical Companion,* edited by Patrick Cheney et al. New York: Oxford University Press, 2007, pp. 240–252.

Wilcox, Helen. *1611: Authority, Gender, and Word in Early Modern England.* Malden, MA: Wiley Blackwell, 2014.

Woods, Susanne. *Lanyer: A Renaissance Woman Poet.* New York: Oxford University Press, 1999.

About the Author

Susanne Woods was Founding Director of the Brown (now Northeastern) Women Writers Project, editor of *The Poems of Aemilia Lanyer* (1993), and author of *Lanyer: A Renaissance Woman Poet* (1999). She was faculty member and Dean at Brown University and is Provost and Professor Emerita of Wheaton College (MA).

6. Archival Bodies, Novel Interpretations, and the Burden of Margaret Cavendish

Marina Leslie

Abstract

This essay explores the myth-making function of archives, identifying the tensions and convergences between scholarly narratives and fictionalized biographies in readings of two contemporary novels featuring Margaret Cavendish. Both Danielle Dutton's *Margaret the First* and Siri Hustvedt's *The Blazing World, A Novel* feature the taint of madness that has haunted the Duchess of Newcastle's reputation for centuries, while offering radically different diagnoses and etiologies. By examining the origins and stubborn staying power of the now discredited moniker "Mad Madge," the nickname by which Cavendish was once believed to have been known to her contemporaries, this essay seeks to reconsider the novelizing and pathologizing tendencies that can drive both scholarly and fictional treatments of early modern women.

Keywords: Margaret Cavendish, Mad Madge, Siri Hustvedt, Danielle Dutton, archives, life-writing

"I am going to build a house-woman. She will have an inside and an outside, so that we can walk in and out of her. [...] She must be large, and she must be a difficult woman, but she cannot be a natural horror or a fantasy creature with a vagina dentata. She cannot be a Picasso or a de Kooning monster or Madonna. No either/or for this woman. No, she must be true."
—Siri Hustvedt. *The Blazing World: A Novel* (p. 207)

When Harriet Burden, the protagonist of Siri Hustvedt's novel *The Blazing World*, sets out to build her multimedia "house-woman" as part of an

Fitzmaurice, J., N.J. Miller, S.J. Steen (eds.), *Authorizing Early Modern European Women. From Biography to Biofiction*. Amsterdam: Amsterdam University Press, 2022
DOI 10.5117/9789463727143_CH06

installation – also entitled "The Blazing World" – both character and author explicitly invoke and reinvent Margaret Cavendish's romance of the same title, challenging readers to determine what is inside or outside this dizzying intersection of worlds. Before embarking on a reading of Hustvedt's *The Blazing World* and Danielle Dutton's *Margaret the First*, two novels which feature the vexed legacy of Margaret Cavendish's life and works, I want to pause over (and perhaps hijack) the question raised by the epigraph above. For how does one tell the truth about early modern women in contemporary art or fiction? Or for that matter in our scholarship? Many of us desire to speak with the dead, but what happens when we speak for them?[1] Which are the permitted arts of necromancy and which to be regarded as acts of dubious or unholy ventriloquism? What counts as timely revivification and what as anachronistic projection or appropriation?

However meticulous our research or robust the archive, it is important to bear in mind that the textual remains of early modern women can only ever tell us part of their stories. Where then does the truth of these women's lived experience reside?[2] What might imagining, displaying, and inhabiting the complex truths of their lives and minds demand of us in the present? To be clear, I do not expect such questions to yield simple answers. For me the particular interest for a volume on early modern women and biofiction is in directing such questions to scholars and novelists alike, with the understanding that both parties share more in their conjuring arts than is often comfortably acknowledged.

Let us begin with the premise that accounts that aim to capture something true about the lived experience of early modern women, whether scholarly or fictional, must at least be in conversation with the evidence available in the archive. But even accepting such a seemingly obvious and baseline premise, two things must be conceded from the outset: 1) archives have never been disinterested repositories of impartial facts; and 2) narrative, with its attendant requirements of compelling story-telling, is the medium by which scholars and writers alike bring early modern women to life and

1 Stephen Greenblatt famously opens *Shakespearean Negotiations* with, "I began with the desire to speak with the dead." As the passage continues, however, Greenblatt finds that what he has conjured is in fact himself, that is to say, the present as constituted by the past: "It was true that all I could hear was my own voice, but my own voice was the voice of the dead, for the dead had contrived to leave traces of themselves, and those traces contrived to leave textual traces of themselves, and those traces make themselves heard in the voices of the living" (p. 1).

2 I'm using the term "lived experience" to signal a reality beyond the reach of truth claims grounded in documentation or verified autograph writings to capture something closer to interiority, subjectivity, or even unconscious experience.

to new audiences.[3] Furthermore, coherence in narrative, whether driven by scholarly argument or writerly intuition, is dependent on a process of discretionary curation. Biographical narratives of early modern women in particular, even when drawn from archival sources, generally rely for their coherence on speculation or elision, whether because the archival record is thin or unreliable, or, as in the peculiar case of Margaret Cavendish, because the record is vast, not always consistent, and contains the strange and mixed evidence of her reception across time. Cavendish has at least eight twentieth-century book-length biographies (to say nothing of the innumerable biographical entries in print and online), and it is as instructive as it is unsurprising that they do not tell the same story or negotiate the relation between her life and work in precisely the same way. That is to say, each scholarly biography must create (or, if you prefer, curate) its own Margaret Cavendish.

This might be said to be true, of course, for any historical figure; and yet for Margaret Cavendish in particular there has always been the persistent characterological question. The echoing assertion of her reputation for "madness," even when demonstrably distorted, retrofitted, and ultimately falsified has had a life of its own that also demands the work of analysis and intuition (that is to say, interpretation) to be fully legible as a story. In other words, for Cavendish (and not only for Cavendish) there is considerable fiction in the archives.

The conflation of the actual and the fanciful in the life and work of the Duchess of Newcastle has a long and complicated history, in no small part because of her own efforts to manipulate the boundaries between the two, both in her writing and in her dramatic costumed appearances in public. Yet perhaps the most distilled and certainly one of the most famous formulations for the convergence of fact and fiction in the singular figure of Margaret Cavendish can be found in one of Pepys's more ecstatic expostulations on Cavendish: "The whole story of this *lady* is a *romance,* and *all* she *do* is romantick" (11 April 1667). Pepys, of course, was not always so generous about the work. Less than a year later, he had penned another of his most famous and oft-quoted lines on Cavendish in a diary entry describing her biography of her husband: "[R]eading the ridiculous History of my Lord Newcastle, wrote by his wife, which shews her to be a mad, conceited, ridiculous woman, and he an asse to suffer her to write what she writes to him, and of him"

3 Of course, the Digital Humanities offer a variety of important non-narrative methodologies for learning true things about early modern texts; however, even DH relies on narrative to frame, interpret, and disseminate findings.

(18 March 1668). This is clearly a highly critical assessment of Margaret's character (and, no less, William's) for undertaking this particular vanity project, but just as clearly this is *not* a free-standing clinical diagnosis. The word "mad" had in the seventeenth century a range of meanings, including "insane," or "mentally unbalanced," but I take Pepys to be using the term here in the sense charmingly phrased by the *OED* as "extravagantly or wildly foolish; ruinously imprudent."

The defining epithet that has haunted Margaret Cavendish's reception and which continues to drive her characterization in the two novels under consideration is that of "Mad Madge of Newcastle," a sobriquet that is not uttered by Pepys or, it turns out, anyone at all until 1872, when a certain obscure antiquarian named Mark Anthony Lower published the first new edition of *The Life of William* in 200 years. In his introduction, Lower notes of the author, "I feel certain, that no modern reader, on a candid perusal of her writings, will concur in attributing to her the nickname which her jealous (female?) contemporaries gave her – Mad Madge of Newcastle!" (p. ix).[4] Where to begin with this back-peddling, back-dated neologism and back-handed compliment! And how to account for its ubiquity after this first retrospective anachronistic invention? By attributing the formulation to Cavendish's jealous female contemporaries even as he himself was inventing it, Lower mitigates the alleged slander by feminizing it. The now widely cited criticisms of Cavendish from Mary Evelyn, Dorothy Osborne, and Anne Conway don't allow for an entirely breezy dismissal of the charges, although none of these women's critical comments, recorded in private correspondence or diary entries, has the particularly contemptuous force of a shared and common nickname.

Lower's strategy of condescension challenges his masculine readers who might question the feminine origins of William's biography not to respond like her peevish, jealous, and female contemporaries. Lower seems less interested in settling questions concerning Cavendish's mental stability than in presenting both her works and her wits as curiosities requiring the scrutiny and judgment of the discerning reader, who is aided in "his" examination of both matters by the inclusion of Margaret's own memoir, "A True Relation."[5] It is, thus, an exquisitely complex irony that Lower's

4 Additional examples of his damning rhetoric of defense include: "That her powers of fancy and sentiment were more active than her powers of reasoning, I will admit; but that her productions, mingled as they are with great absurdities, are wanting either in talent or virtue, or even in genius, I cannot concede" (p. viii).

5 Originally published as part of *Natures Pictures* (1656) and republished for the first time by Lower.

infamous phrase, which is taken up as both support for and evidence of a particularly familiar, demeaning, and deeply misogynist account of her disordered mind, is originally represented (i.e. invented) as a female attack on Cavendish, from which he attempts to defend her.

It is perhaps an entirely different kind of irony that Katie Whitaker, who is to my knowledge the first to attribute this phrase to Lower, takes "Mad Madge" as the title for her important 2002 biography of Cavendish. This epithet is also reprinted as a header on every verso page of the volume, while Whitaker's debunking of the presumed early modern origins of the slanderous epithet is reserved for page 354 of her epilogue. That Whitaker herself is in no way condescending to her subject reminds us that this expression was also useful to Cavendish's most ardent feminist defenders. The mad woman had been since Gilbert and Gubar's *Madwoman in the Attic* an entirely familiar figure in feminist canons and a pathologized Cavendish fits comfortably into those narratives ripe for resistant and recuperative feminist readings.

This is all to say that the history of Cavendish's reception isn't always amenable to correction because the mistakes and the corrections and the sometimes incoherently mixed or variably coded presentations of her character are all part of that legacy. The exposure of "Mad Madge" as a later nineteenth-century formulation has been known for some time. But the mechanisms of its continued reproduction are not, I think, so widely discussed, nor are the implications for our own work when this old and distorted story becomes the grounds for new fiction and the popular dissemination of her character and accomplishments.

To explore what Cavendish's reputation might mean for us now and how the operations of the archive are dramatized and illuminated in fiction, it is instructive to observe how her putative madness and problematic reception are similarly taken up but very differently imagined in Danielle Dutton's and Siri Hustvedt's novels. As its title suggests, Dutton's *Margaret the First* puts Cavendish at the center, whereas Hustvedt's *The Blazing World* centers on a fictional contemporary American artist, Harriet ("Harry") Burden, for whom Cavendish serves as an early modern avatar, muse, and warning. Aside from their fascination with Cavendish, there's not a lot these two novels share. Their historical settings, novelistic styles, and literary projects set them worlds apart. *Margaret the First* takes on (and is a take on) historical romance, with Cavendish as its protagonist and singular subject. Hustvedt's *The Blazing World* summons Cavendish as an artistic and historical problem for interpretation and a repository of work for allusion, adaptation, and outright appropriation. Despite their

many evident differences, their shared investments in understanding and providing contexts for how Cavendish came to be known as "Mad Madge," represent not an accidental convergence, but a sign of the gravitational pull of Cavendish's problematic posthumous reputation. Ultimately, the madness of Madge is not best understood as a diagnostic question, nor even an historical assertion susceptible to documentary proof or disproof, for neither of these principles of evaluation captures the residual, recursive, and repositionable nature of Cavendish's reputation as it has been preserved in and recovered from the archive and as it has now entered fiction, even at the very moment that awkward and squawking albatross has begun to lose its hold over early modern scholarship.

In the readings that follow, I do not intend to take it as my task to verify or challenge these novels' management of particular matters of historical accuracy. Simply put, novels, even historical novels, have no absolute duty to be factually correct. Clearly, there are brilliant and critically regarded historical novels that play fast and loose with the historical record. Conversely, the avoidance of factual inaccuracies in historical fiction does not necessarily confer a compelling verisimilitude. Therefore, instead of reading and evaluating these novels as historical documents – which they clearly are not, and do not pretend to be – I propose to approach them as readings of Margaret Cavendish situated in a long history of critical readings, which sometimes do and sometimes do not acknowledge their own novelizing tendencies.

Crying Woolf: The Novelist as Archive in Danielle Dutton's *Margaret the First*

Dutton's novel, *Margaret the First,* engages Cavendish's reputation for madness from its opening scene, where "a "mob" of excited onlookers, joined by Samuel Pepys, gathers about her carriage repeatedly calling out "Mad Madge!" (p. 4). The novel proceeds to reveal Margaret in a sequence of short breathless vignettes, which vividly summon the sights, tastes, sounds, smells, indeed, the full sensorium of her girlhood and womanhood during the tumults of Civil War, her exile in Paris and Antwerp, and return to Restoration England.[6] Though presenting in this way a fully sensuous historical novel, Dutton takes pains to check any expectation of a sensual bodice-ripping costume drama. On the other hand, she equally eschews representing

6 I am using "Margaret" to denote Dutton's character and distinguish her from the historical Cavendish.

Margaret as a self-realized feminist exemplar. Dutton's protagonist is limited and unformed even to the point of formlessness. She is delicate, fluttering, and febrile. She is a creature of fertile imagination without discipline or training and thus, despite her wide reading, her ferocious and voluminous output, her celebrity, and the fleeting moments of public recognition, she is first and last an object lesson in the waste of female talent in a world where women are denied academic training or a serious place at the table – even when it is their own table.

Dutton's heroine is sympathetic but, by design, something of a shallow vessel, spilling over with the flitting fancies and the frustrations of an ambitious woman with a great deal more urgency and longing than substance. Margaret considers the urgent intellectual preoccupations of the age and her arguments and ideas are fairly enough described to be recognizable. Nonetheless, the impressionistic and kaleidoscopic representation of her thoughts gather to an impressive and glittering quantity without seeming to accumulate in maturity, heft, or seriousness. She is eccentric. She is odd. Even William grows vexed with her. When her sister's grandchildren visit, "they stare at her with bright round eyes" (p. 146).

It is thus unsurprising to learn from the epilogue that Dutton first encountered Cavendish via Virginia Woolf. Here indeed is the Duchess as "bogey to frighten clever girls with" (p. 93): "[T]hat wild, generous, untutored intelligence. It poured itself out, higgledy-piggledly, in torrents of rhyme and prose, poetry and philosophy which stand congealed in quartos and folios that nobody ever reads" (p. 92). "The hare-brained, fantastical Margaret Cavendish" (p. 91). Dutton produces a historically informed and elegantly written novel, but she has also exhumed and re-animated a version of Cavendish that has challenged feminist readers since Woolf originally displayed her pity and distaste for Cavendish in *A Room of One's Own*.

While Woolf's essay may have provided Dutton with her first introduction to Cavendish, Woolf's pseudo-historical novel *Orlando* seems also to have influenced and informed her treatment of her early modern subject. Indeed, the animating spirit of Dutton's Margaret and the way a reader of the novel might most fully recognize her would be to understand her as literary descendent of the passionate but vacuous Orlando, with at least a wink and a nod to the eccentric Archduchess Harriet. Her abstractedness and absurdity carry traces of these characters, described in the same bemused and critical-yet-affectionate tenor.

The influence of *Orlando* is particularly evident about halfway through the novel when Dutton dramatically shifts from presenting Margaret as the first-person narrator to using a third-person omniscient narrator. The

chapter entitled "Restoration," begins as follows: "IT CAME AS A SHOCK. AFTER A BRUTAL CROSSING – IN WHICH SHE HIT her head in a storm and swore she'd seen a bear at the helm of the ship" (capitalization in original). Not as shocking, perhaps, as the mid-novel manifest change of gender in *Orlando*, but Dutton's dramatic, unorthodox, and typographically trumpeted change of voice does feature as fundamental a textual transformation. For just as Margaret comes fully into her writing life, she is inscribed into a narrative she no longer narrates herself. As the passage above suggests, biography and fiction, both authorial and textual Margarets, are merged in the account of a brutal ocean passage that includes the sighting of an anthropomorphic bear in a hallucinated (or, put another way, a fictionally imagined) "real-world" origin story of *The Blazing World*.

This is skilled and densely allusive storytelling that puts together Cavendish's life and works in artful ways drawn from both the archive and fiction. But, finally, this exquisitely realized period piece lands most palpably in Bloomsbury, circa 1928–1929. Ultimately, Dutton's dizzy, whimsical Margaret does not capture the import or intelligence of the work of Cavendish that is represented by the burgeoning recent scholarship on her, yet it is nonetheless very true to the portrait drawn by Virginia Woolf, and thus represents at the least a significant truth about the endurance of the vexed feminist history of representing Cavendish.

The Archive as Assemblage in Siri Hustvedt's *The Blazing World*

Hustvedt's version of the mad woman as artist and intellectual might be even darker and more troubling than Dutton's historical cautionary tale "for clever girls," in no small part because it intrudes upon the present. While Cavendish had been dead for over 300 years by the time of the events detailed in the novel, she is vividly present as the muse and historical alter ego of the novel's late twentieth-century protagonist, Harry Burden. Like Cavendish, Burden is a multidisciplinary thinker and artist who struggles to receive recognition for her body of work. Burden vigorously but ambivalently embraces Cavendish, not least because of certain biographical parallels between her life and the Duchess of Newcastle's. Like Cavendish, Burden is part of a cultural elite, materially well-situated, with an influential husband-patron who both enables and potentially overshadows her artistic endeavors.[7]

7 There is clearly an autobiographical component to the novel, as well. Hustvedt herself is an accomplished multidisciplinary polymath married to the lionized writer Paul Auster. In a

Burden's relationship to and understanding of Cavendish is historically acute, learned, and self-conscious and it is clear that she values both the ambitions and the messiness of Cavendish's *oeuvre*. But this identification offers cold comfort, as is starkly evident when she struggles to express herself and her work in terms that channel Cavendish directly: "I am a Riot. An Opera. A Menace! I am Mad Madge" (p. 207). Burden ultimately understands Cavendish's reception as an object lesson she is powerless to correct. Assert your talents, wasting no time or spirit in self-suppression, and be disregarded for your gender. Take advantage of your privilege and class and find yourself visible but resented, despised, or mocked. Or, perhaps worst of all, achieve praise, but only when your work is attributed to others. In other words, put yourself or your body of work before the world (early modern or modern) at your peril.

Burden finds that she cannot successfully manipulate her reception even when she runs an experiment to control for the variable of gender by displaying her works through a series of masculine proxies. Although she finally receives the recognition she so ardently desired, this occurs only when her work is taken as the very embodiment of hip youthful masculinity, all traits to which she has no claim. Moreover, it turns out that the hoped-for retroactive and triumphant unveiling of herself as artist proves impossible. While she has the bitter satisfaction of having her darkest views of the misogynist biases of the art world vindicated, she succeeds only in proving that her work can be admired only when she disappears. It is the burden of Harry Burden to be herself: female and middle-aged, oversized yet overlooked, and now taken for mad as she tries to persuade an incredulous world that the works claimed by the young, edgy, rising artist known as "Rune" are actually her own. He dies spectacularly without revealing the fraud at the heart of his career, making his *oeuvre* and legend unassailable. Burden gets sick and slowly and ingloriously dies of cancer, her body betraying her one final time.

Burden's biography, however, is only part of her story. In the end, her "remains" are her numerous multimedia and multiform sculptures and her equally numerous cryptic notebooks, each named for a letter of the alphabet. These are remarkable documents, whose intellectual range includes (but is not limited to) literature, philosophy, psychoanalysis,

generally negative and truly bizarre review of the novel, Terry Castle takes these biographical facts and her own distaste for Cavendish as the basis for a pathologized reading of Hustvedt herself. I take Castle's reading to be entirely symptomatic of the problems under examination in this essay.

artificial intelligence, and cognitive science, as well as the full scope
of art/history in theory and practice. They are full of rage and sadness,
illumination and obscurity, analysis and invention, organized by no
discernible principle. In addition to the journal excerpts, the novel is
composed of a sequence of free-standing documents in various genres
(interviews, reviews, newspaper accounts, letters, etc.), whose authors
include Burden, her therapist, her children, her friends, art critics, artist
collaborators, lovers, and boarders. Collectively, these disjointed parts
represent Harriet Burden not as unified subject but as an archive. She
is a puzzle made more, not less mysterious when all these highly medi-
ated and contested documents, constituting and responding to her life
and work, are assembled in one place to produce the work of non-fiction
scholarship that is coterminous with the novel. There is not ultimately
a single coherent through-line to this self-contradictory assemblage of
artifacts. To be coherent would require privileging one interpretation or
narrative line and suppressing others and this novel is not interested in
gratifying yearnings for coherence. Indeed, I believe Hustvedt makes a
convincing case that every interpretation, even the discredited, mistaken,
or ill-intentioned ones tell a truth worth examining, even those offered
by documents which are ultimately revealed to be faked, ventriloquized,
or plagiarized.

Although this is Harry Burden's story, it resonates powerfully with the
historical Cavendish who represents a similarly incoherent archival as-
semblage. The novel suggests, moreover, that neither woman's biography or
body of work can be considered settled or entirely in the past. The urgency
and ongoing demands of the archive for academic readers in particular is
brought home most forcefully in the framing device and central conceit of
the novel. The book opens with an "Editor's Introduction," authored by one
I. V. Hess, a scholar of aesthetics who describes the book before us as the
result of several years' labor to provide a more complete understanding of
Harriet Burden, an unjustly neglected and not yet well-understood artist.
The belatedness of this effort is made even more poignant by the revelation
that Professor Hess's teaching and administrative duties forced a three-year
delay until a sabbatical enabled a return to the project, by which time Burden
is discovered to be two years dead.

While this makes vivid the institutional pressures and constraints of
academic life and the real-world labor conditions of knowledge production,
it is, interestingly, neither the living Burden nor a direct experience of her
art that initially captures Professor Hess's attention or inspires the research
project, but rather a provocative quote from a letter to the editor appearing

in an interdisciplinary journal named "The Open Eye."[8] The letter's credited author, Richard Brickman, outlines Burden's project of presenting her own work behind three male "fronts" in the series she called collectively "Mask-ings." Brickman describes how "[e]ach artist mask became for Burden a 'poetized personality,' a visual elaboration of a 'hermaphroditic self,' which cannot be said to belong to either her or the mask, but to a 'mingled reality created between them'" (p. 3). Hess ultimately learns that this published letter is yet another of Burden's masks, through which she proves her point in a masculine voice full of misogynist condescension and expressed misgivings about Burden's (that is to say, her own) work.

Hess's first explicit remarks on the critical importance of Cavendish as an influence and object of identification connects her to Burden's fascination with monsters: "But the monster is not always a Rabelaisian wonder of hearty appetites and boundless hilarity. She is often lonely and misunderstood (See M and N)" (p. 5). "M and N" refer to the lettered notebooks devoted to Burden's observations on Margaret Cavendish, Duchess of Newcastle, where, rather than focus on her as a pitiable character, Burden shows Cavendish in dialogue with "the work of Descartes, Hobbes, More, and Gassendi." Moreover, as Hess points out,

> Burden links Cavendish to contemporary philosophers such as Suzanne Langer and David Chalmers, but also to the phenomenologist Dan Zahavi and the neuroscientist Vittorio Gallese, among others. After reading the passages in question, a colleague of mine in neurobiology, Stan Dickerson, who had never heard of either Burden or Cavendish, declared Burden's argument "a bit wild but cogent and learned." (p. 5)

Merging past and present philosophers, Cavendish and Burden, this passage deliberately and with energy creates a Cavendish for the ages simply by taking her ideas seriously and offering them to appropriate audiences with no preconception of Cavendish's background or baggage.

Within this novel presenting the tragedy of a brilliant woman humiliated and shamefully underestimated, there also exists a complex ecology of narratives of endless self-reinvention, hermaphroditic performances, and lively posthumous dialogues with invented and impossibly anachronistic interlocutors. From its audacious theft of Cavendish's title to its brilliant

8 To wit: "All intellectual and artistic endeavors, even jokes, ironies, and parodies, fare better in the mind of the crowd when the crowd knows that somewhere behind the great work or spoof it can locate a cock and a pair of balls" (p. 1).

readings of Cavendish's work, life, and reception, Hustvedt's novel presents a maniacally detailed and heavily annotated map for negotiating this uneven territory that comprehends both the limitations of history and its endless possibilities for revision and reassessment. Hess notes at the end of the "Editor's Introduction" that the working title of the book had been "*Monsters at Home*," a line taken from Burden's Notebook R (which Hess speculates is "possibly for revenant, revisit, or repetition" [p. 10]). However, after having at last reviewed and ordered all the texts contained in the volume, "I decided that the title Burden borrowed from Cavendish and gave to the last work of art she was able to complete before her death was better suited to the narrative as a whole: *The Blazing World*" (p. 11). This is where the novel begins, but also where it ends. Hess, the ambiguously gendered academic, now in possession of the most complete – if not always comprehensible or reliable – documentation, moves away from the endless reiterations of the sad and lonely "monster at home" to the possibility of an incandescent world where Burden (Cavendish, etc.) is no monster. This is a moment of possibility whose intimation is recovered from the archive but can only take place beyond its confines.

Fact, Fiction, and the Archive of the Future

If there is a lesson for understanding how one represents a "true" Cavendish in fiction, it is a complex one. Dutton's novel is historically meticulous, but I, at least, don't recognize Cavendish in the character of the woman she portrays. The problem here is not inattention to the historical record, for there is ample and transhistorical evidence in the archive for this characterization. More lacking, perhaps, is Dutton's exposure to or weighing of Cavendish's evolving reputation in more recent (re)considerations of her work. But this would be to locate the truth of Cavendish in the now, not in the past. Like Dutton, Hustvedt presents Cavendish's madness as part of her legacy, but by bringing this legacy into the light of the present, she gives context for why this gendered reception was always wrong on the merits and why its distortions and deformations have endured. By giving us a fictional, though entirely plausible example in Burden of how Cavendish's experience is not relegated to the past, Hustvedt makes painfully clear that it is not just Cavendish who needs to be saved from the archive. We all need saving – and, in fact, we need to do the saving, as well.

As an early modern scholar, I have learned from these novels that I have a reading of Cavendish that isn't fully discoverable in the sum total of her

writings or a comprehensive survey of scholarly books, articles, biographies, or historical reflections on her work and character. Indeed, when scholars disagree in their interpretations of a Cavendishean text (and we still disagree even when we admire) we are in part disagreeing about the mind, character, and perceptions of the woman who wrote it, based not just on reading her publications but on a "reading" of Cavendish herself. Whether such readings are best understood as synthesis, empathy, or what the historian and philosopher R. B. Collingwood once called "historical imagination," it is clear that reading and writing convincingly, ethically, and "truly" about the past requires some ultimately unquantifiable mix of knowledge, experience, and intuition. To write truly about early modern women, requires approaching the archive with a particularly acute skepticism because all species of mediation in production, publication, circulation, and reception can be particularly constraining for them. That is to say that, in the end, the archive is the source of truth and the source of lies. It is a mutable beast, constantly shifting and reconfiguring. As we have seen, it is in its nature to produce and reproduce a composite, chaotic, and in a literal sense incomprehensible Cavendish. Our duties as scholars of Cavendish, given her peculiarly vexed and sometimes fictive legacy, may counterintuitively require that we stop battling and feeding the beast and move on to assess, describe, and assert, that is, to *imagine* Cavendish as she makes sense to us, not as antiquarians or fabulists, detractors or boosters, but rather as scholarly curators of the new knowledge and new genealogies that our future narratives will provide.

Works Cited

Castle, Terry. "The Woman in the Gallery." *The New York Review of Books,* vol. 61, no. 13, 14 August 2014, pp. 34–37.

Cavendish, Margaret. *Natures Pictures Drawn by Fancies Pencil to the Life.* London: J. Martin and J. Allestrye, 1656.

Cavendish, Margaret. *The Description of a New World, Called the Blazing-World.* London: A. Maxwell, 1666.

Cavendish, Margaret. *The Life of the Thrice Noble, High and Puissant Prince William Cavendishe.* London: A. Maxwell, 1667.

Cavendish, Margaret. *The Lives of William Cavendische, Duke of Newcastle, and of His Wife, Margaret, Duchess of Newcastle*, edited by Mark Anthony Lower. London: J. Smith, 1872.

Collingwood, R.B. *The Idea of History.* Oxford: Clarendon, 1946; revised edition, with an introduction by Jan Van der Dussen. Oxford: Oxford University Press, 1993.

Dutton, Danielle. *Margaret The First.* New York: Catapult, 2016.

Gilbert, Sandra and Susan Gubar. *The Madwoman in the Attic.* New Haven: Yale University Press, 1979.

Greenblatt, Stephen. *Shakespearean Negotiations: The Circulation of Social Energy.* Berkeley: University of California Press, 1988.

Hustvedt, Siri. *The Blazing World: A Novel.* London: Sceptre, 2014.

Pepys. Samuel. *The Diary of Samuel Pepys.* Ed. Robert Latham and William Matthews. 11 vols. Berkeley: University of California Press, 1970–1983; vols. 8 and 9, for 1667–1668 (1974): 8.163; 9.123.

Whitaker, Katie. *Mad Madge: The Extraordinary Life of Margaret Cavendish, Duchess of Newcastle.* New York: Basic Books, 2002.

Woolf, Virginia. *A Room of One's Own.* London: Hogarth Press, 1935 (1929).

Woolf, Virginia. *Orlando.* London: Hogarth Press, 1928.

About the Author

Marina Leslie is Associate Professor Emerita of English at Northeastern University. She is author of *Renaissance Utopias and the Problem of History* and co-editor with Kathleen Coyne Kelly of *Menacing Virgins.* Her current book project, "Begetting Crimes," addresses labor, reproduction, and female criminality in seventeenth-century English print culture.

Section II

Materializing Authorship

7. Bess of Hardwick: Materializing Autobiography

Susan Frye

Abstract

Many authors who have chosen to tell the life of Bess of Hardwick have offered book-length versions of a remarkable life that spanned more than 80 years (1527?–1608). There is so much about Bess to tell, and necessarily to imagine, that within biographies or more openly fictional accounts, writers lose sight of the fact that Bess told her own story repeatedly, in what Judith Butler has called "an open assemblage" of texts. Bess's many texts culminate in her embroidered, room-sized hangings, featuring eight female rulers. These hangings are a legacy that provides access to the wide range of Bess's feelings and aspirations, a legacy that provides evidence that she was the most ambitious female artist in sixteenth-century England.

Keywords: Elizabeth Talbot, countess of Shrewsbury; Bess of Hardwick; Mary Queen of Scots; textiles; biography; biofiction

Bess of Hardwick and the Artistry of Autobiography

Many authors who have chosen to tell the life of Bess of Hardwick, including Gillian Bagwell, David Durant, Kate Hubbard, Philippa Gregory, Mary Lovell, and Maud Stepney Rawson, have offered book-length versions of her remarkable life. That life spanned more than 80 years (1527?–1608) and is chockablock with details of the Tudor culture that created her, and which she in turn helped to create. There is so much about Bess to tell, and necessarily to imagine, that within biographies or more openly fictional accounts, writers lose sight of the fact that Bess told her own story repeatedly, in what Judith Butler has called "an open assemblage" of texts (p. 147). In particular, I find that Bess's many texts culminate in her embroidered, room-sized

Fitzmaurice, J., N.J. Miller, S.J. Steen (eds.), *Authorizing Early Modern European Women. From Biography to Biofiction.* Amsterdam: Amsterdam University Press, 2022
DOI 10.5117/9789463727143_CH07

hangings featuring eight female rulers. These hangings are a legacy that provides access to the wide range of Bess's feelings and aspirations, a legacy that provides evidence that she was the most ambitious female artist in sixteenth-century England.

For at least 40 years, from the 1550s through the late 1590s, as Bess completed three great houses at Elizabethan Chatsworth, Old Hardwick Hall, and New Hardwick Hall, she invested her wit, energy, wealth, and connections to materialize her life through all available Renaissance artforms, organized by her skills as artist and project manager. The artforms through which she projected her identity[1] include architecture; the intersecting coats of arms of her three deceased, well-born husbands in plaster, wood, and textiles; commissioned wainscoting and plasterwork, portraiture, pictures, painted cloths and tapestries, as well as an array of luxurious objects, from elaborate sixteenth-century beds to an inlaid gaming table, to the Turkish carpets that, emulating the Tudors, she placed on the floors of her most intimate rooms. These elite dwellings, inside and out, articulated her complex identity through the intersecting narratives of her life, some based in her marriages and service at the courts of Edward VI and Elizabeth I, and some in mythic-historical parallels.

When Bess of Hardwick surrounded herself in her homes with this array of texts and textiles, in effect she was finding multiple ways to tell her life story and affirm the authoritative identity and temporality that she derived from it. In *Gender Trouble*, Judith Butler's analysis of "gender identity" suggests that Bess's many forms of self-recording provide an ongoing expansion of the definitions of her gender and with it, an expansion of time itself. As Butler writes, "gender identity" exists through a multiplicity of expression, what she describes as "an open assemblage that permits multiple convergences and divergences without [...] closure" (p. 16). Butler's analysis urges us to include in our thinking how Bess's modes of representing her long life resulted in "an open assemblage" of deliciously varied verbal and visual texts that point in many directions, and point without end, or "closure," rather than being only dynastic or uni-directional in ambition. In Bess's textile work, past, present and future interconnect and escape the purely linear time through which she tends to be understood.[2]

1 In my use of the term "identity," I interpret for the study of the early modern period Judith Butler's discussion of this term in *Gender Trouble*. Her aim is to destabilize identity as a stable conception of the self: "to affirm the local possibilities of intervention through participating in precisely those practices of repetition that constitute identity and, therefore, present the immanent possibility of contesting them" (p. 147).

2 I discuss the multi-temporal qualities of Bess's Chatsworth in more detail in Frye, 2019.

In all fairness, Bagwell, Durant, Hubbard, Gregory, Lovell, and Rawson manage to capture much of Bess's intense interest in building and furnishing her houses, recognizing that they somehow express the personality of their builder and manager. However, these biographies and novels, while illuminating important aspects of Bess's life and making her an increasingly central figure in sixteenth-century studies, don't discuss the fact that Bess was what we today would call an artist, one whose medium was textiles. Failing to recognize Bess of Hardwick's aesthetic means missing the key to her multifaceted identity.

During the sixteenth century, room-sized tapestries in gold, silver, and vivid silks were used throughout Europe to display the political identities of their elite owners. As part of this form of self-display, Bess's desire to tell her story resulted in the large needle-worked pieces for the most part still on display at New Hardwick Hall, where their ongoing restoration is making them ever more vivid. Unlike the English queen she served, Elizabeth I, and the French and Scottish queen she both served and helped keep under house arrest, Mary Queen of Scots, Bess of Hardwick did not have a system of royal iconography to rely on for her self-representation. Instead, she created her own iconography, envisioning her walls hung with outsized narratives of bold women rulers as versions of her own life. The eight opulent, nine-by-eleven-foot textile pictures that resulted were originally produced at her Chatsworth workshop from 1569 through the 1570s, with some alterations in the 1580s.

Santina Levey, the brilliant textile historian whose catalogue, *The Embroideries of Hardwick Hall*, itself a kind of material biography of Bess of Hardwick, divides Bess's room-sized textile pictures into two series. In the *Noble Women* series, each narrative is associated with a central authoritative female figure from antiquity, flanked by familial coats of arms and two female personifications that amplify the central figure's significance. Concentrating on the central figures of these hangings reveals them to be the renowned women leaders Arthemesia, Zenobia, Lucrecia, Cleopatra, and Penelope. In the so-called *Virtues* series, the figures of Hope, Temperance, and Faith appear (Levey, pp. 58–109). Although there are good reasons that Levey called this second series of hangings the *Virtues*, their complex reworking of published prints means that they address far more than moralistic virtues (Frye, 2018). Bess and her collaborators shaped the iconography of each of these central figures from often overlapping sources including Ovid, Chaucer, Christine de Pizan, the Greek historian Diodorus, and Boccaccio. Providing many of them with the faces of Bess and the two queens whom she served asserts

Bess's lived connections to power, connections which turned familial when Arbella Stuart was born in the midst of the hangings' creation, to Bess's daughter Elizabeth, who had become Elizabeth Stuart, countess of Lennox when she married Charles, earl of Lennox, a descendant of Henry VII.

Bess possessed the time, resources, personnel, and focus to create these hangings that deployed her gynocentric narratives of queens and generals, sufferers and conquerors, all stories that resonate with her own. We know their value to her because she first chose them for the walls of her beloved Chatsworth, then quarreled over who owned them with her husband George Talbot, earl of Shrewsbury, and ultimately took them to her next home at Old Hardwick Hall and finally to her ultimate creation, New Hardwick Hall, where they were hung in strategic places throughout her great house.[3] In the twenty-first century, these narratives can be read individually and collectively as voicing the otherwise unspeakable aspects of Bess's preference for a more fluid definition of the feminine, one that could imagine worlds beyond dualistic gender definitions, while taking into account her four marriages with all their losses and gains, her political ambitions both for herself and family members, as well as her desire to travel back through her memories, to the marital lives that had brought her to the eighteen years she would eventually live as a widow.

Each of Bess's hangings is a multimedia textile presentation of a central ruling woman,[4] with a supporting cast of personifications and historical figures. Some of these female figures are predictable, like Bess's favorite representation of her own loyalty to husbands so frequently away from home – while she managed multiple properties. Bess turned again and again to Penelope, queen of Ithaca in *The Odyssey*, presented as a self-portrait in the *Noble Women* series, with her right hand commandingly uplifted and her left resting on her weaving (Levey, pp. 80–81). In addition, Penelope is a central figure in the professionally produced tapestry suite, *The Return of Ulysses*, which from 1601 hung resplendent in the Upper Great Hall at New Hardwick. Penelope also appears in a painting of the return of Ulysses that Bess commissioned from one of her many artistic employees, John Ballechouse, in which Penelope is painted at home, diligently weaving by lamplight, as her heroic husband returns.

3 *The Hardwick Hall Inventories of 1601* (1971) describe the whereabouts of the hangings at New Hardwick Hall in 1601.

4 Lucretia is the one figure not a ruler in this series, but she was a central royal figure on whom the shift to a Roman republic depended. On these women as rulers, see Frye (2019, pp. 168–172).

Bess also chose less typical narratives for her hangings, including Cleopatra (Levey, p. 85). In the 1570s, more than 30 years before Shakespeare wrote *Antony and Cleopatra*, when Bess and her workshop were creating this hanging, Cleopatra was for the most part a figure reviled for her seductions and she usually represented female dissimulation rather than authority. Cleopatra's less-than-virtuous reputation may explain why Bess's "Cleopatra" is the one hanging of her *Noble Women* series that did not survive the centuries.[5] My conjecture is that the Cleopatra hanging invited neglect because its presence challenged the ability of Bess's descendants to normalize her idiosyncratic hangings as a series of "virtues," when in fact they are a series of female rulers, whose complex narratives of personal challenge and achievement had drawn Bess to them in the first place.

Together, these textile pictures compose critical components of Bess's "assemblage" of texts through which she amplified her sense of her identity. The sheer scale of Bess's textile oeuvre and the massive organization needed to produce it, together with the fact that many of her largest textile pictures include portraits of herself, Queen Elizabeth, and Mary Queen of Scots, suggests how central these textile pictures were to her claiming of mythic history as the means to articulate her life's experiences. Such portraits may be read as a visual autobiography, and constructed deliberately as such. As Andrea Pearson has recently pointed out, studying early modern portraiture allows us to extend women's creative agency from written texts to the visual realm, since "portraits more than any other form of pictorial expression immediately lend themselves to the study of identity and agency" (pp. 1–2). Pearson's use of the word "portraiture" describes both the material fact of resemblance in Bess's hangings, as well as the act of recording them by design.

Bess's decision to create her textile versions of powerful women for the halls of sixteenth-century Chatsworth is without precedent. A generation later, faced with the similar problem of dressing the walls of Knole, the young Anne Clifford and her husband, Richard Sackville, third earl of Dorset, decided to use "all my Lords Caparasons which Edwards the upholsterer

5 Levey speculates that the "Cleopatra" hanging was damaged by light because of its location at New Hardwick Hall, then taken apart to repair the other four hangings (p. 85). But Cleopatra may have been used for repairs because she remained a controversial figure. Only Robert Garnier's *Antonie*, published in France in 1578 and translated by Mary Sidney Herbert in 1592, offers an alternative to the prevalent distaste for her, picturing her as a sovereign queen as well as wife and mother, skilled in diplomacy and languages. Nevertheless, the alternative narratives about Cleopatra featuring her sexuality as well as the supposed dark color of her skin continue to encircle the Egyptian queen, as with all the alternative and sometimes contradictory sources informing Bess's central female figures.

made up" to hang about their gallery, as Anne recorded in her diary.[6] In other words, the earl resolved the problem of "dressing" their splendid interiors by creating hangings from the lustrous clothes once worn by his horses at the equestrian entertainments of James I, an appropriate means to celebrate and preserve his position as favorite in the King's hunting circle.

If there is any source for Bess's overall idea of hangings featuring female figures, it may be the *Citie of Ladies* tapestries, apparently based on Christine de Pizan's work of that name (Bell, pp. 1–42). Both Elizabeth and Mary Queen of Scots owned a suite of tapestries titled the *Citie of Ladies*, although if these tapestries suggested the concept of a series of powerful women, Bess made the decision to add Cleopatra to Christine's figures, flanked by the cardinal virtues Fortitudo and Justitia. Bess's decision that her figure of Cleopatra be attended by two cardinal virtues suggests that Bess chose the narrative of Cleopatra as the virtuous if despairing widow of Roman Egypt from among those narratives available to her.

Like Anne Clifford and Richard Sackville, Bess of Hardwick "dressed" her beloved Chatsworth with the splendid textiles that she had at hand – the embroidered and woven silks of the priests' chasubles and copes acquired by William Cavendish and William St. Loe, her two husbands involved in the dissolution of the monasteries. As each hanging was planned, these garments were cut up to become the human figures, stages, and rooms of her hangings of women rulers.

When it came to producing these large and impressive statements about her life, Bess of Hardwick, like many successful Renaissance artists, organized a workshop. This would only have required that Bess extend country house practice, which meant clearing large areas for collaborative work and to accommodate visiting workers. For her large textile hangings, Bess would have needed to assemble a team that included a designer/draughtsman, patterners and cutters, as well as the many hands required to complete the finishing embroidery of each hanging. As Jeffrey Masten points out, "collaboration was a prevalent mode of textual production in the sixteenth and seventeenth century" (p. 4), and Bess would have thought of the production of her room-sized hangings, each with its own gynocentric narrative, in terms of collaborative production.

6 Clifford, p. 184. Clifford records that "my lord" made the decisions about how to "dress" the house (p. 133). As a widow, Anne Clifford became a great restorer of several of her large country houses and fortresses, the most ambitious of the era's life-writers, and the commissioner of no fewer than three copies of her enormous *Great Picture*, itself an exceptionally detailed combination of verbal and visual texts.

Bess's Chatsworth had a room called a "guarderobe," which may not only have been used to store clothing and decorative textiles, but could have been large enough for the massive nine-foot-by-eleven-foot frames required to suspend the linen backings to which her hangings would be attached for embroidery. Bess contributed people and resources from her own household, and, as was the case later in the seventeenth century for the inhabitants of Knole and Penshurst, in the 1570s Bess drew additional workers from every possible source, including the earl's household, and that of Mary Queen of Scots. For, besides the influence of the English royal court on Bess of Hardwick's taste in interior decoration, the other strong influence on Bess during these years had to have been Mary Queen of Scots and her court, which included between 50 and 70 people during this time, including talented portrait painters who also functioned as Mary's tapestry specialists, or *tapissiers.*

As Bess envisioned how to organize the production of her eight room-sized hangings, it's possible that the central figures were worked out in a single coherent vision from the start. But given the complexities of bringing together enough people from time to time to create each hanging, it is easy to see how this monumental work became the intermittent labor of a decade. As Mary was being moved every few weeks because of the need to clean her lodgings, Bess was herself traveling to court and among the Shrewsburys' many properties. Many of the household members required to mount and embroider the hangings were no doubt available only seasonally.

In spite of their peripatetic lifestyle, this was a period in which several accounts place Mary and Bess embroidering smaller needlework pieces side by side. As a result, it seems reasonable to think that Mary, with her own artisans, her large household of ready hands, and her brilliant continental education that had featured the study of women scholars and rulers, became involved in their production. Moreover, Mary had considerable experience with the techniques used to create Bess's large hangings: the repurposing of medieval priests' garments and the use of portraits of the elite within tapestries as a way to integrate their narratives into the early modern interiors they inhabited.

The English were less familiar with the concept of royal portraits in textiles, which may help to explain why some British scholars have been reluctant to see that Bess's textile pictures contain portraits at all. Many scholars have been reluctant as well to consider that these same pictures contain empowering narratives of female rule, which connect to the events of Bess's life and consequent authority, rather than the expected series of "virtues" that early viewers mistakenly preferred them to be.

Nevertheless, Bess's idea of including portraits of herself and her two queens suggests both a familiarity with the concept of portraiture in tapestries and access to a portrait artist familiar with these techniques. Mary Queen of Scots is not only a probable source for the courtly tradition of showcasing portraits within textiles, but her entourage would have included artisans capable of creating the portraits that feature so prominently in Bess's hangings. Of these, Zenobia and Penelope in the *Noble Women* series are agreed to be portraits of Bess,[7] while Santina Levey conjectures that the three Virtues are portraits of Mary, Bess, and Elizabeth, although the Mary portrait has not survived. I have also argued that the figure labeled "Chastity" attending the figure of Lucretia is a portrait of Mary Queen of Scots in white mourning (2010, pp. 45–74). Once aware of the potential for including portraits in her needlework pictures, Bess embraced this continental tradition, using it to emphasize that the central female figures in her hangings are all about her life. This is especially true of the figures that are clearly portraits of a younger Bess, as the armed widow, general, and ruler Zenobia; the triumphant household manager and weaver Penelope; and the victorious Temperance. By embodying Bess's likeness, these hangings incontrovertibly assert that their mythic-historical narratives are indeed Bess's own narratives, forms of what Susan Green calls "writing the self" (p. 50).

Bess of Hardwick's "Assemblage" within Biography and Biofiction

Biofiction, which Michael Lackey defines as "literature that names its protagonist after an actual biographical figure," has sometimes seemed at odds with "history" as an academic discipline. As Lackey points out, since Georg Lukács's assessment in 1937 that the genre of biofiction "distorts and misrepresents the objective proportions of history,"[8] our theories of both fiction and history have dramatically shifted. We are thinking more theoretically about agency and culture, gender and time, with important implications for biofiction as a genre (Lackey, pp. 5–6). To Lackey's analysis, I would add that in the past twenty years, one way in which "history" has changed has been in the move to study material culture, from archival manuscripts to artwork to architecture. For those writers and scholars, including myself,

7 Only Lovell, among Bess of Hardwick's biographers, mentions and concurs with these portraits' identity, p. 221.

8 Georg Lukács, *The Historical Novel* (1983), pp. 300–322, summarized by Lackey, p. 1.

who seek to illuminate the agency of historical women through the material world that they created, the material aspects of "biography" in works of biography and biofiction are of particular interest.

Any writer of Bess's life runs directly into the need to weave her material world into the narrative. As a result, authors, whether writing fiction or aspiring to write *Geschichte wie es war* ("history as it was"), necessarily imagine ways to fill in the gaps between letters and other written documents to explain where Bess was and what she was doing during her long lifetime, fill in motives for what we know she did and even for what we cannot know, while rebuilding in words the long-lost towns, cities, streets, rooms, and buildings of her world.

Bess's biographers and novelists have much to work with. The sheer amount of material evidence that exists for Bess's familial, political, architectural, artistic, and financial dealings invites those who would write about her to the archives. There, over the decades, her biographers have made layer upon layer of very real discoveries. Kate Hubbard, for example, uses both familiar and newer archival material in her longer, more precise version of Bess of Hardwick's life, *Devices and Desires: Bess of Hardwick and the Building of Elizabethan England* (2019), which follows on her short piece, *A Material Girl: Bess of Hardwick 1527–1608* (2001). Biographers like Hubbard who write extended versions of Bess's life have been doubly productive, adding to our already considerable knowledge of the historical record of her life while striving to articulate her life's larger themes and purpose. In spite of the wealth of evidence about Bess's life, her biographers and novelists inevitably must make up much of it. Providing narrative structure to Bess's life results in making assumptions about her as a gendered subject located in linear, dynastic time.

Many of the versions of Bess that feature her material forms of expression focus on her social ascent from the minor gentry to the aristocracy. Bess of Hardwick was married four times. With each marriage she attained and consolidated lands, great houses, mines, and rents, in large part because her husbands made her co-owner of their property, but also because of her exceptional capacity for making and managing her investments through careful record-keeping and deal-making. Moreover, Bess spent the last eighteen years of her life – nearly a quarter of her 81 years – unmarried, a wealthy widow, the second wealthiest woman in sixteenth-century England after Queen Elizabeth I. Focusing on Bess's social mobility as achieved only through marriage has its roots in a desire to make her understandable as stereotypically "feminine" – or at times its simple opposite, "unfeminine." These constructions of Bess do not, however, define

the "feminine," because writers prefer not to delve into the theoretical problem of its definition. These authors instead prefer to assume that the reader understands what the "feminine" means. Without a doubt, though, the historical woman we call Bess of Hardwick questioned the definition of the feminine in the sixteenth century, in ways that both drove her business dealings and led her to execute her tapestry-sized hangings featuring authoritative women whose narratives exceed their marriages and even their motherhood.

In the biographies about Bess, however, marriage trumps self-expression. Some authors focus on Bess's marriages because of the social ascent they seem to have made possible, an ascent solidified and extended in subsequent generations. But each author has a distinctive take on her life. Maud Stepney Rawson, in *Bess of Hardwick and Her Circle* (1910), while focusing on Bess as a social-climbing wife and mother, is remarkable in her willingness both to include many details of Bess's material existence over the decades, and to acknowledge the extent to which her reconstruction of Bess's life is both a fiction and a solidification of the social hierarchy as a benefit to all British subjects.[9] Mary S. Lovell, in *Bess of Hardwick: Empire Builder* (2005), with its prominent dedication to the Dowager Duchess of Devonshire, also wastes no time in declaring her fascination with class. For Lovell, Bess's marriages are all about her husbands' place in the social hierarchy, as we can discern from her having named chapters according to Bess's marital history. Lovell also adds an appendix that allows us to trace Bess's children, grandchildren, and adopted offspring. Lovell's biography contains many details beyond Bess's life as wife, mother, and grandmother, but the shape of the narrative according to virtuous, expected, yet undefined female roles dominates the work as a whole. Even Bess's widowhood, during which she built the astonishing New Hardwick Hall, in Lovell becomes subsumed in an account of how Bess worked to have her granddaughter, Arbella Stuart, recognized as a principal heir to the English throne by first Queen Elizabeth I and then by Arbella's first cousin, King James VI and I (pp. 365–470).

David N. Durant's title, *Bess of Hardwick: Portrait of an Elizabethan Dynast* (1978), suggests that he is Lovell's precursor. However, while both Lovell and Durant display the impeccable knowledge of Tudor history that their

9 Rawson writes in her foreword, titled "To My Husband," about the relation between Bess's living out a womanly existence and her solidification of class distinctions: "Even while we rejoice over our diminutive home, may we never forget to give thanks to the spirit of those who built the great houses which nourish the little ones" (p. vi). This foreword is also a statement that acknowledges her self-consciousness about the fictional construction of her biography of the woman she likens to "Becky Sharp" (p. 3).

choice of subject requires, their tone differs. Like Rawson 95 years before her, Lovell is enthusiastic about Bess as the model of a feminine social climber. In contrast, Durant is more tart in assessing Bess's life as a dynast. He concludes his *Portrait* by acknowledging that Bess of Hardwick did not conform to the expected feminine norms of the intervening centuries: She has been "judged unjustly according to morals later than her time – morals she could not have understood – and she has been cruelly misrepresented," he writes. To which he adds, "Bess has been accused of trampling down others in the pursuit of her ambition and indeed she did." He concludes, "She ended her life with no regrets and that is how we must judge her" (p. 227). Exactly which "morals" Bess might be said to have violated and when such violations occurred is unclear, as Durant's entire final page both suspends judgment of Bess and invites it. At the same time, to his credit, Durant acknowledges the conceptual gulf lying between his readers and the Bess of 400 years ago.

Of Bess's biographers, only David Durant is ready to accept Bess's achievements as both remarkable and products of a culture much different from our own. Other attempts besides Rawson's and Lovell's to rework Bess of Hardwick's life as more recognizably "feminine" include efforts like that of Gillian Bagwell's biofiction, *Venus in Winter* (2013). This version of Bess's life, a romance novel, retells critical moments in Tudor history, which Bess's life so conveniently spans. In Bagwell's narrative, Bess is not only normatively feminine, but that normative femininity explains her social success. That success gains her access to so many different parts of the Tudor realm that Bagwell's Bess manages to be present at almost every historic occasion. In this way, the reader is able to experience a number of well-known events from a fictionalized, first-person Bess-as-narrator. For example, Bess is supposedly instrumental in helping Queen Elizabeth survive smallpox in 1562 (pp. 365–371). Part of Bagwell's more romantic and gender-normative approach is to make Bess more conventionally emotional than her documents and buildings suggest. This is why Bagwell imagines that William St. Loe is the love of her life, at least in the physical sense, when all that we know about him is his willingness to support her in the ongoing construction of Chatsworth, his payment of her £1000 fine to end her £5000+ debt to the Crown, his paying for her sons to attend Eton, and Lovell's discovery about St. Loe from Bess's accounts, his purchase in 1560 of a French book on the geography of the Mediterranean, André de Thevet's *Cosmographie de Levant* (Lovell, p. 151).

Phillipa Gregory's *The Other Queen: A Novel* (2008), ostensibly about Mary Queen of Scots, is as much about Bess of Hardwick and her last husband,

George Talbot, earl of Shrewsbury. Gregory contrasts Mary's "half divine" femininity (p. 7) with Bess's self-described assertive style, the latter creating a "new woman for this new world" (p. 433). Gregory's account of Mary Queen of Scots, while in some respects hyper-feminized, is still a remarkably strong novel about her, in part because the author understands and includes so much about the contrasting experiences with material culture that Mary and Bess enjoyed. Gregory acknowledges the queen and the countess's years of side-by-side needlework, and the ways in which being the imprisoners of Mary also imprisons the Shrewsburys. Moreover, one of Gregory's central themes is the difference between being a queen whose ambition is to return to living in palaces as the fulfillment of her royal identity, and being Bess of Hardwick, whose great achievement was the creation of her houses and their interiors as expressing her identity.

These biographical and fictional attempts to re-create Bess of Hardwick consider how she expressed herself through her letters, portraits, and building projects.[10] But even the best authors who undertake that daunting project of recreating her life have not yet taken the autobiographical aspects of Bess's "open assemblage" into account. The frequent insistence in biography and biofiction that Bess of Hardwick fit our current stereotypes of class and gender in order to fulfill her assumed social and dynastic ambitions means that all other emotions are erased and time marches to a marital beat. The biography and fiction of the past 110 years omit giving Bess of Hardwick's "assemblage" of texts due weight, as providing access to her ways of seeing. To ignore the complex female figures arrayed in her hangings is to ignore Bess's explorations of the "feminine," including the multi-temporal perspectives of memory.

The biographical and fictional universe of Bess of Hardwick both acknowledges the complexity of her long life, and the general importance of her material existence as builder, finisher of elaborate interiors, record keeper and correspondent. At the same time, Bess's most impressive works, her embroidered hangings of intrepid female counterparts, have at this

10 Although this essay contrasts biography with fiction, these genres are more complementary than opposites. As we know from reading all texts through semiotics as representational, fiction and non-fiction are not diametric opposites so much as they are versions of one another. Biographies tend to be structured like *Bildungsromane* with necessarily fictional elements. These include the need to explain how unknown events came to pass, as when they must explain how, in the absence of precise evidence, Bess of Hardwick managed to marry her daughter Elizabeth to the earl of Lennox, in the hope of producing a grandchild who would be heir to the English throne. On the other hand, fiction about Bess requires much knowledge about the cultural and historical specifics of sixteenth-century England, and as a result often reads like biography.

writing helped to tell her story only in more scholarly genres like this volume. The genres of biography and biofiction have not yet grappled with Bess of Hardwick as an artist. But I have hope that I might someday read such a volume.

Works Cited

Bagwell, Gillian. *Venus in Winter*. London: Berkley, 2013.

Bell, Susan Groag. *The Lost Tapestries of the City of Ladies: Christine de Pizan's Renaissance Legacy*. Berkeley: University of California Press, 2004.

Butler, Judith. *Gender Trouble: Feminism and the Subversion of Identity*. New York: Routledge, 1990.

Clifford, Anne. *The Memoir of 1603 and the Diary of 1616–1619*, edited by Katherine O. Acheson. London: Broadview Press, 2006.

de Thevet, André. *Cosmographie de Levant*. Lyon: Jean de Tourmes and Guillaume Gazeau, 1554, 1556. BNF: http://gallica.bnf.fr/ark:/12148/bpt6k545339/f57.image. Accessed 10 April 2017.

Durant, David N. *Bess of Hardwick: Portrait of an Elizabethan Dynast*. New York: Atheneum, 1978.

Frye, Susan. *Pens and Needles: Women's Textualities in Early Modern England*. Philadelphia: University of Pennsylvania Press, 2010.

Frye, Susan. "Bess of Hardwick's Elizabeth I and Mohamet in Material Context." 2018. Unpublished paper presented at the Renaissance Society of America available on Academia.com.

Frye, Susan. "Bess of Hardwick's Gynocracy in Textiles." *Bess of Hardwick: New Perspectives,* edited by Lisa Hopkins. Manchester: University of Manchester Press, 2019, pp. 159–180.

Green, Susan. "Genre: Life Writing." *mETAphor: English Teachers' Association of NSW*. Issue 2, 2008, pp. 50–55. https://www.englishteacher.com.au/resources/command/download_file/id/138/filename/82LifeWriting.pdf. Accessed 24 February 2019.

Gregory, Philippa. *The Other Queen: A Novel*. New York: Washington Square Press, 2008; kindle edition 2008, Atria Books.

The Hardwick Hall Inventories of 1601, edited by Lindsay Boynton. London: Furniture History Society, 1971.

Hubbard, Kate. *A Material Girl: Bess of Hardwick 1527–1608*. London: Short Books Ltd., 2001.

Hubbard, Kate. *Devices and Desires: Bess of Hardwick and the Building of Elizabethan England*. New York: Harper Collins, 2019.

Lackey, Michael. "Locating and Defining the Bio in Biofiction." *a/b: Auto/Biography Studies*, vol. 31, no. 1, 2016, pp. 2–10.

Levey, Santina. *The Embroideries of Hardwick Hall: A Catalogue*. 2007. Reprint. London: National Trust, 2008.

Lovell, Mary S. *Bess of Hardwick: Empire Builder*. London: W.W. Norton, 2005.

Masten, Jeffrey. *Textual Intercourse: Collaboration, Authorship, and Sexualities in Renaissance Drama*. Cambridge: Cambridge University Press, 1997.

Pearson, Andrea. *Women and Portraits in Early Modern England: Gender, Agency, Identity*. Aldershot: Ashgate, 2008.

Rawson, Maud Stepney. *Bess of Hardwick and Her Circle*. New York: John Lane Company, 1910.

About the Author

Susan Frye is Professor of English at the University of Wyoming. She is the author of *Elizabeth I: The Competition for Representation* and *Pens and Needles: Women's Textualities in Early Modern England*. She co-edited *Maids and Mistresses, Cousins and Queens* and is writing a book on Mary Queen of Scots.

8. The Queen as Artist: Elizabeth Tudor and Mary Stuart

Sarah Gristwood

Abstract

Every queen co-exists with a created image of queenship – but the British Isles in the sixteenth century saw a movement towards the conscious self-fashioning of a reigning queen's image. In letters and portraits, imagery and embroidery, Elizabeth Tudor and Mary Stuart aimed the one to render more palatable her controversial female monarchy, and the other to shape her posterity. Their work reflects the dual nature of the queen as both an individual intent on self-expression, and a political animal aiming at a particular effect. Both women have been the subject of extensive biofiction, but this essay queries to what degree those later fictions, whether on page or screen, were prefigured or contradicted by their own versions of their stories.

Keywords: Queen Elizabeth I, Mary Queen of Scots, needlework, letters, film, biofiction

The Queen as Artist

Elizabeth I made manipulation of her image – in pomp and portraits, in public speeches and in poetry – a key to her queenship; and perhaps also to the expression of her personality. Hers was designed to be an image of unchanging perfection, as evinced by the "Mask of Youth" which in later portraits hid the reality of an aging queen. In recent biofiction, Hollywood has delighted in stripping that mask away; yet revealed behind it is a figure that itself plays well for today.

In life, Elizabeth's kinswoman Mary Queen of Scots was far less successful a self-creator. But her death – and she played a conscious part in this

Fitzmaurice, J., N.J. Miller, S.J. Steen (eds.), *Authorizing Early Modern European Women. From Biography to Biofiction.* Amsterdam: Amsterdam University Press, 2022
DOI 10.5117/9789463727143_CH08

process – gave her the role of a victim, and the status of a martyr, that has served her well down the centuries. It may, however, be a form of validation we accept less readily today.

Elizabeth as creator – and creation

"No ruler," wrote John Guy of Elizabeth I, "has ever better understood the relationship of words to power" (2016, p. 12). She clearly had as keen an understanding of the relationship between personal feeling and the pen. The translation made by an eleven-year-old Elizabeth of Marguerite de Navarre's *The Mirror of the Sinful Soul*, given to her stepmother Katherine Parr at the end of 1544, is well known. So too is the trilingual translation (into Latin, French, and Italian) of Parr's own published *Prayers or Meditations* made for Elizabeth's father a year later.[1] But another present, given to Parr at the same time, is even more interesting.

Prefacing her English translation of the first chapter of John Calvin's *Institution de la Religion Chrestienne*, Elizabeth described how, before written language, "ingenious men [...] carved out crudely and grossly because they did not care how it was that they labored, provided that the memory of their intention was magnified, diffused, and noted by everyone" (Marcus et al, pp. 10–11). It would be hard to find a better description of the creative impulse.

The editors of Elizabeth's *Collected Works* describe an "immensely productive writer" that "piecemeal" consideration of her work had long obscured. Her taste for translation would be lifelong and seemingly "for her private exercise" (Marcus et al, p. xi). Partly so, at least. John-Mark Philo points out that the translation of Tacitus's *Annals* in Lambeth Palace Library, which in November 2019 he identified as her work, exemplifies themes "that speak directly to her approach to rule." The moment of crisis when the Roman matron Agrippina "a woman of great courage played the Captain" to encourage the troops evokes obvious thoughts of Tilbury (Flood; Philo).

Elizabeth also wrote poetry all her life, though usually making efforts "to keep most of her verses out of general circulation" (Marcus et al, p. xx). Thus presumably here too she wrote for personal pleasure, albeit that in, for example, "On Monsieur's Departure," the pleasure may as easily lie in

1 Parr was the first English queen to venture into print; several French royal women, however, did so in the course of the sixteenth century. See Gristwood.

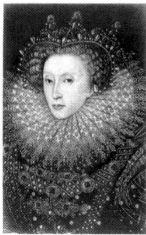

Figure 8.1. The image on the left is from the portrait attributed to William Scrots (Royal Collection); the central one from the "Ermine" portrait variously attributed to William Segar and Nicholas Hilliard (Hatfield House); the image on the right, by an unknown artist, originally showed Elizabeth holding a serpent – symbolizing wisdom, but also associated with Satan – which was altered to less controversial roses (National Portrait Gallery). Science History Images / Alamy Stock Photo.

the expert juggling of Petrarchan contraries and the tropes of courtly love as in the release of deep-felt emotion.

Once she became queen, Elizabeth's speeches and prayers, however, were an integral part of the propaganda of her reign (Levin, p. 128). The question of exactly which words were self-penned and which penned by her ministers in her name must always be a vexed one, though Ilona Bell notes Elizabeth's numerous handwritten corrections to the final draft of one early speech (pp. 8, 68). Susan Frye on the other hand, while describing Elizabeth "engaging in her own construction through language and action," nonetheless dissects the mythology that has accrued to her famous speech at Tilbury (pp. 6, 3).

Carole Levin cites Stephen Greenblatt's thesis that, with no standing army, Tudor power was "'constituted in theatrical celebrations of royal glory'" – and that this was "particularly important" for queens (p. 24). In Elizabeth's later reign the early evocation of a Biblical heroine was superseded by the iconography that figured her as the Virgin Queen. But visually, too, the question of who conceived the elaborate symbolic coding of Elizabeth's portraits – the sieve or rainbow in her hand; the live ermine, symbol of purity, gazing from her sleeve – is up for debate. John Guy suggests that: "One of the great paradoxes of Elizabeth is that she surrounded herself with men who were fascinated by the visual arts, whereas she herself was

profoundly diffident about her own image [...] it was Elizabeth's courtiers, not Elizabeth herself, who commissioned the overwhelming majority of her most famous portraits" (2016, p. 118).

Indeed, Elizabeth preferred, economically, to do her patronage at one remove. The great Elizabethan prodigy houses were built by her courtiers in hope the Queen would grace them with her presence, but they were not funded from her purse. Much of the image-laden pageantry of the court saw her as consumer, rather than creator. Nonetheless, the portrait of Elizabeth as a princess – the simplicity of dress so different from the elaboration of her later years – suggests that she was even in youth sufficiently attuned to her public profile to present herself in a way best suited to her brother's Protestant court. Later, as at very least the inspiration for the coding of her own court, Elizabeth could boast an artistic impact not observable under either her sister and predecessor Mary nor (despite her education at the sophisticated French court) her would-be successor Mary Queen of Scots.

"Good sister" queens

One of Elizabeth's poems, believed to be written around 1571, is said to refer to Mary Queen of Scots, by then her troublesome captive-in-exile. This poem, unusually, was published in miscellanies, though possibly without official sanction, from the 1570s (Marcus et al, p. 133, n.1).

> The daughter of debate
> That discord aye doth sow
> Shall reap no gain where former rule
> Still peace hath taught to know.

Direct communication between Elizabeth I and Mary Queen of Scots – more so, even, than other royal letters of the period – was always a complex mixture of the public and the private (Montini and Plescia, pp. 17, 193).

The English queen's letters of reproof after the death of Mary's second husband, Lord Darnley, in 1567, and the taking of his supposed murderer Bothwell as her third, are as renowned as they are resounding. Their tone suggests not only an urgent anxiety that the fallibility of one queen regnant should not reflect on another, but perhaps also a sense that Elizabeth – so often compared to her disadvantage to the maritally minded Mary – was now vindicated in her celibate choice (Marcus et al, pp. 116–119).

Once Mary had fled to England, however, the dynamic changed: and there is every sign that Elizabeth the captor and Mary the captive were equally profoundly unhappy with their position. Mary's letters display a mixture of what could variously be regarded as artifice or artistry and what was surely honest emotion; the infrequency of Elizabeth's responses reflects unease. "You have experienced what it is to suffer affliction; you may thence judge what others suffer from it," Mary wrote (Strickland, 1: p. 190).

Through the summer and autumn of 1568 an almost obsessive stream of self-justificatory letters flew from Mary to her "good sister" queen, chronicling her wrongs and claiming Elizabeth's support given: "our near relationship, equality of rank, and professed friendship." But an element of doubt was visible: by 5 July Mary was urging that Elizabeth need not fear their meeting, "for I am no enchanter, but your sister and natural cousin" (Strickland, 1: pp. 75, 90).

The element of artifice in Mary's letters becomes clearer after Elizabeth insisted her kinswoman should submit to an inquiry into her actions in Scotland. In spring 1569 Elizabeth's protestations that she had always "discharged the office of a good kinswoman" towards Mary were received with thanks for the "amiable declaration"; the "courteous and favorable letter." The same day, however, Mary wrote to de la Mothe Fenelon that she attached "about as much faith as I consider due" to all the "fine words" of the English (Strickland, 1: pp. 159–165).

As her years of English captivity wore on, Mary would attempt to deploy carrot and stick: her letters a cocktail of compliment, complaint, and warning. Elizabeth's most powerful weapon was silence. Unresponsiveness to letter after letter provoked huffy complaints from Mary: "I had resolved to importune you no more with my letters, seeing they were so little agreeable to you" (Strickland, 1: p. 239).

There had been little evidence of Mary as a successful image-maker either in her youth, as putative queen consort of France, or during her Scottish rule. But as captive it was another story. Joy Currie, discussing the poems Mary wrote in these years, points out that with all other power stripped away, Mary was forced to "place her hopes for her freedom, her rule, and her life on her subjective portrayals" (pp. 192–194). But her writings have received less scholarly attention than has been given to Elizabeth's in recent years, perhaps part of the historic perception of Mary as politically inept "heart" to Elizabeth's astute "head." By the same token, the huge number of often-coded embroideries Mary stitched in her captivity are often passed over as the sterile time fillers of a prisoner. At the time, however, Elizabeth's Privy Council regarded Mary's embroidery as sufficiently important to bring

it into evidence during the investigation of the Ridolfi Plot to assassinate Elizabeth (Swain, p. 75).

Mary herself, in the early days of her captivity, dismissed her embroidery to Elizabeth's envoy Nicholas White as a way of passing the time indoors, saying she did not stop until physical pain forced a halt. "She said that all the day she wrought with her needle, and that the diversity of the colors made the work seem less tedious." But she also "entered on a pretty disputable between carving, painting and work with the needle." Though she judged painting the "most considerable quality," it is interesting to see embroidery in this company (Chalmers, pp. 10–11). By the exigent standards of the sixteenth century the queen herself used a "singularly limited range of stitches" but the point, for her, seems to have lain in the subject matter (Swain, p. 121).

Many of her birds and animals copy woodcuts of Conrad Gesner or Pierre Belon, but some were given her own gloss. Gesner's domestic cat appears, fur as ginger as Elizabeth's red hair, wearing a small crown and toying with a mouse. Most striking of all is the panel that featured in the Ridolfi investigation. It was sent by Mary to the Duke of Norfolk, at whose side it was planned she would replace childless Elizabeth on the English throne. It showed a hand pruning a barren vine with a Latin motto to the effect that "Virtue flourishes by wounding."

Over more than a decade, Mary never abandoned her attempts to manipulate her kinswoman emotionally, even as she connived at plots against her. Mary's letter of October 1586, after her complicity in the Babington Plot finally brought sentence of death, seems – in its requests about the fate of her servants, and disposal of her body – calculated to bring home the enormity of the execution. Laying her fate at the door of "the puritans" (using the time-honored trope of "evil counsellors"), Mary made one final appeal to "our consanguinity [...] the dignity we both held, and of our sex in common." She warned that "one day you will have to answer for your charge" and perhaps it was this thought that, as the Earl of Leicester recorded, drew tears from Elizabeth (Strickland, 2: pp. 200–205).

There had always been a fantasy element in the relationship of the two queens which, even before Mary's imprisonment, employed a complex rhetoric. Mary could write of Elizabeth as "my dear and natural sister"; at other moments they were mother and daughter; in the early days of Mary's Scottish rule they sent jewels, exchanged ardent verses, as lovers might do. There seems to have been a recurring fantasy in currency that they might marry – one jokingly voiced by Mary (Guy, 2004, p. 159). An offer by Mary's envoy James Melville to whisk Elizabeth to Scotland disguised as a page might come from Shakespearian romance (Levin, p. 125). Elizabeth's hope,

at one point, was that Mary might marry Robert Dudley and all live at her court (Guy, 2004, p. 193). Another dream was that "if it had pleased God to have made us both milkmaids with pails on our arms" (Marcus et al, p. 188).

The day of her execution became Mary's most successful piece of self-presentation. The tawny petticoat she wore – the color of Catholic martyrdom – showed Mary's chosen role for posterity. Though she left behind far less striking a body of contemporary portraits than did Elizabeth, the history painters of the eighteenth and nineteenth centuries delighted in her tragedy (Smailes and Thomson, p. 57 on). For as such it was almost universally seen: as the Venetian ambassador in France, Michele Surian predicted in 1569, when the English finally killed Mary, "her life, which till now has been compounded of comedy and tragi-comedy, would terminate at length in pure tragedy" (Warnicke, p. 257). Even Mary's own poetry had cast her as the victim either of others, or of an unkind fate. More recent biofiction has often sought to give a positive spin by stressing Mary's ultimate victory, in that her son inherited Elizabeth's crown. But in the long contest between the two queens the laurels would be variously awarded down the centuries.

The Afterlife

Schiller's 1800 *Mary Stuart* – the basis for Donizetti's 1835 opera *Maria Stuarda* – was recently revived in London's West End and on Broadway, with Janet McTeer in the title role and Harriet Walter as Elizabeth.[2] Besides being one of the first to imagine a meeting between the two queens, Schiller offered a dynamic which still holds sway today. Successive eras had already begun creating an Elizabeth in their own image, from the admirable ruler of the latter seventeenth century (admirable by contrast to the Stuart monarchy) to the opprobrium of the age of sensibility, in which a young Jane Austen infinitely preferred the "bewitching" Mary, love's innocent victim, to "that disgrace to humanity, that pest of society, Elizabeth."

Elizabeth would continue to evolve: the Victorians valuing the brave and be-ruffed icon of empire even as they fretted over any sign of sexuality. By contrast Mary, for better or worse, has been and still is distinguished firstly by her femininity; though recent work –notably John Guy's biography, *"My Heart is My Own"* – has refigured her as at least aspiring to political leadership, even if she could not achieve success in the role. The long disregard

2 Donmar Warehouse, 20 July – 3 September 2005. Apollo Theatre, 19 October 2005 – 14 January 2006. Broadhurst Theatre, 19 April – 16 August 2009.

of Mary's head, as opposed to her heart, has seen little weight given to her artistry in biofiction; as has the tendency in fact and fiction alike to skim over the long years of her captivity.

Philippa Gregory's novel *The Other Queen*, unusually, does take place during those years, focusing on the triangle of Mary, her custodian the Earl of Shrewsbury, and Shrewsbury's increasingly alienated wife, Bess of Hardwick. Gregory presents invented letters to Bothwell but draws on the embroidery Mary and Bess really did together to illustrate their rapport, their rivalry and the ultimate difference between them. Watching Mary's professional assistant drawing up designs to her specification, Bess says to herself: "It is a great thing, I think, to have such an artist as this man in your train. [...] Truly, these are the luxuries of kings" (pp. 83–84). Using a three-way first-person narrative Gregory is able to demonstrate the differ-ence between what Mary thinks and what she says. Gregory also wrote a more conventional novel on Elizabeth: *The Virgin's Lover*.

Alison Weir, the other heavy hitter of the modern marketplace, used two novels, *The Lady Elizabeth* and *The Marriage Game*, to present essentially the Elizabeth she had already explored in extensive non-fiction publication, giving due weight to Elizabeth's formidable education. Though she clearly relishes, in the former, postulating a pregnant princess. "I am not, as a historian, saying that it could have happened," says Weir, "But as a novelist, I enjoy the heady freedom to ask: what if it had?" (pp. 485). Both she and Gregory, inevitably, see the queen's romantic relationships as the most fruitful ground for fictional adventure.

The number of novels written about both queens is huge, but no single modern work has done for either what Hilary Mantel's *Wolf Hall* trilogy has done for Thomas Cromwell. Perhaps the market is too crowded – or possibly serious critical consideration of a work of biofiction comes more readily if the subject is male?

Modern screen has however provided culturally dominant images of Elizabeth, though screen's attempts at Mary have been less successful. Katharine Hepburn, starring in *Mary of Scotland* (1936, dir. John Ford), later said she thought Mary "a bit of an ass," and would prefer to have made a film about Elizabeth. The US television series *Reign* ran to an extraordinary 78 episodes without paying more than lip service to history. Even the 1971 *Mary, Queen of Scots* (dir. Charles Jarrott) saw Vanessa Redgrave outshone by Glenda Jackson reprising her role from the BBC television series *Elizabeth R* that had, earlier that year, re-established Elizabeth for a new generation as a complex and politically capable figure not unlike Jackson herself.

Television can boast memorable Elizabeths even beyond Jackson: Helen Mirren (*Elizabeth I*, Channel 4 and HBO, 2005), Anne Marie Duff (*The Virgin Queen*, BBC/Power 2005), and Miranda Richardson (*Blackadder II*, BBC 1986); to say nothing of various episodes of BBC's *Doctor Who* from 1965 to 2007. From Sarah Bernhardt[3] onwards, a particularly formidable rota of artists have lined up to portray Elizabeth on screen: Quentin Crisp in *Orlando* (1992, dir. Sally Potter); Judi Dench's Oscar-winning cameo in *Shakespeare in Love* (1998, dir. John Madden); and Vanessa Redgrave, reversing her previous role choice to play Elizabeth in *Anonymous* (2011, dir. Roland Emmerich) which, like *Shakespeare in Love* and indeed *Doctor Who*, shows Elizabeth associated with Shakespeare and by implication a partaker in his creativity.[4]

England's Elizabeth: An Afterlife in Fame and Fantasy notes that the early twentieth century saw Elizabeth's immortality as "an artistic achievement as much as a political one, a matter of performative personal style. Drama is always inclined to reimagine Elizabeth in its own image, as above all a star performer" (Dobson and Watson, p. 24). Visiting the set of *Elizabeth: The Golden Age* (2007, dir. Shekhar Kapur) and watching the reactions of passers-by to the filming process, I was struck by the parallels between today's stars and Tudor royalty, even before Kapur began explaining his conception of the battle between Elizabeth and Philip of Spain as one between "divinities.[5] (The conception, as it turned out, was not wholly successful – and yet in a sense Kapur's picture of an Elizabeth sufficiently close to cosmic power to have conjured the storm that destroyed the Armada was prefigured in the Armada Portrait c. 1588 and, even more notably, in a woodcut prefacing John Case's *Sphaera Civitatis* in the same year [Strong, pp. 132–133].)

Carole Levin cites Anne (Righter) Barton: "'Moving about his realm in the midst of a continual drama, the ruler bears a superficial resemblance to the actor'" (p. 129). Surely no coincidence that George MacDonald Fraser could claim: "no historic figure has been represented more honestly in the cinema, or better served by her players" than Elizabeth I (pp. 69–70). It is again no coincidence that the representations tend to make play with one particular aspect of Elizabeth's self-creation. Actresses portraying her have

3 In the "photoplay" *Les amours de la reine Elisabeth* (1912, dir: Henri Desfontaines/Louis Mercanton).

4 *Anonymous* added a whole new query to the fact/fiction issue, less by promoting the controversial theory that Shakespeare's plays were written by Edward de Vere, seventeenth Earl of Oxford, than by proposing a classroom study pack on the authorship debate as the filmmakers perceived it. It also gave Elizabeth several illegitimate offspring, including Oxford himself.

5 Kapur in conversation with the author, St John's College, Cambridge, May 2006.

repeatedly been shown with their mutable living flesh smothered in a ghostly white mask. Many have made a point with a scene where the transformation takes place. As Dobson and Watson put it: "If the Victorians burst into the Queen's bedroom and discovered the real Queen by finding her undressed [...] what exerts real fascination by the end of the [twentieth] century is not the Queen's body, but her extravagant carapace" (p. 216).

While the historical record suggests that the aging Elizabeth did indeed rely on an elaborate maquillage, a recent article claims that, not only is the 1600 report of Elizabeth painting "near half an inch thick" street gossip picked up by a hostile source, but there is no evidence that, as successive biographers reiterate, the Queen used the corrosive ceruse, a mixture of white lead and vinegar (Onion). What Roy Strong dubbed the "Mask of Youth" was a politically expedient rendering of a beautiful never-changing icon (p. 147). There may be something punitive about our readiness to equate it with the clown-mask often imposed on her over the last half-century.

It is ironic that the self-invention that contributed to the success of Elizabeth's monarchy should be refigured as a metaphor for her weakness. It is almost as if religiously inspired disapproval of "painting" in Philip Stubbes' *The Anatomie of Abuses* (1583) and Thomas Tuke's *Discourse Against Painting and Tincturing* (1616) is being used to punish her today. And with it, perhaps, a woman's act of self-creation – or even of woman as creator in a wider sense.

In *Fire Over England* (1937, dir. William K. Howard) Flora Robson, in her mid-30s, plays an Elizabeth of 55: without a clown mask but with an aging vulnerability highlighted by a glowingly youthful Vivien Leigh, as a surrogate tellingly named Cynthia. "Do you like what you see in the glass?" the Queen asks her.

The mirror is an oft-repeated trope, echoing another historical legend that the aging Elizabeth refused to go near one. In *The Private Lives of Elizabeth and Essex* (1939, dir. Michael Curtiz) Bette Davis smashes the mirror that reveals the gulf between her and Essex, though Errol Flynn at 30 was only a year younger than the actress. (If questions of historical fact versus historical fiction are a particularly hot topic in today's climate of "fake news," another is the treatment of women and age on screen.)

The recorded historical incident of Essex bursting into Elizabeth's bedroom and catching her without wig and make-up is often used or adapted to show the queen's vulnerability, and not necessarily in a sympathetic way. But one honorable exception is *The Virgin Queen* (1955, dir. Henry Koster). Bette Davis, playing Elizabeth a second time, asks Richard Todd "Do I look

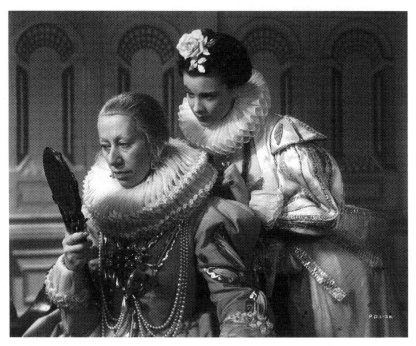

Figure 8.2. Flora Robson as Elizabeth I and Vivien Leigh as Cynthia in *Fire Over England* (1937), United Artists. Masheter Movie Archive / Alamy Stock Photo.

old?" but has in fact taken to her bed only to deceive a foreign ambassador, a scene which may possibly point the way ahead.

Before the release of *Elizabeth* (1998, dir. Shekhar Kapur), the first of the two films in which she played the queen, Cate Blanchett declared that she was not going to play the usual "trout in the red wig."[6] In fact she would ultimately play that image of the queen; but she would play on it, too.

Kapur makes the climax of his film the castrative ritual shearing of the long locks that formerly signaled Elizabeth's sexual availability. "I have become a virgin," she says as the white paint is plastered onto her hands and face. The transformative act is arguably a victory for the queen, hitherto figured as young and uncertain. The film's official synopsis describes the scene: "When Elizabeth next appears in public, she has transformed herself into the legendary Virgin Queen. Formidable, Untouchable, Unbeatable" (*Elizabeth*, p. 17). But it is still a moot point to what degree we really applaud.

The 2018 film *Mary Queen of Scots* (dir. Josie Rourke), reiterates the trope of Elizabeth's maquillage signaling her loss of femininity. Saoirse Ronan's

6 Cate Blanchett interviewed by the author, Venice International Film Festival, September 1998.

Mary, passionate and committed, is fresh-faced throughout; Margot Robbie as Elizabeth is given a more artificial presentation from the start, gradually building to the dead-white mask she dons for the climactic confrontation, in which she declares to Mary that she has become more man than woman. It is only when she realizes that she is now the one in the stronger position that she pulls off her wig, confident enough to let Mary see her real, smallpox-ravaged appearance.

Nor is this the first time this film uses Elizabeth's creativity against her: to signal sterility, effectively. Often seen quilling with her ladies (presumably an art form that reads better for film than embroidery), Elizabeth is on the floor with a pattern of blood-red quill work spreading out between her splayed thighs. The scene cuts to a bloodied baby, the future James VI and I, emerging from between Mary's.

Despite being based on John Guy's notable biography, the film nonetheless drew indignant news stories for its historical inaccuracies. Emily Yoshida memorably described Ronan's Mary as "a woke underdog princess." Especial vitriol was reserved for the climactic imagined encounter between the pair (Horton). Guy stoutly defended the film against what he called the "history police," telling *HistoryExtra* in 2019 that six years after he had finished his book a new letter was discovered in which, only eighteen months before Mary's execution, Elizabeth wrote to her "sister" queen a letter of appeal for a reconciliation. So "although we know a meeting between the two queens never actually took place," he said, "the possibility was still alive." Though some historical facts are "necessarily remoulded theatrically," what mattered for him is that "the dialogue still rings true."

And the truth is that fantasy of a meeting does have a long history to it: in biofiction, never mind in the words of the two queens themselves. As the showbusiness bible *Variety* put it baldly, reviewing the 1971 Redgrave/ Jackson film: "The face-to-face confrontations between the two women are said to be historically inaccurate. The script almost has to have one" (*Mary*). And it is certainly possible to argue that the long correspondence between Elizabeth and Mary, the degree to which the idea of the other featured in each of their lives, constituted a kind of encounter.

There is one further intriguing speculation. Mary and Elizabeth have been presented as opposites down the centuries (Dobson and Watson, pp. 98–111). But one might ask whether their artistic endeavors, as well as their sovereign royalty, gave them a bond if not an equality? And if so, whether both queens might not themselves have been sufficiently awake to the concept of artistic invention to accept this refiguring rather more calmly than modern critics do?

Works Cited

Austen, Jane. "The History of England from the Reign of Henry the 4th to the Death of Charles the 1st." https://penelope.uchicago.edu/austen/austen.html. Accessed 28 June 2020.

Bell, Ilona. *Elizabeth I: The Voice of a Monarch*. New York: Palgrave Macmillan, 2010.

Blanchett, Cate, interviewed by the author, Venice International Film Festival, September 1998.

Chalmers, George. *The Life of Mary, Queen of Scots: Drawn from the State Papers*. 2 vols. London: John Murray, 1818–1822; vol. 2 (1822).

Currie, Joy. "Mary Queen of Scots as Suffering Woman: Representations by Mary Stuart and William Wordsworth." *High and Mighty Queens of Early Modern England: Realities and Representations*, edited by Carole Levin, Debra Barrett-Graves, and Jo Eldridge Carney. New York: Palgrave Macmillan, 2003, pp. 187–202.

Dobson, Michael and Nicola J. Watson. *England's Elizabeth: An Afterlife in Fame and Fantasy*. Oxford: Oxford University Press, 2004.

Elizabeth (dir. Shekhar Kapur), Production Notes, PolyGram Filmed Entertainment, in association with Channel Four Films: a Working Title Production, 1998.

Flood, Alison, on research of John-Mark Philo. "Messy Handwriting Reveals Mystery Translator: Queen Elizabeth I." *The Guardian*, 28 November 2019. https://www.theguardian.com/books/2019/nov/29/handwriting-identifies-elizabeth-i-tacitus-translation. Accessed 5 August 2020.

Fraser, George MacDonald. *The Hollywood History of the World*. London: Michael Joseph, 1988.

Frye, Susan. *Elizabeth I: The Competition for Representation*. New York and Oxford: Oxford University Press, 1993.

Gregory, Philippa. *The Other Queen*. London: HarperCollins, 2008.

Gristwood, Sarah. *Game of Queens: The Women Who Made Sixteenth-Century Europe*. London: Oneworld, 2016.

Guy, John, *"My Heart is My Own": The Life of Mary Queen of Scots*. London: Harper Perennial, 2004.

Guy, John. *Elizabeth: The Forgotten Years*. London, Penguin, 2016.

Guy, John, interview. "Mary, Queen of Scots: The Real History behind the Film." *HistoryExtra*, 6 September 2019. https://www.historyextra.com/period/stuart/mary-queen-scots-real-history-film-movie-husbands-meeting-elizabeth-cousin/. Accessed 28 June 2020.

Horton, Helena. "Mary Queen of Scots Backlash for 'False' Portrayal of a Meeting between the Scottish Monarch and Queen Elizabeth I." *The Telegraph*, 22 July 2018. https://www.telegraph.co.uk/news/2018/07/22/mary-queen-scots-backlash-false-portrayal-meeting-scottish-monarch/. Accessed 28 June 2020.

Kapur, Shekhar, conversation with the author, St John's College, Cambridge, summer 2006.

Levin, Carole. *"The Heart and Stomach of a King": Elizabeth I and the Politics of Sex and Power*. Philadelphia: University of Pennsylvania Press, 1994.

Marcus, Leah S., Janel Mueller, and Mary Beth Rose, eds. *Elizabeth I: Collected Works*. Chicago: University of Chicago Press, 2000.

"Mary, Queen of Scots." Variety, 31 December 1971. https://variety.com/1971/film/reviews/mary-queen-of-scots-1200422750/#!. Accessed 5 August 2020.

Montini, Donatella and Iolanda Plescia, eds. *Elizabeth I in Writing: Language, Power and Representation in Early Modern England*. Cham, Switzerland: Palgrave Macmillan, 2018.

Onion, Rebecca. "The Real Story Behind Margot Robbie's Wild Queen Elizabeth Makeup." *Slate*, 6 December 2018. https://slate.com/technology/2018/12/queen-elizabeth-makeup-margot-robbie-mary-queen-of-scots-real-story.html. Accessed 5 August 2020.

Philo, John-Mark. "Elizabeth I's Translation of Tacitus: Lambeth Palace Library, MS 683." *The Review of English Studies*, vol. 71, no. 298, February 2020, pp. 44–73. doi:10.1093/res/hgz112. Accessed 5 August 2020.

Smailes, Helen, and Duncan Thomson. *The Queen's Image*. Edinburgh: National Galleries of Scotland, 1987.

Strickland, Agnes. *Letters of Mary, Queen of Scots, Vols I and II*. London: Henry Colburn, 1848.

Strong, Roy. *Gloriana: The Portraits of Queen Elizabeth I*. London: Pimlico, 2003.

Swain, Margaret. *The Needlework of Mary Queen of Scots*. Bedford: Ruth Bean, 1986.

Warnicke, Retha M. *Mary Queen of Scots*. London and New York: Routledge, 2006.

Weir, Alison. *The Lady Elizabeth*. London: Arrow, 2008.

Yoshida, Emily. *"Mary Queen of Scots* Turns Its Queen Into a Generic Underdog Figure." *Vulture*, 6 December 2018. https://www.vulture.com/2018/12/mary-queen-of-scots-review.html. Accessed 28 June 2020.

About the Author

Sarah Gristwood is the author of *Sunday Times* bestseller *Arbella: England's Lost Queen*; *Blood Sisters, The Women Behind the Wars of the Roses*; *Game of Queens, The Women Who Made Sixteenth-Century Europe*; and *Elizabeth and Leicester*. An Oxford graduate and former film journalist, she has also written historical fiction.

9. "Very Secret Kept": Facts and Re-Creation in Margaret Hannay's Biographies of Mary Sidney and Mary Wroth

Marion Wynne-Davies

Abstract

This essay explores the difficulties faced by literary biographers, in particular those who attempt to uncover the relatively undocumented lives of early modern women. In order to suggest ways in which these gaps may be re-created, it addresses the complex intersections between literary biography and biofiction; for example, the early example of Virginia Woolf's parodic biography, *Orlando*. The essay analyses Margaret P. Hannay's works in terms of two key aspects of literary biography: verifiable facts and the imaginative re-creation of events in order to ascertain if it is ever possible to uncover what is intentionally kept "secret."

Keywords: biography, early modern women writers, Mary Sidney Herbert, Mary Sidney Wroth

On 9 October 1604 Robert Sidney wrote to his wife, Barbara, concerning their daughter's marriage; he concludes that, if Barbara is right, it is "a great misfortune" and must be "very secret kept." Using meticulous research, Margaret Hannay attempts to deduce "what had happened" so early in Mary Wroth's marriage to Robert Wroth. She suggests "that perhaps the marriage had not been consummated," or that "another possibility" could be that Wroth and her cousin, William Herbert, had made a *de praesenti* wedding agreement, or "perhaps Robert Wroth had discovered that his bride was not a virgin" (Hannay, 2010, pp. 107–108). The key words here are "perhaps" used twice and "possibility," because even an experienced biographer such as Margaret Hannay cannot know what was "very secret kept." This essay, therefore, sets

Fitzmaurice, J., N.J. Miller, S.J. Steen (eds.), *Authorizing Early Modern European Women. From Biography to Biofiction*. Amsterdam: Amsterdam University Press, 2022
DOI 10.5117/9789463727143_CH09

out to explore how Hannay engages with an absence of historical knowledge in her biographies of Mary Sidney, *Philip's Phoenix: Mary Sidney, Countess of Pembroke*, and Mary Wroth, *Mary Sidney, Lady Wroth* (in this essay identified as Sidney and Wroth respectively). First, the essay will detail the difficulties faced by the literary biographer and those who attempt to uncover the relatively undocumented lives of women. Second, it addresses the complex intersections between literary biography and biofiction in order to determine how boundaries are both adhered to and breached in the representation of early modern female identity. Finally, I analyze Hannay's works in terms of two key aspects: verifiable facts and the imaginative re-creation of events in order to ascertain if it is ever possible to uncover what is intentionally kept "secret." But, first, we should acknowledge the importance of Hannay's endeavors and how her works have influenced those who have followed her erudite scholarship.[1] I'd like to pick up on a quote from her husband, Dr. David Hannay: "She loved sleuthing in the archives in England and Wales for her research" (*The Altmont Enterprise*, n.p.) because Hannay chose exactly the same words to describe her research on Wroth in the essay "Sleuthing in the Archives: The Life of Lady Mary Wroth." This desire to "sleuth" or find out the truth about the lives of Mary Sidney and Mary Wroth permeates Hannay's biographies. But, at the same time, she always acknowledged that some information was "very secret kept," and it is precisely this interface between the presence and absence of facts that this essay explores.

For twentieth- and twenty-first-century biographies, the division between establishing truth and creating a sense of personality traces its roots back to Virginia Woolf's "The New Biography" (1927), in which she writes that,

> On the one hand there is truth; on the other there is personality. And if we think of truth as something of granite-like solidity and of personality as something of rainbow-like intangibility and reflect that the aim of biography is to weld these two into one seamless whole, we shall admit that the problem is a stiff one and we need not wonder if biographers have for the most part failed to solve it. (1994, p. 473)

While Hannay does not refer directly to Woolf, she is alert to the difficulties of portraying the personalities of Mary Sidney and Mary Wroth when there

[1] Margaret Patterson Hannay died in 2016, and the numerous obituaries pay tribute to her abilities and dedication; in particular they note that she was the founder, secretary and then president of the Society for the Study of Early Modern Women and Gender and that *Mary Sidney, Lady Wroth* won the 2011 Book of the Year Award from that society.

are very few "granite-like" facts to rely on. In both biographies Hannay immediately acknowledges that fires at Sidney's and Wroth's residences (Wilton, Baynard's Castle and Durrance) destroyed the manuscripts that would have provided factual evidence (Hannay, 1990, p. xi; and 2010, p. xiv). At the same time, however, there is a marked difference between her 1990 biography of Mary Sidney and the 2010 account of Mary Wroth's life when it comes to an assessment of the information available. For Sidney, "more information remains than I had dared to hope," whereas Wroth "left no diary, and few of her letters survive" (Hannay, 1990, p. xi; and 2010, p. xi). In part, this disparity may be explained by the social standing of the two subjects and the subsequent number of references to them in official or court documents, but there is also an added nuance to Hannay's thinking in the later work. In the 1990 biography, Hannay writes confidently that Sidney was "brilliant, learned, witty, articulate, and adept at self-presentation," whereas for Wroth, she admits that "to some extent any biography is a fiction; each biographer interprets the data that has survived to tell a story of a life," and she goes on to quote Richard Holmes's influential essay, "Biography: Inventing the Truth" (Hannay, 1990, p. ix; and 2010, p. xiii). This is a telling allusion, because Holmes reaches a very similar conclusion to Woolf when he argues that in biography "invention marr[ies] truth" meaning that "the fluid imaginative powers of re-creation pull against the hard body of discoverable fact" (Holmes, p. 15). What this means is that Hannay's understanding of literary biography had shifted from a second wave feminist welcoming of any information on early modern women writers to an approach to biography influenced by a later more self-aware exposition in which the dichotomy of the relationship between documentation and, in Hannay's own words, a "story" had developed.

The most important intervention in the theory of literary biography, John Batchelor's *The Art of Literary Biography*, was published when Hannay was researching the biography on Wroth and, tellingly, she includes a reference to Holmes's essay (2010, p. xiii). In his Introduction, Batchelor sums up the tensions between fact and narrative:

> The literary biographer must perform a balancing act. He/she must keep the balance between objectivity and personal engagement, between reliance upon documentary evidence (letters, journals, and memoirs) and intuitive re-creation. (p. 4)

That focus upon "re-creation" was echoed by subsequent influential works on literary biography which described the need to fill gaps in knowledge or

those things which had been kept "secret." Hermione Lee in *Biography: A
Very Short Introduction* wrote that, "there will always be areas of obscurity
and absence," while Michael Benton in *Literary Biography: An Introduction*
commented the biographer had "to acknowledge the inevitable gaps in
the history and, where possible, to fill each with a plausible scenario or
explanation" (Lee, p. 138; Benton, p. 21). The blurring of lines between fact
and fiction has become more acceptable. As Jane McVeigh points out in
"Concerns about Facts and Form in Literary Biography,"

> More recently, there is recognition that a factual non-fiction biography can
> embrace the powers of evocative storytelling in a form of popular narrative
> non-fiction, and that fictional biography, also known as "bio-fiction" and
> based on facts, is extremely influential. (McVeigh, p. 144)

Indeed, in the next essay in this collection, Naomi J. Miller's "Imagining
Shakespeare's Sisters: Fictionalizing Mary Sidney Herbert and Mary Sidney
Wroth" fills in the gaps identified by Hannay by employing biofiction rather
than literary biography.

Inevitably, these absences are far more common if the subject is a woman.
Returning to Batchelor's influential collection, Lyndall Gordon in "Women's
Lives: The Unmapped Country" proposes that "what is most distinctive in
women's lives is precisely what is most hidden" (Gordon, p. 87). At the same
time, as Dale Salwart indicates in "Literary Biography in the Twentieth
Century," feminist biography has recovered "the 'hidden' lives of women [...]
previously lost and neglected within a male culture" (p. 114). Similarly, Lee
traces "the phase of disinterring obscure lives and claiming new status and
significance for women's stories" (p. 127). One of the key differences Lee iden-
tifies between biographies of women and men is "the matter of naming [...]
which sets up expectations for a certain kind of narrative" (Lee, pp. 129–30).
As one looks at how names are used in book-titles it becomes possible to
identify the development of Hannay's understanding of feminist biography.
In 1990, Hannay was certainly discovering the "previously lost" details of
Mary Sidney's life, yet the title of the book, *Philip's Phoenix: Mary Sidney,
Countess of Pembroke*, places the man's name first and the woman's second.
Additionally, the use of the possessive apostrophe implies that Mary Sidney
is the property of her brother. The title of Hannay's 2010 biography, *Mary
Sidney, Lady Wroth*, is very different: Wroth's name stands alone as sufficient
grounds for a serious and lengthy biography. As such, Hannay is not only
a renowned biographer of early modern women's lives; she also represents
a key shift in the way that the privileging of "granite-like" documentation

has given way to a recognition of how a "rainbow" of imaginative narrative is needed to fill in the gaps.

At this point, I want to bring those two elements of Hannay's writing together and set the breakdown of the fact/fiction dichotomy alongside the problems of writing about an early modern woman. Here, it is revealing to look at a single event – the Great Frost of 1608 – in order to understand the differences between the "granite-like" fact and the "rainbow-like" elements of early modern women's representation and to compare Hannay's biography of Wroth with Woolf's parodic biography, *Orlando* (1928). Hannay draws upon two pieces of evidence: Rowland Whyte's letter and Thomas Dekker's pamphlet *The Great Frost: Cold Doings in London* (1608). Whyte was Robert Sidney's agent and appears to have been staying at Baynard's Castle in the winter of 1608 because in a letter to Gilbert Talbot, seventh Earl of Shrewsbury, Whyte wrote, "The frost continues here in a very strange manner, the Thames so hardly frozen that it is made a beaten highway to all places of the city" (Hannay, 2010, p. 151). This account closely resembles Dekker's description that is not quoted by Hannay:

> so that at the length, (the frost knitting all his sinews together, and the inconstant water (by that meanes) being of a floating element, changed into a firme ground) [...] it is the road way between London and West-minster, and between South-warke and London. (Dekker, fols. B–Bv)

Both descriptions concur that the frost has been so severe that the Thames froze allowing people to use it as a "highway" or "road way" across London. However, Dekker's account has already added a fictional element to the account since he describes the frost as a man who tightens his muscles to make his body "firme." Holmes points out that "The biographer has always had to construct or orchestrate a factual pattern out of materials that already have a fictional or reinvented element" (Holmes, p. 17). This blurring of fact (Whyte) and fiction (Dekker) is underscored by Hannay's reason for mentioning the Great Frost: she considers Wroth's reference to "wonders" in her sonnet "Forbear dark night" with its possible autobiographical reference to "the great Snow" in order to determine whether or not Wroth was staying in Baynard's Castle in the winter of 1608 (Hannay, 2010, p. 151). Turning to Woolf's depiction of the Great Frost in *Orlando*, it becomes possible to trace a more decisive shift towards fiction:

> London enjoyed a carnival of the utmost brilliancy [...] the river, which was frozen to a depth of twenty feet and more for six or seven miles on

either side, [...] [was] swept, decorated and given all the semblance of a
park or pleasure ground, with arbours, mazes, alleys, drinking booths,
etc., at his expense. (Woolf, 1993, pp. 24–25)

This elaborate and witty description, with its explicit exaggeration, diverges
considerably from Whyte's terse description, Dekker's brief metaphor, and
Hannay's careful approach to autobiographical readings. And yet, like
the frozen Thames, it is possible to see how hard and firm facts may be
transformed into the fluidity of biographical fiction. Indeed, Naomi Miller's
novel of Mary Wroth, *Secret Story-Maker,*[2] includes a description of the Great
Frost: "With the Thames frozen over, Londoners had resorted to a "frost Fair"
carnival – complete with sledding, horse races, and puppet plays" (Miller,
n.p.). In addition to the factual details of the "fair," Miller replicates the sense
of enigmatic wonder through the use of the word "carnival" that may be
seen in Whyte's "strange manner," Dekker's "inconstant," Hannay's Wroth
quotation "wonders," and Woolf's exact same use of the word "carnival."

At first, the fictionalized accounts of Woolf and Miller seem very far from
Hannay's "sleuthing" for the facts about Mary Sidney and Mary Wroth. Yet,
perhaps there is more that unites these approaches than separates them,
more of a consanguinity between the literary biography and biofiction than
is generally recognized. The next section of this essay, therefore, explores
first, how Hannay uncovered the material facts relevant and second, how she
chose to fill in the many gaps and absences. In both cases, the focus is upon
the relationship between Sidney and Wroth, and the latter's relationship
with William Herbert, Sidney's son and Wroth's cousin/lover.

In "Sleuthing in the Archives: The Life of Lady Mary Wroth," Hannay
points out that, "When biographers fill in the gaps between verifiable facts,
suggesting motivations and causality, those suppositions are signaled by
'hedge phrases'" (2015, p. 20). "Hedge phrases" is a useful term, allowing
an investigation of where Hannay relies upon the "granite-like" facts and
where she expands to "rainbow-like" re-creation. In tracing the relationship
between Sidney and Wroth, the first "verifiable fact" is a letter written by
Robert Sidney to his wife, Barbara Gamage, on 26 April 1588 (Hannay, 2010,
p. 24). At this point England was preparing for an attack by the Spanish
Armada, and Robert Sidney was in Baynard's Castle in London assisting
with the arrangements, while Barbara Gamage had taken her baby daughter,

2 Not yet published, this novel is intended to follow *Imperfect Alchemist: A Novel of Mary
Sidney Herbert*, as the second novel in her projected series about Renaissance Women authors,
Shakespeare's Sisters.

Wroth, to stay in the safety of Wilton with Mary Sidney. The sojourn is first described in *Philip's Phoenix* where Hannay notes:

> From April, as the Armada assembled in Lisbon, until September, when the danger was over, Mary Sidney took care of her younger brother Thomas, her sister-in-law, and little Mall. Her own three children, aged four, five, and eight, would have been safely in Wiltshire as well. (Hannay, 1990, p. 143)

In *Mary Sidney, Lady Wroth,* Hannay goes further, suggesting that this extended stay was where the closeness between Sidney and Wroth began: "Her aunt [Mary Sidney] who had lost her own younger daughter just three months earlier, seems to have demonstrated special affection for her new little goddaughter" (2010, p. 25). The most revealing word in the later biography is, of course, "seems." This "hedge phrase" allows us to understand how the "verifiable facts" of Robert Sidney's letter allows Hannay to suggest the "causality" of the initial stages of affection between Sidney and Wroth. There is, however, a further elaboration in the later work, this time on "Her own three children":

> Mall [Wroth] stayed with her aunt's three surviving children: eight-year-old Will, five-year-old Anne, and three-year-old Philip. Will would have recently been breeched and have begun studying Latin with a tutor, rather than playing in the nursery with the younger children, but no doubt they were all together at family gatherings. (Hannay, 2010, p. 24)

In part, the amplification may be explained by the further research undertaken by Hannay, but the words "no doubt" signify another "hedge phrase." The description of the young William Herbert's activities demonstrates Hannay's construction of a "verifiable" historical context – here the education of young noblemen – while also suggesting the causality of an early closeness between the nine-year-old Will and his baby cousin, Mall. In part, Hannay is relying upon the reader having perused her "Preface" where she clearly states that "We know that Wroth did have an affair with her cousin, William Herbert, third Earl of Pembroke, because she had two children by him" (2010, p. xii). However, Hannay is also trusting that scholarly readers will already know about Wroth's affair with Herbert because they will already be aware of what Robert Sidney hoped would be "very secret kept."

A further subtle shift from "granite-like" facts of *Philip's Phoenix* to "rainbow-like" suppositions of *Mary Sidney, Lady Wroth* may be seen in the ways in which Hannay describes the development of Wroth's relationship

with William Herbert. In the earlier biography, one of the most well-documented events is the death of Mary Sidney's husband, Henry Herbert, Earl of Pembroke, on 19 January 1601:

> she lost not only her husband, but also her position, much of her wealth, the writers who sought her patronage, and most of her influence at court. If this were not sufficient, she also had the impossible task of attempting to control her son William, who responded to his father's death with a callous self-interest and an imprudent affair. (Hannay, 1990, p. 169)

The first consequence of the Earl's death is the impact upon Mary Sidney and, here, Hannay is able to draw an unreferenced conclusion because personal circumstance and historical information elide in the accurate representation of a widow's role in early modern society. Of the second consequence, the "imprudent affair," Hannay is able to confirm that it is as well-documented, so that there is no trouble in finding ample manuscript evidence of William Herbert's notorious affair with Mary Fitton, because "the handsome young earl barely attempted to conceal [it]" and Fitton became "pregnant" (Hannay, 1990, p. 169).

The Earl's death and William Herbert's affair are also described in *Mary Sidney, Lady Wroth*, although in the 2010 work Hannay's focus shifts from "verifiable facts" to "supposition." She notes that,

> We have no record that Mall was there at Wilton during the funeral, although her father was, and it is hard to believe that the family would not have gone to Wilton during that period. But, whether she was in Wiltshire at that time or not, there were two immediate results that had impact upon her future life. The first was that her aunt lost some of her influence [...]. The second result was that Will, freed from restraint by the death of his father, carried on an increasingly scandalous affair with Mary Fitton. (2010, p. 79)

Hannay immediately acknowledges that there is "no record" of the young Wroth being at Wilton, although she adds the hedge phrase, "it is hard to believe" she was not present at Wilton. Hannay then recounts the two consequences of the Earl's death already noted in *Philip's Phoenix*. First, that Sidney had "lost some of her influence." The second consequence, William Herbert's "scandalous affair," similarly echoes the reference to his "imprudent affair" in *Philip's Phoenix*. However, in *Mary Sidney, Lady Wroth,* Hannay's introduction of "supposition" is marked. The two sentences

following the above quotation note that "Mall was thus living in the same house with Will during this sorry affair" and that "Wroth later recast Will's affair with Mary Fitton as Amphilanthus' brief dalliance with Antissia, not yet realising that Mary Fitton's plight foreshadowed her own" (Hannay, 2010, p. 79). Both sentences are significant. If we return to the evidence, Hannay distinctly tells us that there is "no record that Mall was there at Wilton" during the funeral or afterwards, yet four sentences later, she asserts that Mary Wroth and William Herbert were "living in the same house." Of course, there is nothing wrong with this "supposition" and I fully concur that it would have been strange had the Sidney women failed to visit Wilton after the death of the Earl. At the same time, the repetition of the word "affair" and the alteration of the adjective from "scandalous" to "sorry" serve to locate Wroth and William Herbert in a discourse of sexual misdemeanor, thereby provoking the reader to jump ahead in the narrative to the point when the pair were involved in their own "affair." Moreover, this verbal indicator of the future is compounded by Hannay's immediate allusion to *The Countess of Montgomery's Urania* (1621), which Wroth would not begin composing until at least fifteen years later (Hannay, 2010, p. 230). Therefore, the "supposition" that Wroth and Herbert were "living in the same house" appears to suggest the causation of a sexual relation between them as well as to explain Wroth's depiction of the events of 1601 in *Urania*. Yet, there is one further point that needs to be interrogated, because when Hannay suggests that "Mary Fitton's plight foreshadowed" Wroth's, she is not alluding to the verifiable affair between the cousins after the death of Robert Wroth and the birth of their children, William and Katherine, in 1624; rather she alludes to what had to be "very secret kept" only three and a half years after the Earl of Pembroke's funeral.

The specific foreshadowing referred to must have occurred sometime between 1601 and Wroth's marriage to Robert Wroth on 9 October 1604. Therefore, if Wroth's circumstances mirror those of Fitton, at some point during that time she must have believed herself to be betrothed to William Herbert and, as a consequence, begun a sexual relationship with him, although, unlike Fitton, she did not become pregnant. Hannay's extensive archival research provides no documentary evidence for what exactly happened between Wroth and Herbert, so instead she returns to the question of whether or not *Urania* can be considered a verifiable source and focuses upon the events surrounding Wroth's marriage. Hannay readily admits that "no contemporary accounts of Wroth's wedding survive, so it is tempting to read her depictions of Pamphilia's wedding as biography. But any attempt to unravel her real experience from her fiction has to be carefully handled"

(Hannay, 2010, p. 100). Again, in terms of fact and fiction the differences between the two biographies is clear. In *Philip's Phoenix* Hannay notes briefly that "young Mary Sidney was married on 27 September. Although the ceremony was not nearly as extravagant as those of her two Herbert cousins later in the year" (Hannay, 1990, p. 188). In the earlier biography, Hannay also gives some indication of the "discontent" that occurred after the marriage:

> Just two weeks after the wedding, Sidney told his wife that "my son Wroth" found "somewhat that doth discontent him" but would not give any particulars. "It were very soon for any unkindness to begin." (Hannay, 1990, p. 189)

Both comments are verifiable. Financial accounts quoted by Hannay show that Wroth's wedding did not cost as much as William Herbert's and certainly far less than the court extravaganza enjoyed by Philip Herbert, Sidney's younger son, and Susan de Vere. The "discontent" shown by Robert Wroth after the wedding is similarly evidenced from Robert Sidney's manuscript letters. In both cases, the brief details in *Philip's Phoenix* are appropriate since the earlier biography dealt with the life of Sidney rather than Wroth. However, in *Mary Sidney, Lady Wroth* Hannay extends her suppositions beyond contemporary manuscript evidence in an attempt to "sleuth" out what Robert Sidney took pains to conceal.

Correctly, Hannay begins by warning against asserting "a complete correspondence between fact and fiction" and cites two Wroth scholars to support this argument: Jennifer Lee Carrell and Helen Hackett (Hannay, 2010, pp. 100–101). Such caution is embedded in theories of literary biography. For example, Michael Benton notes, "as data the autobiographical text is partial, unstable, circumstantial evidence to be handled with care, if not scepticism." As such he concludes:

> The singular task of the literary biographer is not to seek the man behind the mask, but to accept the persona as a coded version of the subject and to elucidate the relationship between the textual self and the life as it was lived. (Benton, pp. 142, 151)

Here, the telling phrase is "the man behind the mask." Unlike biographers of male subjects, most of those researching women writers are faced with a paucity of verifiable evidence and this is particularly true of early modern women writers, as Hannay points out is the case with Wroth (Hannay, 2010, p. xi). Therefore, those decoding women's autobiographical texts are

hampered by the negligible material on "the life as it was lived" and so need to engage more with "the textual self." Returning to Wroth's wedding, Hannay acknowledges this when she quotes Mary Ellen Lamb's encouragement to "seek to improve our methods of conceptualising" autobiographical writings (Hannay, 2010, p. 101). The theorists of women's biography, such as Lyndall Gordon, concur with Lamb, suggesting a need to explore fictional works as valid sources since such creative "shadow[s]" enabled women writers to hint at what they would otherwise conceal:

> What form do we give to the potent shadow in which women of the past lived? I have proposed, here, that what is most distinctive in women's lives is precisely what is most hidden – not only from the glare of fame, but hidden from the daylight aspect which women present for their protection or [...] for the protection of those who could not face the "Bomb" in her breast. (Gordon, pp. 96–97)

Hannay identifies two such "shadow[s]" of Wroth's marriage: "Bellamira's wedding in *Urania* 1 and Pamphilia's wedding in *Urania* 2" (Hannay, 2010, p. 105). In both instances, the bride mourns the fact that she is not able to marry the man she loves: Bellamira burns "a lock of her beloved's hair," while after the ceremony, Pamphilia "threw herself on her bed, and for two hours 'she wept, she cried, nay she almost roared out her complaints'" (Hannay, 2010, pp. 106–107). Of course, we have no idea if Wroth did either of these things and Hannay makes no claim that she does, yet Wroth was certainly concealing something both for her own "protection" and, as Gordon so effectively phrases it, for the "protection of those who could not face the 'Bomb' in her breast" (the word "Bomb" is quoted from Emily Dickinson's "I tie my hat" [Gordon, p. 98]). Just so, because one week after the wedding just such a "Bomb" exploded in Robert Sidney's life.

The first inkling that something was wrong occurs in Robert Sidney's letter to his wife, Barbara, on 8 October 1604, in which he replies to her "word of grief [...] [that] I do not understand" (Hannay, 2010, p. 107). He then asks if she refers to "something 'which you told me somewhat of. [...] If it be so, I must confess it a great misfortune unto us all [...] it must be 'very secret kept'" (Hannay, 2010, p. 107). On the ninth, he wrote again and here Hannay repeats the quotation from *Philip's Phoenix* about "discontent" and "unkindness," as well as noting that Robert Sidney urged further concealment because "mine enemies would be very glad for such an occasion to make themselves merry at me" (Hannay, 2010, p. 107). As noted in the first paragraph of this essay, Hannay suggests that Wroth believed she had a *de praesenti* marriage

with William Herbert and "so, perhaps Robert Wroth had discovered that his bride was not a virgin, which certainly would 'discontent' him" (Hannay, 2010, p. 108). Finally, returning to the prose romance, Hannay concludes that,

> Though the relationship between fact and fiction is here so vexed, the probability that Wroth did have – or believed that she had, or wanted others to believe that she had – a *de praesenti* marriage with Pembroke is enhanced by the return to this theme toward the end of the second part of *Urania*, written nearly twenty years after her wedding. (Hannay, 2010, p. 108)

The fictional weddings, of course, provide no "granite-like" fact, but rather offer a "rainbow-like" re-creation in which Wroth produces multiple shadows of her relationship with William Herbert. This lack of verifiable evidence is shown by Hannay's use of "probability" that, significantly, in "Sleuthing in the Archives," she notes has "somewhat more certainty" (Hannay, 2015, p. 20). "Probably," therefore, swings precariously between fact and fiction, admitting that, while there is no evidence, a literary biographer may offer a persuasive bridge between truth and re-creation.

Biographers of early modern women must constantly confront the absence of verifiable evidence, and Margaret P. Hannay's research into the lives of Mary Sidney and Mary Wroth is no exception. Yet, changes in the theory of literary biography over the last 25 years mean that new ways of interpreting information from creative texts have become increasingly accepted, especially in the trend towards biofiction. This shift may be seen in Hannay's move from a "granite-like" investigation in *Philip's Phoenix* to the more "rainbow-like" deductions in *Mary Sidney, Lady Wroth*. Such re-creations are now recognized as an essential tool for uncovering what early modern women "shadowed" in their own autobiographical works. For Wroth, this meant that, while any suggestion of a sexually consummated relationship with William Herbert had to be excluded from documents such as letters, she was able to represent their liaison in her fiction. Still, this essay began by asking whether it is ever possible to discover what was "very secret kept" by early modern women writers and, in answer, I can only quote the inestimable Hannay: "Probably."

Works Cited

The Altmont Enterprise. "Margaret Patterson Hannay." https://altamontenterprise. com/08182016/margaret-patterson-hannay, 2016. Accessed 23 May 2020.

Batchelor, John, ed. *The Art of Literary Biography*. Oxford: Clarendon Press, 1995.

Benton, Michael. *Literary Biography: An Introduction.* Oxford: John Wiley, 2009.

Dekker, Thomas. *The Great Frost: Cold Doings in London.* London: Henry Gosson, 1608.

Gordon, Lyndall. "Women's Lives: The Unmapped Country." *The Art of Literary Biography,* Edited by John Batchelor. Oxford: Clarendon Press, 1995, pp. 87–98.

Hannay, Margaret P. *Philip's Phoenix: Mary Sidney, Countess of Pembroke.* Oxford: Oxford University Press, 1990.

Hannay, Margaret P. *Mary Sidney, Lady Wroth.* Farnham, UK: Ashgate Publishing Limited, 2010.

Hannay, Margaret P. "Sleuthing in the Archives: The Life of Lady Mary Wroth." *Re-Reading Mary Wroth,* edited by Katherine R. Larson and Naomi J. Miller with Andrew Strycharski. New York: Palgrave Macmillan, 2015, pp. 19–33.

Holmes, Richard. "Biography: Inventing the Truth." *The Art of Literary Biography,* edited by John Batchelor. Oxford: Clarendon Press, 1995, pp. 15–26.

Lee, Hermione. *Biography. A Very Short Introduction.* Oxford: Oxford University Press, 2009.

McVeigh, Jane. "Concerns about Facts and Form in Literary Biography." *A Companion to Literary Biography,* edited by Richard Bradford. Chichester: John Wiley, 2019, pp. 143–158.

Miller, Naomi. *Secret Story-Maker.* Private papers.

Miller, Naomi. *Imperfect Alchemist.* London: Allison & Busby, 2020.

Salwart, Dale. "Literary Biography in the Twentieth Century." *A Companion to Literary Biography,* edited by Richard Bradford. Chichester: John Wiley, 2019, pp. 107–120.

Woolf, Virginia. *Orlando, A Biography,* edited by Brenda Lyons. Harmondsworth: Penguin Books, 1993.

Woolf, Virginia. "The New Biography." *The Essays of Virginia Woolf,* edited by Andrew McNeillie (vols 1–4) and Stuart N. Clarke (vols 5–6). 6 vols. London: Hogarth, 1986–2011; vol. 4 (1994), pp. 473–480.

About the Author

Marion Wynne-Davies is Professor of English Literature at the University of Surrey. She has published extensively on early modern women writers, including the award-winning *Renaissance Drama by Women: Texts and Documents* (1995) which she edited with S.P. Cerasano. She is interested in how scholarly research intersects with fictional re-creations.

10. Imagining Shakespeare's Sisters: Fictionalizing Mary Sidney Herbert and Mary Sidney Wroth

Naomi J. Miller

Abstract

My projected biofiction series, *Shakespeare's Sisters*, comprises six inter-related historical novels that convey the stories of early modern women authors from their own perspectives. As epitomized by the first of these, *Imperfect Alchemist*, the series offers imaginative engagements with an array of early modern figures, with women writers at the center of the narrative. This essay explores how biofiction can differ from biography in imagining and making visible both individual convictions and strategies of authorship that worked to challenge and transform popular assumptions about gender in another era. My essay considers how authors of biofiction can explore challenges and expectations facing early modern women that resonate with modern audiences.

Keywords: biography, biofiction, Mary Sidney Herbert, Mary Wroth

While initial critical attention to the phenomenon of biofiction centered upon male subjects and masculine narratives, the scholarly field has expanded significantly to address both feminist perspectives and female subjects.[1] Nonetheless, when attending to fiction about early modern

1 Michael Lackey's influential voice on this topic first came to my attention in "The Uses of History in the Biographical Novel" (2012), a round-table conversation with three male novelists that focused on novels about Wittgenstein, Tolstoy, and Nietzsche. However, much to Lackey's credit, his subsequent volume, *Truthful Fictions* (2014), included interviews with Julia Alvarez, Anita Diamant, Kate Moses, Joyce Carol Oates, and Joanna Scott that addressed a range of topics, while his subsequent publications, including "Locating and Defining the Bio in Biofiction" (2016), *Biographical Fiction:*

Fitzmaurice, J., N.J. Miller, S.J. Steen (eds.), *Authorizing Early Modern European Women. From Biography to Biofiction*. Amsterdam: Amsterdam University Press, 2022
DOI 10.5117/9789463727143_CH10

subjects, one finds that popular novels about actual, rather than invented, Renaissance women often picture them in relation to powerful men. One need look no further than the steady stream of novels about the wives of Henry VIII, perpetuating a phenomenon that I have termed the "Noah's ark approach," which positions women in dependent relation to already canonical or culturally powerful male figures.[2] Contemporary readers of historical fiction have missed out on an extraordinary array of women's voices that were heard in their own period – whether acclaimed or reviled – but then silenced over time and excluded from the canon of accepted classics. More recently, however, as this volume of essays indicates, there has been a steady increase in biofiction about women creators from earlier periods.

My own projected biofiction series, *Shakespeare's Sisters*, comprises six interrelated historical novels that convey the stories of early modern women authors from their own perspectives. After 30 years as a scholar of early modern women, I realized that my work wasn't close to being complete as long as the wider public had no awareness of the remarkable women authors who were published and read in the time of Shakespeare. The novels in the series offer imaginative engagements with an array of early modern figures – from queens to commoners. Historical women, including Mary Sidney Herbert and Mary Sidney Wroth, are at the center of the narratives, bringing their voices and experiences to life for modern audiences. I have framed my "pitch" for the series as follows:

> *Shakespeare's Sisters* centers on women whose lives and voices both shape and are shaped by women, many of whom play a part in each other's stories [...]. Spanning generations and social classes, the series paints a multi-hued portrait of Renaissance England, seen through the lives of courtiers, commoners, poets, playwrights, and above all, indomitable women who broke the rules of their time while juggling many of the responsibilities and obstacles faced by women worldwide today.

A Reader (2016), and *Conversations with Biographical Novelists* (2019), have been wide-ranging and comprehensive. More than any other single scholar, Michael Lackey has been responsible for both naming and calling attention to the burgeoning of biofiction in contemporary novels.

2 See "Figurations of Gender," Chapter 1 in my *Changing the Subject* (1996), esp. p. 8. Hilary Mantel's characterization of Anne Boleyn as a powerful political figure in her own right (*Bring Up the Bodies*) offers arguably the most significant exception to this pattern, although, given her subject, her novels attend more substantially to the perspectives of powerful men than women. Sarah Dunant, whose biofiction set in the early modern world gives voice to such compelling historical women as Lucrezia Borgia and Isabella d'Este (*In the Name of the Family*), notes that what Mantel "doesn't do [is] feminism and historical fiction" (Ray [2012], p. 674).

While some of the key figures in the series are invented, the title characters and many others are based on actual historical persons. Committed to writing biofiction about actual historical women, I have chosen to ground each of the novels in the story of a woman author whose words and vision I hope to bring to the attention of a larger public.

Given that the initial works in the *Shakespeare's Sisters* series take inspiration from and draw closely upon the richly detailed biographies of Mary Sidney Herbert and Mary Wroth constructed by Margaret Hannay (and addressed by Marion Wynne-Davies in the preceding chapter), this chapter considers how biofiction can differ from biography in imagining and making visible both individual convictions and strategies of authorship that worked to challenge and transform popular assumptions about gender in another era.

Imperfect Alchemist, the opening novel in the series, is an imaginative reinvention of the remarkable life of Mary Sidney Herbert, the Countess of Pembroke – friend of Queen Elizabeth, visionary scientist, advocate for women writers, and scandalous lover of a much younger man. One of the earliest women authors in Renaissance England to publish under her own name, the Countess successfully forged a place for herself in a man's world. An influential literary patron as well as author, she has been celebrated by historians for convening a literary salon of writers in early modern England, while her published play about Antony and Cleopatra – a creatively adaptive translation of Robert Garnier's *Marc Antoine* – is believed to have influenced Shakespeare. A member of one of England's leading families, she carved out space for herself as a daring and often controversial figure in a royal court riven by jealousies and intrigues.

Authors such as Edmund Spenser, John Donne, and Ben Jonson, interested in testing the limits of literary forms, participated in the Countess's renowned writing circle. Responding to her known patronage of women authors, I have imagined some of these women into the circle, their interaction with the male authors inspiring visions of new possibilities. The Countess's pioneering literary and scientific experiments challenged many of Renaissance England's established conventions – one of the things that most strongly drew me to her. Another was her role as mentor to a cohort of women writers and patrons, including Mary Wroth, Aemilia Lanyer, Elizabeth Cary, and Anne Clifford, as well as Queen Anna of Denmark, all of whom I plan to include in my projected *Shakespeare's Sisters* series.

In *Imperfect Alchemist*, the fictional Mary Sidney Herbert is mediated through my knowledge of her real-life circumstances and her writings. She was also a scientist, practicing alchemy in her private laboratory to

prepare chemical and herbal remedies. Although the Countess was a well-regarded alchemist, no manuscript records of her alchemical recipes or experiments survive. I have drawn on historical accounts documenting the detailed practices of other female alchemists of the period in order to present an authentic, if conjectural, account of her scientific work. As the acclaimed historical novelist Sarah Dunant observes, fashioning historical verisimilitude, "like a pointillist painting," lies in the details (Ray, p. 665).

Indeed, Dunant describes her employment of historical details as "gold dust," enabling her to give readers confidence that they're encountering worlds, previously unfamiliar to them, that actually existed, thus grounding the novel's inventions in a "multicolored" world (Ray, p. 670). Pursuing a related line of thought, the historical novelist Emma Donoghue observes that what "biographical fiction does marvelously" is to include "the really peculiar detail, the detail that does not seem to fit – a kind of oddity that I might not have thought to make up," which makes for "characters who are more rounded and three-dimensional than highly consistent invented ones often are" (Lackey and Donoghue, pp. 128, 132). In the case of *Imperfect Alchemist*, such details include the Countess's practice in later life of shooting pistols and taking tobacco (Hannay, 1990, p. 196).

I introduce an invented character, Rose Commin, her lady's maid, to lend a broader perspective than Mary's point of view alone. Trained to serve and observe, Rose proves to be both a keen judge of character and a skilled artist, whose drawings give new dimension to Mary's own life and writings. The background for my construction of Rose is based on accounts of servants and country folk of the period. Fear of witchcraft was common, and that strand in the story incorporates historical examples of the treatment of women accused of sorcery. Looking at the world through Rose's as well as Mary's eyes has enabled me to broaden both characters' perspectives and their intersecting lives beyond historical facts alone. The supporting cast of characters, both real and invented, supplies three-dimensionality to the fictional story-line. A guiding principle has been to avoid contradicting historical facts, but I have sometimes adjusted the timing of actual events by a couple months or years, in order to serve the story and the narrative flow.

Apart from Rose's family, the Pembroke servants, and a few others, most of the characters in the book are fictional renditions of real historical figures whose roles combine elements of their actual lives with my own inventions. As well as the authors in the Wilton Circle and the courtiers in Mary's life, they include the court painter Marcus Gheeraerts the Younger; the physician, naturalist, and poet Thomas Moffett; the Countess's alchemist associate Adrian Gilbert; the proto-feminist Marie de Gournay; and John Dee, the

most prominent occultist of his time and astrologer to the Queen. Two central figures in the story are also drawn from life. Simon Forman, who plays a key role in Rose's life, was a Wiltshire-bred, London-based astrologer and herbalist who was apprenticed in his youth to a cloth merchant named Commin. Matthew Lister served the Dowager Countess of Pembroke as family physician and was rumored to be her lover.

Once I completed the necessary research and embarked on the first draft of the novel, I had to guard against my tendency, as a scholar, to plunge down historical or literary "rabbit-holes" that enticed me with fascinating details that would interrupt the writing process and might obscure rather than illuminate the story, supplying dust rather than gold dust. As I've noted elsewhere, the most valuable advice I've received came from Jennifer Carrell, a novelist and scholar in her own right, who has published academic work on Mary Wroth and two Shakespeare thrillers. Jenny reminded me that "as a novelist, your responsibility is to the story, not to history. *Just tell the story that matters!*" (Miller, 2018, p. 121).

Sometimes, of course, the challenge for me as a novelist is to recognize that *the story that matters* to the wider public might not be the one that captures my attention as a scholar or a teacher. Some of what thrills me as a scholar/teacher – such as Mary Sidney Herbert's ingenuity in employing 126 distinct stanzaic forms in her creative paraphrases of 107 Psalms, which influenced the poetry of John Donne and George Herbert and opened up what Barbara Lewalski has termed "a new aesthetic consciousness" (p. 245) – is frankly not what attracts trade publishers looking for a novel that can be marketed to the general public.

So what is *the story that matters* in *Imperfect Alchemist*? Most of this novel, which encompasses the period from 1572 to 1616, is written from two alternating points of view: that of Mary Sidney Herbert, in the third person, and her maidservant, Rose Commin, in the first person. As I was writing the novel, the story that came to matter the most to me was about two women, driven by sometimes conflicting imperatives of creative expression and desire – one a quiet artist, the other an outspoken author – who come to connect with each other across class lines, learning truths from each other that they never expected to discover about themselves and their world.

But there is another *story that matters* behind this novel. That's the story of the draft of a novel that I wrote about Mary Wroth before turning to *Imperfect Alchemist*. Beginning that novel was when I learned that if you really want to "change the subject" (the title of my first scholarly book on Wroth) there's nothing like embarking on writing fiction about a subject on which you've become one of the "scholarly authorities," because that's

when you will be forced to recognize, with abashed consternation, that all of your "expertise" can be as nothing – or even pose obstacles – to the story you're trying to tell.[3]

As a Wroth scholar and teacher, I was too knowledgeable about my subject to transition easily into fiction, too expert and too constrained by the invisible but inexorable rules of scholarship – don't make assumptions, and never make an assertion you can't back up with evidence. But as a novelist, that was *precisely* my job – to enter freely into the world of imaginative possibility, to listen to my characters, to employ evidence lightly as gold dust rather than heavily as blocks of marble. I wasn't building a temple to my subject, but seeding a garden with new life, watering, weeding, and welcoming whatever might arise, while maintaining the responsibility to my story to determine whether or not it belonged there, and to what use it might be put.

I slowly learned to adapt the scholarly techniques that had served me throughout my career, researching the material culture of the early modern world, for this new purpose – not to draw connections between early modern text and context, but to create a world in which my protagonist, the early modern woman Mary Wroth, could live and breathe, labor and love. To create the form and texture of the time, I read historical studies documenting early modern clothes and food, source texts containing early modern recipes and medical remedies, collections of letters and diary entries by other early modern women. Most important, I returned to the primary texts that had started me on this journey in the first place: the words and works of Mary Wroth.

I first read Mary Wroth's prose romance, *Urania* (published in 1621), at Harvard's Houghton Library for rare books and manuscripts when I was in graduate school, and subsequently traveled to the Newberry Library in Chicago to read the unpublished, handwritten manuscript continuation of the *Urania*. No modern edition of Wroth's *Urania* existed at that time.[4] Reading those pages in Wroth's own hand, written almost 400 years earlier, I understood Keats's words on first looking into Chapman's Homer: "Then felt I like some watcher of the skies / When a new planet swims into his ken." Except that instead of a male poet reading a male translator of a male

3 For a more detailed account of my composition of the novel about Mary Wroth, see my "Re-Imagining the Subject."

4 After the 1621 publication of *Urania*, withdrawn from publication upon the objections of courtiers in the court of King James, the next published edition of that prose romance was in *The Early Modern Englishwoman: A Facsimile Library of Essential Works*, vol. 10: *Mary Wroth* (1996), while the first ever published edition of Wroth's manuscript continuation of the romance, *Urania II*, appeared in 1999.

classical author, I was a feminist scholar reading an early modern woman author whose words filled me with excitement. I recognized, beyond a doubt, that here was no minor writer whose claim to fame rested solely on the anomaly of her gender as a writer, but an astounding and unique voice for her time – a new planet indeed.

I completed a dissertation on Sidney's *Arcadia* and Wroth's *Urania* in 1987, four years after Josephine Roberts's groundbreaking edition of Wroth's *Pamphilia to Amphilanthus* appeared, and nine years before the first modern edition of *Urania* was published. By that point, I had come to identify the "Noah's Ark approach" to the study of women authors. These juxtapositions, linking an otherwise "minor" woman with a recognized patriarch, served to legitimate the attention to the female half of a given "pair." This "couples" approach was particularly evident in the cases of Mary Sidney, the Countess of Pembroke and sister to Philip Sidney, and Mary Wroth, niece to the same Philip Sidney, whose patriarchal pedigrees provided readymade legitimacy on the margins of the canon through their connections to the powerful male figures of the Sidney and Herbert/Pembroke families. My dissertation itself, pairing Wroth's *Urania* with Sidney's *Arcadia*, was a case in point.

No surprise, then, that my first two scholarly books aimed to focus squarely on Wroth as an author in her own right. Coediting the volume *Reading Mary Wroth* allowed Gary Waller and me to gather cutting-edge essays on Wroth by contributors ranging from graduate students to senior scholars and enhanced the research for the writing of my own book on Wroth. *Changing the Subject: Mary Wroth and Figurations of Gender in Early Modern England* was the first book of interpretive scholarship wholly focused on Wroth, situating all her works – from poetry to drama and fiction – in relation not just to the patriarchs, but to the stunning range of early modern women authors that I was still learning to recognize and appreciate. As a novice Wroth scholar, I was learning that "changing the subject" – from at best one-half of a male-dominated dyad to a primary subject in her own right – was only the first step in a longer journey.

A decade later, as a recognized scholar of early modern women's studies, I could wait no longer to launch my project of bringing this exceptional woman author to the attention of a larger public through fiction. As an aspiring novelist, I found the journey even more rewarding – and challenging – than I had anticipated. I drafted the first 300 pages of the novel during a one-semester breather from an administrative position, and the final 100 pages during the single week of "spring break." I wrote with greater intensity, and with greater joy, than I had ever experienced as an author before. And underlying it all was the same sense of wonder that had precipitated my earliest work on

Wroth – glimpsing that new planet. I realized, then, that writing the novel was another way of focusing the telescope that I had been training on that planet since setting down my very first words about Wroth in graduate school.

When in doubt about what "my" characters might say to one another, I listened to Wroth's characters. Thus I heard one of Wroth's characters advise another to cease to lament her male lover's inconstancy, and instead pursue her own path: "Follow that, and be the Empress of the World, commanding the Empire of your own mind" (Wroth, 1999, p. 112).

Powerful words – indeed, subject-changing. Not typical by any means of what women authors, let alone male authors, were writing in the 1600s. And accessible nowhere other than in the words of these authors themselves. In my novels, not just biographical and historical facts, but the writings of both Mary Sidney Herbert and Mary Wroth are what have at once impelled and liberated me to imagine their characters through fiction. Hilary Mantel maintains that "you become a novelist so you can tell the truth," and observes that "most historical fiction is [...] in dialogue with the past" (2007). My driving aim is to "tell the truth" that becomes visible in these historical women's writings, and to put my own fiction into dialogue with theirs.

As Emma Donoghue observes about her biofiction, she has no obligation "to make the story stolidly representative of everybody's life," but instead can focus on "the oddballs – peculiar individuals who do not seem to fit" (Lackey and Donoghue, p. 128). Indeed, Donoghue finds that "at its best – the biographical novel makes people uncomfortable," because these characters "stay different from us. [...] We should keep that uncomfortable difference [...] [which] should provoke us" (p. 131). To my mind, it is precisely that uncomfortable difference that provoked early modern audiences when confronted with the published words of women authors who refused to play by the rules – the difference that can provoke modern audiences to fascination and wonder that such words could be spoken at that time.

I explore that discomfort in a scene in *Imperfect Alchemist* where Mary Sidney Herbert invites her young niece, Mary Wroth, to read aloud from one of her own love sonnets, after the circle of male authors has already been shaken by some of Aemilia Lanyer's radical verses:

> Following Aemilia's example, Mary stood straight and tall during the Countess's introduction. Her red hair, sharing the family hue, was even curlier than her aunt's, and a few tendrils escaped their binding to tremble beside her cheeks. Seated close to the young woman, Mary glimpsed a sheen of sweat across her forehead. The sheet of paper in her goddaughter's hand trembled slightly, but when she opened her mouth, her voice was strong and clear.

The poem she offered captured the anguish of disappointed love:

False hope, which feeds but to destroy and spill
What it first breeds; unnatural to the birth
Of thine own womb; conceiving but to kill.

A love sonnet crafted around miscarriage! No male sonneteer would even think to convey the pain of love through one of women's most common experiences of death. The Countess saw several of the men shift uneasily, and marveled to find greater discomfort on some faces than Aemilia's more explicitly radical verse had produced. For them, the love sonnet was a familiar and reliable form – but not in this voice. Men were supposed to be the lovers, women the objects. Male sonneteers weren't concerned with women's experiences in love, only with their own successes or failures. She saw Ben Jonson, his eyes alight, fixed intensely on her niece. But William was looking at his knees. As the hoped-for future leader of the Circle, could her son appreciate the language of a battered heart? Value the courage of a voice writing through loss, no matter man or woman? *False hope – conceiving but to kill.* Mary wondered at the evident passion and pain in the verse. She realized, now, that she knew so little of her goddaughter's life – her loves and losses. This child, whose conception she had brought to pass with the remedies she had made for Barbara and Robert Sidney, had grown into an accomplished young woman with an arresting imagination.

What better reader for one of the women author characters than another woman author? Who else, after all, could better appreciate the use of miscarriage in a love sonnet than her godmother and mentor, another woman writing in a world of traditions and assumptions defined by men?

Writing my novel about Mary Sidney Herbert offered a voyage of discovery back to my novel about Mary Wroth, which I am now revising, following the publication of *Imperfect Alchemist*. I discovered that bringing the voices of these two women authors together was one of *the stories that matter* – not just to me, but to both novels and to the series itself.

My novel extends what might be considered the traditional biofiction focus on a historical figure, supplemented by the other historical figures whose paths they cross, by widening the lens. Not only does my narrative focus on the stories of two different women, one historical and one invented, but the story builds upon the recurring image of the double ouroboros – an alchemical figure of two snakes biting each other's tails in a circle, that celebrates the joining of opposites, or the partnering of complementary forces. As the cover design for the novel suggests, *Imperfect Alchemist*

Figure 10.1. Cover image for *Imperfect Alchemist*. Photograph courtesy of Allison & Busby.

explores herbalism as well as alchemy, centered on but not limited to the primary historical figure.

My aim has been to tell a story that imagines the perspectives of historical women in a world that encompasses both known facts and imagined

possibilities, illumining the historical record without being limited by it. I like to think that the real Mary Sidney Herbert, who reinterpreted the Psalms with her brother Sir Philip Sidney, resurrected his *Arcadia,* and reinvented the figure of Cleopatra in her *Antonius*, would appreciate my transmutation of her own story.

Researching the practices of early modern alchemists, I have come to appreciate the potential for biofiction itself to serve as a transformative process of combination, distillation, and reduction to essential elements, which are then subject to recombination and quite literally reformation in fictional narratives with the capacity to conjure gold from elemental materials, or novels from an array of historical and biographical facts – and from the words of women authors themselves.

Works Cited

Carrell, Jennifer Lee. *Interred with Their Bones*. New York: Dutton, 2007.

Carrell, Jennifer Lee. *Haunt Me Still*. New York: Dutton, 2010.

Dunant, Sarah. *In the Name of the Family*. New York: Random House, 2017.

Hannay, Margaret. *Philip's Phoenix: Mary Sidney, Countess of Pembroke*. Oxford: Oxford University Press, 1990.

Hannay, Margaret. *Mary Sidney, Lady Wroth*. Farnham, UK: Ashgate, 2010.

Keats, John. "On First Looking into Chapman's Homer." *John Keats: Complete Poems*, edited by Jack Stillinger. Cambridge: Harvard University Press, 1978, p. 64.

Lackey, Michael. "The Uses of History in the Biographical Novel: A Conversation with Jay Parini, Bruce Duffy, and Lance Olsen." *Conversations with Jay Parini*, edited by Michael Lackey. Jackson: University Press of Mississippi, 2012, pp. 125–148.

Lackey, Michael. ed. *Truthful Fictions: Conversations with American Biographical Novelists*. New York: Bloomsbury, 2014.

Lackey, Michael, ed. *Biographical Fiction: A Reader*. New York: Bloomsbury, 2016.

Lackey, Michael. "Locating and Defining the Bio in Biofiction." *a/b: Auto/Biography Studies*, vol. 31, no. 1, 2016, pp. 2–10. Subsequently published as the volume introduction to *Biofictional Histories, Mutations and Forms*, edited by Michael Lackey. New York: Routledge, 2019.

Lackey, Michael. "Introduction: The Agency Aesthetics of Biofiction in the Age of Postmodern Confusion." *Conversations with Biographical Novelists: Truthful Fictions Across the Globe*, ed. Michael Lackey. New York: Bloomsbury, 2019, pp. 1–21.

Lackey, Michael, and Emma Donoghue. "Emma Donoghue: Voicing the Nobodies in the Biographical Novel." *Éire-Ireland*, Nos. 1 & 2, Spring/Summer 2018, pp. 120–133.

Lewalski, Barbara. *Protestant Poetics and the Seventeenth-Century Religious Lyric.* Princeton: Princeton University Press, 1979.

Mantel, Hilary. "The Day is for the Living." *BBC Reith Lecture One.* 13 June 2007. https://www.bbc.co.uk/programmes/b08tcbrp. Accessed 6 July 2020.

Mantel, Hilary. *Bring Up the Bodies.* London: Harper Collins, 2012.

Miller, Naomi J. and Gary Waller, eds. *Reading Mary Wroth: Representing Alternatives in Early Modern England.* Knoxville: University of Tennessee Press, 1991.

Miller, Naomi J. *Changing the Subject: Mary Wroth and Figurations of Gender in Early Modern England.* Lexington: University Press of Kentucky, 1996.

Miller, Naomi J. "Reimagining Mary Wroth through Fiction." *The Sidney Journal,* vol. 32, no. 2, 2014, pp. 39–64.

Miller, Naomi J. "Reimagining the Subject: Traveling from Scholarship to Fiction with Mary Wroth." *Re-Reading Mary Wroth,* edited by Katherine R. Larson and Naomi J. Miller with Andrew Strycharski. New York: Palgrave Macmillan, 2015, pp. 225–237.

Miller, Naomi J. and Katharine Larson, eds. *Re-Reading Mary Wroth.* New York: Palgrave Macmillan, 2015.

Miller, Naomi J. "Fictionalizing Shakespeare's Sisters: Mary Sidney Herbert." *Early Modern Women: An Interdisciplinary Journal,* vol. 12, no. 2, 2018, pp. 117–126.

Miller, Naomi. *Imperfect Alchemist.* London: Allison & Busby, 2020.

Ray, Meredith. "A Conversation with Sarah Dunant." *ITALICA,* vol. 90, no. 4, 2013. pp. 663–676.

Woolf, Virginia. *A Room of One's Own.* New York: Harcourt, 1929, rpt 2005.

Wroth, Mary. *Pamphilia to Amphilanthus. The Poems of Lady Mary Wroth,* edited by Josephine Roberts. Baton Rouge: Louisiana State University Press, 1983.

Wroth, Mary. *The Countesse of Mountgomeries Urania,* in *The Early Modern English-woman: A Facsimile Library of Essential Works,* vol. 10: *Mary Wroth,* edited by Josephine Roberts. Brookfield, VT: Scolar Press/Ashgate, 1996.

Wroth, Mary. *The Second Part of The Countess of Montgomery's Urania,* edited by Josephine A. Roberts, completed by Suzanne Gossett and Janel Mueller. Tempe, AZ: RETS/SCMRS, 1999.

About the Author

Naomi J. Miller is Professor of English and the Study of Women and Gender at Smith College. She has published award-winning books on early modern women and gender, and teaches courses on Shakespeare and his female contemporaries. *Imperfect Alchemist* (Allison & Busby, 2020) launches a series of novels called *Shakespeare's Sisters.*

11. Anne Boleyn, Musician: A Romance Across Centuries and Media

Linda Phyllis Austern

Abstract

This chapter situates Anne Boleyn's reputed musicality within five centuries of endless fascination with her. Beginning the year of her execution (1536), an ever-expanding range of histories, biographical accounts, novels, and works of visual and performing arts have presented Anne as a singer, instrumentalist, composer, and/or consumer of musical performances and products. What remain to be acknowledged are the ways in which otherwise rigid academic studies since the eighteenth century romanticize Anne's engagement with music, and, conversely, how often fictitious representations of her have incorporated historically accurate musical information. At the center of these contrasting depictions stand questions of Anne's musical agency, musical training, and with whom and how she shared her musical abilities.

Keywords: Anne Boleyn, Anne Boleyn Music Book (GB-Lcm MS 1070), Henry VIII, historical fiction, romance (literary genre), women composers and musicians

Accounts of the life of Anne Boleyn (c. 1500–1536), the second wife of England's King Henry VIII, have hovered between biography and fiction since more than 125 years before the former term entered the English lexicon and over a half-century before the latter became a recognized genre. A riveting amalgam of invention and fact, the pivot between the oldest definitions of "fiction" and chronicle life-writing, has dominated her story since the final years of her life.[1] The historical Anne has merged with a succession

[1] "Biography, n," *OED Online*; "Fiction, n." *OED Online*; Ives 2004a; and Warnicke, pp. 2–3.

Fitzmaurice, J., N.J. Miller, S.J. Steen (eds.), *Authorizing Early Modern European Women. From Biography to Biofiction.* Amsterdam: Amsterdam University Press, 2022
DOI 10.5117/9789463727143_CH11

of exemplary characters who share her name and ostensibly inhabit her world, but speak primarily to and about women from subsequent eras. In a 2012 television documentary on the rise of young Anne Boleyn fans, the "biggest-selling female historian in the United Kingdom," Alison Weir, explains that "[t]here are cults around Elizabeth the First, but not the way there are around Anne Boleyn [...]. Anne Boleyn has been highly romanticized [...] and this is the fault of some historians as well." Anne's influence, she continues, has been drastically overstated since the 1960s by scholars as well as novelists and film-makers when during her life "her only power came from a man" (Burden). Such valorization is hardly a product of the past half-century. Shortly after her execution in 1536, Anne was already the subject of international mass-media speculation (Carles). By 1842, British historian and poet Agnes Strickland could assert that "[t]here is no name in the annals of female royalty over which the enchantments of poetry and romance have cast such bewildering spells as that of Anne Boleyn" (Strickland, p. 148). A previously unremarked feature that spans creative representation and cross-disciplinary scholarship about Anne from 1536 through the present is her reputed musicianship – and how it has served her image as a cultured and influential woman who perhaps did exceed conventional limits of her gender.

Anne Boleyn is an ideal subject for biofiction since little verifiable information about her survives. Multidisciplinary experts disagree about how to interpret and order extant evidence – let alone what is spurious and what authentic (Bernard, pp. ix and 4–18; Bordo, pp. 4–6; Norton, p. 7). Was Anne a scheming seductress or victim of circumstance, a heroine of the English Reformation or political pawn? Where and when was she born, and, as surprisingly few scholars have asked, what were her relationships with powerful women at the international courts in which she served from childhood? How can we best contextualize those few surviving artifacts with which she may have come into contact? As a member of the first generation of European courtiers for whom musical skill was deemed necessary for both genders, what were her musical tastes and training? Did she sing, dance, compose, write song-lyrics, play musical instruments, or collect them as did her royal husband (Fallows; Lyndon-Jones)? Did she prefer to perform or listen, among whom, and under what circumstances? So many details of her life remain shrouded in mystery that they invite postulation; even her appearance remains debatable (Bernard, pp. 19–20, 196–200). Like Weir, culture critic Susan Bordo argues that it is not only novelists and film-makers who blend fact and fantasy about Anne "[b]ut

few historians or biographers acknowledge just how much of what they are doing *is* storytelling" (Bordo, p. 4).

Perhaps because of its embodied, affective qualities, ontological mystery, and long-standing association with both female accomplishment and seduction, music and its materials have been part of Anne Boleyn's story since the year of her death. Otherwise meticulous scholars have, as we shall see, constructed wild speculations around musical relics possibly associated with her. Yet a touch of period musical detail helps make Anne's life more immediate and compelling, especially for general audiences. It helps immerse the reader in a Tudor sensorium as Evelyn Anthony introduces the title character of her 1957 novel, *Anne Boleyn*. It further enables Anthony to create an engaging narrative around surviving musical compositions by Henry and the historical presumption that Anne played lute. As Anthony's two characters stroll in "a rose garden, where the rich sensual flowers bloomed" at her family's home, Hever Castle, Anne drops a crimson rose which Henry hands her. Then

> Anne laid her flowers on a little seat set into the [garden] wall [...] [A]t last she led him to the statue of the [little stone] faun [playing pipes].
> "I've often wondered what tune he plays," Anne said [...]
> "Do you like music, Mistress?"
> "Very much, Sire. I pass much of my time here playing. And my lute is well acquainted with Your Grace's melodies." (Anthony, pp. 5, 7)

The same sensory signifiers enhance a 2015 museum display at the historic Hever Castle and Gardens. Among the carefully researched wax figures representing her life at the Castle is "Anne reading a love letter written by Henry VIII following her return to Hever to escape rumours." She holds a red rose beneath her heart as she listens to "a minstrel playing his lute – a popular form of musical entertainment in Tudor England" (Hever Castle).[2]

Viewers are thus invited to share Anne's plausible, multisensory experience of an extant object complete with imagined period soundtrack. The life-sized, three-dimensional tableau immerses viewers in a seamless blend of past and present, documentary evidence and speculation: compelling "romanticization" as in Anthony's novel and long-dominant in the collective imagination of this enigmatic woman. The *Oxford English Dictionary* defines "romance" not only as a narrative "relating the legendary or extraordinary

2 For a modern-spelling edition of the love-letters between Henry and Anne, see Norton, pp. 39–46.

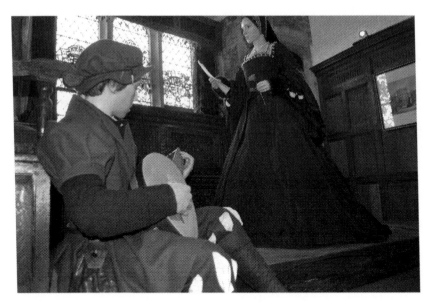

Figure 11.1. Waxwork Minstrel with Anne Boleyn, Hever Castle & Gardens, Kent, UK. Photograph courtesy of Hever Castle & Gardens.

adventures of some hero of chivalry" but also "[t]he character or quality that makes something appeal strongly to the imagination, and sets it apart from the mundane." The term may indicate "An extravagant fabrication; a wild falsehood, a fantasy" or "[a] fictitious narrative [...] in which the settings or the events depicted are remote from everyday life, or in which sensational or exciting events or adventures form the central theme." Since the early twentieth century, "Romance" has additionally denoted "[a] story of romantic love, *esp.* one which deals with love in a sentimental or idealized way" ("Romance, n," *OED Online*). Each of these meanings has contributed to the portrait of Anne as musician from the sixteenth century onward, across media, and in biography as well as biofiction.

Anne has been presented playing the lute in an astonishing range of media from novels such as Anthony's to china figurines to history paintings to character dolls to television shows to her own waxworks, to say nothing of scholarship.[3] Anne's widespread reputation as a lutenist likely began with the 1545 publication of Lancelot de Carles's 1536 poetic account of her life, trial, and execution, which states that she "knew well how to play the lute

3 See, for example, "Anne Boleyn" china figurine; "Anne Boleyn" waxwork (Madame Tussauds 1993, n.p.); Sharon Paxon Carlisle, dollmaker, "Henry VIII and His Six Wives"; Debbie Dixon-Paver, *Debbie Cooper Dolls* "King Henry VIII and his Six Wives."

and other instruments to chase away sad thoughts" (Carles, p. 5).[4] Historian Norah Lofts presents Anne in a 1979 biography as "an accomplished lute player." She emphasizes, if on more traditional than evidentiary basis, that Anne was also a singer, lyricist, and composer who "accompanied herself when she sang her own songs" (pp. 67, 165). Lofts's biography features a photograph of Anne's lute, a prize relic later deemed no more authentic than the one made for the waxwork minstrel (p. 165; Sotheby, p. 126). Yet it stands as a fitting signifier of Anne's creative agency.

In contrast, more frankly fictitious versions of Anne rarely play the instrument for purposes other than Henry's entertainment. Their music mostly inflames his erotic desire, though sometimes, as in Anthony's novel, the lute or other shared musical interests provides a bond between them. Any music Anne makes alone or among women in such tales belongs to her maidenhood of waiting for a man or her service to Catherine of Aragon. For example, the title character of Francis Hackett's 1939 novel *Queen Anne Boleyn* "obeyed the routine of a young lady's existence at Hever – prayers to say, meals to eat, dogs to walk, music to play, clothes to wear, and weather to talk about" before Henry's first visit. During their courtship he commands her to play her lute and sing, sometimes singing with her (pp. 23, 383–384). Reginald Drew's 1912 *Anne Boleyn* was created to "refute the conception that Anne was a base courtesan, striving by all means to rise, and at last succeeding." According to Drew, it is "only a novel [...] but with more truth than fiction" (Foreword [n.p.]) Its title character, "an accomplished musician," is first shown playing lute for Catherine of Aragon and her ladies "engaged in tapestry work, embroidery, and making garments for the poor." Henry intrudes into this industrious domain, "critically listen[s] to [Anne's] fingerings," and orders his wife to "have [Mistress Boleyn] sing for us" (Drew, p. 154).

In Anthony's novel, Anne's discriminating musicianship enchants the King. At the end of their first meeting, after discussing several of his compositions, he observes that she has "a fine [aural] perception" and adds that "if your musicianship is good, then you must play for me." "It's no match for yours," replies this Anne, "But for a woman I play quite well" (Anthony, pp. 7–8). From then on, the lute signifies Henry's desire for Anne and the body over which he has ultimate control. Long before she becomes his mistress, a lute he accidentally kicks reminds him of her. So he orders his page to "Request [the Queen] to send Mistress Anne Boleyn to me [...] and

4 "Elle sçavoit bein [...] /Sonner de lucz, & daultres instrumens/Pour diverter les tristes pensemens."

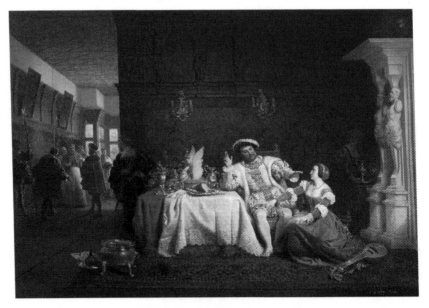

Figure 11.2. Emanuel Gottlieb Leutze, "Anne Boleyn Advising Henry VIII to Dismiss Cardinal Wolsey." Photograph courtesy of VAN HAM Fine Art Auctioneers / Saša Fuis.

command her to play" (Anthony, pp. 24–25). A similar command performance is shown in Marcus Stone's 1870 painting of "Henry VIII and Anne Boleyn Observed by Queen Catherine" in which the dominant figure of the King towers over a deferential lute-playing Anne as numerous courtiers look on and Catherine passes in a corridor (Christie's, p. 191). During Anthony's version of the exchange of letters when Anne had returned to Hever, the sight of his lute provokes Henry's thoughts of her. At the novel's end, Anne goes to her death knowing that Henry "would never be free of her; he would hear her voice in every song and her touch when the lute was played" (Anthony, pp. 45, 309).

Emanuel Gottlieb Leutze's 1858 painting "Anne Boleyn Advising Henry VIII to Dismiss Cardinal Wolsey" features the instrument among an arsenal of sensory delights to ensnare the King (Figure 11.2). Leutze positions Henry between Anne and a sumptuous banquet dominated by a pie with swan's wings and a crowned swan-head. Anne gazes imploringly up at Henry, her right hand caressing his thigh, her lute cast aside. He seems enraptured. In a corridor behind them, opposite Anne and her discarded lute, Wolsey is stopped by the King's guard. Having accomplished its task, there is presumably no more need for the instrument. Anne's lute has continued to signify her sexuality in scholarship as well as creative media. In a seminal 1971 article, musicologist Edward Lowinsky skips over the predominantly

devotional content of the manuscript music-book likely owned by Anne to present Claudin de Sermisy's secular *chanson* "Jouyssance vous donneray" as "the kind of song that Anne may have sung to the accompaniment of the lute for Henry's pleasure" (Lowinsky, p. 181; and GB-Lcm MS 1070, fol. 113v-114r). In his 2004 CD "Madame D'Amours," Philip Thorby, director of Musica Antiqua of London, likewise invites listeners "to imagine Anne singing [her 'old flame Thomas Wyatt's'] poem 'Blame Not My Lute' to her own accompaniment" (Thorby, 5).

The most extended and deliberately fictionalized depiction of Anne as lutenist, in Rosemary Anne Sisson's "Catherine of Aragon" episode for the 1970 BBC Television series *The Six Wives of Henry VIII*, also affirms her calculatedly seductive use of the instrument. Like Lowinsky and many novelists, Sisson inaccurately renders music a hobby Henry shared with Anne but not with Catherine.[5] Anne first appears in a sequence that starts with Henry singing alone to his lute in "a room in Greenwich [Palace]"; the scene shifts to the Queen's quarters from which we hear him as from a distance. The camera "[z]ooms up on the face of Anne Boleyn" who "listens to the song, smiling a little to herself." "The song he wrote for the queen," pronounces lady-in-waiting Iñes de Venegas. "Did he?" retorts this combative Anne, who subsequently "bursts into peal after peal of laughter" as other ladies "coming and going, pause, glancing at her and at each other." She smiles, "walks slowly away," and eventually "laughs again [...] insolently loud for the Queen's apartments, and takes a lute from a young man who has just come in, and sits down to amuse herself with it." Focus shifts from Catherine's ladies to Anne "playing an intricate little tune on the lute while the young man gazes at her adoringly" (Sisson, pp. 48–53). According to the rules of courtly conduct for the would-be lady musician in Castiglione's *Book of the Courtier*, first printed around the time shown in Sisson's drama:

> "When [a woman] cometh to [...] show any kind of musicke, she ought to be brought to it w[ith] suffering her selfe somewhat to be prayed, and with a certain bashfulness, that may declare the noble shamefastness that is contrarye to headiness" (Castiglione, sig. Cciv).

Sisson's is a headstrong Anne who thrusts herself into a man's world and takes what she wants. Furthermore, that "intricate little tune" violates Castiglione's dictum that women instrumentalists should eschew "those

5 On Catherine's music, see Austern 2008, p. 132; and Little, pp. 8–9 and 36–57.

hard and fast divisions" that demonstrate mastery of technique rather than sweetness (Castiglione, sig. Cc1).

What of Anne's "other instruments"? Much like his French contemporary Carles, George Cavendish, "gentleman usher to Cardinal Wolsey," states that Anne was trained to sing, dance, and play unspecified musical instruments (Strickland, p. 161). A 1538 memoir by Jean de Laval, Comte de Châteaubriant, recalls a young Anne who accompanied her own songs on the lute, "harped [...] and handled cleverly both flute and rebec" (Lowinsky, note 72; Strickland, pp. 158–159). Drew's purportedly "more truth than fiction" Anne of 1912 is praised by Henry for her fine technique on the harp when he finds her playing in Queen Catherine's chambers. The novel also shows Anne at the harpsichord (Drew, pp. 154–156). Musicologist Edith Boroff claimed in 1987 that Anne had owned such an instrument, perhaps following a tradition that one decorated with her heraldic badge but actually built in 1594 had been hers.[6] Season 2 of the 2007–2010 Showtime television series *The Tudors* presents an introspective Anne playing the Elizabethan tune "Fortune My Foe" on a harpsichord (Hirst, Episode 6). Biofictional Annes eschew both flute and rebec. Perhaps Strickland speaks for succeeding centuries as well as her own by claiming that "[o]ur modern taste could dispense with [Anne's] skill on the flute and fiddle" (Strickland, p. 159). *The Tudors,* however, shows Anne learning to play an anachronistic Baroque-style violin (Hirst, Episode 1).

Anne's early biographers list song first and foremost among her musical skills, and the extant musical object most likely to have come into her possession features vocal music (GB-Lcm MS 1070). Carles prioritizes song and dance ahead of the other courtly arts that made her seem like a well-born Frenchwoman (p. 5). Châteaubriant attributes to Anne a siren-like voice and the musical-poetic powers of a second Orpheus (Lowinsky, note 72). And eighteenth-century music-scholar Sir John Hawkins cites a French historian's opinion that Anne Boleyn "could sing and dance too well to be wise or staid" (Hawkins, p. 833). Hawkins also became the first commentator to suggest repertory she may have enjoyed. He recounts that Anne, "who had lived some years in France, doted on the compositions of Josquin [des Prez] and [Jean] Mouton," which she sang decorously with her "maiden companions" (Hawkins, p. 335). Although this turn-of-the-sixteenth-century French repertory dominates the music manuscript she may have owned, biofictional Annes and their more academic counterparts are rarely shown singing it, and never among their "maiden companions." If the lute becomes a

6 See Boroff, p. 14; Ives 2004, p. 257; Victoria and Albert Museum.

signifier of Anne's erotic desire and/or desirability across scholarly and more imaginative products, her voice – her physical singing voice and the creative one sometimes attributed to her – is linked in romanticized interpretations to remembrance, foreboding, true love, and death. In this we see not only historiographic understanding of the place of vocal song in Anne's social and cultural milieu, but also a nod to deep-seated, longstanding Western connections between song, breath, soul, and remembrance (Austern, 2020, pp. 199–205). In several twentieth-century novels, vocal duets between Anne and Henry signify the moment when Henry's lust turns to love and Anne is prepared to reciprocate. Irish novelist Francis Hackett typically presents a title character in his 1932 *Queen Anne Boleyn* who sings and plays the lute; Hackett's Henry is conventionally a composer-connoisseur who, in this case, also sings and plays clavichord (Hackett, pp. 23, 48–50, and 383–384). As "[t]he imminence of the[ir] marriage was at last upon them," it is Anne who takes her lute and asks Henry to sing with her. He chooses "his own little song," "Grene growth the hol[l]y," an extant composition by the historical Henry (Hackett, pp. 383–384; and GB-Lbl MS Add. 31922, fol. 37v–38r).

The broadcast version of Nick McCarty's teleplay "Anne Boleyn" from *The Six Wives of Henry VIII* begins with a montage of intimate moments shared between Anne and Henry from courtship through the birth of Elizabeth. It concludes with them singing "Grene growth the hol[l]y," lingering on the final cadence. For McCarty, this marks the end of any concord between them as Anne begins her journey to the inevitable (Glenister; McCarty, p. 111). Thorby balances his image of Anne singing provocatively to her lute with an evocation of her death "after three short years of marriage" (Thorby, 5). And where Lowinsky asks his reader to imagine Anne singing "Jouyssance vous donneray" to Henry, he introduces the next song in the same manuscript, "Venes regres, venes tous" as "one we could well picture Anne singing while in the Tower of London" (Lowinsky, pp. 181–182).

The image of Anne singing in the tower is a powerful one for which no evidence survives. It was set in motion no later than the eighteenth century when Hawkins, who greatly admired Anne as "a beautiful, modest, and well-bred young woman," presented two anonymous sixteenth-century songs as "either written by, or in the person of, Anne Boleyn." The authority behind this pronouncement is an unnamed "very judicious antiquary lately deceased" (Hawkins, pp. 30–32, 373). Although this attribution has been discredited, the opinion of that mysterious antiquary remains part of the musical romance of Anne Boleyn (Austern, 2008, p. 138). Strickland perceives evidence of "musical cultivation in [Anne as] the composer" of the better-known of these songs, "O Death Rock Me Asleep," and presents

a genesis for it that only enhances the legendary qualities of the tragic queen's biography:

> When [Anne] received the awful intimation that she must prepare for her own death she met the fiat like one who is weary of a troublous pilgrimage [...]. Such are the sentiments pathetically expressed in the following stanzas, which she is said to have composed after her condemnation, when her poetical talents were employed in singing her own dirge. (Strickland, p. 266)

Lofts's extended account of Anne's preparation for her end is positively operatic. Imprisoned in the Tower, bereft of hope, at last "Anne tuned her lute and fitted words to the sad tune:

> O death rock me asleep
> Bring on my quiet rest,
> Let pass my weary guiltless ghost
> Out of my careful breast.
> Ring out my doleful knell,
> Let its sound my death tell;
> For I must die,
> There is no remedy,
> For now I die ... (Lofts, p. 164, ellipsis in source)

This "sad tune" and especially its sensationalized genesis earned Anne a lasting reputation as one of the sixteenth century's few women composers. Boroff explains that

> "O Deathe, rock me asleep" for voice and keyboard or lute, represents a compendium of the certainties and also the probabilities of Anne's life as a musician. Although the authenticity of this work has not been established, it comes down to us as a piece written in the Tower of London as Anne faced execution. (Boroff, p. 14)

If Anne's ghost doesn't haunt the Tower as legend has long held, her (attributed) music does. A review of the 1966 concert to mark the reinstatement of the Tower Chapel as a Chapel Royal states that "[u]nforgettable, heralded by a passing-bell three times tolled, was the death-song attributed to Anne Boleyn sung most touchingly to Michael Jessett's lute accompaniment by a girl chorister beside the forlorn Queen's grave" (Poston). In 2015, the

similarly attributed piece was sung in the same location as part of a concert memorializing "some of the major figures buried in the Chapel," including Anne (Spitalfields Music).

This spurious work continues to dominate Anne's musical presence as what Strickland called "the enchantments of poetry and romance" still "cast such bewildering spells" on memories of the tragic queen, especially where the aesthetics of fiction enhance documentable fact. Weeks before the 2015 release of their CD "Anne Boleyn's Songbook: Music & Passion of a Tudor Queen," British vocal ensemble Alamire presented a concert that "included [...] a haunting setting of 'O death rock me asleep', the poem, thought by some, to have been written by Anne as she awaited her fate in the Tower of London" (Alamire). Yet, in keeping with nearly every aspect of Anne's life, the manuscript songbook on which the concert and CD are based remains subject to imagination and more than a little glamour cast by the cryptic, remarkably unobtrusive appearance of her name on an interior folio in the middle of a piece by French composer Loyset Compère (GB-Lcm MS 1070, f. 79). Historians and musicologists continue to debate every aspect of this early sixteenth-century document, including its significance, its actual connection to Anne, how and when it was created for whom, and especially what it may say about Anne's musical taste, training, participation, and abilities (i.e. Skinner; Urkevich; and Warnicke, pp. 248–249). Perhaps the next biofictional Anne will be shown singing some of its contents among her "maiden companions" as Queen or as a young lady-in-waiting in France. If the multi-century romance of Anne Boleyn, Musician, can be summed up, it's that from biography to biofiction Anne loans name-recognition and a malleable human presence to changing perceptions of early sixteenth-century educated women's engagement with music. And it permits even scholarly chroniclers to borrow literary techniques from the novel to keep Anne and her music freshly engaging.

Works Cited

Alamire. "Anne Boleyn's Songbook at Shakespeare's Globe (Two Concerts)." http://www.alamire.co.uk/events/2015/anne-boleyns-songbook-shakespeares-globe-two-concerts. Accessed 22 September 2015.

"Anne Boleyn" china figurine. https://www.flickr.com/photos/neomax/5542875160/in/pool-809917@N21/. Accessed 1 February 2020.

Anthony, Evelyn. Anne Boleyn. New York: Thomas Y. Crowell, 1957.

Austern, Linda Phyllis. "Women's Musical Voices in Sixteenth-Century England." Early Modern Women vol. 3, 2008, pp. 127–152.

Austern, Linda Phyllis. *Both from the Ears and Mind: Thinking About Music in Early Modern England*. Chicago: University of Chicago Press, 2020.

Bernard, G. W. *Anne Boleyn: Fatal Attractions*. New Haven and London: Yale University Press, 2010.

Bordo, Susan. *The Creation of Anne Boleyn*. Boston and New York: Houghton Mifflin Harcourt, 2013.

Boroff, Edith. "Anne Boleyn (1507–1536)." *Historical Anthology of Music by Women*, edited by James R. Briscoe. Bloomington: Indiana University Press, 1987, pp. 14–17.

Burden, Charli. "Alison Weir: Anne Boleyn as a Cult Figure." Filmed by Becca Attfield as part of an MA project, City University (London), published 2 July 2012. https://www.youtube.com/watch?v=cl2Ndooq_Ak. Accessed 28 March 2020.

Carles, Lancelot de. *Épistre contenant le procès criminal de la royne Anne Bouillant d'Angleterre*. 1536; Lyons: n.p., 1545.

Carlisle, Sharon Paxon, dollmaker. "Henry VIII and His Six Wives." http://www.angelfire.com/la2/mcasares/index14.html. Accessed 1 February 2020.

Castiglione, Baldassarre. *Il libro del cortegiano*. Venice: Romano & Asola, 1528; translated by Thomas Hoby as *The Courtyer*, London: Wyllyam Seres, 1561.

Christie's. *Victorian Pictures, Drawings and Watercolours*. London: Christie's, 1992.

Dixon-Paver, Debbie, *Debbie Cooper Dolls*. "King Henry VIII and his Six Wives." https://www.flickr.com/photos/91756407@N04/8418402806/in/photostream. *Accessed 1 February 2020.*

Drew, Reginald. *Anne Boleyn*. Boston: Sherman, French & Company, 1912.

Fallows, David. "Henry VIII as a Composer." *Sundry Sorts of Music Books*, edited by Chris Banks, Arthur Searle and Malcolm Turner. London: British Library, 1993, pp. 27–39.

GB-Lbl MS Add. 31922, "Henry VIII Songbook," c. 1518. British Library. https://www.bl.uk/collection-items/henry-vlll-songbook. Accessed 2 September 2020.

GB-Lcm MS 1070, "Anne Boleyn Music Book," c. 1505–1513. Royal College of Music. https://www.diamm.ac.uk/sources/2033/#/. Accessed 2 September 2020.

Glenister, John, et al. *The Six Wives of Henry VIII*. BBC 1970; Distributed by Warner Home Video, 2006.

Hackett, Frances. *Queen Anne Boleyn: A Novel*. N.P.: Doubleday, Doran & Company, Inc., 1939.

Hawkins, Sir John. *A General History of the Science and Practice of Music*. London: T Payne, 1776.

Hever Castle & Gardens. *News: New Waxwork Minstrel* (2015) https://www.hever-castle.co.uk/news/new-waxwork-minstrel/. Accessed 28 March 2020.

Hirst, Michael et al. *The Tudors: Complete Second Season*. Showtime Entertainment, Distributed by Paramount Home Entertainment, 2008.

Ives, E. W. "Anne [Anne Boleyn]," *Oxford Dictionary of National Biography*. Oxford University Press, 2004a. https://www.oxforddnb.com/. Accessed 11 April 2021.

Ives, E. W. *The Life and Death of Anne Boleyn*. Malden, MA; and Oxford, UK: Blackwell Publishing, 2004b.

Little, Brooke. "The Musical Education and Involvement of the Six Wives of Henry VIII." MM Thesis, University of Missouri – Kansas City, 2017.

Lofts, Norah. *Anne Boleyn*. New York: Coward, McCann & Geoghegan, 1979.

Lowinsky, Edward E. "A Music-Book for Anne Boleyn." *Florilegium Historiale*, edited by J. G. Rowe and W. H. Stockdale. University of Toronto Press 1971, pp. 161–235.

Lyndon-Jones, Maggie. "Henry VIII's 1542 and 1547 Inventories." *FOMRHI Quarterly*, vol. 92, July 1998, pp. 11–13.

Madame Tussauds London. *Illustrated Guide*. N.P., 1993.

McCarty, Nick. "Anne Boleyn." *The Six Wives of Henry VIII*, edited by J. C. Trewin. London: P. Elek, 1972, pp. 104–186.

Norton, Elizabeth, ed. *Anne Boleyn In Her Own Words & the Words of Those Who Knew Her*. Stroud, Gloucestershire: Amberley, 2011.

OED Online. Oxford University Press, 2020. https://www.oed.com/. Accessed 11 April 2021.

Poston, Elizabeth. "[London Music:] St Peter Ad Vincula, Chapel Royal." *The Musical Times*, vol. 107, no. 1485, November 1966, p. 977.

Sisson, Rosemary Anne. "Catherine of Aragon." *The Six Wives of Henry VIII*, edited by J. C. Trewin. London: P. Elek, 1972, pp. 1–103.

Skinner, David. "Context and Earlier Ownership." *The Anne Boleyn Music Book (Royal College of Music MS 1070)*. DIAMM Facsimiles, 2017, pp. 1–11.

Sotheby Parke Bernet & Co. *The Hever Castle Collection*, 2 vols. London: Sotheby Parke Bernet & Co, 1983; vol. 2.

Spitalfields Music. "Weary, Guiltless Ghosts: Summer Festival 2015." http://www. spitalfieldsmusic.org.uk/whats-on/summer-festival-2015/weary-guiltess-ghosts. Accessed 15 September 2015.

Strickland, Agnes. *Lives of the Queens of England*, 12 vols. Revised edition. London: Henry Colburn, 1840–1848; vol. 4 (1843).

Thorby, Philip. Liner notes to *"Madame d'Amours*: Songs, Dances & Consort music for the Six Wives of Henry VIII." Signum Records Ltd., 2004.

Urkevich, Lisa. "Anne Boleyn's French Motet Book, A Childhood Gift.*" Ars musica septentrionalis*, edited by Frédéric Billiet and Barbara Haggh. PUPS 2011, pp. 95–119.

Victoria and Albert Museum. "'Queen Elizabeth's Virginal,' Giovanni Baffo, 1594." http://www.vam.ac.uk/content/articles/q/queen-elizabeths-virginal/. Accessed 19 May 2020.

Warnicke, Retha. *The Rise and Fall of Anne Boleyn.* Cambridge: Cambridge University Press, 1989.

Weir, Alison. "Alison Weir: UK Author and Historian." http://alisonweir.org.uk/. Accessed 28 March 2020.

About the Author

Linda Phyllis Austern is Professor of Musicology at Northwestern University. Her most recent monograph is *Both from the Ears and Mind: Thinking About Music in Early Modern England*, and she is presently completing *Gendering Music in Early Modern England*.

Section III

Performing Gender

12. Reclaiming Her Time: Artemisia Gentileschi Speaks to the Twenty-First Century

Sheila T. Cavanagh

Abstract

This essay addresses three of the plays circa 2020 being presented about Italian painter Artemisia Gentileschi's life and works. Breach Theatre's *It's True, It's True, It's True* toured the United Kingdom and was presented electronically. The New York-based Anthropologists' production of *Artemisia's Intent* toured in the United States. The work's director, Melissa Moschitto, and its star, Mariah Freda, also hosted Zoom gatherings that presented segments from the performance, along with discussions and Artemisia-themed quiz competitions. The third play, Emily McClain's *Slaying Holofernes,* was a 2019 winner of Essential Theatre's New Play competition. Artemisia's striking artistic works, combined with the well-documented aspects of her painful personal history, translate into powerful theater.

Keywords: Artemisia Gentileschi, Italian painting, rape trial

Among the many losses littering the globe during the 2020 pandemic was the postponement of the National Gallery in London's highly anticipated exhibition "Artemisia," dedicated to the work of seventeenth-century Italian painter Artemisia Gentileschi. Billed as the "first major exhibition of Artemisia's work in the UK," the National Gallery promised to display her "best-known paintings" as well as "recently discovered personal letters." Potential visitors were invited to "Follow in Artemisia's footsteps from Rome

Fitzmaurice, J., N.J. Miller, S.J. Steen (eds.), *Authorizing Early Modern European Women. From Biography to Biofiction.* Amsterdam: Amsterdam University Press, 2022
DOI 10.5117/9789463727143_CH12

to Florence, Venice, Naples and London. Hear her voice from her letters, and see the world through her eyes" (National Gallery).[1]

Opening this exhibition on schedule eventually became impossible, much to the dismay of those eagerly awaiting the opportunity to come face to face with the works of this renowned though also under-recognized artist, whose paintings and life story have captivated many people.

The widespread COVID-19 closures thwarted many Artemisia-related events, but simultaneously enabled others, emphasizing the relevance of this artist's life and work to our present circumstances. There are many scholarly books and articles devoted to Artemisia,[2] novels, films, a graphic novel, and several plays.[3] This essay will address three of the current plays being presented about her life and works, two of which are being promoted electronically during this time of social distancing.[4] One, Breach Theatre's highly regarded production of *It's True, It's True, It's True*, was going to be livestreamed into the National Gallery in April 2020 as part of their "Artemisia" exhibition programming. Instead, with the support of London's Barbican Theatre, which had planned to host the play earlier that month, this drama was made freely available to the public through the Internet for an entire month. Some performances of the New York-based Anthropologists' production of *Artemisia's Intent* were also canceled, but the work's director, Melissa Moschitto, and its star, Mariah Freda, hosted Zoom gatherings that presented segments from the performance, along with discussions and Artemisia-themed quiz competitions. The third play included here, Emily McClain's *Slaying Holofernes,* a 2019 winner of Essential Theatre's new play competition, was staged several months before theaters everywhere were forced into hiatus.[5] This painter's striking artistic works, combined with the well-documented aspects of her painful personal history that resonate with modern preoccupations, translate into powerful theater. As Jesse Locker notes: "Artemisia's story is a gripping one. It is a story of nearly insurmountable odds: overcoming illiteracy, sexual violence, and being a woman in what was considered a man's profession, to

1 Although the exhibition was postponed, Letizia Treves's catalogue was available, and the BBC made available an audio program in conjunction with the planned exhibit, entitled "Artemisia Gentileschi: The Painter Who Took On the Men."

2 I am following Garrard's decision to refer to the artist as "Artemisia" (1989, p. 489n1).

3 See, for example, Banti, Jones, Merlet, and Siciliano.

4 Since there is another essay in this collection discussing Joy McCullough's work, I am not including her play here.

5 I am very grateful to Emily McClain and Melissa Moschitto for their willingness to meet with me in person and to share materials with me.

become a successful artist" (p. 1). Dramatizing her story, therefore, speaks to contemporary concerns while drawing renewed attention to the works of a talented artist.

It's True, It's True, It's True and *Artemisia's Intent* are both devised pieces developed by established companies, while the solo-authored *Slaying Holofernes* was chosen for workshopping in 2019 as part of the Ethel Woolson Lab program, in conjunction with Working Title Playwrights (see Ethel Woolson) before being produced at the Essential Theatre Festival. As theatrical productions, not scholarly works, each play disregards the cautionary tenets proposed, but then nuanced, by art historian and Artemisia expert Mary Garrard: "[I] know well the scholar scolding that has followed every writer's attempt to connect Artemisia's dramatic pictures with her colourful life; we are constantly cautioning one another about the danger of the biographical fallacy. Yet Artemisia plays games with her own history" (2020, p. 123, Kindle location 1471). Scholars understandably warn against tracing too many correlations between Artemisia's personal experiences and her artwork, even though Garrard and others simultaneously emphasize the painter's own incorporation of her life into her art. Garrard further notes that there are both challenges and benefits to such practices: "The relationship of this violent image to the artist's experience of rape has been much discussed. Psychological interpretations of the Uffizi *Judith* may have exaggerated its importance, but critics of those interpretations have unduly minimized it" (2020, p. 139, Kindle location 1660).

Despite understandable scholarly concerns, playwrights engaging with Artemisia regularly place connections between biography and artistic creation at the heart of their dramas. Each of these current pieces focuses significantly on the court proceedings against Artemisia's accused rapist, Agostino Tassi, and draws repeated parallels between the recorded details of this traumatic event and the subjects and details of Artemisia's art, which often presents famous stories involving women and violence. Warning about the limitations of such maneuvers makes sense from a scholarly perspective. But theatrically, the existence of transcripts from the rape trial, the ever-expanding *oeuvre* of powerful paintings attributed to Artemisia, and the strong parallels between this artist's life experience and the #MeToo movement, which continues to grow in prominence internationally, offer enticing material for dramatic presentation. Breach Theatre describes how the extensive, though incomplete, historical materials and events informed their process of devising: "We took those existing interferences and the – in some cases – literal holes in this document as a theatrical invitation [...] an invitation that is, to re-order and re-word testimonies,

to discard and fabricate episodes, to devise flashback sequences and even dramatise Gentileschi's paintings as their own form of "evidence" ("Notes," n.p.). *Artemisia's Intent* draws from many of the same historical sources, then incorporates lines from prominent modern legal proceedings, including testimony about Bill Cosby and Harvey Weinstein (p. 2). Breach introduces twenty-first-century parallels aesthetically rather than linguistically, by using music and costuming from different eras to signal correspondences between Artemisia's life and current events. They describe this strategy in the "Staging" section of their published drama: "Our costumes clash together the historical and the contemporary, with sharp jackets and outsized cuffs and collars, contrasting with velvet cloaks, fake beards, and ornate dresses. Music – baroque, punk and contemporary – was integral to creating our show" ("Staging," n.p.).

Slaying Holofernes takes a different route in order to link current events with Artemisia's history. It includes graphic accounts of her assault and physical torture at the trial, but unlike the other plays, McClain also constructs a concurrent modern fictional narrative focused on sexual behavior and consent in the workplace. In addition, she suggests that Artemisia and Agostino engaged in both romantic banter and professional rivalry prior to the assault. These scenes do not resonate as powerfully, however, as the other writers' excerpts from historical transcripts and borrowings from accounts of contemporary sexual aggression and assault. Given how much attention such situations are receiving today, *Artemisia's Intent* and *It's True, It's True, It's True* can allude to the twenty-first century without drawing attention away from the artist. *Artemisia's Intent*, accordingly, includes material from the Brock Turner trial, presenting *"Artemisia sitting at a kind of shrine/table, sipping from a wine cup. Heavy techno or club music plays. The text is given very casually, conversationally:* 'What did you eat that day? Well what did you have for dinner? Who made dinner? Did you drink with dinner? No, not even water? When did you drink? How much did you drink?'" (p. 30). Like Emily Doe in this modern case, Artemisia had her own actions scrutinized during Tassi's court proceeding.[6]

The three plays share many narrative and some theatrical elements, but vary in their presentational styles. *Artemisia's Intent*, for instance, includes only one performer on stage, who primarily represents the artist as she tells the story of her life, then briefly transforms into a modern curator at the end of the piece. The script quotes from the historic trial transcripts and

6 "Emily Doe" was the pseudonym given Brock Turner's victim during his trial. See Concepción de León.

incorporates considerable detail about Artemisia's paintings and other relevant persons and events, as the comments accompanying the text note:

> In this play, Artemisia Gentileschi is a conduit for other voices, at times from her own past (Agostino Tassi), from history (Roberto Longhi) or most importantly, contemporary women (Andrea Constand, Taylor Swift, etc.). However, she always appears as Artemisia. There may be some adjustments in voice/accent but not in costume (p. 2).

The Anthropologists' Artemisia clearly and emphatically details, for instance, the ways that her works, while presenting familiar stories, differ from those created by her male counterparts:

> You think my father could have painted this Susanna?
> His Susanna looks [...] incidental. She may as well have been a garden statue with those hovering globes. She barely even protests as the old men claw her bare skin—
> No, my Susanna is not pleasingly dimpled. Look at the pendulum of the breast. The crease in the elbow, the extra fold at the abdomen, the swell of fat under the arm. The barely noticeable ring of hair around the nipple. I made her *real*. I made her *true*.
> (p. 10)

She also presents a powerful first-person account of the circumstances leading to her sexual assault and the trauma resulting from this event and its aftermath. The play limits references to other aspects of Artemisia's life, although some of Artemisia's comments and the brief interlude with the curator point toward the lengthy period where the artist's works were misidentified or underacknowledged. Both the production and its related Zoom events include substantial direct audience address, inviting its viewers to draw significant parallels between the artist's life and her creations.

> *[The actor] is both Artemisia creating a painting and Judith, the subject of the painting:*
> On my feet: strong boots. A small detail but quite *importante* if you consider the convention of the time: the flimsy sandals of a maiden.
> (pp. 4-5)

The remarks here correspond with Garrard's comments about the same aspect of this painting: "The expressive consequence of Artemisia's decision

to expose Judith's booted foot is our recognition of the garments as a disguise" (1989, p. 331). Garrard also argues that Artemisia's perspective on this story varies from that of her male contemporaries: "The depiction of Judith as a heroic defender was unusual in early seventeenth-century Florence, where the theme had largely been returned to its religious context" (2020, p. 139, Kindle location 1643). Predictably, each of these theatrical pieces regularly provides such evidence of drawing from Garrard's extensive work on Artemisia.

It's True, It's True, It's True includes three main performers, who rotate roles effectively throughout the drama. Like *Artemisia's Intent*, this production draws many parallels between the artist's personal experiences and her artistic creations, but it draws additional voices from the historical record, including some of the derogatory testimony offered in court against the artist. This performance also intensifies correlations between Artemisia and the subjects of her paintings by having Artemisia/Susanna (Ellice Stevens) disrobe and display her naked breasts to the audience, representing the scene depicted in Susanna and the Elders (p. 11). Breach Theatre presents a compelling representation of Artemisia's life and work, including chilling renditions of the assault and the trial, where many of those involved endeavored to destroy the young woman's credibility and reputation.

Slaying Holofernes takes some historical liberties by suppressing Artemisia's sexual encounters with Tassi after the rape and by having the artist claim she called for help during the assault, despite the trial testimony which indicates that Tassi impeded her ability to scream.[7] As noted, the play also interweaves a modern narrative with its account of Artemisia's career and her treatment during the trial. The twenty-first-century story takes up a substantial portion of the script, but it lacks the striking detail provided by Artemisia's artistry and by the historical documents related to the trial. #MeToo is so well-known now that the Anthropologists' decision to allude briefly to modern cases in *Artemisia's Intent*, and Breach Theatre's skillful mixture of modern and historic music and costuming, keep twenty-first-century parallels to the story at the forefront of these dramas. Artemisia's biography and artistic accomplishments provide ample dramatic fodder without extraneous additional fictionalization.

Modern concerns play a significant part in the increasing interest surrounding this important painter and her story. It is, therefore, not surprising that so many different theatrical artists, novelists, filmmakers,

7 Garrard (1989) includes translations of the trial transcripts. This portion about Artemisia being silenced appears on p. 416.

and graphic designers have been attracted to Artemisia. It also makes sense that the postponed exhibition at the National Gallery garnered so much attention. Artemisia Gentileschi's artistic creations warrant their acclaim and would be worthy of wider dissemination regardless of this woman's life story. The existence of many transcript pages from Agostino Tassi's rape trial and other historical documents, in addition to the regular "discovery" or reattribution of many of Artemisia's creations makes her biography a rich source for fictional recontextualization. The plays included here, as well as the 2019 Seattle production of Joy McCullough's *Blood Water Paint*, make it clear that playwrights and audiences alike find Artemisia's history and creative output intriguing and compelling. Each of these dramas tells this story with an intensity infused through historical re-creation.

Works Cited

The Anthropologists. *Artemisia's Intent.* Unpublished PDF and private Vimeo recording. 2018. https://www.theanthropologists.org/artemisiasintentpress. Accessed 15 April 2020.

Banti, Anna. *Artemisia*. Lincoln: University of Nebraska Press, 1995.

BBC. *Artemisia Gentileschi: The Painter Who Took On the Men,* 2020. https://www.bbc.co.uk/programmes/w3csyp69. Accessed 30 April 2020.

Breach Theatre. *It's True, It's True, It's True.* London: Oberon Books, 2018. https://www.barbican.org.uk/read-watch-listen/watch-its-true-its-true-its-true-by-breach. Accessed 24 April 2020.

de León, Concepción. "You Know Emily Doe's Story. Now Learn Her Name." *New York Times*, 9 September 2019. https://www.nytimes.com/2019/09/04/books/chanel-miller-brock-turner-assault-stanford.html. Accessed 30 July 2020.

Ethel Woolson Lab program, in conjunction with Working Title Playwrights https://workingtitleplaywrights.com/programs/ethel-woolson-lab/. Accessed 30 August 2020.

Garrard, Mary D. *Artemisia Gentileschi.* Princeton: Princeton University Press, 1989.

Garrard, Mary D. *Artemisia Gentileschi and Feminism in Early Modern Europe.* London: Reaktion Books, 2020.

Jones, Jonathan. *Artemisia Gentileschi.* London: Laurence King Publishing, 2020.

Locker, Jesse M. *Artemisia Gentileschi: The Language of Painting.* New Haven: Yale University Press, 2015.

McCullough, Joy. *Blood, Water, Paint.* Macha Theatre Works, Seattle, 2019. https://www.machatheatreworks.com/currentshow. Accessed 20 April 2020].

McClain, Emily. *Slaying Holofernes.* Unpublished PDF, 2019. https://www.essen-tialtheatre.com/past-productions/. Accessed 31 August 2020.

Merlet, Agnes. *Artemisia.* Bluebell Films, 2004.

National Gallery, London. *Artemisia* exhibit. 2020 (postponed). https://www.nationalgallery.org.uk/exhibitions/artemisia. Accessed 21 April 2020.

Siciliano, Gina. *I Know What I Am: The Life and Times of Artemisia Gentileschi.* Seattle: Fantagraphic Books, 2019.

Treves, Letizia, with contributions from Sheila Barker, Patrizia Cavazzini, Elizabeth Cropper, Francesca Whitlum-Cooper, Francesco Solinas, and Larry Keith. *Artemisia* exhibition catalogue. London: National Gallery, 2020.

About the Author

Sheila T. Cavanagh, Director of the World Shakespeare Project, is Professor of English at Emory University. Author of *Wanton Eyes and Chaste Desires: Female Sexuality in the Faerie Queene* and *Cherished Torment: The Emotional Geography of Lady Mary Wroth's Urania*, she has published widely on pedagogy and Renaissance literature.

13. Beyond the Record: *Emilia* and Feminist Historical Recovery

Hailey Bachrach

Abstract

Shakespeare's Globe's 2018 world premier play *Emilia* aimed to restore the spotlight to Aemilia Lanyer, a poet who has been proposed as the true "Dark Lady" of Shakespeare's sonnets. In so doing, playwright Morgan Lloyd Malcolm proposed that only fiction, not history, can free women of the past from the dismissal and neglect perpetuated by patriarchal historians. This chapter explores the nature and methods of this rejection of the possibility of feminist historical scholarship, tracing Lloyd Malcolm's historical and cultural influences and the nature of audience response to the production to demonstrate the radical possibilities both permitted and foreclosed by Lloyd Malcolm's approach.

Keywords: feminism, historical fiction, Aemilia Lanyer, Shakespeare's Globe, Morgan Lloyd Malcolm, performance

Just over 50 pages of the printed text of the play *Emilia* is a reprinting of poems from the titular Aemilia Lanyer's work *Salve Deus Rex Judaeorum*, which was itself first printed in 1611 and is one of the first collections of published poetry by an Englishwoman (Woods, p. xv).[1] The play text was initially released in conjunction with *Emilia*'s 2018 premier at Shakespeare's Globe, with a new version printed to accompany the production's 2019 West End run; both include Lanyer's poetry after the text of the play itself.[2] In the 2018 edition, the poems are presented without annotation or any

1 The accepted scholarly spelling of Lanyer's name is Aemilia; references to the play and its central character will observe the chosen spelling of Emilia.
2 For a modern scholarly edition of the poems, see *The Poems of Aemilia Lanyer* edited by Woods.

Fitzmaurice, J., N.J. Miller, S.J. Steen (eds.), *Authorizing Early Modern European Women. From Biography to Biofiction*. Amsterdam: Amsterdam University Press, 2022
DOI 10.5117/9789463727143_CH13

commentary save an introduction from playwright Morgan Lloyd Malcolm, in which she explains the decision to include the poetry in this format: she and her collaborators read the oft-quoted excerpts about Lanyer from Simon Forman's diaries, in which he writes that "she is or will be a harlot" and that "[s]he was a whore and dealt evil with him after" (Lloyd Malcolm, p. 105). Lloyd Malcolm explains that she and her collaborators "were pretty angry that his words have come to be so important in the retelling of her story for so many [...] the more recent publication of [Lanyer's poetry] by A. L. Rowse unfortunately includes a lot of what Simon Forman said about her in the introduction. I wanted to re-publish her poems with the play to hopefully give them exposure through a different lens" (p. 105). While Lloyd Malcolm acknowledges that Forman's diary is "a valuable document and if it didn't exist perhaps we would not know anything at all about Emilia," she also finds it "unfortunate" that a scholarly edition of the poems includes reference to the only contemporary description of Lanyer herself (pp. 104–105). This tension encapsulates what I argue is the driving desire of *Emilia*: unmediated access to the past; specifically, a lost feminist heritage that patriarchal history has disrupted. In seeking to both embrace the inspirational power of an apparently true story and reject the "bio" in favor of the "fiction" of biofiction, *Emilia* activates the fundamental tensions of a form that is both defined by and often operating in defiance of the traditional historical record.

Lloyd Malcolm reiterates repeatedly in her paratexts that her play is not history or even biography. In her preface to the poems, she is careful to deline-ate that she is not speaking as or for the historical Aemilia Lanyer, but rather that "[o]ur version of Emilia knew that if she was going to be remembered she needed to publish her poems" (Lloyd Malcolm, p. 105; emphasis mine). However, this insistence that her Emilia is not the historical Aemilia Lanyer, and is not trying to be, sits in fascinating contrast with the production's statements – partly given voice by Lloyd Malcolm, but also by marketing apparatus presumably outside of her control – that the play's aim is to revive Aemilia Lanyer's legacy, to grant access to the feminist heritage described above. The text, for example, on the back of the play reads, "Her Story has been erased by History [...] this world premier will reveal the life of Emilia: poet, mother and feminist. This time, the focus will be on this exceptional woman who managed to outlive all the men the history books tethered her to." The "unfortunate" historical record can be swept aside. Imagination becomes a tool to reveal, as the cover states, that which traditional history has effaced. This is just one example of a consistently antagonistic position not only towards the idea of historical accuracy, but to the historical and

literary scholarship that underpins it. Through this antagonistic relationship, Lloyd Malcolm's play proposes that anachronism is the only means for feminist engagement with historical subjects. Lloyd Malcolm thus uses art to engage in what I will call an act of feminist historical recovery: using imaginative and anachronistic gestures to recover women's history that has been occluded by patriarchal historical and literary scholarship. As this chapter shall explore, however, this rejection of patriarchal historiography is not as straightforwardly triumphant as it may first appear.

Lloyd Malcolm's skeptical engagement with conventional historical narratives is made clear in the play's opening moments, when Emilia3 (the eldest of the three characters who embody Emilia at different ages, one acting out scenes while the other two narrate and comment) opens by reading from what the stage directions indicate should be a copy of A. L. Rowse's *Sex and Society in Shakespeare's Age: Simon Forman the Astrologer*. The text Emilia3 reads is identified in dialogue as an extract from Forman, but the stage directions make explicit that it is also a quotation from Rowse (p. 1). Lloyd Malcolm's deliberate inclusion of Rowse, not just Forman, as source points to the play's dual position as a retort to the sexist early modern society that obscured Lanyer's accomplishments and to what the play frames as the inescapably sexist historical work that is based on the documents of that society. It is also an early and explicit anachronistic gesture, one emphasized in the original Globe production by the subsequent appearance of Emilia's Muses, an ensemble dressed all in white, twenty-first century clothing.

Subtler and more consistent, however, is deliberate anachronism in structure and style, usually intended to draw a direct line between the gender and racial discrimination that Emilia faces and the sexism and racism of the present. Emilia's first encounter with the other young women of the court exemplifies this tendency:

LADY KATHERINE. Speaking of breeding – what's yours?
EMILIA1. Pardon?
LADY KATHERINE. Where are you from?
EMILIA1. London.
LADY KATHERINE. No. Where. Are. You. From?
EMILIA1. I. Am. From. London.
LADY KATHERINE. But you don't look like us.
EMILIA1. Is this your first time in London? [...] My family hark from over the sea [...]
LADY KATHERINE. I knew it! My father said that we were being inundated by families like yours. Fleeing wars, men migrating for work. Craftsmen

are furious. Coming over here to take their work. That's what they're saying. That's who you are. Too many. Too many of you coming over. It's a real problem, that's what my father said. (pp. 11–12)

The invocation of both a familiar racial microaggression in Lady Katherine's stubborn disbelief that Emilia is really English and the language of Brexit-inflected anti-immigrant sentiment situate Emilia as the subject of recurrent prejudices. The sixteenth century saw serious and sometimes violent xenophobic prejudice, as Shakespeare's contributions to *Sir Thomas More* famously dramatize. However, the conflation of early modern xenophobia with the racist terms of contemporary debates about immigration and refugees creates an anachronistic temporal overlap between the two eras, rendering Emilia's race, her father's nationality, and English xenophobia transhistorical – and thus, topics that can be fully understood without mediation by a historian, recovering access to a supposed shared feminist and anti-racist past that conventional historical narratives occlude.

Lanyer's published poetry, what Lloyd Malcolm describes as the period's only pathway to "make a mark and be remembered," naturally becomes an important site for this struggle for unmediated access to the past and the desire to insist upon the timeless universality of female experience and ambition (Lloyd Malcolm, p. 105). As Lloyd Malcolm notes in her preface to Lanyer's poetry, she was introduced to Lanyer partly as "a woman forgotten by history who was one of the best cases for being the 'Dark Lady of The Sonnets' and therefore potentially Shakespeare's lover" as well as being "a woman who was a talented writer herself" (Lloyd Malcolm, p. 104). Scholars of both Shakespeare and Lanyer reject this reading, originated by Rowse (Woods, p. 74). Lloyd Malcolm does not, and Emilia's dual identity as muse and artist, and the tension between the two, becomes a driving subplot of the middle portion of the play. Once again, Lloyd Malcolm tackles historical and contemporary precedents simultaneously in her treatment of Emilia's literary ambitions, most conspicuously seeming to reference the 1998 film *Shakespeare in Love* as a model for the relationship between William Shakespeare and his female muse, a young woman who longs to be an actor but instead accepts a conventional life as a wife, bidding Shakespeare as she departs from his life and the story to "Write me well." She, the film's final moments reveal, will become the namesake and inspiration for *Twelfth Night*'s Viola, allowing her to achieve the artistic immortality she craved not through her own craft, but through Shakespeare's – the writer who will, it is suggested, now achieve greatness thanks to the experience of loving her.

Emilia seems to directly subvert this strategy. Rather than offering literary immortality as a substitute for personal achievement, Lloyd Malcolm's play instead draws the logical historiographical conclusion from this Shakespeare origin story: if writing is the way to enter history, to invisibly contribute to Shakespeare's plays must be read not as empowering, but rather as the ultimate form of historical exclusion. The Hollywood film version of *Emilia* would surely end with Shakespeare writing Emilia into his work after they part ways, but Lloyd Malcolm refuses to frame Emilia's potential absorption into Shakespeare's legacy as either a positive, or as the end of her story. Midway through the play, Lloyd Malcolm's Emilia goes to the theater having recently ended her relationship with Shakespeare after the death in infancy of their illegitimate child. When she arrives at the playhouse, she finds a performance of *Othello,* and is horrified to find her words in the mouth of the fictional Emilia, who, though *Emilia*'s cast is designated as all female, is established as a boy playing a woman: "He wishes me silent. To watch his display. But these [words] are mine, why can't I keep them?" In defiance of the docile exit of the other Will's lover, she leaps onto the stage and recites her words along with the fictional Emilia, chasing the boy player from the stage until she herself is dragged away (pp. 58–59). What would be the ending of *Shakespeare in Love* is only the end of Lloyd Malcolm's first act. The second act is dedicated to Emilia's discovery of her own voice as a writer, first by circulating manuscript poetry amongst the wives of aristocrats, then by publishing and distributing her own work thanks to a network of both upper- and lower-class women.

But what the play frames as a feminist reclamation of patriarchal literary history becomes more troubling when considered in light of Aemilia Lanyer's own writing, which the play barely depicts. The most prominent quotation from her actual work comes from her prefatory "To The Virtuous Reader," which also appears on the back of the playtext: "[M]en, who forgetting they were borne of women, nourished of women, and that if it were not by the means of women, they would be quite extinguished out of the world: and a finall ende of them all, doe like Vipers deface the wombes wherein they were bred." The appeal of this apparently uncomplicated feminist statement to a contemporary writer and audience is clear. The play also quotes ten lines from the 52-line "A Description of Cooke-ham" (p. 93) and seven lines from the 91-line "To All Virtuous Ladies in General" (p. 95), though many of these are isolated snippets rather than extended and contextualized quotations. In an early scene, the child Emilia1 also recites eight lines from "Salve Deus Rex Judaeorum" (p. 5), the only quotation of the poem from which her collection of verse takes its title. This title is never spoken – indeed, it is

actively erased from the early moments of the play, when Emilia3 recites
Lanyer's message "To the doubtful Reader" in defense of the poem's somewhat
blasphemous title, replacing Lanyer's with Lloyd Malcolm's own: "If you
desire to be resolved, why I give this title, 'Emilia', know for certain that it
was delivered to me in sleep many years before I had any intent to write in
this manner and was quite out of my memory, until I had written this script"
(pp. 1–2). However, as the existence of this defense itself suggests, Lanyer's
title is an essential part of the radicalism of her poetic project. Moreover,
erasing Lanyer's most significant artistic achievement and claim to a place
in literary history from a play that is dedicated to celebrating her legacy tilts
the scales heavily away from biography and towards fiction, transforming
the play's central character from the Aemilia Lanyer who wrote "Salve Deus
Rex Judaeorum" into Emilia, a symbolic figure of Lloyd Malcolm's creation.

"Salve Deus Rex Judaeorum" itself is a retelling of biblical narratives,
primarily the crucifixion of Jesus. In it, as Susanne Woods writes, Lanyer
"rehearses some of the varied religious discourse of the period, at the same
time challenging the authorities by which it was traditionally dispensed: men
in power" (p. 127). Thus, her narrative centers and insists upon the importance
of women, including a defense of Eve and a depiction of Pilate's wife attempt-
ing to dissuade her husband from condemning Jesus to death. The form of
redemption that Lanyer depicts is one that resonates remarkably well with the
Shakespearean historical narratives discussed in this essay. As John Rodgers
writes, in the aftermath of Lanyer's depiction of the crucifixion, "[t]he entire
category of verbal action – in fact, a category that the poem had labored to
derogate as both Hebraic and feminine – is redeemed, implicitly redeeming
the verbal agency of this woman of Jewish descent [...] Emilia Lanyer" (p. 441).
This startlingly contemporary-sounding revisionist narrative was nominally
participating in a lengthy tradition of devotional poetry that Lanyer seeks to
invoke at various points in the poem, as discussed below. However, Lanyer's
decision to publish, combined with the audacity of her subject, affirms to a
certain extent Lloyd Malcolm's sense of Lanyer's singularity. Rodgers describes
the title of the work itself – quoting the sarcastic salutation of a Roman soldier
to Jesus – as "astonishing," a symbol of Lanyer's "[s]hedding any affiliation with
the resigned femininity of her text's Christ and appropriating the activity of
poetic work" (Rodgers, pp. 445–446). From the poem's title onwards, Lanyer's
feminism is inseparable from her choice of religious subject, meaning the
precise nature of her radicalism is obscure without sufficient understanding
of her cultural and especially her religious context.

Lloyd Malcolm's location of an explicitly feminist impulse in Lanyer's work
is not itself anachronistic, as Janel Mueller describes: "Lanyer proves every

bit our contemporary in her resolve to locate and articulate transformative possibilities in gender relations that will bear their own urgent imperatives for enactment. For this purpose, which is to say, oddly from a contemporary point of view, she looks to the figure of Christ in history [...] as she reads the record of Scripture with wholly unconventional eyes" (p. 101). Suzanne Trill highlights the fact that while "most modern forms of Western Christianity are currently subject to a right-wing agenda [...] [i]n Lanyer's case, faith does not preclude feminism; rather, her feminism is facilitated by her faith" (p. 76). Both Trill and Mueller allude to a perceived disjunction between contemporary feminism and religious faith, one that is mirrored in Lloyd Malcolm's distinct avoidance of religion despite the fact that this makes any serious discussion or depiction of Lanyer's actual work impossible. But Lloyd Malcolm seems to see the unity of faith and feminism as equally impossible.[3] While much of her introduction maintains a careful separation between her Emilia and the historical Lanyer, the distinction collapses on the topic of religious poetry: "[S]he knew that to be published as a woman she needed to get past the censor and write religious poetry and within it she hid messages for her fellow woman" (Lloyd Malcolm, p. 106). Lloyd Malcolm's preface frames it as self-evident that the poetry's religious content was imposed by outside forces, and that Lanyer's feminist messages are concealed within the religion, rather than dependent upon it. The decision is depicted in the play in comic terms: "What can women write? What will get past the censor?" a friend asks. The answer: "Religious texts" (p. 91). The line, delivered with flat sarcasm in the Globe production, was received with laughter by the audience the performance I saw. This faintly derisive framing of the content of the poetry justifies its exclusion from the play. Said exclusion combines with the play's copious quotations from Shakespeare to suggest that Lanyer would surely have written like Shakespeare if she could have. Ironically, this reifies Shakespeare, the iconic literary man, as the arbiter of what makes for writing worthy of notice, and reinforces his white, male perspective as fundamentally universal. The failure to give Lanyer's actual writing the same time and space as Shakespeare's means that her greatest creative contribution even within the world of the play is not her own poetry, but her supposed ghostwriting of Shakespeare's. Failure to engage with Lanyer's poetry prevents the play from recognizing that

3 This also forcefully erases Lanyer's potential Jewish identity – one that, as Rodgers's reading suggests, may have been of equal importance to her Biblical revisions as her gender. Instead, the play consigns her possible Judaism to the realm of post-mortem conjecture, pointedly refusing to admit it as one of the marginalized identities the play seeks to reclaim.

both Lloyd Malcolm's play and Lanyer's poem share an interest in restoring admirable women to the historical record, and to recover their reputations from the distortions of patriarchal history – in Lanyer's case, specifically biblical history. But this requires complicated and nuanced engagement with Lanyer's religion and culture. Shakespeare's greatness requires no literary or historical context; understanding how Emilia's poetry is simultaneously religious and radical does. Such a cultural shortcut perhaps makes the play's aims more accessible, but at cost of undermining its biofictional premise: there is no way to honor Aemilia Lanyer's legacy if her art is deemed too complicated to celebrate.

Marketing for the original Globe run drew frequently on images of Charity Wakefield as Shakespeare, emphasizing his importance as a symbolic as well as literal antagonist for Emilia's artistic aspirations. A scene between Shakespeare and Emilia3 concludes the play, in which he enters to complain that "[t]his is my gaff" (p. 98), a line that traversed past and present when spoken on the stage of the reconstructed Globe. "Not today it isn't," Emilia replies, and in defiance of the ending of the first act, she then takes the stage to deliver a rousing final speech, urging the women of the audience to "burn the whole fucking house down" (p. 100). Her reclamation and destruction of Shakespeare's work, reputation, and famous stage itself form the play's climax of triumphant fury. However, this fury is underpinned narratively by further creative anachronism that erases rather than recovers a feminist early modern literary history. A key case in point is the play's treatment of Mary Sidney, to whom the real Lanyer dedicated one of her more extravagant dedicatory verses (Chedzgoy, p. 8). Lloyd Malcolm's Sidney appears only once, and is simultaneously artistically encouraging and threateningly sexual, the latter trait disrupting her potential presence as a mentor for Emilia and instead pushing Emilia to the patronage of Lady Margaret Clifford. As Kate Chedzoy writes, in Lanyer's poetry, Mary Sidney is a key link in the chain of female literary heritage that Lanyer strives to create in her dedicatory verses (p. 10). Lloyd Malcolm instead isolates Emilia from her poetic forebears, complexly figuring Sidney as both inspiration – "I desire my poems will be published," she says. "And I will see that they are. You, Emilia Bassano, will one day do the same" (p. 22) – and threat: Lady Margaret warns Emilia to "beware the ones who appear as ally but play to the same tune as the enemy" (p. 23). Her warning comes on the heels of a series of insinuations about Sidney's sexual aims: "I had hoped to speak to [Emilia] about a position but I see you were already attempting to get her into one ahead of me," Lady Margaret says, and accuses Sidney of "prey[ing] on a young lady's naivete" and "consider[ing Emilia] a mere object of desire" (pp. 22–23).

The implication seems to be that Sidney, like Shakespeare (whom Emilia first encounters in Sidney's company) views Emilia only as sexual object and potential muse. It is difficult to discern any other meaning behind Lady Margaret's warning about "the ones who appear as ally," a statement that Lloyd Malcolm underlines with the help of the narrating Emilias: "Stop. This. This here. Listen. [...] That. *She smiles at the memory*" (p. 23). In proposing and then rejecting Sidney as a mentor, Lloyd Malcolm seems to explicitly reject the notion that Emilia is indebted to any previous artistic tradition. Sidney is the "enemy," despite her words of encouragement. The idea of the possibility of publication – the goal that Emilia carries for the remainder of the play – is never acknowledged as originating in Sidney's advice.

Lanyer's poetry, as Susanne Woods writes, "is dedicated and addressed only to women, assumes a community of intellectual women, and makes no serious apology for a woman poet publishing her own work" (Lanyer, p. xxxi), a female literary heritage that implicitly legitimizes Lanyer's own artistic efforts (Chedgzoy, pp. 8–11). Lloyd Malcolm disrupts this assumed community in favor of constructing a community of women who will support Emilia's creative endeavors but never seriously attempt their own. This framing of Emilia's work suggests a distinctly modern insistence on individual artistic brilliance over collaboration or collectivity, and a demand for exceptionalism that particularly characterizes contemporary depictions of historical female characters. We see this tendency in the previously discussed Shakespearean biopics, where Shakespeare's muse Viola likewise displays her feminist credentials not only by being more talented and open-minded than any other women she encounters, but also in her uniquely clear-eyed awareness of the absurdity and injustice of society's demands to be married, silent, and obedient. Such characters' extraordinary status renders them incapable of integration into the broader stream of history, one that in actuality featured networks and communities of women who staged the forms of resistance that these works frame as impossibly unique: women who took a keen interest in the arts, published or privately disseminated their own writing, and worked in the playhouses.[4] It is a tendency inextricably tied to Aemilia Lanyer's re-entry into the established literary canon, which was initiated in large part by Rowse's identification of her as Shakespeare's "Dark Lady." As Lloyd Malcolm's introduction to her under those terms demonstrates, she has not escaped this association despite the scholarly consensus that the identification is incorrect. The appeal of justifying Emilia's importance because of her unique and mysterious connection to Shakespeare mirrors the demand that a popular historical heroine be extraordinary and

4 See Korda, p. 1.

highly individual, resulting in creative anachronism that elevates the heroine at the expense of the women who would surround her in her full historical context. Lloyd Malcolm's Sidney exemplifies this contradiction, as a woman that the real Lanyer sought as a patron in terms that emphasized their shared positions in a single literary culture is instead transformed into a predator, explicitly identified as an "enemy."

Lloyd Malcolm imagines a different, largely fictional literary community for Emilia, one that more readily reflects present day desires for intersectional feminist class relations through Emilia's engagement with and employment of a group of lower-class "Bankside women." The Bankside women help Emilia publish and distribute her poetry in manuscript and printed form, until one of the women is arrested for distributing pamphlets: "They found her with some, and said it was the devil's work [...] Her trial was yesterday, they burn her tonight [...] They're burning her for what we did" (p. 97). This incident brings the play to an abrupt end, as Emilia3 laments, "What I did. This is what happens when we speak. When we do not cut out our tongues. When we do not stay silent. This is what they do. This is what they did" (p. 97). The image of their friend's burning at the stake feeds the closing monologue's imagery of fire, a vivid symbol of patriarchal violence, repression, and injustice throughout history, emphasized by the factual-sounding conclusion, "This is what they did." In these terms, it hardly matters that the idea of burning a woman at the stake for distributing pamphlets of poetry is wildly inaccurate. However, as with Mary Sidney, it is an inaccuracy that obscures the actual work of women in the early modern period, including the many women who worked as printers and booksellers, again replacing a nuanced historical vision with easily accessible, visceral stereotype. It is in this moment that the play's dual aims – to recover the voices of historical women and to use an imagined past to galvanize a feminist present – come into most direct conflict. To imagine an Emilia utterly crushed by violent patriarchy, whose voice can only be recovered in the more-empowered present, the realities of her own life and the lives of women surrounding her must be erased.

Emilia's subsequent cry to "burn the whole fucking house down" becomes a reclamation in itself, repurposing the fire that has supposedly been used to silence female artists through the centuries and instead turning its destructive power on the monuments – like the present-day Globe Theater – to the male artists who, in the play's telling, have trampled these women in order to achieve greatness. This conflation of Globe past and present, of Shakespeare as symbol and character, was mirrored in social media responses to the play: playwright James Graham, for example, praised the production for "reclaiming that Wooden O for voices ignored" (@mrJamesGraham). The

idea of reclamation recurred repeatedly, as Emilia's fictional claim to the sixteenth century Globe and Lloyd Malcolm's of the current Globe were framed as equally important: "Reclaimed the fuck out of history and The Globe. Thank you so much (@RossWilliso)"; "What a way to claim that stage. Thank you so much" (@rachel_bagshaw); "The glory of [...] Emilia is the utter clarity of its endeavor: leading us on every level to question, ignite, burn, revel in the possibility of theater, the power of reclaiming the story for us here, now. It changes everything" (@sedickenson). Other responses took the conflation farther, extending the antagonism to the play's Shakespeare to the actual Globe company: "I'm annoyed yet another woman's work, SUCCESS is underestimated with a short run (@NerissaGamboa)." Another added, "Short run. No merchandise. No post show talks (was there one?), YO @The_Globe you did well getting it on that stage but you really underestimated women" (@NastazjaSomers). *Emilia* ran for what was then the standard number of performances of any new work at the Globe, with a customary single pre-show talk. However, the recurring language of underestimation reflects a determination to see *Emilia*'s treatment in the terms the play itself proposes, of antagonism and lack of recognition by both the symbolic and literal Globe, a relationship that obscures – or only grudgingly acknowledges – that the Globe commissioned the play and produced it in the first place.

The interplay between reality and reputation in relation to the Globe that gives rise to this attitude is perhaps best encapsulated by the Twitter user who gleefully described a supposed encounter with a "normal" Globe patron: "Me: BURN THE FUCKING HOUSE DOWN!!! Old white guy behind me: what is this nonsense?! This isn't Shakespeare?!?!? Why are all the women cheering?!?! DISRESPECTFUL!!!" As she clarified in response to another tweet, "He didn't actually say it" (@NicoleBurstein). However, this points to the simultaneous power and problem of the Globe's reputation in housing a play like *Emilia*. Assumptions about the "ordinary" audience for such a venue, their tastes and opinions, colored the reception of this new work – on the one hand, making its presence seem like a powerful reclamation of a white, male space, and on the other, forcing the venue, like Shakespeare in the play, into the role of patriarchal antagonist. Perhaps the Globe's marketing team noticed this tendency, because announcements of the production's West End transfer were much more careful to highlight Globe artistic director Michelle Terry as the third member of the trio of women – writer, director, and commissioning artistic director – responsible for the play and its success.

There are clear parallels here between the Globe and A. L. Rowse as symbols of a white, patriarchal literary and artistic hegemony. Social media

responses to the play suggest that Shakespeare's Globe – whose debt to Shakespeare is in its very name – can never collaborate with diverse voices, but must be reclaimed by them, just as Lloyd Malcolm proposes that Rowse and other voices of formal scholarship can only reinforce the patriarchal forms of history they operate within. But even though new play production apparatus is complex and often discriminatory and problematic, these responses simply misunderstand how the production came to be in favor of a narrative that reinforces a legitimate sense of grievance against patriarchal institutions in general. Along the same lines, Lloyd Malcolm's rejection of a historical record she understands as irrevocably biased against women in general and Lanyer in particular rejects any notion of a feminist histori-cal scholarship, turning instead to fiction as the supposed only means of recovering a feminist artistic legacy in the past.

Emilia presents an irresolvable conflict: a desire to share the inspirational potential of a radical female artist from history who really existed, and a deep mistrust of the patriarchal historical frameworks that have prevented this woman's work and life from achieving the same mainstream fame as her male contemporaries. Biofiction thus becomes both the problem and the solution, Lloyd Malcolm's version of Lanyer's story gaining force from its apparent historical truth even as it rejects historical truth itself as impossibly biased. Any effort to recover the real Lanyer's voice or culture is thus sacrificed in favor of more readily accessible fiction, beginning with the neglect of Lanyer's poetry and culminating in a version of early modern England where the penalty for being a woman found with a pamphlet is death. In *Emilia*'s closing image, we see the fruits of the generations of patriarchal scholarship that Lloyd Malcolm and her collaborators place themselves in opposition to: an understanding of the past that entirely erases the legitimate literary and publishing work of women. The success of *Emilia* points to the difficulty of challenging popular assumptions about the exclusive, patriarchal nature of both the academy and the theatrical industry, assumptions that potentially stand in the way of academics or theater institutions being accepted as agents of genuine inclusivity and change. These assumptions are not without basis. But the irony of *Emilia*'s rejection of historical or literary study is that feminist scholars have labored for decades now in service of precisely Lloyd Malcolm's goal: to restore the work of women – within the arts, within the theater, within academia – to the historical record.[5]

5 See Woods's essay in this volume, "Lanyer: The Dark Lady and Shades of Fiction," for analysis of a wide range of textual examples that fictionalize Lanyer, along with their consequences.

Works Cited

Chedzgoy, Kate. "Remembering Aemilia Lanyer." *Journal of the Northern Renaissance*, vol. 2, 2010. http://www.northernrenaissance.org/remembering-aemilia-lanyer/. Accessed 10 August 2020.

Korda, Natasha. *Labor's Lost: Women's Work and the Early Modern English Stage.* Philadelphia: University of Pennsylvania Press, 2011.

Lanyer, Aemilia. *The Poems of Aemilia Lanyer: Salve Deus Rex Judaeorum*, edited by Susanne Woods. New York and Oxford: Oxford University Press, 1993.

Lloyd Malcolm, Morgan. *Emilia.* London, Oberon, 2018.

@mrJamesGraham (James Graham). "Well #Emilia supercharged The Globe like almost nothing I've seen. Had a fist-pumpingly fun time last night, not to mention the largest lump in my throat when @mogster took her bow at the end of an extraordinary run, reclaiming that Wooden O for voices ignored. Loved " *Twitter*, 2 Sept. 2018, 2:12 PM. https://twitter.com/mrJamesGraham/status/1036240490268643328 Accessed 2 April 2021.

Mueller, Janel. "The Feminist Poetics of *Salve Deus Rex Judaeorum*." *Aemilia Lanyer: Gender, Genre, and the Canon*, edited by Marshall Grossman. Lexington: University of Kentucky Press, 2009, pp. 99–127.

@NastazjaSomers (Nastazja Somers). "Short run. No merchandise. No post show talks (there was one?), YO @The_Globe you did well getting it on that stage but you really underestimated women..." *Twitter*, 3 Sept. 2018, 4:34 PM. https://twitter.com/NastazjaSomers/status/1036638487242596352 Accessed 2 April 2021.

@Nerissa_Gamboa (Nerissa Gamboa). "I saw it last night,loved it with a passion,I'm annoyed yet another woman's work,SUCCESS is underestimated with a short run." *Twitter*, 2 Sept. 2018, 1:41 PM. https://twitter.com/Nerissa_Gamboa/status/1036232536098304002 Accessed 2 April 2021.

@NicoleBurstein "Me: BURN THE FUCKING HOUSE DOWN!!! Old white guy behind me: what is this nonsense?! This isn't Shakespeare?!?!? Why are all the women cheering?!?! DISRESPECTFUL!!! @The_Globe #Emilia" *Twitter*, 30 Aug. 2018, 10:55 PM. https://twitter.com/NicoleBurstein/status/1035284898448371717 Accessed 2 April 2021.

@rachel_bagshaw (Rachel Bagshaw). "#Emilia @The_Globe has just totally floored me and then filled me with fire to send me back out into the world. What a way to claim that stage. Thank you so much @mogster @sophieLstone @NadiaAlbina and the entire team of clever women and men" *Twitter*, 1 Sept. 2018, 11:40 PM. https://twitter.com/rachel_bagshaw/status/1036020974993457152 Accessed 2 April 2021.

Rodgers, John. "The Passion of a Female Literary Tradition: Aemilia Lanyer's 'Salve Deus Rex Judæorum'." *Huntington Library Quarterly*, vol. 63, 2000, pp. 435–446.

@RossWilliso (Ross Willis). "#Emilia @The_Globe was ELECTRIC. Shook the ground. Never had a theatre experience like it and probably never will again. Reclaimed the fuck out of history and The Globe. Thank you so much @mogster" *Twitter*, 2 Sept. 2018, 11:29 AM. Account no longer active.

Rowse, A. L. *Simon Forman: Sex and Society in Shakespeare's Age*. London: Weidenfeld & Nicolson, 1974.

@sedickenson (Sarah Dickenson) "The glory of @mogster and @NicolefcCharles production of #Emilia @The_Globe is in the utter clarity of its endeavour: leading us on every level to question, ignite, burn, revel in the possibility of theatre, the power of reclaiming story for us here, now. It changes everything." *Twitter*, 19 Aug. 2018, 12:24 AM. https://twitter.com/sedickenson/status/1030958605581918210 Accessed 2 April 2021.

Stoppard, Tom, and Marc Norman. *Shakespeare in Love*. Directed by John Madden. Miramax, 1998.

Trill, Suzanne. "Feminism versus Religion: Towards a Re-Reading of Aemilia Lanyer's 'Salve Deus Rex Judaeorum'." *Renaissance and Reformation / Renaissance et Réforme,* vol. 25, no. 4, 2001, pp. 67–80.

Woods, Susanne. *Lanyer: A Renaissance Woman Poet*. New York and Oxford: Oxford University Press, 1999.

About the Author

Hailey Bachrach is a Leverhulme Trust Early Career Fellow at the University of Roehampton working on the project "Shakespeare and Consent." She completed her doctorate at King's College London in collaboration with Shakespeare's Globe, researching the dramaturgical position of women in early modern history plays and modern historical dramas. She is also a dramaturg and playwright.

14. Writing, Acting, and the Notion of Truth in Biofiction About Early Modern Women Authors

James Fitzmaurice

Abstract

This essay explores the notion of truth in biofictional accounts of early modern women authors as that notion applies to dialogue (what is "on the nose" and what not) and to plot as well as character development (what is "jumping the shark" and what not). The essay first focuses on a series of professional solo performances of *Love Arm'd* written by Karen Eterovich about the seventeenth-century author Aphra Behn. It then goes on to consider in the same way a filmed student performance of my play that imagines a meeting of Margaret Cavendish and Virginia Woolf, *Margaret Cavendish, Virginia Woolf, and the Cypriot Goddess Natura*.

Keywords: Margaret Cavendish, Aphra Behn, early modern women, biofiction, truth.

The assertion is often made that a particular stage play or film is characterized by truthfulness or is lacking therein. So, too, related assertions about honesty and authenticity, but I will focus on truth within the context of writing and acting. Glowing claims of truth found in publicity blurbs, of course, are generally to be taken with a grain of salt, but in other circumstances and, particularly where biofiction is concerned, a look at the topic can be useful. Such is very much the case when the application is to early modern women authors.

It is quite reasonable to say that dialogue either "rings true" or does not. The phrase in the TV and film industries for success is "on the nose." Can we imagine the poet Veronica Franco actually saying the words spoken

Fitzmaurice, J., N.J. Miller, S.J. Steen (eds.), *Authorizing Early Modern European Women. From Biography to Biofiction*. Amsterdam: Amsterdam University Press, 2022
DOI 10.5117/9789463727143_CH14

by Catherine McCormack in the 1998 film *Dangerous Beauty*? If so, then a feeling of truthfulness is achieved. Otherwise, we may have the impression that the character is saying something a little too far away from our understanding of our own world or our sense of sixteenth-century Italy. Accusations of outright dishonesty can involve elements of plot or character that are known by the viewer to be either distorted or omitted. Distortion is a consideration when a screenwriter hopes to attract the viewer's attention with, say, with an element of plot or character that is highly unlikely. In TV and film such an attempt is referred to as "jumping the shark."

All of this said, it seems to me that it is sometimes good to produce dialogue that is a little off – that is not quite on the nose – or to jump the shark in this or that way. A perfectly "truthful" biographical drama or screenplay may not be as desirable as one that is just a bit slant. Scripts and performances are, after all, indebted to the imagination.

I

A great many plays written by early modern women have been staged in the last 25 or 30 years, but there have been only a few plays and screenplays in which the lives of these women figure prominently. An interesting exception to what seems a general rule is the solo-performed *Love Arm'd*, which focuses on the relationship between the writer Aphra Behn and a bisexual lawyer named John Hoyle. Solo shows can be long-running and economically robust, as with Hal Holbrook's *Mark Twain Tonight*, which continued for some 2,000 performances. Solo performance is not necessarily a minor genre.

I will closely examine Karen Eterovich's solo performance in *Love Arm'd* for several reasons. First, I am familiar with Aphra Behn's life and use of language. Second, I am fortunate in that Eterovich, who wrote, acted in, and was producer for the play, has allowed me access to her script and given me a large amount of detail about its various performances. Finally, I taught much of the material that Eterovich includes in her show and know what my own audience of students appreciated and what worked less well for them. My students not only discussed Behn's letters but read them aloud. It was clear what rang true for the classes, and I listened as the students wondered if parts of certain of Behn's letters to Hoyle involved plot manipulation.

We also asked, "Were these letters strictly private or composed with the thought that they would find their way into print?" If the letters were intended to be read by the general public, then, might it be that Behn was asking her readers to understand them as a sort of auto-biofiction? As

Figure 14.1. Karen Eterovich as Aphra Behn in *Love Arm'd* (2002). Photo by Rob Ferguson. By kind permission of Karen Eterovich.

regards the plot lines of some letters, my students were effectively asking if Behn was guilty of jumping the shark in a bad way. But, perhaps, Behn was merely engaging in a comic routine by being intentionally outlandish.

Eterovich structures her play, which I viewed in a video recording, as a one-sided dialogue between Aphra Behn, who speaks, and John Hoyle, who is imagined to be listening off-stage. As the play begins, Behn, wrapped in a sheet, emerges onto the stage having just finished making love with Hoyle. It is a dramatic opening visually, and Eterovich hurls many of her lines at the

imagined Hoyle, cursing him in a way that my students found wonderfully funny in reading the letters. Eterovich's technique is "true" in the sense that her viewers could imagine a person wanting to deliver such a curse, even if it never happened. Eterovich writes a portion of the curse as follows:

> You [Hoyle] will never, from this night forward, be able to get me or my life out of your thoughts. Thou haunt'st my inconvenient hours and I shall haunt you! May your women and your many men, be all ugly, ill-natured, ill-dressed, and unconversable and may every moment of your time be taken up with thoughts of me!

In my view, Behn wrote fully aware that her letter might find its way into print and, indeed, she easily could have sold or tried to have sold the set of eight letters among which this one is found to a printer of scandalous material, a printer of the sort later made famous by Edmund Curll. The letters were printed posthumously in 1696 in *Histories and Novels of the Late Ingenious Mrs Behn*, and some doubt has been cast on their attribution, but my sense of Behn as a writer is that these letters are very much in her style and carry her tone. If they are fakes, then whoever composed them knew how to evoke Behn as a writer. They also ring true in the context of the time, for they are witty and arch in the manner of a Restoration comedy.

Eterovich does not simply cut and paste from the letters, however. Rather, she makes a point of adding in the phrase "your many men" so as to point up John Hoyle's bisexuality. Her approach rings true, I would say, "is on the nose" as biofiction. The added phrase fits nicely with well-known poems of the time, especially Rochester's "Song: Love a Woman," which concludes with the lines, "There's a sweet, soft Page of mine, / Do's the Trick worth Forty Wenches." At the same time, Eterovich leaves out of the curse "ill-fashioned" along with "for your greater disappointment," probably just to shorten the speech in which it is contained, thus making it easier to understand for her modern audiences.

When creating dialogue in the style of the seventeenth century, as Eterovich has done, it is necessary to give the flavor of and to not burden the listener unduly with period grammar and diction. Sentences of the time were often long and difficult, so much so that most students these days need to work to get through a play by Behn. I edited Behn's comedy *The Rover*, modernizing spelling and punctuation so as to reduce strain on an upper division student reader, but the writing style remained difficult. The task for Eterovich, however, was more difficult as she needed to keep her audience with her: they could not go back and reread a passage.

Eterovich reports that *Love Arm'd* went down well with the midshipmen at the Naval Academy, though she suggests that that they were perhaps mostly impressed with her costume and delivery. Her performance at the Western Society for Eighteenth Century Studies brought a greater appreciation by an audience for the connection between the life of Behn and its depiction in biofiction.

II

In the autumn of 2016, I wrote *Margaret Cavendish, Virginia Woolf, and the Cypriot Goddess Natura.* In the story line of this play, there is an imaginary meeting between Margaret Cavendish and Virginia Woolf, a pair of authors whose serio-comic exchange of words is facilitated by time travel. In *The Common Reader* and *Room of One's Own*, Woolf pronounced on the subject of Cavendish in quips that have been much quoted to demonstrate a sort of bemused contempt. My hope was to surprise modern audiences by suggesting, instead, a friendly rivalry between the two women across time. I found a director among lecturers in Performance at Sheffield Hallam University and obtained travel funding to stage the play in Cyprus using student actors from Hallam and the University of Sheffield. In Nicosia in the spring of 2017, these students put on the show for an audience made up of delegates to the Othello's Island Conference and local CVAR Museum supporters. The conference contains the Early Modern Women Writers Colloquium, so there was a portion of the audience well acquainted with what from Woolf was in print about Cavendish. Quite coincidentally, I followed the same model used by Eterovich in staging a play at an academic meeting and was rewarded, as was she, with a sympathetic audience.

Three student actors stood out in the dress rehearsal, which was filmed and is available gratis on Vimeo. Two of the three actors jumped the shark, one in choice of accent and the other in a visual routine. The third actor was absolutely "on the nose" in his delivery of lines. The actor who took the part of Virginia Woolf presented me with a problem of vocal interpretation. In the audition, she was far ahead of her many competitors in having thoroughly read the script. She knew how she wanted to present the part and had chosen a passage to read aloud. She had decided that Woolf was to be a posh, grand literary lady. I had no real knowledge of the dialect that Woolf used, but imagined that, given her parents, Woolf would be more upper-middle class in accent, perhaps in an Oxbridge sort of way.

Did I attempt to guide the actor towards what I thought was most accurate for accent? No. I chose to let her follow her own inclinations, and jump the shark in her character. My reasons were three in number. First, she had the posh accent down very well and we did not have much time to change it. Second, inaccurate as it might have been, it increased the self-importance in the character, which is what I wanted. Third, the director, who was not at this particular audition, let the dialect choice stand. Thus the accent stayed posh and the shark was jumped, in the process producing a truth for biofiction, if not for biography. Fortunately, our costume for Woolf fit exactly with the posh accent, as the dress was slinky and blue in a flapper style and was accompanied by a crushed blue hat. The show's Woolf could have walked into Downton Abbey as mistress of the house. Finally, this student actor also took the part of a waitress in a cafe in which the time travel took place, a waitress who was not the least bit posh. The contrast was dramatically striking: sullen, pouty girl becomes grand literary lady.

Although we were short of male actors and a female was drafted in to play John Evelyn, our one male played Constantijn Huygens exactly as I wished, which was as a louche older man. Huygens was indeed a ladies' man in real life, and someone (either actor or director) decided to change a brief phrase, "Thank you," into the Greek word "Parakalo." Many of the CVAR Museum supporters were Greek Cypriots or knew Greek sufficiently to be surprised. The actor was absolutely on the nose in being thoroughly louche as he delivered the word. He contributed to the truth of the biofiction.

The third student actor jumped the shark in a way that was completely visual and much in keeping with the episode in the TV sit-com *Happy Days*, from which the term derives its name: a water-skiing Fonzie literally jumps a shark in a scene without much connection to the plot of the episode. In the play, the actor portraying Cavendish's waiting lady, Elizabeth Chaplain, jumped the shark in what was a essentially a visual joke. Chaplain entered while Cavendish was describing the beauty of young ice-skaters on a frozen canal in Antwerp. It is a touching winter scene worthy of Brueghel. The actor asked if she could cross the stage on her toes using ballet toe shoes, literally gliding as if she were on ice. The director and I agreed that the effect would be startling to good effect. Such was the case when the shark was jumped, perhaps with more connection to the plot than was true with Fonzie.

Dangerous Beauty, the film on the life of the poet Veronica Franco mentioned earlier in this chapter, was costly to make and a financial failure. Only a few other big-budget films about the lives of early modern women writers have been produced, perhaps because the topic does not draw large paying audiences. Be that as it may, it is clear that solo performance and

Figure 14.2. Emilie Philpott Jumping the Shark at the dress rehearsal of *Cavendish, Woolf, and the Cypriot Goddess Natura*. Nicosia, Cyprus, 7 April 2017. Photo Credit / Permission: James Fitzmaurice.

student productions do not require large financial commitments. And so, writers and actors are freer to explore the notion of truth in biofiction without the worries that accompany the enormous productions of, say, West End theater and Hollywood film.

Works Cited

Behn, Aphra. *Histories and Novels of the Late Ingenious Mrs Behn*. London: Printed for S. Briscoe, 1696.

Dangerous Beauty. A film directed by Marshall Herskovitz and based on the biography *The Honest Courtesan* by Margaret Rosenthal. Produced by Regency Enterprises and Bedford Falls Production Company, 1998.

Eterovich, Karen. *Love Arm'd: Aphra Behn and Her Pen*. Love Arm'd Productions. Copyright 1997 and 2000.

Fitzmaurice, James. *Margaret Cavendish, Virginia Woolf, and the Cypriot Goddess Natura*. Performed at the CVAR Museum in Nicosia, Cyprus, on 7 April 2017.

Woolf, Virginia. *The Common Reader*. London: Hogarth. 1925.

Woolf, Virginia. *A Room of One's Own*. London: Hogarth. 1929.

About the Author

James Fitzmaurice is emeritus professor of English at Northern Arizona University and honorary research fellow at the University of Sheffield. He has published a great deal on Margaret Cavendish and his screenplays have been selected for or won prizes at many film festivals.

15. Jesusa Rodríguez's Sor Juana Inés de la Cruz: Reflections on an Opaque Body

Emilie L. Bergmann

Abstract

Sor Juana en Almoloya (*Pastorela Virtual*) ("Sor Juana in Prison: A Virtual Pageant Play") and *Striptease de Sor Juana* ("Sor Juana Striptease") by playwright, actor, director, and feminist activist Jesusa Rodríguez stand apart among the dozens of competing biofictions that spin imaginative conjectures about the poet Sor Juana's intimate life and political consciousness. This essay considers how both performances stage distinct readings of the Mexican Baroque: the satirical *Sor Juana en Almoloya* is a raucous postmodern riff on censorship, while in *Striptease* Jesusa uses her voice and body to interpret Sor Juana's long epistemological *Primero sueño* ("First Dream") and bring the language and insights of Sor Juana's greatest poem into the lives of her audiences.

Keywords: El Hábito, Jesusa Rodríguez, Mexican theater, *Sor Juana en Almoloya*, Sor Juana Inés de la Cruz, *Striptease de Sor Juana*

Fictional avatars of colonial Mexican poet, nun, and intellectual Sor Juana Inés de la Cruz (1648–1695) began to proliferate during her lifetime. Like other learned women writers of the early modern period, Sor Juana was awarded the honorific titles of "Tenth Muse" and "Phoenix," both denoting a status other than human. The brilliance that brought her to the Viceregal court of New Spain was regarded as freakish, and she knew it: Pedro del Santísimo Sacramento, a Spanish cleric who wrote one of the numerous encomiastic prologues to the second volume of her works, published in Barcelona in 1692, called her "Monstruo de las mujeres y prodigio mexicano" ("Monster among women and Mexican prodigy"; Sor Juana, 1995, p. 26). Mexican poet Felipe Luis Fabré cites this encomium in the title poem of his

Fitzmaurice, J., N.J. Miller, S.J. Steen (eds.), *Authorizing Early Modern European Women. From Biography to Biofiction.* Amsterdam: Amsterdam University Press, 2022
DOI 10.5117/9789463727143_CH15

verse biofiction *Sor Juana y otros monstruos*, taking the pejorative meaning to
a violent conclusion in which a monstrous Sor Juana slaughters the scholars
who quibble about her life and her writing; her relationship to her patron,
the Condesa de Paredes; and the reasons for her silence in the last years of
her life. In her wake, the monstrous Sor Juana leaves a trail of unfinished
blood-spattered dissertations and contentious treatises, and she will hover
above us, open her wings like opening a book, "y remontará la noche y
ascenderá, / bellísima y monstruosa, / una vez más hasta las esferas" ("and
she will fly above the night, ascending – / gorgeous and monstrous – / once
more toward the spheres"; pp. 16–17).

The seventeenth-century cleric's use of the term "monstruo," however,
would have been recognized in Sor Juana's time as the baroque response of
astonishment or "admiración" toward the excessive, strange, or spectacular.
Sor Juana herself, aware of the double edge of such "admiración" for a woman,
regarded her fame with irony, and anticipated the current marketing of her
image: "¡Qué dieran los saltimbancos, / a poder, por agarrarme / y llevarme,
como Monstruo, / por esos andurriales [...] / diciendo: *Quién ver al Fénix
/ quisiere, dos cuartos pague!*" ("What would the mountebanks not give /
to seize me and display me, / taking me round like a Monster, through /
byroads and lonely places [...] / hoping folks would pay to see, / 'If you wish
to see the Phoenix / step up and pay two farthings'"; Sor Juana, 1951, p. 147;
2009, p. 201).[1]

My subtitle is taken from *Primero sueño* ("First Dream"), Sor Juana's long
epistemological poem narrating the mind's search for all-encompassing
knowledge. The "cuerpos opacos" ("opaque bodies") in line 369 refer to
pyramids, not, at least ostensibly, those of Tenochtitlan but the Egyptian
pyramids of Memphis, as solid forms grounded in the material world,
attenuated as they rise, to figure the human spirit's desire for universal
knowledge; the poem recounts the failure of this aspiration. I apply "opaque
bodies" here to Sor Juana, object of countless projections that reveal more
about the observers' desires than the poet herself, elusive and unknowable.
In a ballad found unfinished in her cell after her death, Sor Juana wrote of
the alienation of seeing her self-image distorted in European acclaim: "y
diversa de mí misma / entre vuestras plumas ando, / no como soy, sino como
/ quisisteis imaginarlo" ("I am not who you think I am; and different from
myself I am borne among your pens' plumes not as I am but as you insist on

1 Until 2019, Sor Juana's solid value as cultural currency was signaled by her circulation
on the 200-peso note. When her portrait was removed, it took two male heroes of Mexican
independence, Miguel Hidalgo and José María Morelos, to replace her.

imagining"; Sor Juana, 1951, p. 159; Merrim, p. 103). The poem "combats the falsely exalted image with a hyperbolically abject one" (Merrim, p. 176); a unified authorial persona continues to elude scholars.

Rather than providing reliable autobiographical accounts to those in search of a coherent self, Sor Juana's familiar anecdotes in the *Respuesta a sor Filotea* ("Answer to Sister Philothea") – hair-cutting when she failed to reach a goal in learning Latin, refusing to eat cheese because it was said to dull the intellect, and begging her mother to dress her in male clothing so she could attend the University – are "strategic craftings of the self, employed as part of a larger persuasive design" in defense of Sor Juana's determination to study and write (Luciani, p. 80). The sparsely documented details of Sor Juana's life have been intertwined with selections of her poetry to support widely divergent Sor Juanas: the pious and chaste icon of national culture; the wily feminist intellectual dodging persecution by ecclesiastical authorities, if not the Inquisition; or the rebellious patron saint of Latin American queerdom. These fictional Sor Juanas are the protagonists of dozens of novels, films, a Mexican *telenovela*, and at least three operas – not to mention a *lucha libre* Sor Juana on posters advertising the university housed in the former cloister once inhabited by Sor Juana. Emily Hind lists the titles of recent novels that announce imagined lesbian and heterosexual Sor Juanas, among them José Luis Gómez's *El beso de la Virreina* ("The Vicereine's Kiss," 2008), Kyra Galván's *Los indecibles pecados de Sor Juana* ("Sor Juana's Unspeakable Sins," 2010), and *Arrebatos carnales* ("Carnal Eruptions," 2009) by Francisco Martín Moreno, which sold 160,000 copies in the first year of its release (p. 116). Hind tempers these twenty-first century visions of Sor Juana, however, with a sobering reminder that Sor Juana was also her convent's accountant "with a sharp eye for investments, as well as a slave-owner" (p. 112). Among scholars, Sor Juana's relationship to the metropolis as a colonial subject of the Spanish empire is a complex and contradictory topic. Her works were published in Spain by a powerful member of the aristocracy, María Luisa Manrique de Lara, Condesa de Paredes. While her writing displayed her prodigious erudition in the European classical and renaissance tradition, Sor Juana also wrote songs in Nahuatl and *bozal,* the Spanish speech of enslaved Africans, and was aware of her status as an outsider: woman, illegitimate, and born in the Americas.

Among the dozens of competing biofictions based on conjectures about Sor Juana's intimate life and political consciousness, two performances by playwright, actor, director, scenographer, and feminist activist Jesusa Rodríguez stand apart as distinct but equally audacious approaches to an early modern intellectual woman's life and art: *Sor Juana en Almoloya (Pastorela*

Virtual) ("Sor Juana in Prison: A Virtual Pageant Play," 1995) and *Striptease de Sor Juana* ("Sor Juana Striptease," 2002–2013). Distinct as they are, both are postmodern riffs on two versions of the Hispanic Baroque: pastiche and irony at a frenetic pace in *Sor Juana en Almoloya*, and, in *Striptease de Sor Juana*, the solemn, slow-paced, intensely intellectual exploration of micro- and macrocosm. *Sor Juana en Almolaya* is political satire interspersed with well-known citations from Sor Juana's poetry, prose, and theater. The *Striptease* is a dramatic recitation of a single 975-line epistemological poem, Sor Juana's *Primero sueño*. Both performances staged the liberation of a figure as iconic as the Virgin of Guadalupe: in *Almoloya*, the political and anticlerical satire culminates with an outrageously comic staging of lesbian embraces between Sor Juana and her patron, the Condesa de Paredes, and, in *Striptease*, nakedness makes visible the poem's philosophical exploration of mind-body relationships.

Sor Juana en Almoloya (Pastorela virtual)

Jesusa Rodriguez's "Virtual Pageant Play" is an uproarious satire of political corruption in Mexico in the mid-1990s, as well as the ideological uses of the colonial Mexican past. Jesusa lampoons hypocritical conservative authority figures while impersonating Sor Juana, unjustly imprisoned by a repressive secular and religious culture, with inadequate legal defense and an unwieldy, outdated Macintosh computer. The play was written for Channel 40 in Mexico City and performed in December 1995 in the independent Mexico City theater-bar El Hábito (Rodríguez, 2003, p. 212).[2] She established this space for performances free from the censorship and self-censorship of state-subsidized and commercial theaters (Franco, pp. 166, 168). Censorship is central in *Sor Juana en Almoloya*; the play concludes as the authorities who imprisoned Sor Juana ban the traditional Nativity play, the *pastorela* within the *Pastorela*, objecting to the nudity of the newborn Jesus and other "indecencies."

"Almoloya" in the title of Jesusa's performance is Almoloya de Juárez, the maximum-security prison built during the presidency of Carlos Salinas de Gortari, from 1988 to 1994. In Jesusa's *Pastorela*, the prison onstage replaces

2 A videotape of the 22 December 1995 performance can be accessed on the Hemispheric Institute website. The name of the theater-bar, co-owned and managed by Jesusa with her wife, Argentine musician and composer Liliana Felipe until 2005, embraces two distinct worlds: drug addiction and the cloister.

the cloistered Hieronymite convent of Santa Paula where the poet lived from 1669 to her death in an epidemic in 1695. Ironically, at the time of the performance, Salinas de Gortari's brother was in fact imprisoned in Almoloya for corruption and for ordering the assassination of a 1994 presidential candidate, while Salinas himself was in exile (Costantino, p. 196). The dramatic genre and the date, around December 21, offer another kind of framing for the performance: the *pastorela*, the traditional Nativity pageant in Mexican and Mexican-American churches and communities. Jacqueline Bialostozky points out that Jesusa "appropriates the *pastorela*'s own tools and structure to subvert its original [colonial] evangelizing purpose" (p. 83). Costantino points out the compatibility of the traditional *pastorela* with humor and satire, including "intricate word play (known as *albures*, whose double-meanings are often sexual or scatological in nature) so typical to Mexican Spanish" (pp. 197–198), an observation borne out by the Spanish text of *Sor Juana en Almoloya*.

The year 1995 marked the tercentenary of Sor Juana's death, commemorated with international conferences and publications re-evaluating her life and work. *Sor Juana en Almoloya* is firmly situated in the politics of the place and time of performance, although the action is projected five years into the future, "The Blessed Year of our Lord 2000," in which Jesusa predicted accurately the rise of the conservative PAN (National Action Party), closely associated with the Catholic Church. According to the prologue, the "Party of National Re-Action" has finally "reestablecido la moral, y las buenas costumbres en la vida social y política de nuestro país" ("restored decency and good manners to the social and political life of our country"; Rodríguez, 1995, p. 395; and 2003, p. 212).[3] Jesusa appears on stage in the habit seen in the early eighteenth-century Miguel Cabrera and Juan de Miranda portraits of the Hieronymite nun, a costume Jesusa has worn in numerous public performances, including her role as Master of Ceremonies in the Zócalo, the enormous plaza in front of the Cathedral, for Mexico City's Fifteenth Annual Gay Pride March in 1999. By appearing as Sor Juana, Jesusa reclaims her from the Church, whose clergy and scholars "insist that Sor Juana died having abdicat[ed] her ideas, having given away her books and her instruments [...] a good Catholic, a believer" (Costantino, p. 191).

As the play opens, Sor Juana sits at a computer, laughing at the audacity of a letter that ex-president Salinas de Gortari had sent to the Mexican media

3 All references to the Spanish text of *Sor Juana en Almoloya* are to the text published in *Debate feminista*; English translations are from Diana Taylor and and Marlene Ramírez-Cancio's text in *Holy Terrors*.

in November 1995 in an attempt to exonerate himself. She then reads aloud a letter she is writing to him, ostensibly to defend herself from the authorities who have imprisoned her. As she reads, the image of a mustached Salinas de Gortari dressed in a nun's habit is projected onto a screen behind Jesusa. Her audience would recognize the fictitious "Carta Zopilotea" (literally, "vulturous letter") as a satirical updating of the *Respuesta a sor Filotea*, Sor Juana's defense of her intellectual life of study and writing on secular topics, in response to the reprimand that Manuel Fernández de Santa Cruz, Bishop of Puebla, signed with a female pseudonym.[4]

In addition to the pastiche of Sor Juana's feminist manifesto, the loosely structured plot of *Sor Juana en Almoloya* allows Jesusa and the other actors to recite passages from the best known among Sor Juana's ironic, humorous, and defiant works, modified to refer to current political scandals in Mexico. These include her philosophical sonnets on love; her sensuous, witty description of the Condesa's body from head to toe; and a monologue from Sor Juana's secular *Los empeños de una casa* ("The Trials of a Household") in which a male character admires himself in drag, a scene that displays Sor Juana's spot-on parody of gender performance.[5] Jesusa updates the target of Sor Juana's witty exposure of the sexual double standard in the "Sátira filosófica" ("Philosophical Satire"), a ballad memorized by generations of Mexican schoolchildren: "Hombres necios, que acusáis / a la mujer sin razón, / sin ver que sois la ocasión / de lo mismo que culpáis" ("You foolish and unreasoning men / who cast all blame on women / not seeing you yourselves are cause / of the same faults you accuse"; Sor Juana, 1951, p. 228; 2009, p. 164).

Most pertinent to the question of biofictions in the *pastorela,* however, is Jesusa's sendup of Octavio Paz's equivocation regarding the question of Sor Juana's relationship to her patron, María Luisa Manrique de Lara, Condesa de Paredes, in his monumental study *Sor Juana, o, las trampas de la fe* (1982) ("Sor Juana, or the Traps of Faith," 1988). In *Sor Juana en Almoloya*, an authoritative offstage voice cites passages in which Mexico's Nobel laureate dismisses the possibility of a sexual relationship between the two women in a passage that encapsulates the absurdity of Paz's evasion of the obvious. Drawing on Plato, Ficino, and Freud, Paz devoted three chapters of *Las trampas de la fe*

4 For a detailed analysis of the political significance of Jesusa's dense wordplay and the "queering" of the colonial past in *Sor Juana en Almoloya*, see Bialostozky, pp. 70–97.

5 While the independent, brilliant intellectual protagonist of *Los empeños de una casa* has been interpreted as a portrait of Sor Juana, it may also be an homage to the Condesa de Paredes. Several translations and adaptations have been created for performances for English- and Spanish-speaking audiences. The cross-dressed male character is one of the rare exceptions in early modern Spanish theater, while dozens of plays featured cross-dressed female protagonists.

to his struggle to understand the "enigma" of the relationship that inspired Sor Juana's passionate poems to the Condesa. Paz concludes with a decisive disavowal: "The only thing that is sure is that their relationship, although impassioned, was chaste" (1988, p. 217).[6] I interpret Paz's vacillation in light of Joan DeJean's study of the varying narratives of lovelorn heterosexual, lesbian, and even dual Sapphos devised by generations of her male heirs.[7] From antiquity to twentieth-century Mexico, generations of male poets have been incapable of accepting the sexuality of the mothers of European and Latin American lyric poetry.

In caricaturing Paz's disavowal, Jesusa hardly needs to modify his words; she defies them with an enactment of the lesbianism he pronounced impure and indecent. The onstage action blatantly contradicts the narration from offstage and citations from *Las trampas de la fe*:

> Voz en off: La mayoría de los biógrafos de Sor Juana darían el monto total de la becas y premios que han ganado por tener la oportunidad de atisbar desde lejos lo que vosotros tenéis ante vuestras narices. [...] Nótese el safismo sublimado. (Ahora se besan apasionadamente.) Vedlas entregadas a las silenciosas orgías de la meditación. Una monja, la otra casada. ¿Qué podrían hacer juntas? (Sor Juana salta encima de la virreina y ambas se repantigan a sus anchas.)
>
> (Rodríguez, 1995, pp. 401–402)
>
> Voice off: The majority of Sor Juana's biographers would give their fellowships and grant money to have the opportunity to catch a glimpse of the scene that you are about to see. [...] Note the sublimated sapphism. (The women start kissing passionately.) Regard how they surrender to the silent orgies of meditation. One a nun, the other married. What could they possibly have done together? (Sor Juana jumps on top of the Vicereine and they frolic wildly)
>
> (2003, p. 218).

Following this scene, the Prosecutor sings a blatantly homophobic "PAN anthem" to the tune of Shostakovich's Seventh Symphony, bans the Nativity play, and condemns Sor Juana not only to life in prison, but perpetual torture.

6 Since publication of Paz's study, Amanda Powell's research on the lost language of "an international Sapphic discourse employing a wide range of rhetorical modes: tender friendship, playful wooing, and eroticism" (p. 75) provides a context for Sor Juana's poems to the Condesa.
7 See Bergmann and De Jean. Ironically, following the publication of the English translation in 1988, conservative Catholic clergy published negative reviews and essays to discredit Paz for exposing the Church's persecution of Sor Juana and for his discussion of her sexuality.

Primero sueño | Striptease de sor Juana

A different kind of performance, by a single speaking body in motion, was needed to liberate Sor Juana from the accumulation of ideologically motivated narratives. The two partial transcriptions of *Sor Juana en Almoloya* that I have consulted do not match the video recorded on December 22, 1995 at El Hábito but the text of Jesusa's *pastorela* on the Hemispheric Institute website opens with the first 24 lines of Sor Juana's long philosophical poem, *Primero sueño*, which is not part of the videotaped performance. Whether or not this was included in any of the performances, its presence in the transcript of the 1995 performance coincides with Jesusa's decision, at age 40, to commit to memory the poem that she would spend the next twelve years memorizing (Rodríguez and Taylor, 2016, p. 304). She would perform it throughout the Americas from 2002 to 2013.[8]

Sor Juana en Almoloya refers, like so many impersonations of Sor Juana, to the often-reproduced posthumous portraits of Sor Juana in her nun's habit. Jesusa also wears the recognizable habit in the opening passage of *Striptease de sor Juana*, but she removes it and the layers beneath to reveal the surface of her body and then its inner organs, by drawing on it or projecting anatomical diagrams of heart, lungs, stomach, and trachea. She also inscribes Mesoamerican symbols on her upper body with an ink pad and rubber stamp. The *pastorela virtual's* pastiches quoted familiar lines of Sor Juana's poetry and her self-defense in the *Respuesta*; the *Striptease* devotes 80 to 90 contemplative minutes to the recitation of the entirety or lengthy sections of a single unabridged text that is so formidable that it is rarely cited beyond its first line. The context of *Sor Juana in Prison* is Jesusa's late twentieth-century Mexico; *Sor Juana Striptease* invites the audience into the intellectual landscape of *Primero sueño*: Greek, Roman, and Egyptian mythology and the exciting developments in the seventeenth-century scientific study of the material world, including light and sound. Isabel Gómez, who attended the 2010 and 2013 performances in Los Angeles, sees it as a "gestural translation" of the text of *Primero sueño* (p. 149). I would add that this one-woman performance is a biofiction based entirely on words written by its subject, creating a self-portrait of the poet at her freest, the

8 The performances in Lima as *El striptease de sor Juana* in 2002, and as *Primero sueño* in Buenos Aires in 2007 and Chiapas in 2009 left out portions not yet fully memorized, but those in Los Angeles in 2010 and 2013 were of the complete poem (Gómez, p. 160, note 4). Videos of the performances in Buenos Aires (2007) and Chiapas (2009) are available on the Hemispheric Institute website.

self Sor Juana found missing from the accolades of her contemporaries. In the *Respuesta a sor Filotea,* Sor Juana claimed that the *Sueño* was the only writing she chose for herself, rather than for a patron or on commission from the Cathedral. Her statement invites a reading of the *Sueño* as an intricately constructed attempt at a system of knowledge, a key to the poet's conception of human consciousness. Jesusa accepts that invitation, using the cadences of her voice reciting lines of poetry and her body, clothed, unclothed, and clothed again, interacting with a collection of movable objects, several of which are transparent, light-producing, or reflective.

In order to approach Jesusa's performance, it is useful to have a general idea of *Primero sueño* as a poem and as an exploration of the cosmos, both macro and micro. This intellectual flight differs from other poems that narrate journeys to another world: there is no Virgil to guide the cosmic traveler. Sor Juana's protagonist, "Alma" (literally, soul, but in this case, mind) dares to soar toward the unknown, actively seeking an all-encompassing method of knowledge. *Primero sueño*'s 975 lines are not divided into stanzas, and sentences can extend for dozens of lines, displaying the poet's skill at baroque hyperbaton, the Latinate rearrangement of syntax. While she recites the poem, Jesusa's excessively clothed and then naked body moves in solemn chiaroscuro, following the flexible rhythm of the *silva,* an irregularly rhymed series of seven and eleven-syllable lines.[9] The cadences of these lines in seemingly random patterns is rhetorical, interspersing two or three emphatic short lines with blocks of longer ones; Jesusa uses these patterns for pauses that give the audience time to experience the phrases as they might listen to music. Jesusa's performance makes audible and accessible the anatomy, geography, and cosmology of the poem.

The dream journey begins with nightfall; freed from the sleeping body, "Alma" attempts to embrace all of creation at once, culminating in a passage on the Egyptian pyramids as a geometrical figuration of human aspiration to knowledge; the prospect overwhelms her but she is determined to try another method. After a second attempt to organize objects through Aristotelian categories, she recognizes the impossibility of understanding even the simplest of objects; as dawn chases away the night, the poem ends with the revelation that the speaker is female: "y yo despierta" ("And I, awake"; Sor Juana, 1951, p. 359; 2016, p. 66). After the initial passage describing nightfall,

9 The *silva* is an adaptation of a Latin verse form practiced by poets known for their erudition (and difficulty); the first edition of *Primero sueño* identified it as an imitation of Luis de Góngora's *Soledades,* but Sor Juana turns her predecessor's sensuousness toward the exploration of the physical and mental universe.

Jesusa removes her nun's habit. Gómez sees this as a liberation from "the scholarly apparatus around Sor Juana that cloisters the nun's work within the language of specialists" in order to emphasize instead "the parts of the poem that discuss the human body and everyday life as sites of empirical observation and knowledge" (p. 151). Jesusa points out that "apparently the habit had thirty-two pieces back then – I just have thirteen" (Rodríguez and Taylor, 2016, pp. 307–308). In the Chiapas performance, Jesusa's long nightgown is the only garment below her habit, and she only strips to the waist, but in the more elaborate Buenos Aires performance, there is another voluminous garment whose removal requires the untying and unwinding of crossed ribbons, emphasizing the release of the body from confinement. Jean Franco describes Jesusa's use of her body: "She is not so much nude as naked, and it is a nakedness that gives the body a power of expression that we normally associate with the face alone. She plays the body like a virtuoso" (p. 163).

The technological production, projection, and reflection of light varies among the performances, from a lit candle to spotlights, a mirror, a large lens, and a computer monitor. At the beginning of the performance, spotlights create a triangular lighted shape on the back wall, while Jesusa creates a black "pyramid" using the veil of her habit, to embody the opening lines describing the conical shadow of Earth extending toward the moon: "Pyramidal, funesta, de la tierra / nacida sombra, al Cielo encaminaba / de vanos obeliscos punta altiva" ("Pyramidal, funereal, a shadow / born of earth, aspiring to highest heaven, / the haughty tip of its great obelisks / striving in vain to climb up to the stars"; Sor Juana, 1951, p. 335; 2016, p. 45). Gómez describes how "[t]he performer's gestures of preparing to sleep, combined with the tableau of a body laid out prone in sleep or death, achieve a gestural translation of the conceit connecting sleep with a limited experience of death" (p. 152). The mirror will prove to be an essential prop, as the poem presents a model of mind whose highest faculty is the creative "fantasía" (distinct from imagination and memory), comparing it to a mirror, specifically, the enormous mirror of the lighthouse at Alexandria (lines 267–291). Images projected onto a round screen suspended above the space suggest the functioning of "fantasía," with baroque prints of mythological and symbolic figures projected onto its surface. At times, video images of Jesusa are also projected onto the onstage screens.

In an interview with Latin American theater scholar Diana Taylor, Jesusa explains her method and motivation for memorizing and performing Sor Juana's most formidable poem. From childhood, she found that committing poetry to memory was the most effective way to understand it. Although at first *Primero sueño* seemed esoteric, she found, as she memorized more of

the poem, that the wisdom and images became part of her everyday life. It helped her find the language she needed to think about political change, and as she performed in cities throughout Latin America, she was surprised at the responses of audience members who had no previous acquaintance with the poem (pp. 304–305). In it, she found new language to inspire political action. Sor Juana's description of the sorrow of Demeter looking for her daughter Persephone reminds Jesusa of the "mothers of disappeared children," victims of drug wars in Mexico, but also the Madres de la Plaza de Mayo in Buenos Aires, still protesting the disappearance of their children (p. 306). In Sor Juana's poem Jesusa found another political insight, illustrating her view that the poem is not impossibly cryptic. Jesusa paraphrases Sor Juana's description of the loss of body heat with each breath, imagining the process as small thefts: "'call no theft small when oft repeated.' Even though they may only steal a little bit at a time from us, they will end up taking the entire country" (p. 305).

In interviews about her theater in general and *Striptease* in particular, Jesusa imagines performance as an "intellectual kitchen" (Franco, p. 55; Costantino, p. 191), calling up Sor Juana's example in the *Respuesta* of the irresistible desire for knowledge that compelled her, when forbidden access to her books, to conduct chemistry and physics experiments with eggs, sugar, flour, and a child's top. Sor Juana slyly concludes, "Si Aristóteles hubiera guisado, mucho mis hubiera escrito" ("Had Aristotle cooked, he would have written a great deal more"; 2009, pp. 74–75). Gómez observes that Jesusa's delivery "invites her audience to reconsider their own performance of the everyday" (p. 151). A recurring topic in Jesusa's interview with Diana Taylor is her educational purpose, to make one of the greatest achievements of Mexican culture available to all Mexicans. She even suggests that high schools should require students to memorize it in order to make its brilliant insights part of their consciousness. Her performance of the *Striptease* in Chiapas, one of the poorest Mexican states, exemplifies her project of making *Primero sueño* accessible to diverse audiences, not only the few who are familiar with passages of the formidably complex poem. In the process of committing *Primero sueño* to memory Jesusa found "a political asylum [...] it relieves my heart, rehabilitates me and allows me to return to the fight with new energy and new insights" (2016, p. 307). *Striptease* challenges her audiences to experience the extraordinary beauty and everyday wisdom of a poem regarded as impossibly difficult and thus beyond the easy com-modification that motivates other biofictions. Jesusa's performance aims to transform the relationship between the poet and Mexican audiences from fetishization to inspiration for political renewal.

Works Cited

Bergmann, Emilie. "Fictions of Sor Juana / Fictions of Sappho." *Confluencia*, vol. 9, no. 2, 1994, pp. 9–16.

Bialostozky, Jacqueline. "Aesthetics of the Surface: Post-1960s Latin American Queer Rewritings of the Baroque." PhD Dissertation, University of California, Berkeley, 2017.

Costantino, Roselyn. "Jesusa Rodríguez: An Inconvenient Woman." *Women & Performance: A Journal of Feminist Theory*, vol. 11, no. 2, 2000, pp. 183–212.

DeJean, Joan. *Fictions of Sappho, 1546–1937*. Chicago: University of Chicago Press, 1989.

Fabré, Luis Felipe. *Sor Juana y otros monstruos: Una ponencia en verso, seguida de tres mashups in homenaje / Sor Juana and Other Monsters: An Academic Paper in Verse, Followed by Three Mash-ups in Homage*. Translated by John Pluecker Señal. Ugly Duckling Presse, BOMB Magazine, Libros Antena, 2015.

Franco, Jean. "A Touch of Evil: Jesusa Rodríguez's Subversive Church." *Negotiating Performance: Gender, Sexuality, and Theatricality in Latin/o America*, edited by Juan Villegas Morales and Diana Taylor. Durham: Duke University Press, 1994, pp. 159–175.

Gómez, Isabel. "The *Sor Juana Striptease* by Jesusa Rodríguez: Gestural Translation and Embodied Protest as Knowledge Production." *Hispanic Journal*, vol. 38, no. 2, 2017, pp. 145–162.

Hind, Emily. "Contemporary Mexican Sor Juanas: Artistic, Popular, and Scholarly." *Routledge Research Companion to Sor Juana Inés de la Cruz*, edited by Emilie Bergmann and Stacey Schlau. New York: Routledge, 2017, pp. 107–117.

Juana Inés de la Cruz, Sister. *Obras completas*, edited by Alfonso Méndez Plancarte. 4 vols. Mexico City: Fondo de Cultura Económica, 1951–1957; vol. 1: Lírica personal (1951).

Juana Inés de la Cruz, Sister. *Segundo volumen de sus obras*, edited by Gabriela Eguía-Lis Ponce, and Margo Glantz. Mexico City: UNAM, 1995.

Juana Inés de la Cruz, Sister. *The Answer / La Respuesta*, edited and translated by Electa Arenal and Amanda Powell. 2nd edition. New York: Feminist Press, City University of New York, 2009.

Juana Inés de la Cruz, Sister. *Sor Juana Inés de la Cruz: Selected Works: A New Translation, Contexts, Critical Traditions*, edited by Anna Herron More, translated by Edith Grossman. New York: W. W. Norton, 2016.

Luciani, Frederick. *Literary Self-Fashioning in Sor Juana Inés de la Cruz*. Lewisburg: Bucknell University Press, 2004.

Merrim, Stephanie. *Early Modern Women's Writing and Sor Juana Inés de la Cruz*. Nashville: Vanderbilt University Press, 1999.

Paz, Octavio. *Sor Juana, o, las trampas de la fe*. Mexico: Fondo de Cultura Económica, 1982.

Paz, Octavio. *Sor Juana, or the Traps of Faith*, translated by Margaret Sayers Peden. Cambridge, MA: Harvard University Press, 1988.

Powell, Amanda. "Passionate Advocate: Sor Juana, Feminisms, and Sapphic Loves." *The Routledge Research Companion to the Works of Sor Juana Inés De La Cruz*, edited by Emilie L. Bergmann and Stacey Schlau. New York: Routledge, 2017, pp. 63–77.

Rodríguez, Jesusa, and Liliana Felipe. *Sor Juana en Almoloya (Pastorela Virtual)*. *Debate Feminista*, vol. 12, 1995, pp. 395–411.

Rodríguez, Jesusa. *Sor Juana en Almoloya (Pastorela Virtual)*. December 1995, Hemispheric Institute Digital Video Library. http://hidvl.nyu.edu/video/001148708. html. Accessed 7 August 2020.

Rodríguez, Jesusa. *Sor Juana en Almoloya (Pastorela Virtual)*. Text. Hemispheric Institute of Performance and Politics, Jesusa Rodríguez and Liliana Felipe: El Hábito Collection. https://hemisphericinstitute.org/es/hidvl-collections/ elhabito-performances/item/40-habito-almoloya/40-habito-almoloya. Accessed 28 July 2020.

Rodríguez, Jesusa. *Sor Juana in Prison: A Virtual Pageant Play*, translated by Diana Taylor and Marlène Ramírez-Cancio. *Holy Terrors: Latin American Women Perform*, edited by Diana Taylor and Roselyn Costantino. Durham: Duke University Press, 2003, pp. 211–226.

Rodríguez, Jesusa. *Sor Juana Striptease*. Video of performance at Sixth Annual Hemispheric Institute Seminar, Corpolíticas en las Ámericas / Body Politics in the Americas, Buenos Aires, 11 June 2007. Hemispheric Institute Digital Video Library, 2007. https://www.youtube.com/watch?reload=9&v=jqb2WSzx4x0. Accessed 7 August 2020.

Rodríguez, Jesusa. "Sor Juana's *First Dream* at FOMMA [Fortaleza de la Mujer Maya, San Cristóbal Las Casas, Chiapas]." Hemispheric Institute Digital Video Library, 2009. http://archive.hemisphericinstitute.org/hemi/en/hidvl-profiles/ item/2571-jesusa-sor-juana. Accessed 7 August 2020.

Rodríguez, Jesusa, and Diana Taylor. "Interview with Jesusa Rodríguez: On Sor Juana Inés de la Cruz." Video, Hemispheric Institute Digital Video Library, 2010. http://hidvl.nyu.edu/video/003742321.html. Accessed 7 August 2020.

Rodríguez, Jesusa. "Demo Primero Sueño." (Video for Mexican Television) *YouTube*, uploaded by Lucitzel, 30 May 2013. http://hidvl.nyu.edu/video/000549445.html. Accessed 7 August 2020.

Rodríguez, Jesusa, and Diana Taylor. "'First Dream' Performed: Diana Taylor Interviews Jesusa Rodríguez." Edited and translated by Isabel Gómez, in *Sor Juana Inés de la Cruz, Selected Works*, edited by Anna More. W. W. Norton, 2016, pp. 304–310.

About the Author

Emilie L. Bergmann is Professor Emerita of Spanish and Portuguese at the University of California, Berkeley. She is co-editor, with Stacey Schlau, of *Approaches to Teaching Sor Juana Inés de la Cruz* (2007) and the *Routledge Research Companion to the Works of Sor Juana Inés de la Cruz* (2017).

Section IV

Authoring Identity

16. From Hollywood Film to Musical Theater: Veronica Franco in American Popular Culture

Margaret F. Rosenthal

Abstract

This essay examines American culture's popular fictionalization of the biography and published works of Venetian courtesan poet Veronica Franco for the Hollywood screen. A comparison of the original screenplay of *Dangerous Beauty* with the 1998 film reveals how Franco's story changes from a proto-feminist portrayal of women's agency and literary skill into a romance between Veronica Franco and Marco Venier, a powerful Venetian senator, who defends her against male detractors in the Inquisition courts. While the original screenplay (and the musical that followed in 2011) depicts Franco as a courageous and independent advocate of women's self-determination and creative freedom, in the Hollywood film she becomes a powerless victim who depends on male support to escape public humiliation and ignominy.

Keywords: Veronica Franco, Courtesan, Venice, Hollywood, *Dangerous Beauty*

On February 13, 2011, *Dangerous Beauty* the musical, based on the life of sixteenth-century courtesan poet Veronica Franco, and inspired by the Hollywood film *Dangerous Beauty* (Warner Bros. 1998) reopened the Pasadena Playhouse in Los Angeles.[1] It boasted a Broadway cast and an all-woman creative team that included Jeannine Dominy, the author of the filmic

1 I would like to thank my undergraduate research assistant, Kako Ito, for all of our conversations about the popularizations of Veronica Franco's writings and biography. They have helped shape my views for this essay.

Fitzmaurice, J., N.J. Miller, S.J. Steen (eds.), *Authorizing Early Modern European Women. From Biography to Biofiction.* Amsterdam: Amsterdam University Press, 2022

DOI 10.5117/9789463727143_CH16

screenplay, who drew inspiration from my book *The Honest Courtesan* (1992).[2] Intent on addressing the film's missteps, the writer, producers, and director sought to reinstate the feminist content in Franco's published writings and biography that had been drained from the Hollywood love story that championed romantic intrigue and the sexualized courtesan's body over the outspoken courage of the courtesan poet.[3]

Adapting her original screenplay for the musical book, Dominy returned eleven years later to her powerful biofictional characterization of Franco as a proto-feminist who defended women's autonomy, social justice, and creative freedom.[4] In both the musical and the original screenplay, Veronica struggles to extricate herself from misogynous restrictions that sought to control all Venetian women but never succumbs to victimhood or repentance for the dubious morality associated with her profession.[5] After almost a decade of workshops and performed staged readings at Northwestern, Vassar, ASCAP, the National Alliance for Musical Theatre, and the Rubicon Theater, the musical highlighted Franco's verbal eloquence and poetic wit. According to the show's creative team, it offered a "sequel to the girls who grew up 'Defying Gravity' with *Wicked* and who are now ready as young women to embrace Veronica Franco" (Behrens).

In this essay, I will compare the film *Dangerous Beauty*, directed by Marshall Herskovitz and produced by Ed Zwick (*Shakespeare in Love*) with Dominy's original "Gondola" script (dubbed "Gondola" because Veronica tells the story of her life while traveling through Venice in a gondola), in order to show how the Hollywood film ultimately undoes the "Gondola" script's portrayal of Franco's life and writings as multidimensional and proto-feminist in favor of romance and the conventions of American popular culture.[6] In the "Gondola" screenplay, Veronica seeks to educate Isabelle

2 Published under the title *The Honest Courtesan*, Dominy's screenplay is hitherto referred to as the "Gondola" screenplay, the name she used in discussing it.

3 Deborah Behrens, a Los Angeles journalist, documented the process of bringing Franco's story from book to film to musical stage.

4 On the process of moving from my biography to film and musical, see Rosenthal and McHugh, 2017. Miller and Walters have also written about *Dangerous Beauty* in "Reframing the Picture."

5 I wish to thank Jeannine Dominy for her generous assistance by making available to me her original screenplay and for all of her valuable insights on the process of revision from screenplay to screenplay. I refer to the historical poet as "Veronica Franco" or "Franco" and the character in the film as "Veronica."

6 Marshall Herskovitz said in a 2007 personal interview with my former undergraduate student, Shannon McHugh, that he planned to make the first two thirds of film an advertisement for being a courtesan, and the last third what price she pays for that decision. He added: "I wanted to say something about how hard it is still for us in our culture today to embrace joy

about the underbelly of the courtesan's profession because she suspects that the young girl's mother is forcing her into the profession. Over the course of 24 hours, Veronica relates in unsparing detail her own progression from adolescent to celebrated courtesan. With the benefit of hindsight, she takes her young friend on a gondola journey to the places where courtesans once lived and entertained men in relative luxury. It is Veronica's empathy, wit, and humor that finally earn the trust of this frightened and jaded young woman. At the end of their long day together, they return to Veronica's home in the Casa del Soccorso (a shelter founded in 1577 for married women in danger of sexual corruption); when they part, Isabelle expresses to Veronica her youthful wish that Veronica had stayed with Marco, her lover, and continued to be a courtesan despite the public scorn she endured.[7]

Veronica's life story in the original screenplay is shaped not by men who speak on her behalf but by the distinctly female experiences (mothering, friendship, mentoring) that Franco describes in her familiar letters. Dominy's secure grasp of both Venetian social history and Franco's writings vividly recreates Franco's voice. Historical documents (wills, tax reports, Inquisition trial hearings) also inform Veronica's engagement with the men and women at the center of Dominy's narrative, supplying multidimensional individuals who were subsequently reduced to flat characters in the Hollywood film. A series of flashbacks from 1560 to 1591 constitute the screenplay's dramatic action and bring into sharp relief women's protected lives. Regardless of social register or wealth, whether in marriage or prostitution, women were vulnerable to the trafficking and regimentation of the female body. One of Franco's published letters (22) weaves its way into a number of scenes, particularly those between Isabelle and her mother, who Veronica suspects is coercing her daughter to become a courtesan for her own financial security. In another scene, the language of letter 49 informs Veronica's suspicion that a male writer seeks to defame her with satirical verses.[8] Positioned from the start as an independent-minded young woman aspiring to be a poet, in short measure Veronica is invited to Domenico Venier's informal literary academy to share her verses with the male members.[9] In numerous letters, Franco proudly announces her participation in their meetings and, in one

and sensuality – that we are still so mired down in the destructive, dark difficulties of life that we still live in the residue of the puritanical culture which is really what took over Europe."

7 On the Casa del Soccorso and the Casa delle Zitelle, see Chojnacka, Jones, and Cricchio.

8 Franco, pp. 64–67 and p. 43 respectively. For an in-depth analysis of letter 22, see Ray, pp. 151–154.

9 On the literary salon of Domenico Venier, see Quaintance, pp. 7, 61–62, 68–71, 79–80, and 88–89.

specific letter (39), she adds that unfortunately she was unable to attend as she had hoped because of her responsibilities as a single mother:

> I've neglected writing to you not by choice but against my will, since the misfortune has befallen me of my two young sons' illness these past days – one after the other has come down with fever and smallpox – along with other crises that have kept me busy and worried beyond all measure. Now that, by God's mercy, they're a good deal better, as soon as I could catch my breath in order to fulfill my duty to answer your very gracious letters, and to please myself in no small measure, I've taken pen in hand to write to you, if not as much as I would like, given my other occupations – which like a many-headed serpent, the more I cut them off, the more they multiply – at least enough to pay you the respect I owe. (Franco, p. 43)

Her identity as a mother is entirely omitted from the Hollywood film but is present throughout the "Gondola" screenplay. This level of attention to the complexities of Franco's life is what first encouraged me when embarking on the Hollywood adventure. However, despite the director's best intentions to portray Franco as a pro-woman advocate, Warner Bros.' marketing campaign squashed them when publicizing the film as a bodice-ripping romance. So, too, the US print ad campaign was radically different from others around the globe. In France, Franco is dressed in renaissance garb with sword in hand as a woman ready for combat, while the US campaign featured Franco seductively lying upon red satin sheets in a contemporary-styled nightgown. It is no wonder that one film critic labeled the film "a rousing call for women's lib from the Joan of Arc of post-medieval call girls," adding that Herskovitz and Dominy had "found a modern feminist role model in the world's oldest profession" (Matthews). As the literary theorist, Tania Modleski asserts, it is important to study not only films that are inescapably anti-feminist, but also those that are part of "a major conservative shift in the cultural climate" (Modleski, 1982, p. 34). Herskovitz's professed pro-woman intentions fit this description as he masked the "evils" lurking behind "the most orthodox plots." However "seductive" Franco's story of freedom might have appeared to him, his ideas only "[masqueraded] as theories of liberation."[10]

Accompanied by George Fenton's stirring, melodramatic score, *Dangerous Beauty* pays lip-service to Franco's feminist themes. It ultimately reinforces women's dependency on men. The story of Veronica Franco is told through

10 Modleski (1991, p. 4). I thank Shannon McHugh for pointing out to me this connection between Franco's film reception and Modleski's theories.

a rose-colored lens. It focuses on Veronica's hope to rise above her family's established but impoverished social status by marrying the man whom she loves, the Venetian aristocrat, Marco Venier (Rufus Sewell), a powerful senator. Marco claims to return her love but is forced by his father and mother to marry a noblewoman, Giulia da Lezze (Naomi Watts). Franco's business-like mother, Paola (Jacqueline Bisset), a former courtesan not as brilliant as her daughter, sees the financial advantages that a union with Marco Venier might provide. But she also knows that Veronica will never be able to marry him for want of a sufficient dowry, and their lower social status. She instructs Veronica that she "can still have Marco. But not in wedlock."

When Marco confirms that he cannot marry her, Veronica indignantly insists that her family are "citizens." Indeed, Franco was a Venetian native-born citizen, belonging by hereditary right to a professional caste that made up the government bureaucracy and confraternities. Marco has all the economic and societal privilege that his station affords him. But the film concentrates less on his social status and more on how his romantic feelings substitute for privilege because he is trapped into a dutybound and loveless marriage. Even though Veronica lacks the ability to make choices about her own life, Herskovitz never refrains from displaying her unabashed enjoyment of sexual pleasure. When interviewed, Herskovitz expressed his fascination with the contrast between the courtesan's "open expression of female sexuality" and Venetian women of high standing's "inability to speak of such things or act upon them."[11]

Veronica's mother instructs her daughter in how to become a high-level courtesan. As Veronica becomes more and more visible with high-profile men, married women shun her. Similarly, those men who cannot afford her favors condemn her, using her as a scapegoat when Venice's indulgence in luxuries and opulence bring the wrath of God upon the Venetian populace. Maffio Venier (Oliver Platt), Marco's cousin, publicly humiliates her because he, as a courtier poet, is threatened by the attention she receives from his uncle, Domenico Venier (Fred Ward), the once powerful senator.

Veronica makes much use of her intelligence and the intimacy she shares with men to build a life of luxury. She exercises considerable political savvy. However, when Venice is under threat by the Turkish sultan and the plague decimates the Venetian population, her glamorous life takes a dramatic downturn, culminating in accusations of witchcraft that land her in the Venetian Inquisition courts. Her passionate avowal of the power of love as a redemptive force prompts a backlash from both religious and political figures. Although she exposes her life to mortal danger, she prevails in the

11 Personal interview with Marshall Herskovitz, conducted by McHugh.

end by relying on the support of her lovers, in particular Marco Venier, who literally stands in her defense. In the film, it is Marco's heroic act, more than any words of her own, that acquits her. He rescues her from imprisonment or death. She lives happily ever after with him and, in the film's closing shot, we see them sail in a gondola into the sunset.

While a number of precise details come from Franco's real-life circumstances, numerous changes to her biography move the film's protagonist so far away from the historical record that she disappears into a fictional construction buoyed by the romance plot. Modleski uses the term "disappearing act," a term she borrows from a television commercial for the popular Harlequin romance novels in which a middle-aged woman describes how the paperbacks allow her to "hide" from the real world. Modleski says that the romance novel's female protagonist "can achieve happiness only by undergoing a complex process of self-subversion, during which she sacrifices her aggressive instincts, her 'pride,' and – nearly – her life" (1982, pp. 36–37). It is precisely this type of "self-subversion" and "sacrifice" that Hollywood imposes on Veronica, who is no longer the definer of her own actions.

While the opening credits roll, the viewer is asked to believe that "the following story is true." Constructed on Fellini's legendary sets that hosted such epics as *La dolce vita, Amarcord, E la nave va*, to the unsuspecting eye the film appears to unfold in Venice itself. However, after scouting locations in Venice, the producers decided that filming on the Grand Canal was logistically difficult and expensive. The ornate architecture and canals were re-created by award-winning production designer, Norman Garwood (*Brazil*), and only a few scenes were shot on location. This hyper-real Venice mimics the fictionally constructed romance plot. The aesthetic alignment of Herskovitz's cinematic simulacrum of Venice with America's obsession with "hyper reality," deepens the divide between history and biofiction, between feminist biography and romance bodice-ripper. Any commitment to historical context or feminist content that biography and history allow is replaced with a make-believe, hyper-real simulacrum of Venice and the Venetian courtesan. No longer does Veronica openly counter the men who had once championed her talents as an extension of the Republic's liberality. Rather, she is forced into silence for overstepping prescribed female behavior.

The film's opening slow-motion zoom on Veronica's expressionless face, with sensual painted lips slightly parted, then moves over her reclining body propped up on red and gold bed cushions. Stereotypical romantic images appear in slow motion one after the other – glittering waves in the Venetian sunlight; pink and red rose petals tossed into the air; gondola-perched courtesans in soft focus and muted chiaroscuro shading. The voiceover of

an unknown woman whom we come to understand is Veronica speaks in
rhymed couplets invented for the film, while gondolas parading courtesans'
fetishized bodies for public entertainment and male consumption float
down the Grand Canal.

Conversely, the first flashback in the "Gondola" screenplay introduces a
young, more worldly and clever Veronica, not yet a courtesan, as she watches
bejeweled courtesans competing in gondola races. Among the spectators
is Marco Venier, who is described as "regally self-assured, jovially good
humored, and a bit of a rake." Franco is with her childhood friend, Beatrice,
Marco's prim and straight-laced sister, who has been sheltered from the
coarser realities of Venetian life:

> Beatrice
>
> The bishop says sin's catching.
>
> Veronica
>
> He didn't mean sin he meant syphilis.
>
> Beatrice
>
> Veronica! What's syphilis?
>
> Veronica
>
> The French pox.
> (Dominy, p. 5)

To introduce courtesans and their high-level male clients as connected to
contagious diseases quickly reverses Hollywood's insistence on glamorizing
the courtesan's life or normalizing the threat of sexual violence and contagion.
This scene draws from Franco's powerful indictment of prostitution in her
letter 22. She writes forcefully to a mother who wants to prostitute her young
daughter's body for personal gain. She cautions her that the life of even the
most skilled courtesan "always turns out to be a 'misery'." Written in the invec-
tive mode, Franco angrily chastises her friend's unethical behavior. Similarly,
Veronica will try to disabuse Isabelle from the notion that a courtesan's riches
are acquired at no physical or spiritual expense to herself; no wealth, she
tells Isabelle, will ever minimize the horror of selling one's body and soul.

In letter 22, Franco equates the sexual exchange between client and courtesan as a rape. If it results in being exposed to "dreadful contagious diseases," this mother is then the equivalent of a rapist's accomplice because she is the initial instigator of her daughter's ruin.

> It is a most wretched thing, contrary to human reason, to subject one's body and industriousness to a servitude whose very thought is most frightful. To become the prey of so many, at the risk of being despoiled, robbed, killed, deprived in a single day of all that one has acquired from so many over such a long time, exposed to many other dangers of receiving injuries and dreadful contagious diseases; to eat with another's mouth, sleep with another's eyes, move according to another's will, obviously rushing toward the shipwreck of one's mental abilities and one's life and body. What greater misery? What wealth, what luxuries, what delights can outweigh all this? (Franco, p. 39)

Although Franco recognized how social and gender inequities contribute to how men and women experience poverty differently, she was also aware of the existence of Venetian charitable institutions that protect girls "at risk." Franco implores her friend to reconsider her actions before the fate of her innocent daughter is permanently sealed:

> Where once you made her appear simply clothed and with her hair arranged in a style suitable for a chaste girl, with veils covering her breasts and other signs of modesty, suddenly you encouraged her to be vain, to bleach her hair and paint her face. And all at once, you let her show up with curls dangling from her brow and down her neck, with bare breasts spilling out of her dress, with a high, uncovered forehead, and every other embellishment people use to make their merchandise measure up to the competition. I showed you how to shelter her from danger and to help her by teaching her about life in such a way that you can marry her decently. I offered you all the help I could to assure that she'd be accepted into the Casa delle Zitelle, and I also promised you, if you took her there, to help you with all the means at my disposal, as well. (Franco, p. 65)

The mother had rejected her help just as Veronica suspects Isabelle's mother will do.[12] However, in the "Gondola" screenplay, Franco's concern is less with the mother and more with the daughter. Rather than divide mother and

12 Veronica convinces Isabelle's mother that she is taking her daughter to her first client but is using this as a pretense to be able to have sufficient time to advise Isabelle about her choices.

daughter from one another, Veronica, in an act of female friendship, offers to mentor Isabelle. In Janice Radway's essay on the romance genre, she states that because the heroine's ultimate fulfillment is to be found through heterosexual romantic love alone, it "ensures the impossibility of women getting together" and therefore precludes any challenge to the hegemonic patriarchy (p. 43). Conversely, Veronica is ready to help steer Isabelle away from prostitution by first correcting her mistaken beliefs that riches (especially the jewels Veronica wears) are the sole rewards of the courtesan's occupation.

Unlike the "Gondola" screenplay, *Dangerous Beauty* never depicts courtesans as allies, or any two women as friends in support of one another. Women are competitors and they do not even possess a voice to complain. A small section from Franco's letter 22 is evident in a brief but poignant exchange between Beatrice and Veronica. Beatrice romanticizes the courtesan's freedom when she entreats Veronica to make her daughter into a courtesan. Beatrice compares her loveless marriage to Veronica's independence. In response, Veronica takes her to the poorest region of Venice "where courtesans go to die."[13] Rather than investigate the severe compromises courtesans like Franco had to make, the film turns the aging courtesan into a potential procurer of another woman's "freedom." Veronica refuses to "pimp" Beatrice's daughter and corrects her misguided ideas about the courtesan's livelihood: "My cage seems bigger than yours, but it is still a cage." When Veronica refuses to comply with Beatrice's wishes, the gulf between them widens even further.

When compared to the Hollywood film, the "Gondola" screenplay's depiction of a courtesan's life is sobering if not frightening. In an early scene, Veronica loses her virginity to the Venetian Doge. She is prepared by her maid and offered to him like a newborn lamb led to slaughter:

> Clarice, a lady's maid, helps Veronica undress from the ball. The doors open. Paola ushers in the Doge. Veronica gasps, yanks up her dress and curtsies simultaneously. Clarice bustles out, looking daggers at Paola. Paola exits, closing the door. Veronica peers up. The Doge approaches. Runs a finger along her cheek and throat. She's trembling violently. He pulls her up. Burrows his face in her neck. Veronica screams: "Mama. MAMA!"
> (Dominy, p. 10)

13 Franco fell on hard times in the last decade of her life. A pair of legal documents and a petition to the Venetian government clarify her impoverished economic situation in her mid to late thirties. See Rosenthal (1992, pp. 85–87). On the gendering of female spaces in Venice, see Sandra Weddle, and for the erotically charged spaces for prostitutes, see Diane Wolfthal.

In later scenes, when Veronica has become a successful courtesan she enters into sparring matches with Venetian poets like Marco Venier, who is both her lover (but never her client) and fellow poet. Jealous of the men whom Veronica entertains, he chastises her publicly.[14] In another sequence, Veronica is part of an all-male hunting group led by Marco, which includes a number of Veronica's clients. Marco asks Veronica to exchange verse with him. Having already crossed over into male territory, this poetic exchange places her in an even more precarious position. As she delights her male listeners with wit and poetic acumen, Marco interrupts her performance with jealous vitriol and obscene retorts that are at once sexually graphic and vicious.

 Marco

Madonna Veronica.
Veritably unique whore.
May sing and rhyme and more. She's still at best a slut,
For every horny mutt [...]

 Veronica

Though I hold a poet's pen,
And discourse with learned men,
I am still a woman born
And cannot escape your scorn.

 Marco

You pride yourself on arts and letters,
And fucking best your manly betters.

 Veronica

I save the goodly wives of Venice
From their husband's lustful menace.
(Dominy, p. 34)

14 Dominy conflates Marco and Maffio Venier when Marco delivers scathing attacks against Veronica. In fact, it was Maffio, his cousin, a Venetian dialect poet, who wrote poems against her. See Rosenthal (1992, pp. 51–57).

As if to dramatize in graphic detail the bodily risks and public humiliation that await the courtesan, these filmic sequences also emphasize Franco's gender-bending language. When Marco's rejoinders become more and more personally humiliating, Veronica is left to defend herself alone. Unarmed in the physical world but not in the literary realm, she fights Marco on his own turf: they both have studied the same poetic styles and are on equal ground. But this lover's quarrel is more than a poetic contest. His insults catapult her into an arena that knows no control:

Marco

Then you confess you love to rut
And your beauties gladly strut.

Veronica

I confess I fuck divinely those
Who love and well opine me [...]

Marco

What cost to greet with open legs
All comers to your busy beds.

Veronica

A heart and mind and soul like you,
And not the weakness you imbue.

Marco

A greedy hand and empty heart
is all that wrests your lips apart.

Veronica

And if my friend they part for you,
Would you know quite what to do?

Marco

I'd fill the void with nature's spite,
And not be missed by slut or wife.

Veronica

To arms, to the battlefield,
You do all women false.
I shall show the gentle sex
What their silence costs.

Marco

Ever and abominable war man wages,
Against himself in sweet loves' Rages,
That in the end he cannot love nor trust,
His beloved's heart stained by repugnant lust.
(Dominy, pp. 34–35)

Driven from the hunt by a sense of danger lurking in Marco's slander, Veronica wanders distraught and confused into the woods where she views a hut surrounded by rough-looking men lining up "waiting their turn." They include a "pock-faced man who exits, buttoning his pants." This unruly mob is about to gang rape a courtesan, just like Angela Del Moro (dubbed "la Zaffetta") was allegedly ravaged by no less than 80 men in front of her Venetian noble lover, who had planned the attack against her. Angela's shame for resisting him was the cause for celebration "both by the collective of rapists who victimized her and by the poet himself."[15]

Dominy dramatizes the Venetian *trentuno* (euphemism for gang rape), a satiric poem made popular by Venetian male poets in the 1530s. She invents Firmatta, a Venetian courtesan, who is brutally ravaged. In a collective display of male sexualized power, Firmatta, the unruly courtesan, "needs to be disciplined" by the grotesque assault of a group of men. Courtney Quaintance explains that Venetian poets used the print medium to defame and discipline "hypersexual, promiscuous women who transgress social boundaries." Male writers, she argues, "judge and then dominate prostitutes,"

[15] For an extensive explanation of the literary *trentuno* within Venetian male literary society, particularly in Ca' Venier, see Quaintance, pp. 41–49, and Rossi.

thereby affirming and strengthening "the bonds between men" (Quaintance, p. 49). The historian Guido Ruggiero notes that actual group rapes such as the one against Angela Del Moro (la Zaffetta) were most likely not uncommon in sixteenth-century Venice (1993, pp. 7–18).

Dominy sutures this gruesome scene of sexual violence onto the intimate story of Marco and Veronica's love but does not use it to sanitize sexual abuse in favor of romance. Because Marco can never fully accept the fact that Veronica, a courtesan, has multiple lovers, his jealousy builds to such a degree that he places Veronica in an increasingly vulnerable position. When Veronica witnesses Firmatta's *trentuno*, her horror drives her to assist Firmatta, who desperately needs physical and emotional help. The specter of syphilis looms large when Firmatta exclaims: "He had syphilis; they do it on purpose. Give it to you. Don't let them love you. It makes them mean."[16] Since Veronica is recounting this ordeal to a panic-stricken Isabelle, she reminds her that Firmatta "regained her reputation, the smartest ones always do" (Dominy, p. 36). So that Isabelle does not confuse sexual aggression with passionate love, Veronica also quickly equates sexual and physical danger to when a "man falls obsessively in love with a courtesan. He can't marry her, but he can't bear anyone else having her. He stops playing by the rules" (Dominy, p. 37).

In the final sequences of the "Gondola" screenplay, Veronica is tried before the Inquisition tribunal. Once again, she refuses to "play by the rules," when asked to confess her "sins" of witchcraft as the court demands. In the end, both Veronica and the real-life Franco were exonerated from accusations of witchcraft and heresy owing to their self-defense. Franco benefitted greatly from the tribunal's leniency because in 1580 they dropped numerous charges of magical incantations against women.[17] The high drama of the Inquisition scene in *Dangerous Beauty* when Veronica "hovered on the brink of extermination" parallels the exaggerated romance between Veronica and Marco. Conversely, in the "Gondola" script when she leaves the Venetian tribunal in triumph, she finds Marco waiting to take her away. When he asks her: "Will you let me," Veronica quickly finishes his sentence with, "Keep me as your mistress? The old ways are dead. There are no consorts now.

16 On the scourge of syphilis in early-modern Venice, see McGough. On sex in Venice in the sixteenth century, see Ruggiero, 2013.

17 These types of accusations and hearings were not uncommon in the late sixteenth century in Venice: the tensions resulting from the plague, from an increased counter-reformatory religious fervor and the many petty and vindictive squabbles between neighbors, spurned lovers and disgruntled servants, brought hundreds of trials before the Inquisition courts that should have been more properly heard in the state courts. On the Inquisition hearings against Venetian women, and Franco, in particular, see Rosenthal (1992, pp. 163–177).

Only whores." He follows with, "How can I love you," to which she resolutely responds: "Give me my freedom" (Dominy, p. 63). Unlike the Hollywood film that defines "freedom" as living out her days with Marco as her lover, Veronica's definition of "freedom" in the original screenplay means living independently of men and on her own terms.

Many of the misfortunes that Franco endured in the last decades of her life are omitted in the Hollywood film, including being robbed of precious items from her dowry during the plague of 1575–1577, and the death of Domenico Venier, her patron, in 1582. A final tagline in the film announces: "[I]n the years to come, Veronica Franco used her home as a sanctuary for victims of the Inquisition" – a statement as false as the film's opening line, "the following story is true."[18] In marked contrast, the final scene in the "Gondola" script has Veronica returning to the Casa del Soccorso, her new home, after the day she has spent with Isabelle. She says goodbye to her young friend but not before telling her that she "can always come here. You'll be welcome. The choice is yours."[19]

With these simple parting words, Veronica articulates a vision of collective female unity, a woman's power to choose her purpose in life, and the importance of female friendship, often expressed in Franco's poems and letters. This call to women does not exclude men but it reaches beyond them to generations of women who still find comfort and inspiration in her pioneering wisdom.

> As if jolted awake from sweet sleep all at once,
> I drew courage from the risk I avoided,
> though a woman, born to milder tasks [...]
> And to prove to you that I speak the truth,
> among so many women I will act first,
> setting an example for them all to follow [...]
> And I undertake to defend all women
> against you, who despise them so
> that rightly I'm not alone to protest.

(Franco, *capitolo* 16, lines 31–33, 73–75, 79–82)

18 In a personal interview, Dominy stated: "Audiences are smarter than we give them credit for. They can deal with truth and probably would've come away with a greater appreciation of Veronica Franco if we told the truth about how hard it was" (Dominy 2006).

19 In the "Gondola" script, Marco and a few Venetian noblewomen even contribute funds to support the founding of this female asylum. On Franco's conception of the Casa del Soccorso in a petition she drafted in 1577 to the Venetian government, see Rosenthal (1992, pp. 131–132).

Works Cited

Behrens, Deborah. https://thisstage.la/2011/02/the-dangerous-beauty-diaries. Accessed 28 January 2011.

Chojnacka. Monica. "Women, Charity and Community in Early Modern Venice: The Casa delle Zitelle." *Renaissance Quarterly*, vol. 51, no. 1, 1998, pp. 68–91.

Cricchio, Kelly R. "Reforming Beauty: The Casa delle Zitelle and Female Asylums in Early Modern Venice." PhD dissertation, San Jose State University, 2019.

Dominy, Jeannine. *The Honest Courtesan* (called the "Gondola" screenplay by author). Los Angeles: Creative Artists' Agency, 1994.

Dominy, Jeannine. Personal interview with Shannon McHugh. 29 June 2006.

Jones, Ann Rosalind. "Prostitution in Cinquecento Venice: Prevention and Protest." *Sex Acts in Early Modern Italy*, edited by Allison Levy. New York: Routledge, 2017, pp. 43–56.

Franco, Veronica. *Veronica Franco: Poems and Selected Letters*, edited by Margaret F. Rosenthal and Ann R. Jones. Chicago: University of Chicago Press, 1998.

Herskovitz, Marshall, director. *Dangerous Beauty*. Warner Bros., 1998.

Herskovitz, Marshall. Personal interview conducted by Shannon McHugh. 15 May 2007.

Matthews, Jack. "Bawdy Silliness Reigns in *Dangerous Beauty*." *Los Angeles Times*, 20 February 1998. https://en.wikipedia.org/wiki/Tronc. Accessed 12 November 2017.

McGough, Laura J. *Gender, Sexuality, and Syphilis in Early Modern Venice: The Disease That Came to Stay*. New York: Palgrave Macmillan, 2011.

Miller, Naomi J., and Lisa Walters. "Reframing the Picture: Screening Early Modern Women for Modern Audiences." *World-Making Renaissance Women: Rethinking Women's Place in Early Modern Literature and Culture*, edited by Pamela S. Hammons and Brandi R. Siegfried. Cambridge: Cambridge University Press, forthcoming 2021, pp. 70–85.

Modleski, Tania. *Loving with a Vengeance: Mass-Produced Fantasies for Women*. Hamden, CT: Archon Books, 1982.

Modleski, Tania. *Feminism Without Women: Culture and Criticism in a "Postfeminist" Age*. New York: Routledge, 1991.

Quaintance, Courtney. *Textual Masculinity and the Exchange of Women in Renaissance Venice*. Toronto: University of Toronto Press, 2015.

Radway, Janice. *Reading the Romance: Women, Patriarchy and Popular Literature*. Chapel Hill: University of North Carolina Press, 1984.

Ray, Meredith K. *Writing Gender in Women's Letter Collections of the Italian Renaissance*. Toronto: University of Toronto Press, 2009.

Rosenthal, Margaret F. *The Honest Courtesan: Veronica Franco: Citizen and Writer in Renaissance Venice*. Chicago: University of Chicago Press 1992.

Rosenthal, Margaret F., and Shannon McHugh. "From Helicon to Hollywood: A Dialogue on Veronica Franco and *Dangerous Beauty*." *Early Modern Women: An Interdisciplinary Journal*, vol. 11, no. 2, 2017, pp. 94–114.

Rossi, Daniella. "Controlling Courtesans: Lorenzo Venier's *Trentuno della Zaffetta* and Venetian Sexual Politics." *Sex Acts in Early Modern Italy*, edited by Allison Levy. New York: Routledge, 2017, pp. 225–240.

Ruggiero, Guido. "Marriage, Love, Sex and Renaissance Civic Morality." *Sexuality and Gender in Early Modern Europe: Institutions, Texts, Images*, edited by James Grantham Turner. Cambridge: Cambridge University Press, 1993, pp. 10–30.

Ruggiero, Guido. "Wayfarers in Wonderland: The Sexual Worlds of Renaissance Venice Revisited." *A Companion to Venetian History, 1400–1797*, edited by Eric Dursteler. Leiden: Brill, 2013, pp. 543–569.

Weddle, Sandra. "Mobility and Prostitution in Early Modern Venice." *Early Modern Women: An Interdisciplinary Journal*, vol. 14, no. 1, 2019, pp. 95–108.

Wolfthal, Diane. "The Woman in the Window: Licit and Illicit Sexual Desire in Renaissance Italy." *Sex Acts in Early Modern Italy*, edited by Allison Levy. New York: Routledge, 2017, pp. 57–75.

About the Author

Margaret F. Rosenthal is Professor of Italian at the University of Southern California, author of *The Honest Courtesan: Veronica Franco, Citizen and Writer of Sixteenth-Century Venice*, and editor and translator of *Veronica Franco: Poems and Selected Letters* and *Clothing of the Renaissance World*, a translation of Vecellio's 1590 costume book.

17. The Role of Art in Recent Biofiction on Sofonisba Anguissola

Julia Dabbs

Abstract

In recent years the life stories of early modern women artists have inspired many works of biofiction; yet often authors know more about what the artists created than the facts of their lives. This essay will explore the intermediality between visual and verbal content by exploring the role of art in two recent novels on the Italian Renaissance painter Sofonisba Anguissola: Donna DiGiuseppe's *Lady in Ermine: The Story of a Woman Who Painted the Renaissance* and Chiara Montani's *Sofonisba: Portraits of the Soul*. In the process I will explore the Renaissance *paragone* debate and consider how verbal descriptions of artworks may (or may not) enhance our understanding of the artist's fictionalized character.

Keywords: *paragone*, women visual artists, Sofonisba Anguissola, biofiction, Donna DiGiuseppe, Chiara Montani

What makes biofiction about an early modern woman painter different from that concerning female musicians, authors, or other artists? In a word, paintings. Biographical background is frequently lacking on these women, so known artworks can supply helpful information regarding who the artists knew, what their artistic ambitions were, and what they looked like (if they created self-portraits). However, artworks can do more than provide missing information: they can serve as windows into the artist's physical, intellectual, and emotional worlds, allowing us to more fully enter into the life of that protagonist, to see what they see, think, and feel – if the artworks are used effectively.

Two recent works of biofiction about the Italian Renaissance painter Sofonisba Anguissola (c. 1535–1625) particularly have struck me in terms of

Fitzmaurice, J., N.J. Miller, S.J. Steen (eds.), *Authorizing Early Modern European Women. From Biography to Biofiction*. Amsterdam: Amsterdam University Press, 2022

DOI 10.5117/9789463727143_CH17

how her artworks were integrated into the novels: Donna DiGiuseppe's *Lady in Ermine: The Story of a Woman Who Painted the Renaissance* and Chiara Montani's *Sofonisba: Portraits of the Soul*. Anguissola has been the subject of eight works of biofiction between 2006 and 2019,[1] even though she is less well-known than the Baroque superstar Artemisia Gentileschi. Yet there are numerous reasons why Anguissola would be a popular subject. First, Anguissola had either direct or indirect ties with significant historical figures such as Michelangelo, Pope Pius IV, and King Philip II and Queen Isabel of Spain. Anguissola served the Spanish royalty from 1559 to 1573, allowing for a fictionalized setting of court intrigue and glamour seen through the eyes of a modest "outsider" with whom the reader might more readily connect. In addition, Anguissola's personal life had some dramatic vicissitudes: she received an invitation to serve at the court in Spain, but this meant leaving her family in Cremona, Italy indefinitely (and as it happened, for the rest of her life). Anguissola's first marriage was arranged by the Spanish court; but this obligatory relationship ended after eight years when her husband died at sea. A few years later while traveling back to her family in Cremona, Sofonisba[2] fell in love with the ship's captain, Orazio Lomellino, and despite objections from her family, the couple married. Through these personal as well as professional challenges, Anguissola kept painting, which suggests a woman of great personal strength, independence, and resilience – character traits which readers might value as inspiring or even heroic.

Finally, and especially significant, there is Anguissola's art: some 34 paintings and drawings have been firmly attributed to her (Cole, pp. 155–186),[3] and they've gained some public notice through museum exhibitions and publications. Indeed, one of the first modern-day books about the artist titles her the "first great woman artist of the Renaissance" (Perlinghieri). Anguissola's particular gift was for naturalism, as we see in her early masterpiece, *The Chess Game*, which captures three of her sisters in a moment in time. Even in her court portraiture Anguissola stood apart from her male colleagues by humanizing the harsh formality of official portraits, such as her portrait of King Philip II in which he holds a rosary (Madrid, Prado Museum). She also painted her self-portrait at least ten times, the most of

1 The authors of these novels (in addition to DiGiuseppe and Montani) are Boullosa; Cullen; Damioli; de Medici; Pierini; and Sautois.

2 I will be referring to the artist as "Sofonisba" in more personal contexts and "Anguissola" in professional ones.

3 Numerous other paintings have been attributed to Anguissola, for which see Cole (pp. 186–253).

any artist before Rembrandt, allowing us to visually connect with this artist who gazes confidently at us.[4]

Clearly there is much historical and art historical content that novelists could work from; but when writing biographical novels about women artists in particular, the focus can often be on the emotional tides brought on by internal and external conflicts,[5] leaving the creation of art to the background. One potentially key difference here is that both of these novelists have backgrounds in art or art history: DiGiuseppe wrote her master's thesis on Anguissola, and Montani's background is in art and design.[6] Additionally, both authors indicate that they studied Anguissola's artwork in person, which makes a significant difference when writing authentically about art. In this essay I will examine how each author makes use of these paintings to construct the narratives and to illuminate the artist's character, and then will directly compare their discussions of a few key paintings by Anguissola. In so doing we will reprise the Renaissance *paragone* debate between visual and verbal descriptions, and thus give further attention to the limitations of and liminalities between these two media. Ultimately, I hope that this intermedial approach will broaden our methods of analyzing biofiction about women artists.

The role of art in DiGiuseppe's *Lady in Ermine*

DiGiuseppe, a first-time author, ambitiously explores Anguissola's life from her teenage years to her deathbed in this third-person narrative. "Sofi" (as she is informally nicknamed) is absorbed by art from a young age; in an initial scene the young artist is mesmerized by a saint's face in a church altarpiece because it seems to reveal the holy woman's soul – and as the reader discovers later, this is the goal that Anguissola has for her portraiture as well (p. 36). Although that goal is very much in keeping with how an art historian might interpret Anguissola's artwork, the novelist's description of particular portraits consistently are too brief to adequately convey the "soul-like" quality of the sitter, at least to this reader. For example, one of the key portraits in

4 Sources used for background on Anguissola are Cole and Gamberini. Anguissola was also the subject of numerous life stories in the early modern period; one of the most complete and knowledgeable is that of Raffaele Soprani, translated in Dabbs (pp. 112–118).

5 As Alexandra Lapierre states, "Inner conflict is at the heart of every literary work dealing with a woman artist" (p. 77). See also Lent on the exaggerated emotionalism apparent in fiction concerning Artemisia Gentileschi.

6 See Montani's website for more on her as an artist.

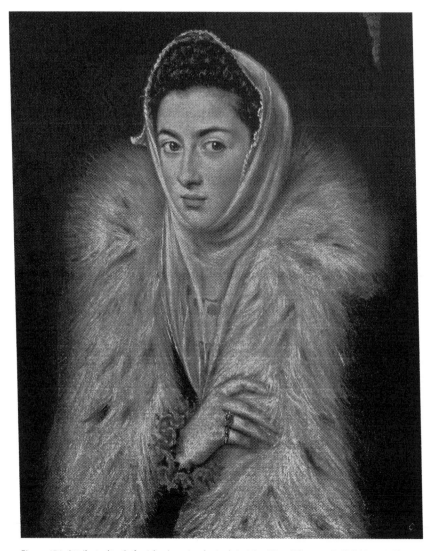

Figure 17.1. Attributed to Sofonisba Anguissola, *Lady in A Fur Wrap* (Glasgow, Pollok House). Photo credit: Album / Alamy Stock Photo.

the novel, the titular "Lady in Ermine" portrait purported to be of the Infanta Catalina Michaela (Fig. 17.1), is sketched out in the following passage:

> Instead of a formal gown, Sofonisba posed the duchess in a headscarf wrapped in ermine, as if she were set to travel – ready to go, but waiting for the opportunity. [...] The painter emphasized the duchess' searching eyes: open to possibilities she might never know [...] Sofonisba decided the portrait would have no background. (p. 331)

To be fair, this is not the entirety of the portrait-making process as described by DiGiuseppe, since preceding this passage we hear Anguissola's internal dialogue regarding how she "reads" Catalina's physical and emotional traits, as filtered through the lens of their past interactions. Her interpretation is encapsulated by the words "lovely and sad" (p. 331), and certainly the resulting portrait is strikingly beautiful; but is the young woman also sad? This emotional trait suits the verbal Catalina in the plotline that DiGiuseppe has constructed, yet to my mind is questionable when applied to the visual Catalina, given her alert, bright eyes and the upturned corners of her mouth. Certainly this discrepancy could be a matter of interpretation; yet if the author had indicated *how* this sadness was conveyed in the portrait through further description, that quality of her soul might have been more effectively reinforced. Thus, when actual artworks are described in biofiction there can be some complication for readers if the author's interpretation of that visual "truth" doesn't coincide with what we see and interpret (and especially when that artwork is on the book's cover).[7]

Early in the narrative DiGiuseppe establishes another artistic goal for the painter: the creation of a "masterpiece." This *topos*, a familiar one in artistic biography, is introduced as something that Sofonisba feels she must achieve in order to gain credibility as a woman artist. Prior to leaving for the Spanish court she realizes, with her father's encouragement, what the ultimate subject for this masterpiece would be – a portrait of King Philip II (p. 60). This would be a lofty goal for any Renaissance artist but virtually impossible for a woman, for even if she were able to obtain a court position as a portraitist, she would be relegated to painting portraits of the female members of the court, or their children, simply due to her gender.[8] Nevertheless, this career goal helps to propel the narrative for the first two-thirds of the book. First, Anguissola must gain the confidence and trust of the Queen and the King as a loyal court member despite her "outsider" (that is, non-Spaniard) status. She then paints a portrait of Queen Isabel that is well-received (but barely described by the author), as well as a successful

7 Another potential problem is an artwork's attribution; the consensus of most art historians is that *The Lady in Ermine* is not by Anguissola, but by either Alonso Sanchez Coello or El Greco. However, DiGiuseppe is aware of this issue, and explains on her website why she believes the painting is Anguissola's (October, 2019). Interestingly, the cover image was changed to a self-portrait by Anguissola in a self-published 2020 edition of the book.

8 One notable exception was Levina Teerlinc, who served the English court in the sixteenth century; however, as a miniaturist, her skills would be seen as entirely appropriate for a woman artist and thus not as transgressive as Anguissola's creating a larger-scale, official portrait of the king.

portrait of the erratic Prince Carlos, moving closer to her goal. However, DiGiuseppe then introduces a dramatic biographical *topos* especially associated with male artists: competition (Kris and Kurz, pp. 120–125). For Anguissola to create a portrait of the king her skills must match or even go beyond those of the king's misogynistic official portraitist, Alonso Sanchez Coello. She also knows that such a portrait would be compared to those by the even greater Venetian Renaissance artist Titian, whose works could be seen in the royal collection.

Coello's opposition is rather quickly eliminated after Anguissola's portrait of Queen Isabel is publicly celebrated; and with the intercession of Queen Isabel, the woman painter receives her ultimate commission. But now more drama ensues, again reliant on *topoi* from artistic biography. First, in the process of painting the king's portrait, Sofonisba suffers from artist's block (which happens on other occasions as well), primarily because her internal image of the king is negatively framed by his involvement with the Inquisition in Spain. Nevertheless, Anguissola perseveres and finally completes the canvas, but is so dissatisfied that she destroys the portrait just prior to its being unveiled to the court – thus fulfilling the artist "self-destruction" *topos* demonstrated so effectively by Michelangelo in Irving Stone's *The Agony and the Ecstasy*. Now Sofonisba is under even more pressure to produce the "masterpiece." She re-paints the portrait, but both she and the king realize that it lacks the ineffable quality of being *al vero* ("truthful" or verisimilar).

Anguissola then asks to redo the portrait after she observes the king's expression of intense grief and piety following the death of Queen Isabel. The artist finally is able to capture this new, and rather vulnerable, "truth" of King Philip, who in the final painting holds a rosary and has one arm upon a chair's armrest for support.[9] As the narrator confirms, "Sofonisba found her *al vero*" (p. 247).

But at this critical narrative juncture in which Anguissola has achieved her long-desired "masterpiece," there are 50 more years in her life. The artist's creativity, which had been effectively foregrounded by the author up until this point, is now submerged by a dramatic story line focused on personal issues: the arranged, unhappy first marriage; financial difficulties; the sudden death of her husband; new love; familial objection; and second marriage. This is not to say that Anguissola's artwork is completely disregarded; it can't be, given DiGiuseppe's adherence to the chronological

9 Technical studies have shown that this portrait indeed was repainted (de Celis, Garcia, and Carcelén, p. 76), which presumably informed DiGiuseppe's plotline.

output of her work, which lends the novel a greater sense of historical veracity. Now, however, those few paintings mentioned are used as a rather perfunctory means of revealing the artist's emotions. For example, Anguissola's altarpiece of the *Madonna dell'Itria* is painted as a means of expiating her guilt and contrition at the sudden death of her husband (p. 283). Then slightly later in the novel, regretting her lack of biological children, Anguissola "returned home and transferred her unrequited urges to painting a Madonna and Child for her own collection" (p. 337). Here DiGiuseppe makes use of another literary *topos* in which works of art substitute for biological children (Kris and Kurz, pp. 115–116).[10] For the modern reader, however, this psychoanalytical and biologically limiting emotional reaction can seem unsatisfying; it ignores other factors that may have led Anguissola to paint a Madonna and Child, such as her own religious devotion.

The role of art in Montani's *Sofonisba: Portraits of the Soul*

Montani, also a first-time novelist, focuses on a shorter time span in Anguissola's life, from her teenage years to the beginning of her second marriage. From the opening we see that art will play a central role in this narrative, for example when the author states: "In the beginning there was colour" (p. 12). As in DiGiuseppe's novel, Anguissola's artworks are frequently mentioned in Montani's biofiction, and similarly serve as chronological markers of the artist's life. However, there is much less narrative emphasis on achieving an artistic "masterpiece"; in fact, this "Sofi" is initially "dismayed" when she is asked to paint King Philip II's portrait because of the inevitable comparisons that would be made to great masters such as Titian (p. 112). What Montani does emphasize, and to a much greater degree than DiGiuseppe, are the psychological, physical, and intellectual processes involved in creating art. This emphasis likely reflects Montani's identity as a practicing artist, but also is consistent with the fact that this novel is a first-person narrative voiced by Anguissola.

An early example that demonstrates this depth of creative as well as psychological vision occurs soon after Sofonisba's sister Elena, who had studied painting alongside her in the Campi studio, tells her that she will be entering a convent to become a nun. Sofonisba is hurt and upset, unable

10 Jacobs (pp. 27–63) discusses in-depth the notion of procreativity and its associations with women artists.

to speak a word to her closest sister; she quickly gets up to leave the room, then looks back at her sister:

> The late afternoon light played on her face, moulding the lines in a splendid ethereal glow. Her tranquil features, her large modest eyes, remote from the world's concerns, the strong-willed curl of her lip, that grown-up and very aware expression [....] Against my will, I imagined her framed in the glow of a novice's habit, with its severe, purely geometrical lines sculpted in a cascade of white, modelled solely by shade and light. I saw the pure white shape, motionless, emerge from the dark background, warmed slightly by a diffused glow and taking life thanks to the mobility of the face and hands [....] The urgency with which the picture sprang to mind was stronger than my willpower. I simply had to fix it there. To my surprise I realized that this desire had taken the place of the pain I had felt. (pp. 22–23)

Montani (via her English translator, Verna Kaye) has beautifully evoked not only the actual painting by Anguissola (*Portrait of Elena Anguissola*, 1551; Southampton City Art Gallery), but also has conveyed how it was conceived in the mind's eye of the artist. We can sense what Elena looks like in the flesh, and how that will be translated by Sofonisba into a timeless image. Yet we also gain an understanding of the artist's character, specifically how her love for her sister is able to transform the selfish pain and hurt of impending loss into a visual testament to Elena's pure faith.

The most extensive discussion of the artist's process, both psychological and physical, occurs when she paints the *Madonna del' Itria* following her first husband's unexpected death. In this religious painting Sofonisba is not looking into another individual's soul to bring out its essence, but instead into her own, in the light of an unhappy marriage. Montani's description of the painting process is visceral; Sofonisba relates that parts of her skin and blood (from broken blisters) filter into the paint: "The awareness that the work would contain parts of my body too made me feel it more intensely" (p. 207). This physical–emotional connection ultimately serves as a catharsis for Sofonisba's grief and guilt: "With each brushstroke and each glaze of colour I felt the grips of my consuming remorse start to ease slightly" (p. 207). The description of the finished painting is more matter-of-fact; what primarily mattered was the outpouring of Sofonisba's soul through the act of painting, rather than the outcome.

In addition to the psychological and physical aspects of being an artist, Montani also weaves in the intellectual element through the recurring motif

of chiaroscuro. This process of shading by using varying degrees of light and shade to create the illusion of a lifelike, three-dimensional form was a significant development in Renaissance art, and thus of great interest to artists who strove for naturalism, such as Anguissola. Yet we also find it used for conceptual effect in certain passages, such as the description of Elena's portrait, in which the young nun's form spiritually shines forth from the dark obscurity surrounding her. In contrast, the portrait of conflicted prelate Ippolito Chizzola with its "absolute black of the cloak and the ice white of the vestments" were "[t]wo opposites placed side by side which would never meet" (p. 33). Later in the novel this conceit of light versus shade is discussed in a philosophical manner by Sofonisba and her future husband Orazio, who associate these two fundamental elements with the "mirror of life." The artist eventually unifies the two extremes when she remarks, "As in the technique of sfumato, the line between the two [light and shade] is lost in a soft progression, from which you can slip alternately into one or the other. Or perhaps have them live together in the same instant, letting them blend so closely [...] so no further distinction is possible" (pp. 245–246). As I read these lines, I was reminded of another type of art, that of biofiction, with its shades of historical "truth" versus imagined "truth," often imperceptibly merged so as to create a fuller literary reality for a particular individual. Montani's imagined incorporation of art and especially the artistic process are essential to her Sofonisba's tangible, authentic presence.

Paragone: visual and verbal

To their credit, both DiGiuseppe and Montani emphasize the visual creations and processes of their protagonists within their biographical novels – even though they (perhaps necessarily) still allow narrative space for love, betrayal, sex, heroic deeds, and family drama. Both authors also go to the effort of making illustrations of pertinent Anguissola artworks available to their readers through electronic or published means,[11] which I've rarely encountered in biographical fiction about artists. This dual importance of image and word immediately calls to mind the *paragone* debate of

11 DiGiuseppe published a booklet, *A Pictorial Companion to Lady in Ermine*, which has seven illustrations of Anguissola's works accompanied by brief discussion, primarily based on her direct viewing of the artworks. A more complete resource to images is found on her website at "Paintings by Chapter." Montani sends her readers an electronic file of Anguissola's artworks upon request.

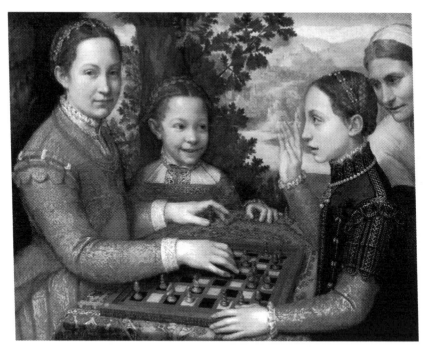

Figure 17.2. Sofonisba Anguissola, *The Chess Game* (Poznan, National Museum). Photo credit: The Picture Art Collection / Alamy Stock Photo.

Anguissola's own time, in which intellectuals, courtiers, and artists actively discussed the relative merits of various media, such as painting versus poetry, or sculpture versus painting.[12] In fact, this debate is encountered in Montani's novel, when Anguissola's portrait of Queen Isabel is shown to Francesco de' Medici and various members of the court. Is Anguissola's painting superior to the other arts because of its "realism and harmony," as one individual suggests? Or is there more of an equilibrium between painting and poetry, following Horace's dictum of *ut pictura poesis*, as another courtier states (p. 102)?

To consider this question further in relation to these biofictions, we might directly compare how two Anguissola paintings emphasized by both DiGiuseppe and Montani are verbally rendered. The first example is the artist's early masterpiece, *The Chess Game*, which depicts with remarkable verisimilitude three of the Anguissola sisters engaged in a game of chess, while a maidservant hovers in the background (Fig. 17.2)

12 For useful background on the *paragone* debate in Renaissance Italy, see Ames-Lewis (pp. 141–176).

Even in the Renaissance this painting was singled out for praise: Giorgio Vasari saw the painting in the Anguissola home and remarks in his *Lives of the Most Excellent Painters, Sculptors, and Architects* that the figures are "all done with such care and such spirit, that they have all the appearance of life, and are wanting in nothing save speech" (2: p. 466). Vasari's last phrase exposes the limitations of the visual form, no matter the artist's excellence – it is mute. Therein lies a potential advantage for writers, who can give voice to the scene before our eyes. But correspondingly, how completely or effectively can the writer convey the visual richness of this painting, from the intricate gold-brocade gowns to the varied expressions on the girls' faces? DiGiuseppe focuses on providing context for the scene: Sofonisba is asked to look in on her younger sisters, and when she sees them playing chess she realizes that she must capture this extraordinary moment and begs her sisters to stay still while she sketches them (p. 20). Although DiGiuseppe doesn't describe the finished painting, there is no need to since she also gives voice to the sisters' interactions, thus conveying the immediacy of the scene rather than attempting to describe its details.

In contrast, Montani undermines the naturalism and immediacy that we see in the painting by indicating that Anguissola has very deliberately set up the scene, including what each sister will wear, what each will be doing, and what the stage-setting will be (p. 28). The one moment of spontaneity comes when the maidservant Maria happens upon the scene being painted, and Sofonisba asks her to remain looking on, an important aspect of the painting in terms of social proprieties and class issues that DiGiuseppe omits. Montani does provide greater overall description of the finished painting (pp. 28–29) compared to DiGiuseppe, but while it may be sufficient for the reader to imaginatively see the painting, there also seems to be a missed literary opportunity in comparison to other published ekphrases of *The Chess Game*.[13]

The other Anguissola painting that both DiGiuseppe and Montani give greater attention to is her *Family Portrait*, which features Sofonisba's father, brother Asdrubale, sister Minerva, and the family dog (Fig. 17.3).

Vasari comments on this painting, too, stating that "these [figures] [...] are executed so well, that they appear to be breathing and absolutely alive" (2: p. 466). Although a painting might be "mute," to say that the figures seem to breathe and be "absolutely alive" was very high praise indeed from Vasari. But do our biofiction authors convey this quality? In this instance

13 Anguissola's *Chess Game* was the featured "challenge" of the *Ekphrastic Review* in March 2019 ("Ekphrastic").

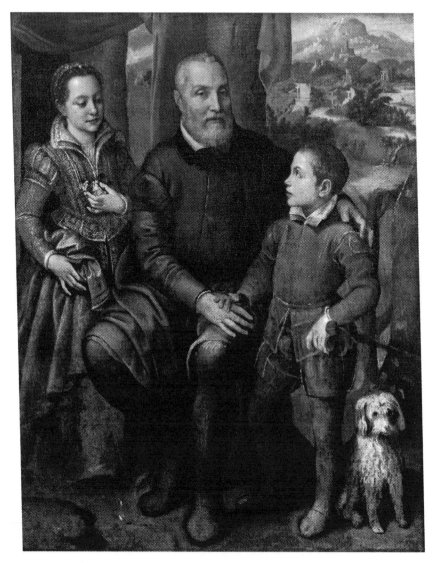

Figure 17.3. Sofonisba Anguissola, *Family Portrait* (Niva, Nivaagaards Art Gallery). Photo credit: Heritage Image Partnership Ltd / Alamy Stock Photo.]

it is DiGiuseppe who imagines an intentionally selected and deliberately posed portrait-making context, with Sofonisba as artistic director; as a result, the immediacy which Vasari saw is blunted. The author primarily focuses on the presumed symbolism within the portrait, such as the dog as a symbol of familial loyalty; this may be because the portrait was intended, per DiGiuseppe's narrative, as an homage to her father before Sofonisba left for Spain, and thus is embedded with meaning (p. 59). As a result, the

narrative momentarily takes on an art historical aspect, which may give readers a stronger impression of the potential intellectual depth of Anguissola's paintings – all important, in my opinion, when one is writing about a woman artist, whether historically or fictionally.

Montani describes the portrait as a focal point during a poignant interlude in the narrative: Sofonisba (via her father, Amilcare) has recently accepted the Spanish court's invitation, but now both characters are realizing the impact that this separation will have on their close relationship. They look together at this nearly finished portrait of familial devotion that now must forego the final touches to the foreground (which is true to the painting's current condition). "Sofi" describes the facial expressions, the colors, and the composition for us, effectively getting at their lifelikeness – yet with one surprising difference: Amilcare is said to be standing "in a heroic pose, like a statue dressed in black" (p. 46).[14] Such a pose would physically demonstrate the father's importance, and would be more typical of sixteenth-century Italian portraiture, but it is a significant change from the painting itself. There we see Amilcare seated and turned slightly towards Asdrubale, with one hand warmly placed on his shoulder, while the son reciprocates by placing his hand upon his father's other hand. To my mind it is this warmth and intimacy of Anguissola's remarkable family portrait that both honors the father figure, and makes them all, as Vasari perhaps best captured it, "absolutely alive."

As is typically the case for a Renaissance *paragone* debate, there is no clear "winner" here; instead, by comparing the strengths and weaknesses of each side, we can better appreciate their relative merits. In varying ways, DiGiuseppe and Montani successfully demonstrate the "artfulness" of writing about an artist, and through the intermediality of visual and verbal content allow us to more fully enter into the character and world of Sofonisba Anguissola. Certainly there are also the inevitable gaps and fissures between these media too; painting cannot fully speak, and literature cannot fully reveal. Yet these openings can also allow the reader to enter into the narrative and imaginatively expand on what is or is not written, or to look at the paintings and form their own impressions, and thus truly give the artist, and her art, life.[15]

14 Montani's Italian version does not literally state that Amilcare is standing, but it is understandable that Kaye would translate the description in this way, given that he is said to be "in posa staturia ed epica" (p. 42).

15 I would like to gratefully acknowledge the University of Minnesota, Morris Faculty Research Enhancement Fund for providing support for this project.

Works Cited

Ames-Lewis, Frances. *The Intellectual Life of the Early Renaissance Artist*. New Haven: Yale University Press, 2000.

Boullosa, Carmen. *La Virgen y el violin*. Madrid: Ediciones Siruela, 2004.

Cole, Michael W. *Sofonisba's Lesson: A Renaissance Artist and Her Work*. Princeton: Princeton University Press, 2020.

Cullen, Lynn. *The Creation of Eve: A Novel*. New York: G. P. Putnam's, 2010.

Dabbs, Julia. *Life Stories of Women Artists, 1550–1800: An Anthology*. Farnham, UK and Burlington, VT: Ashgate, 2009.

Damioli, Carol. *Portrait in Black and Gold: A Novel of Sofonisba Anguissola*. Toronto: Inanna Publications, 2013.

de Celis, Maite Jover, M. Dolores Gayo García, and Laura Alba Carcelén. "Sofonisba Anguissola in the Museo del Prado: An Approach to her Technique." *A Tale of Two Women Painters: Sofonisba Anguissola and Lavinia Fontana*, edited by Leticia Ruiz Gómez. Madrid: Museo Nacional del Prado, 2019, pp. 71–87.

de Medici, Lorenzo. *Il Secreto di Sofonisba*. Barcelona: Ediciones B, 2007.

DiGiuseppe, Donna. "Sofonisba Anguissola: An Accomplished Renaissance Woman." MA Thesis, San Francisco State University, 2009.

DiGiuseppe, Donna. *Lady in Ermine: The Story of a Woman Who Painted the Renaissance: A Biographical Novel*. Tempe, AZ: Bagwyn Books, 2019.

DiGiuseppe, Donna. *A Pictorial Companion to Lady in Ermine*. Independently published, 2019.

DiGiuseppe, Donna. "Paintings by Chapter." https://sofonisba.net/paintings-by-chapter/. Accessed 9 June 2020.

DiGiuseppe, Donna. "Sofonisba or El Greco? Sofonisba Cradle to Grave." Blogpost of 16 October 2019. https://sofonisba.net/category/ladys-blog/. Accessed 25 August 2020.

"Ekphrastic Challenge Responses: Sofonisba Anguissola." *The Ekphrastic Review*, 29 March 2019. https://www.ekphrastic.net/ekphrastic/ekphrastic-challenge-responses-sofonisba-anguissola. Accessed 23 June 2020.

Gamberini, Cecilia. "Chronology." *A Tale of Two Women Painters: Sofonisba Anguissola and Lavinia Fontana*, edited by Leticia Ruiz Gómez. Madrid: Museo Nacional del Prado, 2019, pp. 230–231.

Jacobs, Fredrika H. *Defining the Renaissance Virtuosa*. Cambridge and New York: Cambridge University Press, 1997.

Kris, Ernst, and Otto Kurz. *Legend, Myth, and Magic in the Image of the Artist*. New Haven: Yale University Press, 1979.

Lapierre, Alexandra. "The 'Woman Artist' in Literature: Fiction or Non-Fiction?" *Italian Women Artists: From Renaissance to Baroque*, edited by Carole Collier Frick et al. Milan and New York: Skira/Rizzoli, 2007, pp. 75–81.

Lent, Tina. "'My Heart Belongs to Daddy': The Fictionalization of Baroque Artist Artemisia Gentileschi in Contemporary Film and Novels." *Literature/Film Quarterly*, vol. 34, no. 3, 2006, pp. 212–218.

Montani, Chiara. *Sofonisba. I ritratti dell'anima*. Lurago d'Erba: Edizione Il Ciliegio, 2018.

Montani, Chiara. *Sofonisba: Portraits of the Soul. A Novel*. Translated by Verna Kaye. Independently published, 2019.

Montani, Chiara. "Chiara Montani: Writer and Artist." https://chiaramontani. com/?lang=en. Accessed 25 August 2020.

Perlinghieri, Ilya. *Sofonisba Anguissola: The First Great Woman Artist of the Renaissance*. New York: Rizzoli, 1992.

Pierini, Giovanna. *La dama con il ventaglio: romanzo*. Milan: Mondatori Electa, 2018.

Sautois, Agnès. *Le jeune fille au clavicorde*. Bressoux: Dricot, 2016.

Vasari, Giorgio. *Lives of the Painters, Sculptors and Architects*. 1568. Translated by Gaston du C. de Vere. New York: Alfred A. Knopf, 1996.

About the Author

Julia Dabbs is a Distinguished Teaching Professor of Art History at the University of Minnesota Morris. Her research focuses on the lives of historical women artists; she has published *Life Stories of Women Artists, 1550–1800* and numerous essays. Dabbs is working on an edited collection concerning visual artists and biofiction.

18. "I am Artemisia": Art and Trauma in Joy McCullough's *Blood Water Paint*

Stephanie Russo

Abstract

Joy McCullough's 2018 verse novel *Blood Water Paint* is the first novel to imagine Artemisia's story for a Young Adult (YA) audience. The novel takes as its focus Artemisia's girlhood, and the novel ends after the rape trial of Agostino Tassi. *Blood Water Paint* is a portrait of the young Artemisia for the #MeToo generation, a novel that positions trauma as key to understanding Artemisia's art while at the same time affirming her ability to overcome her circumstances. McCullough's representation of Artemisia differs from other Artemisia biofictions in its portrait of female creativity. In *Blood Water Paint*, it is Artemisia's dead mother, as well as an imagined sisterhood of her artistic subjects – Susanna and Judith – who are her artistic inspirations.

Keywords: Artemisia Gentileschi, early modern women, historical fiction, Young Adult fiction, rape

The early modern painter Artemisia Gentileschi is one of the relatively few early modern female artists whose life has been regularly inscribed into fiction. Artemisia is consistently represented as an exceptional woman, in that she achieved success as a professional painter at a time hostile to female artists. Biofictions about Artemisia, however, generally foreground her rape in 1611 at the hands of another painter, Agostino Tassi, as central to understanding both her life and her art. Artemisia's father, Orazio, also a painter, had seemingly hired Tassi to teach Artemisia perspective. After the rape, Orazio pressed charges against Tassi, who was banished from Rome; while Artemisia's account was vindicated, the sentence was never carried out. Like other biofictions, Joy McCullough's recent Young Adult biofiction,

Fitzmaurice, J., N.J. Miller, S.J. Steen (eds.), *Authorizing Early Modern European Women. From Biography to Biofiction*. Amsterdam: Amsterdam University Press, 2022
DOI 10.5117/9789463727143_CH18

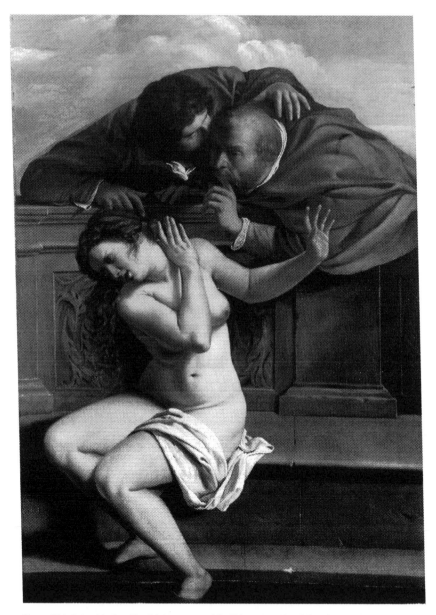

Figure 18.1. Artemisia Gentileschi, *Susanna and the Elders*, signed and dated 1610, oil on canvas. Collection Graf von Schönborn, Pommersfelden, Germany.

Blood Water Paint (2018), positions this trauma as key to understanding Artemisia's art, while at the same time it affirms her ability to overcome her circumstances to become a successful professional artist. Unlike its predecessors, *Blood Water Paint* foregrounds the female influences on the

development of Artemisia's art, and speaks directly to the #MeToo generation in its portrait of Artemisia's trauma and recovery.

Artemisia Gentileschi's art has long been interpreted through the lens of her life. Mary D. Garrard's 1989 *Artemisia Gentileschi: The Image of the Female Hero in Baroque Art* was the first major monograph about Artemisia and has been a foundational text in restoring Artemisia to her place in early modern art history. Garrard does not solely read Artemisia's art through the lens of her biography; she also places Artemisia firmly within her social and artistic context. Nonetheless, Garrard's readings of Artemisia's paintings stress the impact that her rape had upon her life and her art. Garrard argues that Artemisia's painting *Susanna and the Elders* (Figure 18.1), one of the paintings dealt with at length in *Blood Water Paint,* can be read as a retelling of her trial experience: "the painting of *Susanna and the Elders* may literally document Artemisia's innocence and honest testimony in the trial" (1989, p. 207).[1]

The painting retells the biblical tale in which Susanna is preyed upon while at her bath by two older men; she rebuffs them, and they are later executed for providing false testimony that she had committed adultery. The other painting that is at issue in *Blood Water Paint* is the 1612–1613 *Judith Slaying Holofernes,* which depicts the Israelite Judith and her maid in the act of beheading Holofernes to save their city from his tyranny (Figure 18.2). In discussing this painting, and a later 1620 version of the painting, Garrard argues that Artemisia finds "especially, [in] Judith [...] models of psychic liberation, *exempla* for an imagined action upon the world" (1989, p. 279), but also warns against interpreting the painting "purely as an expression of fantasy revenge against a rapist" (p. 278). In his recent biography of Artemesia, Jonathan Jones makes an even stronger claim about life in art, asserting that "to say that this book is about her art as well as her life would be tautological. They are the same thing" (p. 6). Jones also confidently asserts that *Judith Slaying Holofernes* is an "untamed scream" because Artemisia "painted it in the immediate aftermath of her rape" (p. 34).

The persistence of biographical readings of Artemisia's art reflects the long-standing presumption that women's art reflects their individual experiences, whilst men's art is perceived as universal. Griselda Pollock objects to the biographical impulse in art history, which she argues "collaborates with

1 While the painting is dated 1610, and so predates the rape of Artemisia, Garrard contends that the date of the painting may have been changed by Orazio, or that it documents an experience of sexual harassment by Tassi and other men prior to the rape itself (p. 207).

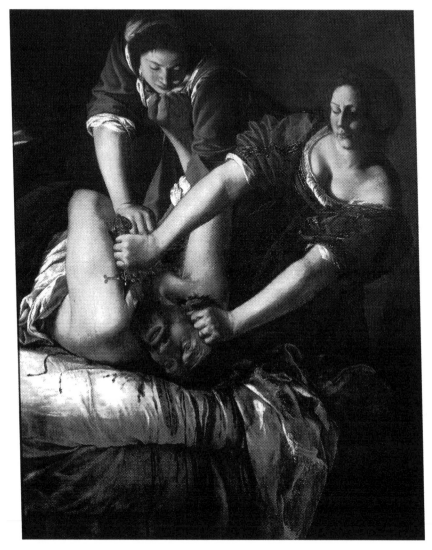

Figure 18.2. Artemisia Gentileschi, *Judith Slaying Holofernes*, c. 1612–1613, oil on canvas. Museo Capidimonte, Naples, Italy.

canonical devaluation of women artists" and decontextualizes Artemisia's work from a world in which "images of sex and violence were so imaginatively central" (p. 111). Pollock's work is reflective of a movement away from a masculinist model of art history, in which the individual genius is valorized; such a movement inevitably shifts the focus of art criticism from individual biography to the context that surrounds the artist. Nanette Salomon also warns that biographies portray Artemisia's art as a "visual record of her

personal and psychological makeup," and thus treat her as an aberration or an oddity (p. 229). Richard E. Spear is blunter in his assessment of biographical criticism: "a lot of psycho-babble has distorted both Artemisia's art and the worth of psychoanalytical investigation" (p. 569).

The *Künstlerroman* is a type of *Bildungsroman* that dramatizes the development of the artist, rather than the more generalized process of development that the *Bildungsroman* tracks. The female *Künstlerroman* dramatizes, as Tina Olsin Lent argues, the struggle of female artists to "reconcile a model of artistic development based on male cultural expectations with their own experience of female social roles" (p. 213). Likewise, Linda Huf has argued that the central tension of the female *Künstlerroman* is the mismatch between cultural expectations of women in relation to caring and service, and the individualistic nature of artistic practice (p. 5). In other words, the writing and the life are distinctly at odds, and therefore one cannot be understood without reference to the other. Men are free to be esoteric and disconnected in their interests, but women's lives and art are thought to be embedded in the material realities of the everyday. A female *Künstlerroman*, *Blood Water Paint*, for instance, dramatizes Artemisia's frustration over being interrupted to perform mundane domestic duties, such as purchasing treats for her lazy and disengaged brothers (p. 14).

Biofiction can and should be differentiated from biographical readings of Artemisia's art. Biofictions sit at the border of history and fiction, and expose the essential constructedness of both. As Michael Lackey argues of the genre, "foregrounding the biographical is problematic because most authors of biofiction explicitly claim that they are not doing biography" (p. 5). Instead, biofictions look for a kind of symbolic biographical truth. It might not be literally true that Artemisia imagined or hallucinated her subjects Susanna and Judith as living women, as she does in *Blood Water Paint*, but that she felt some kind of kinship with them as women is felt to be symbolically or emotionally true. Biofiction can posit a way of thinking about Artemisia's art, but that reading is necessarily speculative and bound to the interests of the novelist.

However one thinks about the link between Artemisia's life and art, the appeal of Artemisia's life for writers of biofiction is undeniable. Artemisia is exceptional insofar as she is one of the few well-known female artists of the time, and exemplary lives have long been of interest to novelists. Germaine Greer calls Artemisia "the magnificent exception" in her work *The Obstacle Race: The Fortunes of Women Painters and Their Work* (p. 189), thus drawing attention to Artemisia's perceived difference from other women – and other

early modern artists – as the source of her appeal. As Julia Novak writes, female artists are an attractive subject for biofiction because their stories offer a model of female achievement that can be looked to by readers to understand contemporary expectations of gender (p. 45). The poet Helen Rickerby, who includes poems about Artemisia in her collection *My Iron Spine*, acknowledges that reading Artemisia's art through her life "is reductive and problematic," but argues that "it *is* true that many of her female characters *do* look quite similar to how she depicts herself in a self-portrait, and a biographical reading of her paintings is certainly interesting" (p. 25).

The tendency to look for the biographical echoes between the female artist and her work has also meant that Artemisia's work has been read as a reflection of her relationships with men. Kirsten Frederickson writes that "to be a famous female artist [...] requires a compelling life story or an attachment as wife, lover, sister, daughter, or devoted student to a male artist with a compelling life story" (p. 3). This tendency has certainly played itself out in relation to Artemisia, in that the influence of her father Orazio and the impact of her rape at the hands of Agostino Tassi are consistently foregrounded in accounts of both her life and her art. The first biofiction about Artemisia was Anna Banti's 1947 Italian novel *Artemisia*. Banti was the pseudonym of the Italian art historian Lucia Lopresti; her husband Roberto Longhi has been credited with the rediscovery of Artemisia's art in the early twentieth century. Banti's novel combines the voice of the contemporary narrator, who is lamenting the destruction of her home in World War II, with that of Artemisia. The narrator and Artemisia argue throughout about how to fictionalize Artemisia's life, thus drawing attention to the difficulties of interpreting life through art, and vice versa. JoAnn Cannon describes Banti's novel as "convincingly set[ting] forth both the dilemma of the woman artist and the dilemma of the writer of a woman's life" (p. 322). However, the central force of the novel is Artemisia's relationship with her father. At the beginning of the novel, she constantly strives for Orazio's approval, and by the end of the novel, when the pair have reunited in London, she still imagines herself as a "raw, inferior pupil in the presence of a master" (p. 173).

Banti's novel is complex and self-reflexive in its portrait of the female artist, an early example of what Linda Hutcheon would call historiographic metafiction (p. 5). However, Banti's foregrounding of Artemisia's relationship with Orazio has been troublingly replicated in almost all the Artemisia biofictions that followed. Lent has argued that, "in all of the 'Artemisia fictions,' Orazio emerges as the true artist: he is Artemisia's master, the source of her talent, her inspiration, her love" (p. 216). Similarly, Laura Benedetti

argues that the tendency of creative writers after Banti is to "lessen the antagonism between Artemisia and the men around her," either as part of a backlash to feminism or a reaction "to what could be perceived as an excessive victimization of an exceptional woman" (p. 59).[2]

Alexandra LaPierre's 1998 novel *Artemisia* opens with Artemisia lamenting the death of Orazio: "the woman is weeping for her life, and for the man who was the heart of it, her father" (p. 3). Likewise, Susan Vreeland's *The Passion of Artemisia* (2002) focuses on Artemisia's relationship with Orazio. The novel concludes at Orazio's deathbed, at which Artemisia forgives her father for his ongoing friendship with Agostino Tassi, even after his rape of Artemisia. Artemisia tells her dying father that "you taught me to see, and to use my imagination. You spared me a life of needlework and picnics" (p. 313). Julia Novak has argued of this novel that Artemisia "first needed to develop an independent identity and profile as an artist" before she could reconcile with her father, and that their reconciliation is based on a recognition of their "joint foreignness" in England (p. 55). However, the very structure of the novel suggests that a return to the father is central to Artemisia's development as both woman and artist, and thus reiterates that her relationship with Orazio is the defining one of her life. As I will show, *Blood Water Paint* is unique in its deviation from this pattern of representation: the novel is almost solely concerned with Artemisia's relationship with women, and does not hesitate to present her as a victim of male violence.

Joy McCullough's verse novel *Blood Water Paint* was marketed as a Young Adult (YA) novel, and accordingly takes as its focus Artemisia's girlhood. The novel concludes soon after the rape trial of Agostino Tassi, with Artemisia about to be married to Pierantonio Stiatessi, whom she has never met. *Blood Water Paint* was probably conceptualized and largely written before the launch of the #MeToo movement in October 2017, but the novel nonetheless fits neatly within the interests of that movement. The novel begins with Tassi's entry into the world of Artemisia's workshop, and covers his rape of Artemisia, the immediate aftermath, and the trial. Biofiction as a genre emphasizes the consciousness of the subject, and the novel is largely in first person, which gives readers a direct insight into Artemisia's mind and the development of her art. Interspersed into the narrative are Artemisia's recollections of her mother Prudentia telling her the biblical stories of Susanna and Judith which, in turn, inspire Artemisia's paintings *Susanna*

2 Benedetti is referencing both Lapierre's novel and Agnes Merlet's film *Artemisia* (1997). Merlet's film, while an interesting consideration of the life of Artemisia, is beyond the scope of this essay.

and the Elders and *Judith Slaying Holofernes*. Susanna's and Judith's stories focus on female suffering at the hands of men, and Artemisia draws links between what her mother has told her and both her own sexual trauma and her art: "She knew I'd need Susanna / when I found myself / a woman in a world of men" (p. 65). Prudentia's stories are the only sections of the novel in prose, and so are more narratively driven than the fragmentary pieces of poetry in Artemisia's voice. These prose sections also expand upon the stories of Susanna and Judith immortalized in Artemisia's artworks, and thus contextualize her unique interpretations of these stories. It is important to note that Prudentia tells Artemisia that Judith has had to give herself sexually to Holofernes to carry out her scheme: "He devours her" (p. 144). In the biblical story, Holofernes has too much wine to drink and falls asleep (Garrard, 1989, p. 280). McCullough therefore adds an additional sexual element to the story that has the effect of further strengthening links to Artemisia's experiences.

What unites women across time and space in *Blood Water Paint* is the inevitability of sexual trauma. The novel ends with paratextual material about rape crisis support organizations that the novel's presumably teenage readers might call upon if they are in need of assistance. McCullough notes that, "you may recognise yourself in parts of Artemisia's story in much the same way as Artemisia recognised herself in Susanna and Judith's stories" (p. 298). The reader is thus implicitly linked to an ongoing legacy of sexual violence against women that unites an early modern woman and a twenty-first-century reader. Prudentia tells the young Artemisia stories about historic sexual violence, and so these stories are imparted to the modern reader as a warning, a solace, and a potential therapeutic tool. Both of these stories also provide a model for women speaking out and seeking justice, inspiring Artemisia to do the same. The Elders who attempt to rape Susanna are themselves executed for providing false witness against her, while Judith's story, to borrow Mary Garrard's words, "symbolizes female defiance of male power" (1989, p. 280).

McCullough's representation of Artemisia also differs markedly from other Artemisia biofictions in its understanding of the source of Artemisia's inspiration. While most biofictions center on Artemisia's representation of her father, in *Blood Water Paint*, it is Artemisia's dead mother and her two most famous artistic subjects in an imagined sisterhood who act as her artistic inspirations. *Blood Water Paint* dismisses Orazio as a mediocre painter who needs the young Artemisia to improve his art: "A mediocre painter, / Orazio Gentileschi, / but from time to time / he drops a seed / I can nurture / into something more fruitful /than he's ever imagined" (p. 9).

Artemisia notes that neither Orazio nor other male artists can accurately represent either Susanna or Judith's stories, commenting that her mother "knew the men / who paint Susanna / could not comprehend / a woman's feelings in that moment" (p. 65). While men paint Susanna as an aesthetic object to be admired by men, Artemisia knows, through her mother's stories and her own experiences, that to paint Susanna authentically is to represent her vulnerability and fear. Prudentia is not a painter herself, but Artemisia claims that she was an artist in her own way: "My mother never held a brush / but still composed / the boldest images / from the brightest colours / drawing the eye – the mind – / to what mattered most" (p. 28). *Blood Water Paint* therefore at least partially rejects the focus on the female artist's relationship with men characteristic of many *Künstlerromanne*, in that other women act as her artistic muses. As Cortney Cronberg Barko points out, too, "art historians and authors alike see Artemisia's rape as a focal point in studies of her work, but the trauma of her mother's death when Artemisia was twelve is ignored" (p. 94). While *Blood Water Paint* also positions Artemisia's rape as the focal point of her narrative, the trauma of her mother's death is evident throughout the book and is far more formative on her creative practice than her father's weak artistic mentorship.

After Artemisia is raped, she turns again to her mother's stories as a means of processing her trauma. When her hymen is examined semi-publicly as part of her rape trial, Artemisia imagines Susanna and Judith holding her hands and talking her through this new trauma. Judith takes her hand and whispers *"these women who dare / to judge / your heart / by your body / will never have / an ounce of your worth"* (p. 245, original emphasis). Susanna and Judith also exhort Artemisia to paint: *"Paint the blood / Paint the blood"* (p. 198). Artemisia, Susanna and Judith are linked in a sisterhood of female suffering through Artemisia's mother's stories, and it is their shared trauma that will emerge as the subject of Artemisia's art. Artemisia's talent is to act as a representational conduit for the long, and still ongoing, history of women's suffering at the hands of men. Art and female solidarity are positioned as central to the recovery process. That Susanna and Judith actively encourage Artemisia to paint her experiences deviates from the tendency of YA rape fiction to represent victims as silent sufferers. As Aiyana Altrows has argued, these novels often represent the victim's silence as "the conflict that the novel must resolve" (p. 3). By way of contrast, *Blood Water Paint* dramatizes the (albeit unsatisfactory) punishment of Artemisia's rapist and her insistence upon speaking to her experiences. The novel repeatedly emphasizes that female-centered art can be both private and political.

Blood Water Paint understands sexual violence as a bodily and psychic trauma that threatens to overpower Artemisia entirely. She descends into a state of shock: "I'm staring at my hands, still, / hours later, / maybe days" (p. 165). Artemisia's verse becomes starker and splays out over the page in increasingly irregular fragments, reflecting Artemisia's rapidly disintegrating mental state. However, as Cronberg Barko writes, such accounts of Artemisia's rape essentially impose a modern view of sexual violence onto an early modern woman (p. 89). Moreover, the importance given to the rape in accounts of Artemisia's life has the unfortunate side-effect of defining Artemisia through her experience of sexual violence. Elizabeth S. Cohen outlines the gap between portraits of Artemisia as a woman defined by her rape – and the assumption that that experience inspired her art – and early modern understandings of rape. Cohen explains that, at her trial, "Artemisia spoke of her body [...] but as the material upon which a socially significant offence had been committed" (p. 65). Rape was conceived of as a social offence, and less connected to the body than it might be today: Cohen writes that Artemisia's testimony indicates that it is her "social persona that has been violated" (p. 68). Moreover, Artemisia presents as "active and self-possessed" (p. 68) at her trial, rather than traumatized. McCullough neglects to mention aspects of Artemisia's behavior after the rape that might be confusing to young contemporary readers; there is no mention, for example, of Artemisia maintaining a sexual relationship with Tassi or that he had promised her marriage. Marriage to her rapist would have essentially "made good" the rape and restored Artemisia's reputation in early modern Rome but may be understandably difficult for modern audiences to accept as an appropriate course of redress for rape. Dramatizing Artemisia's bodily or emotional recovery from her trauma is far more important in twenty-first-century literature, and particularly for younger readers, and so the early modern preoccupation with the social is transformed in *Blood Water Paint* to a focus on the individual.

Blood Water Paint, like all biofictions, does not represent history as it was, but instead presents an imagined version of a life that is felt to have some kind of broader symbolic or emotional truth. As Lackey writes, the author of biofiction is presenting "the novelist's vision of life and the world, and not an accurate representation of an actual person's life" (p. 7). At the end of the novel, Artemisia acknowledges that her rape will recede in importance in her life: "One day, this will all / recede into the background, / underpainting / giving texture to / the master's strokes, / and I, the master" (p. 289). The experience of the rape will never be entirely erased, but it will only be part of the background texture of her art. McCullough is not concerned with

representing early modern experiences of rape or presenting an authoritative portrait of Artemisia's views about her rape. Instead, she is modeling a way of thinking about both the experience and aftermath of sexual violence for her teenage readers through the experiences of Artemisia Gentileschi, a teenage girl who was raped and who did achieve some measure of justice by articulating her trauma in public. As Altrows has written, the #MeToo movement has redeployed the second-wave feminist strategy of disclosing rape narratives as a means of building solidarity: "The repetition of narratives of true experiences fosters empowerment through solidarity and is politically effective because it demonstrates the scale of such shared experience" (p. 3). *Blood Water Paint* exemplifies this model of feminist truth-telling in its representation of a lineage of female sexual violence.

Blood Water Paint is not alone in its representation of Artemisia as a feminist icon from whom today's women and girls can gain inspiration. Her 1620 painting of Judith went viral on social media in the lead-up to the controversial confirmation hearing of Justice Brett Kavanaugh to the United States Supreme Court in 2018, at which Christine Blasey Ford testified about her sexual assault at the hands of Kavanaugh. The painting's representation of female rage resonated with women who disclosed their own experiences of sexual assault in solidarity with Blasey Ford, or simply felt that the painting articulated their own rage at the situation. In an article about the subsequent increased market value of Artemisia's paintings, Judith W. Mann comments that the "#MeToo movement has played a role in the current interest in her work" (Sutton). Likewise, Jenni Murray, the host of the popular BBC Radio 4 program *Woman's Hour*, argues in her book *A History of the World in 21 Women* that Artemisia prefigured the #MeToo movement in *Susanna and the Elders*: she "got it in 1610 and wasn't afraid to make it known that treating women as sexual objects was really not on" (loc. 594).

Artemisia's story has also been transformed into another book marketed to appeal to teenage readers: Gina Siciliano's graphic novel *I Know What I Am* (2019). Like *Blood Water Paint*, the novel draws a direct connection between the rape of Artemisia and the sexual violence inflicted on contemporary young women. Siciliano states in her preface that, "after years of struggling to heal from my own history of sexual abuse, I wondered if perhaps we have to look back in order to move forward" (p. viii). Like most Artemisia fictions, with the exception of *Blood Water Paint*, Orazio is central to the development of Artemisia's art, and even a collaborator on her most significant early works, while Artemisia's mother is barely mentioned after her death (p. 58). *I Know What I Am* also implicitly challenges Elizabeth Cohen's reading of Artemisia's reaction to her rape, suggesting that Artemisia's reaction

went beyond concern for her social persona. In a sequence documenting Artemisia's process of painting *Judith Slaying Holofernes* in 1612, Siciliano's omniscient narrator comments that "rape was not considered a violation of the body and spirit, but only a disruption of the family name and social status," but goes on to assert that "rape has always wounded women, perpetuating grief and shame" (p. 132). *I Know What I Am* thus replicates *Blood Water Paint*'s insistence on understanding the rape of Artemisia through modern ways of thinking about sexual violence and affirms its importance on the development of her artistic practice. What both novels insist upon is Artemisia's relevance to the lives of contemporary young women. By looking into history to provide a framework for sexual trauma, both *Blood Water Paint* and *I Know What I Am* exemplify the ethos of the #MeToo movement: even this most accomplished seventeenth-century woman experienced sexual harassment and assault in the workplace.

Artemisia's emergence as a feminist icon is not a new phenomenon or exclusively tied to the #MeToo movement. Writing in 1991, Benedetti argued that "Artemisia has risen to a kind of feminist Olympus" (p. 46). Elena Ciletti has also described Artemisia as the object of "an industry or cult of late" (p. 64). Mary Garrard's latest work extends her analysis of how Artemisia was situated within early modern Italian feminism, thus linking her art not just to her life, but to the debates about the nature and role of women that were playing themselves out around Artemisia: "Artemisia encountered the debate about female capability, not as a theoretical claim, but as an argument that could be heard in the streets of her Roman neighbourhood, which rang with misogynist insults and coarse rebuttals" (2020, loc. 261). Before the COVID-19 pandemic postponed it, April 2020 was to mark the opening of a new exhibition on Artemisia at the National Gallery in London, the first major exhibition of Artemisia's work in the United Kingdom. On the exhibition website, the quote "I will show Your Illustrious Lordship what a woman can do" is prominently displayed before a short blurb advertising the exhibition, suggesting Artemisia's feminist credentials and positioning the exhibition as a feminist victory ("Artemisia"). The rich legacy of feminist art history scholarship on Artemisia is testament to her enduring interest to both academic and general audiences. Artemisia is continually made and remade in the pages of fiction, suggesting that the allure of her life and her art are inexorably intertwined. That her story has recently been translated into works for younger readers, too, demonstrates that her story has fresh appeal for the #MeToo generation. In the pages of *Blood Water Paint*, Artemisia may be a victim, but she is also a survivor.

Works Cited

Altrows, Aiyana. "Silence and the Regulation of Feminist Anger in Young Adult Rape Fiction." *Girlhood Studies*, vol. 12, no. 2, 2019, pp. 1–16.

"Artemisia." *National Gallery*, 2020, https://www.nationalgallery.org.uk/exhibitions/artemisia. Accessed 16 August 2020.

Banti, Anna, and Shirley d'Ardia Caracciolo (translator). *Artemisia*. Serpent's Tail, 1995.

Barko, Cortney Cronberg. *Writers and Artists in Dialogue: Historical Fiction about Women Painters*. New York: Peter Lang, 2015.

Benedetti, Laura. "Reconstructing Artemisia: Twentieth-Century Images of a Woman Artist." *Comparative Literature*, vol. 51, no. 1, 1999, pp. 42–61.

Cannon, JoAnn. "Artemisia and the Life Story of the Exceptional Woman." *Forum Italicum*, vol. 28, no. 2, 1994, pp. 322–341.

Ciletti, Elena. "'Gran Macchina E Bellezza': Looking at the Gentileschi Judiths." *The Artemisia Files: Artemisia Gentileschi for Feminists and Other Thinking People*, edited by Mieke Bal. Chicago: University of Chicago Press, 2005, pp. 63–105.

Cohen, Elizabeth S. "The Trials of Artemisia Gentileschi: A Rape as History." *The Sixteenth Century Journal*, vol. 31, no. 1, 2000, pp. 47–75.

Frederickson, Kristen. "Introduction: Histories, Silences, and Stories." *Singular Women: Writing the Artist*, edited by Kristen Frederickson and Sarah E. Webb. Berkeley: University of California Press, 2003, pp. 1–19.

Garrard, Mary D. *Artemisia Gentileschi: The Image of the Female Hero in Italian Baroque Art*. Princeton: Princeton University Press, 1989.

Garrard, Mary D. *Artemisia Gentileschi and Feminism in Early Modern Europe*. London: Kindle, Reaktion Books, 2020.

Greer, Germaine. *The Obstacle Race: The Fortunes of Women Painters and Their Work*. New York: Farrar Straus Giroux, 1979.

Huf, Linda. *A Portrait of the Artist as a Young Woman: The Writer as Heroine in American Literature*. New York: Frederick Ungar Publishing Company, 1983.

Hutcheon, Linda. *A Poetics of Postmodernism: History, Theory, Fiction*. New York and London: Routledge, 1988.

Jones, Jonathan. *Artemisia Gentileschi*. London: Laurence King Publishing, 2020.

Lackey, Michael. "Locating and Defining the Bio in Biofiction." *a/b: Auto/Biography Studies*, vol. 31, no. 1, 2016, pp. 3–10.

LaPierre, Alexandra, and Liz Heron (translator). *Artemisia: A Novel*. New York: Grove Press, 1998.

Lent, Tina Olsin. "'My Heart Belongs to Daddy': The Fictionalization of Baroque Artist Artemisia Gentileschi in Contemporary Film and Novels." *Literature-Film Quarterly*, vol. 34, no. 3, 2006, pp. 212–218.

McCullough, Joy. *Blood Water Paint*. New York: Dutton Books, 2018.

Murray, Jenni. *A History of the World in 21 Women*. London: Kindle, Oneworld Publications, 2018.

Novak, Julia. "Father and Daughter across Europe: The Journeys of Clara Wieck-Schumann and Artemisia Gentileschi in Fictionalised Biographies." *European Journal of Life Writing*, vol. 1, 2012, pp. 41–57.

Pollock, Griselda. *Differencing the Canon: Feminism and the Writing of Art's Histories*. London: Routledge, 1999.

Rickerby, Helen. "Articulating Artemisia: Revisioning the Lives of Women from History in Biographical Poetry." *Biography*, vol. 39, no. 1, 2016, pp. 23–33.

Salomon, Nanette. "The Art Historical Canon: Sins of Omission." *(En)Gendering Knowledge: Feminists in Academe*, edited by Joan E. Hartman and Ellen Messer-Davidow. Knoxville: University of Tennessee Press, 1991, pp. 222–236.

Siciliano, Gina. *I Know What I Am: The Life and Times of Artemisia Gentileschi*. Seattle: Fantagraphics Books, 2019.

Spear, Richard E. "Review: Artemisia Gentileschi, Ten Years of Fact and Fiction." *The Art Bulletin*, vol. 82, no. 3, 2000, pp. 568–579.

Sutton, Benjamin. "Artemisia Gentileschi's Market Gains Steam as Collectors Catch Up with Art Historians." *Artsy.Net*, 2018, https://www.artsy.net/article/artsy-editorial-artemisia-gentileschis-market-gains-steam-collectors-catch-art-historians. Accessed 16 August 2020.

Vreeland, Susan. *The Passion of Artemisia*. New York: Penguin, 2003.

About the Author

Stephanie Russo is a Senior Lecturer in the Department of English at Macquarie University, Australia. She is the author of *The Afterlife of Anne Boleyn: Representations of Anne Boleyn in Fiction and on the Screen* (Palgrave Macmillan, 2020), and has published widely on representations of early modern women.

19. The Lady Arbella Stuart, a "Rare *Phoenix*": Her Re-Creation in Biography and Biofiction

Sara Jayne Steen

Abstract

The Lady Arbella Stuart long has been the subject of biography and fiction, as writers have been drawn to the dramatic story of a royal woman who defied both Queen Elizabeth and King James. The Lady Arbella also was a fine writer whose over 100 letters to relatives, friends, her husband, and the royal family delineate her personal and public drama. This essay explores two centuries of re-creations of the Lady Arbella in biography and fiction, tracing the evolution of the genres of biography and fiction, the increased interest in her when women's roles and rights have been at issue, and the uncertain and sometimes uneasy balance between historical accuracy and fictional invention.

Keywords: Arbella Stuart, biography, biofiction, early modern English women, early modern letters

Unlike some of the early modern women explored in this volume, the Lady Arbella Stuart offers abundant material on which an author can draw for biography or biofiction. Hundreds of sixteenth- and seventeenth-century letters, official papers, dedications, and poems document her life. And she has long been a subject for biography and fiction. Although not as widely known as her kinswomen who reigned, Mary Queen of Scots and Queen Elizabeth, the Lady Arbella across centuries has been re-created in biographies, poems, ballads, romances, novels, drama, television, and through editions of her letters. Portraits of Arbella and members of her family exist, as do objects such as her Hebrew/Syriac/Greek Bible. At Hardwick Hall, visitors can see

Fitzmaurice, J., N.J. Miller, S.J. Steen (eds.), *Authorizing Early Modern European Women. From Biography to Biofiction*. Amsterdam: Amsterdam University Press, 2022

DOI 10.5117/9789463727143_CH19

Arbella's room and can walk the gallery where she was interrogated by one of Queen Elizabeth's commissioners. On 17 November of 2018, I attended a performance of a new biodrama, *Ralegh: The Treason Trial*,[1] performed in the Great Hall in Winchester, knowing that Arbella was present there 415 years earlier when Sir Walter Ralegh was convicted of conspiracy to remove King James and place her on the throne. Could anyone not imagine what she might have felt?

Arbella's story of a noblewoman who defied two sovereigns is dramatic. A descendant of Henry VII and thus a member of the royal family, Arbella grew up under the supervision of her grandmother Bess of Hardwick and was educated and guarded as a potential queen. When she was eleven, her aunt Mary Queen of Scots was executed for conspiring with Catholics against Queen Elizabeth. Since Queen Elizabeth had no direct heirs, Arbella and her cousin James VI of Scotland were Elizabeth's likeliest successors. Marital prospects included much of Europe's nobility, but Queen Elizabeth did not conclude a match. In late 1602, when Arbella was 27 years old and Elizabeth was dying, Arbella defied the crown by attempting to marry another claimant and perhaps seek the throne. The attempt failed. After James's accession, he brought Arbella to court but also did not approve a match for her. In 1610, Arbella clandestinely married William Seymour, a claimant of similar education and interests. Imprisoned separately, the couple coordinated escapes. Arbella fled on horseback dressed as a man, intending to reach France with her husband. William was late in escaping the Tower, and because Arbella delayed to wait for him, she was captured off the coast of Calais. She died in the Tower of London in 1615, at the age of 39.

Because of Arbella's rank, documents associated with her were retained as state papers and in private collections. Letters and dispatches provide stories about when she dined with the queen or was praised by Lord Burghley and offer rumors about her religious faith and suitors. Bess saw that Arbella received a fine classical education, and even as a young woman Arbella was praised for her learning, skill in languages, and literary and musical understanding. Later, she was recognized at James's court as a woman of the arts. For example, in a dedicatory sonnet to his translation of Homer's *Iliad*, George Chapman describes her as "*our English Athenia, Chaste Arbitresse of virtue and learn-ing*," high praise even given the conventions of book dedications. Similarly, Aemilia Lanyer in a dedicatory poem to her *Salve Deus Rex Judaeorum* says that she has known Arbella long, but less well than she would have liked, and describes Arbella as a "Rare *Phoenix*, whose faire feathers are your owne, /

1 Compiled, edited, dramatized, and directed by Oliver Chris.

With which you flie, and are so much admired," a lady "accompan'ed / with *Pallas*, and the Muses." Lanyer's lines could suggest that Arbella was a poet; certainly her reputation as a poet has persisted, although no poems yet have been identified.[2] Her imprisonment prompted literature that drew on strong public interest in her case. John Webster's popular *Duchess of Malfi* would have reminded audiences of the royal woman imprisoned nearby (Steen, 1991), and Shakespeare's *Winter's Tale* and Ford's later *Perkin Warbeck* are among pieces that may have evoked her situation (Tomasian; Hopkins, pp. 174-176).

The most important resources for writers of biography or biofiction are Arbella's letters. She is among the few early modern women for whom over 100 letters have been located, and her use of language is impressive. Her 1603 letters from Hardwick Hall after her attempted marriage was disclosed to the court sometimes begin carefully and then shift into an outpouring of anger and self-justification unusual for any era, but certainly so for a royal woman in the early seventeenth century. She describes herself, appropriately, as "condemned to exile with expectation" (Stuart, letter 16). She even develops a fictional lover to force waning court attention to her plight. (It worked.) When she was "second lady" at King James's court, she wrote home to her family letters that are warm, affectionate, teasing, with vivid descriptions of court activities and her opinion of, for example, James's "eve[r]lasting hunting" and Queen Anna's courtesy in speaking warmly to the people (letters 27, 25). After Arbella's marriage, she carefully crafted the appeals that might mean her freedom, making her direct language more subservient (Steen, 1988). In another era, she might have written fiction. Authors of fiction who have recreated Arbella as a writer first imagined her as a poet, and later, when her letters became more widely available, also as a writer creating a self in prose, her letters as autobiography.

There was not always a wealth of material available. For decades after Arbella's death, documents largely remained inaccessible. Later in the seventeenth century, Dr. Nathaniel Johnson, a physician and antiquarian, collected and praised some of Arbella's familial letters: she "hath left a very well Enameld Picture of her self drawn by her own pen, wherein Equal Commendation is to be given to the Easiness of stile, and the quickness of her invention and phancy" (7:2). His goal, however, was to assemble the papers of the Earls of Shrewsbury. Over the next century, others, too, gathered a

2 Bathsua Makin in 1673 wrote that the Lady Arbella "had a great faculty in Poetry" (p. 20), and many writers have presented her as an excellent poet. In 1899, Alastor Graeme (Alice Cecil Marryat) wrote that as a poet Arbella Stuart "should rank with the highest," as demonstrated by poems in the private library of a Stuart descendant (p. 256), but she did not name the owner.

few documents, such as Isaac D'Israeli, who in his *Curiosities of Literature* describes Arbella's as a "secret history" unlikely ever to be recovered (p. 258).

What follows about biography and fiction is not comprehensive, but illustrates trends, as antiquarians over time became evidence-based historians and biographers who provided texts and interpretations, while fiction writers drew on the increasing availability of historical materials to add a more factual basis to the expressive strength of fiction. History/biography and fiction diverged as fields across the nineteenth century, but the distinction was not straightforward.

For example, in 1828, Romantic poet Felicia Hemans included Arbella in her best-selling *Records of Woman*. According to Hemans's modern editor, Paula R. Feldman, Hemans "sees history as the recording not so much of grand occurrences but of human emotion" (p. xxi). In doing so, she shifts the focus from great men's actions to individual women's lives, an approach also associated with historians of the later twentieth and early twenty-first centuries. "Arabella Stuart" is the first of nineteen extended poems in the collection. Though Hemans is providing women's history, she emphasizes that her poem is and must be fictional: if as D'Israeli noted, the actual history of Stuart's imprisonment cannot be recovered, Hemans says she can fill that gap with "the imagined fluctuations of her [Arbella's] thoughts and feelings," beginning when Arbella expected that she and William still might live together – "in this trust, / I bear, I strive, I bow not" – through her fears of being forgotten, her faith in William, and her desire that he be happy after her death (pp. 7–15). In imagining what Arbella might have felt – because she must have felt something – Hemans draws on Arbella's single surviving letter to William printed in D'Israeli's *Curiosities* and composes the poem entirely in the first person; and in emphasizing Arbella's consciousness, Hemans prefigures modern biofiction. Her Arbella is a courageous woman in a terrible situation, a heroine.

Over the nineteenth century, documents about the sixteenth and seventeenth centuries became more accessible. Louisa Stuart Costello, in her 1844 *Memoirs of Eminent Englishwomen* argued that the sixteenth century was the earliest era for which it was possible to write a history of women: "The accounts, before that period, respecting them, are so meager and uncertain, that imagination must supply much of the void left by historians" (1: p. B). In her biography of Arbella, Costello employed the voice we recognize as a historian's and provided as many documents as she could. Two other nineteenth-century biographers also located significant numbers of Elizabethan and Jacobean papers. Elizabeth Cooper, whose two-volume *Life and Letters of Lady Arabella Stuart* appeared in 1866, examined manuscript and

printed sources in what became the British Library and the Public Record Office. Emily Tennyson Bradley followed in 1889 with another two-volume *Life of the Lady Arabella Stuart.* Bradley had uncovered the manuscripts of Queen Elizabeth's counselor Robert Cecil, papers that dealt with the events of 1602–1603, when Arbella had attempted to contract a secret marriage seven years before she actually did so. To both Cooper and Bradley, Arbella's case was one of justice and human rights.

Writers of fiction drew on the published documents and, then as now, often tried to clarify what was fact from what was fiction. Diplomat, historian, and novelist George Payne Rainsford James in 1844 published *Arabella Stuart: A Romance from English History* to illustrate virtuous womanhood. The romance is a fully realized novel, with a poem the fictional Arbella wrote in prison and subplots he invented. In his dedication, James wrote: "all the principal events are so strictly historical that little was left to the author but to tell them as agreeably as he could." He didn't want to be untrue, he said, because "we try them in a court where they cannot plead." To James, historical accuracy meant following the "principal events," which he did, but conversations and related events were understood to have been invented. Alastor Graeme (Alice Cecil Marryat), in the prelude to her 1899 *Romance of the Lady Arbell*, indicated that recent research was not enough to bring Arbella from the shade into the light: "Who shall decipher the secrets of the silenced heart?" She appealed to Arbella to "yield me thy noble thoughts and dreams [...] so that a sculptured tomb be raised in fantasy for thee" (pp. vii–viii). Her Arbella is a writer of "genius" and a woman of "daring passion" (p. 256). On the other hand, Hector de La Ferrière's 1898 *Arabella Stuart* was advertised as a novel, one of two "romans d'aventure au XVIe siècle" ("sixteenth-century novels of adventure/romance") but reads much like a researched biography. Blanche Christabel Hardy and M. Lefuse published biographies in 1913, but little else appeared until mid-century.

Interest in the Lady Arbella Stuart has been highest at periods when women's roles and rights have been undergoing reassessment. The Romantic era. The later nineteenth and early twentieth centuries. The mid-twentieth century, which saw novels by Doris Leslie (1948), who attributed Arbella's errors to the negative influence of her aunt Mary Talbot, and by Molly Costain Haycraft (1959), who emphasized Arbella's intelligence and lack of ambition for the throne, as well as biographies by Phyllis Margaret Handover (1957), who focused on Arbella's unsuitability for the world of politics, Ian McInnes (1968), who stressed her spirit, and David N. Durant (1978), who looked to her childhood to explain what he considered self-destructive behavior. And the late twentieth century until our own time. Not surprisingly,

writers also reflect the concerns of their eras, as anyone who writes about historical figures reflects both the past and the present: female strength to the Romantics, human rights as the West moved toward women's suffrage, feminism in the late twentieth and early twenty-first centuries.

The increasing availability of historical information across time raises questions about how we read earlier biography and fiction. What standards do we apply? Do we recognize what the writers could not have known and assess them differently than we would our contemporaries who have so much additional information? Do we evaluate the fiction according to the conventions of fiction alone? The corollary is how new information and approaches change how we read and are read, how we interpret the past, and how we assess each other.

As an example of new approaches that impact interpretation, I turn to my edition of Arbella's letters, which appeared in 1994, with additional letters, newly recovered documents about her years in the Tower, and a lengthy biographical introduction. My interpretations and editorial decisions were shaped in part by research in the materiality of manuscripts and in modern medicine and medical history.

In preparing the edition, I wanted to work with manuscripts in Arbella's handwriting whenever possible. I soon realized how much could be learned from the manuscripts that could not be learned from printed letters that had been modernized.[3] I am not criticizing early editors, whose work was excellent, but the difference went beyond the personal connection of seeing a paper once held by Arbella, moving as that was.

Arbella wrote in two hands, a formal presentation hand and an informal hand, and there is meaning when a formal hand shifts to an informal hand in mid-sheet, as though what had been an ornate presentation piece has now been relegated to a draft. Or when a neat informal hand becomes hasty and blotted, suggesting an emotional component that the printed words do not. This is particularly meaningful in the letters of 1603, when Arbella's attempt for independence, marriage, and perhaps the crown, was being investigated and she was under significant stress.

One letter may exist in multiple drafts, with additions and deletions throughout. By working with the revisions, we can trace Arbella's handling of language and can approach her thinking as she changes emphasis or refashions an argument. After her marriage, for example, a bright woman drafts and redrafts in order to shape a more submissive persona that might

3 On early modern women's letters, see Daybell; and on Arbella Stuart's, see Steen, 1994 and 2001b.

be acceptable to King James. Earlier writers imagined Arbella's thinking; at some limited level, her revisions allow us to examine it. In this scholarly edition, original spelling and punctuation are retained, with manuscripts described and revisions indicated.

Two-fifths of Arbella's manuscript letters are undated. Even if the reader knows they are undated, the order in which they are read shapes the narrative. Looking to material evidence such as paper or dockets, and ordering letters on that evidence, changes the traditional narrative. For example, some appeals written after her marriage seem anguished in tone, and editors relying on internal evidence associated those letters with her years in the Tower, and placed them in an order that implied steady psychological decline after her recapture. The manuscript evidence, however, places those letters with others written before her escape, and suggests illness and then recovery, after which she wrote one of her most successful letters.

In that letter, Arbella responds to James's order that she travel to imprisonment in the north. She thanks James for the respite he had granted because of her illness and requests an additional month. She emphasizes that she had been ill, not refusing to obey (as the king believed), and promises to "undergoe the Jorney after this time expired without anie resistans or refusall." Her obedient language was read with approval, and the king consented to the delay. He might have responded differently had he seen the draft with her resentful marginal comments, including "as thoughe I had made resistans [...] I belye my selfe extremely in this" (letter 101). The marginal note transforms our reading: she was saying what she needed to say in order to win the month during which she and William planned their escapes. And she had been ill.

My exploration of medical history began with that marginal note and the "what if" question: What if she had been too unwell to travel? I assembled evidence from letters and historical documents about Arbella's episodes of pain and agitation, as well as those of other members of her family, and following previous suggestions, and working with physicians, psychologists, and especially medical geneticist Dr. John M. Opitz, explored diagnoses. Acute intermittent porphyria, an inherited enzyme disorder unknown in the seventeenth century, causes pain said to be worse than childbirth and can recede as quickly as it appears, leading onlookers to suspect duplicity.[4]

4 The manuscript and medical evidence is supported by documents related to Arbella's years in the Tower that the British Library acquired while I was preparing my edition (Add. MS 63543). They include descriptions of episodes of convulsion and recovery, visits by her physician and a divine, indications of what may have been another fictional ploy by Arbella, and an attempt to free her. These are the papers that D'Israeli imagined would never be recovered.

The disease is confirmed in Arbella's family. If we believe that Arbella had a serious illness that manifested itself during her adulthood and led to her death, we read her letters and actions differently – in my case, with respect for how Arbella, struggling to command her destiny, could manage that pain and even use her illness to her advantage (Steen, 2001a). That biographical interpretation would have been impossible before modern medicine.

Among the seven full-length biographies and biofictions on the Lady Arbella published since 2002, I will focus on two, Sarah Gristwood's biography *Arbella: England's Lost Queen* (2003) and Elizabeth Fremantle's novel *The Girl in the Glass Tower* (2016).[5] Both books were published by major presses with broad distribution and have been warmly received. They also can be usefully paired for this discussion.

Sarah Gristwood is a biographer, novelist, broadcaster, and former journalist. Her *Arbella: England's Lost Queen* is a scholarly biography intended to reach a wide audience, and it became a top-selling, widely praised volume. To the thorough research of a historian, Gristwood brings the distinctive voice and sense of audience associated with journalists and broadcasters, as well as the descriptive detail and strong narration associated with novelists. (Subsequent to *Arbella,* Gristwood became a novelist.) Good writers employ these techniques in varied degrees across the genres, of course; and Gristwood here balances them effectively to engage readers. Reviewers describe *Arbella* as "a powerful story," an "enthralling account of an extraordinary life," a "human drama truly Shakespearean."[6]

From the preface onward, Gristwood as guide is personally present. She brings readers with her to the British Library and to Longleat to see the manuscript letters in their minds, to discuss her approach of taking Arbella's political standing as seriously as it was taken in the sixteenth century, and to explain how she became interested in the subject.

The prologue is a vivid description of Arbella's escape and recapture, with an active and defiant Arbella. Then Gristwood begins the story of what led to that point, starting with Rufford Abbey, where Arbella's parents met, not as it was then, but as it is today, in ruin, "where birds now fly straight through the glassless windows of the cellarium" (p. 11). Using "we" with the reader, writing of what we do and do not know and of places we can visit, Gristwood brings the reader with her as she examines Arbella's life.

5 For others, see Norrington; Martin; Lee; Armitage; and Walsh. Interest has been strong: a 2015 exhibit at Hardwick Hall commemorating the 400th anniversary of the Lady Arbella's death was so popular with visitors that it was extended for a second year.

6 Sharpe, *Sunday Times*; Ridley, *Spectator*; *Kirkus Review*.

The volume is richly documented and textured. Gristwood cites extensively from contemporary letters, official papers, and diaries. And she provides details of daily life: the "carved snarling lions" on Burghley's stone stairs or the need for a woman to manage a farthingale when dancing (pp. 65–66). The volume contains drawings, maps, and book illustrations, such as the thanksgiving celebrations after the defeat of the Spanish Armada, and Essex on horseback; as well as colorful photos, such as a close-up of the Lennox Jewel, the eyes and ears embroidered on one of Queen Elizabeth's dresses, and Hardwick Hall today.

To Gristwood, Arbella was a strong woman who, like Webster's Duchess of Malfi, "fought [...] for her identity" (p. 368). And as Gristwood moves through the years and the evidence, she maintains a strong narrative pace. Longer scholarly discussions that might interrupt the reader are relegated to notes and appendices: Was Arbella's tutor Morley actually Christopher Marlowe? (Uncertain.) Did Arbella suffer from porphyria? (Likely.) And if the reader should want to continue research, Gristwood provides descriptions of places and locations of portraits. She closes as she began, on the personal note of being a biographer and finding the Lady Arbella everywhere.

Gristwood's narrative techniques serve the biography, anchoring Arbella in her time and making that era vivid and engaging. At the same time, Gristwood maintains the historian's voice as she fills in gaps or explores options, distinguishing what "must have been" or "might have been" from what "was" or "was said to be."

By way of contrast, Elizabeth Fremantle, in her biofiction *The Girl in the Glass Tower*, employs biography to serve her vision for the novel. Hers is not fictionalized biography with an emphasis on the biography, but fiction set in the historical past with an emphasis on the fiction. In a 2013 interview, she said that her use of the present tense reminds readers that, although set in an earlier era, her novels are contemporary fiction (Rouillard).

To structure the novel, Fremantle turns to literary history and juxtaposes her Arbella Stuart (the girl of the glass tower) with another woman writer of the period, the poet Aemilia Lanyer. Fremantle interweaves their imagined characters and experiences to examine her theme: "storytelling and the invisibility of early modern women's lives" (p. 452).

Fremantle begins with Arbella in the Tower remembering her childhood, then shifts to Aemilia, nicknamed Ami (or "friend"), whose son has brought her a sheaf of papers from the man cleaning out Arbella's room in the Tower after her death. The papers are Arbella's autobiography, and through the novel Ami reads Arbella's words for an answer to the central

narrative question: did Arbella forgive her? The reader does not know why forgiveness is needed.

Variously described as historical fiction and as a literary or historical thriller in part because of the suspense generated by the narrative question, the novel alternates between the characters' lives. Their shared story begins at court as Ami, Lord Hunsdon's lover, reads aloud the story of Philomel, the silenced woman; and continues through their changed circumstances, Arbella imprisoned and Ami poor and taking in laundry. Throughout, Fremantle incorporates seventeenth-century women's issues: a woman condemned for witchcraft, destitute women's vulnerability to sexual advances, the lack of education for girls.

Fremantle forges bonds between Arbella and Ami as writers, symbols of women's voices: the tragedy of Philomel that Arbella was composing, their having met to discuss Eve (portrayed in Lanyer's *Salve Deus* as unfairly blamed for the Fall), their agreeing to exchange their poetry, Aemilia's dedicatory poem to Arbella. As Ami reads Arbella's manuscript – a woman writer interpreting another woman writer's story – she recognizes that, like Philomel, Arbella eventually was silenced, and Ami begins to shape Arbella's life into verse. Fremantle emphasizes the distinction between the women: Arbella's chapters are in the past tense of the found manuscript and Ami's in the present tense of the novel's action.

What had Ami done? She had been trusted to help William Seymour escape, but when her printer couldn't finish *Salve Deus* for publication without her help, she went to the printshop before the Tower. Because she was late to the Tower, William was late leaving, which led to Arbella's delay and her recapture and imprisonment. At the novel's conclusion, Ami, beginning a school for children in Arbella's honor, learns the answer from William Seymour: Arbella forgave her, as does he.

In her author's note, Fremantle comments that the novel is fiction "largely based in fact": Arbella Stuart and Aemilia Lanyer existed, "but they also exist in the world of the novel as my own inventions." Going beyond earlier novelists who emphasized their historical accuracy, and treating an issue debated among current theorists and practitioners of biofiction, she says that Arbella's and Ami's stories were written "to support the thematic aims of my novel rather than with an eye to historical veracity." The only historical links between the women are Lanyer's dedicatory poem to the Lady Arbella and their presence among Queen Anna's circle. Any connection of Lanyer to Seymour's escape is entirely fictional (pp. 452–453).

For many people, Fremantle's disclaimer will be fine – the novel was a *Times* Book of the Year – and perhaps was not even needed. The book is

fiction, to which we bring different expectations than to biography, and some connections between the women well might have occurred. But other readers who care about these historical women will be uncomfortable with having Lanyer, contrary to known facts, bear responsibility for Arbella Stuart's imprisonment, shifting their stories. Ami's choice and Arbella's understanding of it make the novel contemporary and feminist in its concern with women's voices, as Fremantle suggests. The question is one of fairness to women whose lives are being re-created in ways that are contrary to modern feminist scholarship. How to determine that ethical line in biofiction is debated in *Conversations with Biographical Novelists*, edited by Michael Lackey,[7] and the conversation has only begun. It is treated in this volume by numerous authors and, with regard to Lanyer, by Susanne Woods and Hailey Bachrach.

Biographies and fictions about the Lady Arbella argue that distinctions between biography and biofiction are not simple or pure, nor have they ever been, though both biography and fiction begin with storytelling and imagination.[8] Authors of biofiction use imagination to fill historical gaps, which invite invention. Biographers use historical imagination to see beyond the evidence to understand what might be plausible and distinguish between "perhaps" and "was" in their analyses. Those distinctions are difficult to make in biofiction, where novelists, poets, playwrights, and screenwriters make choices and present certainty according to their visions and the techniques of their genres. Writers of both genres vary in their emphasis on the historical or the contemporary.

It is interesting to speculate about the surge of interest in biofiction now. Some have suggested that it is tied to our cultural moment, when people unsure of truth would like to believe their fiction has a basis in fact. If so, we shouldn't be surprised by scrutiny of the relationship between fact and fiction, even as postmodernism questions those categories. The public interest creates both opportunity and creative conflict for those of us who write about early modern women.

When Aemilia Lanyer in her dedicatory poem described the Lady Arbella Stuart as a "Rare *Phoenix*," she was prophetic. She praised Arbella as learned, admired, honorable, and accompanied by the Muses of poetry and the arts, but it is the image of the phoenix with its vibrance and regular renewal that is striking. The Lady Arbella Stuart was conscious of her rank, educated

7 See interviews with Laurent Binet, Colum McCann, Nuala O'Connor, and Susan Sellars. See also Michael Lackey's *American Biographical Novel*.

8 The French *histoire* still refers both to history and invented stories.

to reign, and defiant enough to take action against the people and norms that restricted her. She lost in life, but her powerful letters and story over centuries have engaged writers, many of them women writers, who have read her words, imagined her character, and re-created her, authoring her identity for their eras.

Works Cited

Armitage, Jill E. *Arbella Stuart: The Uncrowned Queen*. Stroud, Gloucestershire: Amberley, 2017.

Bradley, E[mily] T[ennyson]. *Life of the Lady Arabella Stuart*. 2 vols. London: Richard Bentley and Son, 1889.

British Library, Add. MS 63543, on Arbella Stuart's years in the Tower of London.

Chapman, George. "*To Our English Athenia, Chaste Arbitresse of ver*tue and learning, the Ladie Arbella." *Homer Prince of Poets*. London: for Samuel Macham, c.1609, sig. Ee.

Chris, Oliver. *Ralegh: The Treason Trial*. A Shakespeare's Globe production, presented in the Great Hall, Winchester, and the Sam Wanamaker Playhouse, London, November 2018.

Cooper, Elizabeth. *The Life and Letters of Lady Arabella Stuart*. 2 vols. London: Hurst and Blackett, 1866.

Costello, Louisa Stuart. *Memoirs of Eminent Englishwomen*. London: Richard Bentley, 1844, vol. 1: Introduction, B-viii; "Arabella Stuart," pp. 197–333.

Daybell, James. *Women Letter-Writers in Tudor England*. Oxford: Oxford University Press, 2006.

D'Israeli, Isaac. "The Loves of 'The Lady Arabella'." *Curiosities of Literature, and the Literary Character Illustrated*. 1791; reprint. New York: D. Appleton, 1844, pp. 257–262.

Durant, David N. *Arbella Stuart: A Rival to the Queen*. London: Weidenfeld and Nicolson, 1978.

Fremantle, Elizabeth. *The Girl in the Glass Tower*. London: Michael Joseph, 2016.

Graeme, Alastor [Alice Cecil Marryat]. *Romance of the Lady Arbell*. London: F. V. White, 1899.

Gristwood, Sarah. *Arbella: England's Lost Queen*. London: Bantam, 2003.

Handover, P[hyllis] M[argaret]. *Arbella Stuart: Royal Lady of Hardwick and Cousin to King James*. London: Eyre and Spottiswoode, 1957.

Hardwick Hall. "Arbella Stuart – the Lost Queen?" Exhibit on the 400th anniversary of Arbella's death, 2015–2017. Derbyshire, England.

Hardy, B[lanche] C[hristabel]. *Arbella Stuart: A Biography*. London: Constable, 1913.

Haycraft, Molly Costain. *Too Near the Throne: A Novel Based on the Life of Lady Arbella Stuart*. Philadelphia: J. B. Lippincott, 1959.

Hemans, Felicia. *Records of Woman, With Other Poems*, edited by Paula R. Feldman. Lexington: University Press of Kentucky, 1999.

Hopkins, Lisa. "On the Edge of the S(h)elf: Arbella Stuart." *Women on the Edge in Early Modern Europe*, edited by Lisa Hopkins and Aidan Norrie. Amsterdam: Amsterdam University Press, 2019, pp. 159–178.

James, George Payne Rainsford. *Arabella Stuart: A Romance from English History*. 1844; reprint. New York: Harper and Brothers, 1845: "Dedication to Rear-Admiral Sir George F. Seymour," front matter, n.p.

Johnson, Nathaniel. Chatsworth MS "Lives of the Earls of Shrewsbury" (1693), 7:2. Chatsworth House, Derbyshire, England.

Kirkus Review of *Arbella, England's Lost Queen*, 1 April 2005, posted online 12 May 2010. https://www.kirkusreviews.com/book-reviews/sarah-gristwood/arbella/. Accessed 13 August 2020.

Lackey, Michael. *The American Biographical Novel*. New York: Bloomsbury, 2016.

Lackey, Michael, ed. *Conversations with Biographical Novelists: Truthful Fictions Across the Globe*. New York: Bloomsbury, 2019.

La Ferrière, Hector de. *Deux romans d'aventure au XVIe siècle: Arabella Stuart, Anne de Caumont*. Paris: Paul Ollendorff, 1898.

Lanyer, Aemilia. "To the Ladie *Arabella*." *Salve Deus Rex Judaeorum*. London: by Valentine Simmes for Richard Bonian, 1611, sig. C.

Lee, Georgina. *Arbella*. Guildford, Surrey: Grosvenor House, 2016.

Lefuse, M. *The Life and Times of Arabella Stuart*. London: Mills and Boon, 1913.

Leslie, Doris. *Wreath for Arabella*. 1948; reprint. London: Heinemann, 1968.

Makin, Bathsua. *An Essay To Revive the Antient Education of Gentlewomen*. London: by J. D. to be sold by Tho. Parkhurst, 1673.

Martin, Margaret. *Arbella's Baby: A Jacobean Mystery*. Claremont, Western Australia: Freshwater Bay Press, 2003.

McInnes, Ian. *Arabella: The Life and Times of Lady Arabella Seymour, 1575–1615*. London: W. H. Allen, 1968.

Norrington, Ruth. *In the Shadow of the Throne: The Lady Arbella Stuart*. London: Peter Owen, 2002.

Ridley, Jane. "The Stuart We Fail to Remember." *The Spectator*, 22 February 2003. https://www.spectator.co.uk/article/the-stuart-we-fail-to-remember. Accessed 13 August 2020.

Rouillard, Rebecca. "Interview with Elizabeth Fremantle." *Writers' Hub*, 22 April 2013. http://www.writershub.co.uk/features-piece.php?pc=1976&utm_source=Writers%27+Hub+Database&utm_campaign=768ee06b6d-Writers_Hub_Newsletter_April_34_21_2013&utm_medium=email. Accessed 13 August 2020.

Sharpe, Kevin. "Review: Biography: *Arbella, England's Lost Queen* by Sarah Gristwood." *Times,* 2 February 2003. https://www.thetimes.co.uk/article/review-biography-arbella-englands-lost-queen-by-sarah-gristwood-8bd3lvzjkcc. Accessed 13 August 2020.

Steen, Sara Jayne. "Fashioning an Acceptable Self: Arbella Stuart." *English Literary Renaissance,* vol. 18, no. 1, Winter 1988, pp. 78–95.

Steen, Sara Jayne. "The Crime of Marriage: Arbella Stuart and *The Duchess of Malfi.*" *Sixteenth Century Journal,* vol. 22, 1991, pp. 61–76.

Steen, Sara Jayne. "Manuscript Matters: Reading the Letters of Lady Arbella Stuart." *South Central Review,* vol. 11, 1994, pp. 24–38.

Steen, Sara Jayne. "'How Subject to Interpretation': Lady Arbella Stuart and the Reading of Illness." *Early Modern Women's Letter Writing, 1450–1700,* edited by James Daybell. Basingstoke: Palgrave, 2001, pp. 109–126.

Steen, Sara Jayne. "Reading Beyond the Words: Material Letters and the Process of Interpretation." *Quidditas,* vol. 22, 2001, pp. 55–69.

Stuart, Arbella, owner. Hebrew/Syriac/Greek Bible, with a cover said to be Arbella's embroidery. Durham Chapter Library, B.III.31. Durham Cathedral, Durham, England.

Stuart, Arbella. *The Letters of Lady Arbella Stuart,* edited by Sara Jayne Steen. New York and Oxford: Oxford University Press, 1994.

Tomasian, Alicia. "Her Advocate to the Loudest: Arbella Stuart and Female Courtly Alliance in *The Winter's Tale.*" *The Politics of Female Alliance in Early Modern England,* edited by Christina Luckyj and Niamh J. O'Leary. Lincoln: University of Nebraska Press, 2017, pp. 146–164.

Walsh, Alexandra. *The Arbella Stuart Conspiracy.* Leeds: Sapere Books, 2020.

About the Author

Sara Jayne Steen has authored and edited five volumes largely on early modern women and theater, including *The Letters of Lady Arbella Stuart,* and has received awards for teaching and scholarship. She was faculty member, chair, and dean at Montana State University and is president emerita of Plymouth State University.

20. *The Gossips' Choice*: Extending the Possibilities for Biofiction with Creative Uses of Sources

Sara Read

Abstract

Historical fiction based on historical figures with just their names changed was common in the distant past but fell out of favor in the last century. One reason for this was the additional transparency that biofiction with the protagonist as a named figure can offer. This chapter makes the case that using the practices of older historical fiction combined with the transparency of biofiction in a hybrid fashion, blending the real and the imaginary, offers great scope for bringing women's lived experiences to life. In this essay, I discuss my own praxis while writing *The Gossips' Choice* to illustrate my argument.

Keywords: midwifery, childbirth, case histories, gossips, Sarah Stone, Jane Sharp

Michael Lackey has explained that "in the past, writers frequently based their novels on actual historical figures, but they changed the name in order to give themselves more creative freedom," and that this practice fell out of favor from the mid-twentieth century (Lackey and Donoghue, p. 81). Here we might think of Hester Prynne, protagonist of *The Scarlet Letter* (1850), who some believe to have been inspired by several historical women alive at the time and place of the novel's setting. For Lackey, the matter is straightforward: biofiction and historical fiction are distinct in that the former is "literature that names its protagonist after an actual biographical figure" (Lackey, p. 3). However, this concluding chapter will make the case that in certain circumstances using the practices of older historical fiction,

Fitzmaurice, J., N.J. Miller, S.J. Steen (eds.), *Authorizing Early Modern European Women. From Biography to Biofiction.* Amsterdam: Amsterdam University Press, 2022
DOI 10.5117/9789463727143_CH20

Figure 20.1. The frontispiece of Jane Sharp's *The Compleat Midwife's Companion*, 1724. Credit: Wellcome Library, London.

combined with the transparency of biofiction in a hybrid fashion, blending the real and the imaginary, offers great scope for bringing women's lived experiences to life in extended and significant ways.

My own attempt at achieving this in the novel that was published as *The Gossips' Choice* began life as a "practice-as-research" creative writing project in which I produced a full-length 90,000-word novel about a seventeenth-century midwife. As Bethany Layne has commented, "people have written novels based on actual people for centuries, but biofiction offers greater explicitness" (Layne and Lodge, p. 120). My novel offers transparency by making clear which sources I drew upon in the paratextual notes. The narrative is anchored in the published writings of midwives Jane Sharp (*fl.* 1671) and Sarah Stone (*fl.* 1737), whose accounts I have drawn on frequently in my research into early modern women's reproductive health.[1] It uses some of the cures and practices described by Jane Sharp, the first named English woman to publish a midwifery guide, *The Midwives Book*, 1671, in the fictionalization of episodes documented in Stone's case notes, published in *A Complete Practice of Midwifery*, 1737. The first source is a standard midwifery textbook with six sections ranging from an anatomical description of male and female genitalia to diseases "incident to women after conception [...] with proper cures for all diseases Incident to young children" (Sharp, p. 1). In large part it is a compilation drawing on many English and continental texts, but, throughout, the reader is left with a sense of Sharp as a person and practitioner, in the way she amends her sources to fit her views.

Nothing is yet known about the biography of Jane Sharp, other than her claim to have been a midwife about 30 years, and a tantalizing clue in the dedication of the book to a "Lady Ellenour Talbutt," sister of the tenth earl of Shrewsbury (Sharp, p. 3). Sharp refers to Lady Eleanor as "her much esteemed, and ever honoured friend" and herself as "An Admirer of Your Vertue and Piety, Jane Sharp." If it was the case that Sharp, like the Talbot family, was of the Catholic faith, then this would explain her absence from the records as she would have been ineligible for formal licensing, which was authorized by officials of the Church of England. However, the text seems to be almost certainly written from a standard Anglican perspective; she quotes the King James Bible at length and accurately. It might be, then, that details of her life – like those of Lady Eleanor, who herself is almost absent from the record – remain extant and ready to be found in time.

The second text consists of a preface and 42 "observations" of challenging cases, covering nearly 50 births in all, at which Sarah Stone was

1 See, for example, Read, 2013.

present. Just over half the infants failed to survive; but only three of 47
mothers died, either in or just after childbirth (Grundy). Stone did not
hold herself responsible for these deaths, claiming she was often called
in too late. Average maternal mortality rates have been calculated at 17
per 1000 in 1650–1674 and 12.3 in 1725–1749, but the cumulative risk over
several births would be higher, of course (Galley and Reid, p. 71). Stone's
maternal mortality rate in this text at around six percent is therefore a
high for the era, but her actual rate would likely be lower than average
since none of dozens of unremarkable births she attended are recorded.
You would not realize from Stone's text, then, that trouble-free births were
the norm, and this is something that I needed to take into consideration
when I was planning the novel. More is known about Stone than Sharp
because of the locations given in the case histories but also because she
includes biographical details in her text, some of which are verifiable from
historical records. Stone was originally from Somerset where she trained
under her own mother, a well-reputed midwife, "the famous" Mistress
Holmes, who was "the best Midwife that I ever knew" according to Dr. John
Allen, in a commendatory letter attesting to Stone's skills (Stone, p. xiii).
Sarah Holmes married apothecary Samuel Stone on 29 November 1700 in
Bridgewater, and the protagonist of *The Gossips' Choice*, Lucie Smith, too, is
married to an apothecary. The novel centers on their home at the shop at
the sign of the three doves, which offers the novel a deep sense of place. In
keeping with my practice of blending historical and biographical fact with
fiction, the sign was one which a sixteenth-century apothecary, William
Normevyll of Bucklersbury Street, in the City of London, used to mark
his shop (Raynalde, 108r–v). The Stones had a daughter, Sarah, who was
baptized on 17 October 1702; they may, of course, have had more children
(Woods and Galley, pp. 67–68). Given the date of her wedding and the
time of publication of her case notes, Stone probably would have been in
her late fifties around the time of publication. Taking commonalities such
as that both women practiced for above 30 years, were likely of a similar
age, and were literate and forthright as the point of departure, I invented a
fictional world that allows readers to "see" anew the world of professional
women and the families they attended in the early modern era. Telling a
story with a mature female protagonist was also important to me in the
modern era when the voices of post-menopausal women are seldom heard,
and giving voice to an older woman in this way also helps normalize mature
women in historical fiction. By publishing, Jane Sharp and Sarah Stone
demonstrate that in the past some older women strove to be heard against
the paradigms of their age too. I use the language and expression of both

women in the creation of a fictional midwife, Lucie Smith, who is in some
ways an amalgam of both women. The character produced as a sum of the
information available, is, I believe, a more rounded one than I would have
written had I ventured down a more typical biofictional route.

The hybrid approach taken in *The Gossips' Choice* means that it does
contain many of the more traditional elements of biofiction. Lucie Smith
has an apprentice called Mary Thorne who takes her name from a historical
figure, a provincial midwife who was licensed in 1724. Other characters are
given the same identity as the patient in the entry I adapt for their story,
since Stone tends to refer to her patients through the lens of their husbands'
occupations. For example, in "Observation XXI" Stone was called to "a
Soap-boiler's wife" (Stone, p. 69). On other occasions I took the name of
the location of the episode for a family name, so in "Observation II," Stone
describes how she was called to *"Bromfield* to a Farmer's wife" who in the
novel became Jenny Bromfield (Stone, p. 3).

While not illustrative of typical births, Sarah Stone's case notes or
case histories are ripe for dramatizing in a work of fiction because she
presents herself as a heroic figure, swooping into desperate scenarios and
saving the day. As Isobel Grundy has noted, this text was clearly "shaped
by techniques borrowed from heroic romance and scriptural narrative.
Stone fashions herself as a hero, whose labours [...] involve a non-climactic
series of patient, resolute cooperations" (Grundy, p. 131). She is also evasive
about her methods, especially her unique method of stopping bleeding
where others have failed:

> It is a secret I would willingly have made known, for the benefit of my
> Sisters in the Profession: But having a Daughter that has practised the
> same Art these ten years, with as good success as my self, I shall leave it
> in her power to make it known (Stone, p. 148).

This at the same time she claims to want to instruct her fellow midwives. In
a work of fiction this obfuscation would be unsatisfying to a reader following
the experiences of early modern women's childbirth. These two factors are
the main reasons I decided against making the protagonist Sarah Stone; I
wanted a character with flaws and self-doubt, and one who was open to
the reader about her techniques.

Emma Donoghue explains that, "At its best, I find the biographical novel
makes people uncomfortable. They will easily and strongly identify with
the main character for some things, and then they will suddenly have [...]
the opposite response" (Lackey and Donoghue, p. 86). There are several

moments in *The Gossips' Choice* when readers will find their identification with a character shaken. Lucie Smith is the authority in the birth chamber, a strong, capable, articulate mature woman, yet because she is a good wife in the seventeenth century, she defers to her husband over matters which a modern woman might find alienating. This sense of defamiliarization is also a factor in the methods and cures drawn from Jane Sharp, which Lucie Smith employs for some treatments. As Elaine Hobby explains, "Sharp's matter-of-fact recommendation of the application of a hot iron to the vagina might cause the modern reader to flinch, but also to reflect: inhabiting a seventeenth-century body seems to have been a more brutal experience than living in a modern one is thought to be" (Hobby, p. 30). From treating a pregnant woman's bleeding by satisfying her *pica,* or pregnancy craving for a plump peasecod, giving birth on a straw mattress, to washing a newborn in diluted wine, not all the treatments in *The Gossips' Choice* are brutal but they are very far removed from modern day experiences.

Ultimately, the novel imagines a world in which midwives Sharp and Stone could have existed, matching what Michael Lackey describes when he comments that "what we get in a biographical novel, then, is the novelist's vision of life and the world and not an accurate representation of an actual person's life" (p. 7). It is more than a historical fiction because of the way it draws on the two female practitioners for the protagonist; and by using Stone's case notes to tell the stories of the mostly ordinary, unremarkable women she attends, this project offered a rare opportunity to share some of the attitudes and practices of those women and of early modern midwifery with readers of historical fiction and to bring the very often different experiences of childbirth in the past to a wide audience. It necessarily offers up a picture of everyday seventeenth-century women's lives in a way which is biofiction, but it is not just one woman's story – it is many women's stories. Details of labor and childbirth are often skimmed over in historical fiction or based on long-standing stereotypes, and I wanted to use my skills as a researcher of early modern reproductive health to show that the picture was more varied, and to tell the story of early modern women. While some treatments these women receive might seem alarming to a modern reader, they were based on the best practices of the time, the inherent logic of which in the proper context will hopefully become apparent to a reader. In the course of doing this, *The Gossips' Choice* also gives voice and recognition to those "nobodies," to borrow Donoghue's term, the everyday women attended to by Sharp, Stone, and Thorne, whose names and scant biographical details only exist through their husbands' names or occupations, if at all.

Works Cited

Culpeper, Nicholas. *Directory for Midwives*. London: Peter Cole, 1662.

Galley, Chris, and Alice Reid, "Sources and Methods: Maternal Mortality." *Local Population Studies*, 2014, pp. 68–78. 10.35488/lps93.2014.68. Accessed 27 August 2020.

Grundy, Isobel. "Sarah Stone [née Holmes] (fl. 1701–1737)." *Oxford Dictionary of National Biography*. https://www.oxforddnb.com/view/10.1093/ref:odnb/9780198614128.001.0001/odnb-9780198614128-e-45828. Accessed 27 August 2020.

Grundy, Isobel. "Sarah Stone: Enlightenment Midwife." *Medicine in the Enlightenment*, edited by Roy Porter. Amsterdam: Rodopi, 1995, pp. 128–144.

Hobby, Elaine. "Yarhound, Horrion, and the Horse-headed Tartar: Editing Jane Sharp, *The Midwives Book* (1671)." *Women and Literary History: "For There She Was,"* edited by Katherine Binhammer and Jeanne Wood. Newark: University of Delaware Press, 2003, pp. 27–42.

Lackey, Michael. "Locating and Defining the Bio in Biofiction." *a/b Auto/Biography Studies*, vol. 31, no. 1, pp. 3–10. DOI: 10.1080/08989575.2016.1095583. Accessed 27 August 2020.

Lackey, Michael interviewing Emma Donoghue. "Voicing the Nobodies in the Biographical Novel." *Conversations with Biographical Novelists: Truthful Fictions Across the Globe,* edited by Michael Lackey. London: Bloomsbury, 2018, pp. 81–92.

Layne, Bethany interviewing David Lodge, "The Bionovel as a Hybrid Genre." *Conversations with Biographical Novelists: Truthful Fictions Across the Globe*, edited by Michael Lackey. London: Bloomsbury, 2018, pp. 119–130.

Raynalde, Thomas. *The Byrth of Mankynde, Otherwyse Named the Womans Booke*. London: Thomas Raynalde, 1545.

Read, Sara. *Menstruation and the Female Body in Early Modern England*. Basingstoke: Palgrave, 2013.

Read, Sara. *The Gossips' Choice*. Hull: Wild Pressed Books, 2020.

Sharp, Jane, *The Midwives Book Or The Whole Art Of Midwifry Discovered*, edited by Elaine Hobby. Oxford: Oxford University Press, 1999.

Stone, Sarah, *A Complete Practice of Midwifery. Consisting of Upwards Forty Cases or Observations in that Valuable Art, Selected from Many Others, in the Course of an Extensive Practice*. London: T. Cooper, 1737.

Thorne, Mary. "Mary Thorne midwife her Mark 10 September 1724." Herefordshire Archives, list of midwives used and oaths. MSS BB80& HD5/1-4.

Woods, Robert, and Chris Galley. *Mrs Stone & Dr Smellie: Eighteenth-Century Midwives and their Patients*. Liverpool: Liverpool University Press, 2014.

About the Author

Sara Read is a senior lecturer in English at Loughborough University. She researches literary and cultural representations of women, bodies, and health in the early modern era. Her first monograph was *Menstruation and the Female Body in Early Modern England* (Palgrave Macmillan, 2013). *The Gossips' Choice* is her debut novel.

21. Afterword

Michael Lackey

Abstract

In this Afterword, Michael Lackey explores how the essays in this volume significantly contribute to the booming field of biofiction studies. By clarifying what biofiction actually is and how it uniquely functions and signifies, the authors are able to illustrate how fictionalized versions of the lives of early modern women can expose insidious forms of patriarchal control, illuminate contemporary debates about art, and offer alternative ways of seeing the world.

Keywords: biofiction, early modern women, feminism, agency, social justice

From the 1930s through the early twenty-first century, prominent scholars and writers as varied as Georg Lukács, Carl Bode, Paul Murray Kendall, Jonathan Dee, and Fredric Jameson have condemned or ridiculed the biographical novel, and what enabled them to do this was a faulty conception about the way the literary form functions and signifies. Because these authors see the genre as a version of the historical novel or biography, they use inappropriate models to analyze and interpret individual works. What the contributors to *Authorizing Early Modern European Women* do so well is to clarify what biofiction actually does, which enables them to subsequently clarify how authors can use the lives of early modern women to offer new insight into many fields of intellectual inquiry.

The volume opens with a splendid essay from Bárbara Mujica, who, as a scholar of Spanish literature and a biographical novelist (she has published influential biofictions about Frida Kahlo and Teresa of Ávila), provides an excellent framework for comprehending what the literary form is and is not and what readers should and should not expect to find in specific biofictions. Because Mujica so clearly establishes how the aesthetic form

Fitzmaurice, J., N.J. Miller, S.J. Steen (eds.), *Authorizing Early Modern European Women. From Biography to Biofiction.* Amsterdam: Amsterdam University Press, 2022
DOI 10.5117/9789463727143_CH21

functions and signifies, readers are then in a position to appreciate the questions informing the subsequent essays: What is the value of biofiction? How can it be used to advance knowledge and understanding of history, women, humans, and life more generally? And specifically, how can fictional texts about the lives of early modern women contribute to the scholarly record and knowledge about contemporary culture? For example, Catherine Padmore clarifies how authors of biofiction use the life of the Flemish artist Levina Teerlinc to illuminate "ways of seeing and modes of representation" in both the past and present in order to affirm "female voice and agency"; Susanne Woods examines how Aemilia Lanyer biofictions can be used to interrogate founding histories, which are fictional whether acknowledged or not, about the supposed "Dark Lady" of Shakespeare's sonnets; and Marina Leslie illustrates how Margaret Cavendish biofictions can be used to shed new and important light on scholarly representations and the archives of the Duchess of Newcastle.

Some of the essays clarify how the surge and legitimization of biofiction can illuminate literary history more generally, as we see in Marion Wynne-Davies's analysis of biographies about Mary Sidney and Mary Wroth. Margaret Hannay used a traditional empiricist method of biography in her 1990 text about Sidney, but in her 2010 study about Wroth, she used a more creative and inventive approach to her subject, which Wynne-Davies illustrates by showing how Hannay sometimes uses the kind of creative strategies found in Naomi Miller's 2020 biofiction about Sidney. Biofiction had one of its biggest surges between 1990 and 2010, and through her analysis of the biographies, Wynne-Davies compellingly suggests that the intellectual forces that legitimized and popularized the literary form were having a similar impact on other areas of intellectual and scholarly inquiry, specifically biography.

That biofiction would have such a wide-reaching impact should not be surprising because, as Miller argues in her essay, her objective as a scholar and novelist is to make the case to the larger reading public about the value of early modern women's lives for the contemporary world. Within this framework, biofiction does not primarily give readers detailed facts about sixteenth- and seventeenth-century women. Rather, it clarifies how certain aspects of these lives can enable contemporary readers to see, imagine, and experience new possibilities in thinking and being, which they get from the verbal portrayals of extraordinary women who achieved exactly that. By briefly describing her method of fictionalizing her subject in her novel *Imperfect Alchemist*, Miller provides readers with useful insight into her objectives as a writer, the power and value of biofiction, and strategies for

reading the fiction, thus confirming Sheila Cavanagh's claim about Artemisia
Gentileschi biofictions, which is that biofiction speaks "to contemporary
concerns while drawing attention to the works of a talented" person from
the past.

But not all biofictions succeed, as Linda Phyllis Austern demonstrates in
her essay about the representations of Anne Boleyn as a lutenist in many
biofictions. Instead of emphasizing "Anne's creative agency," many authors
treat her as a simple-minded seductress whose musical talent is mere foreplay
for gratifying her King's sexual desire. In an essay on a play about Lanyer,
Hailey Bachrach suggests that the biofictional failures might actually be
intrinsic to the literary form. Through the effort to make the life of a histori-
cal person relevant to audiences in the present, authors, Bachrach argues,
inevitably distort and misrepresent the marginalized subjects they are
ironically seeking to recover, which thus re-marginalizes the very figure that
the contemporary author has tried to return to the cultural and epistemic
center. What contributes to the failure of biofiction is the battle between
the artist's fictionalization of a life and the need to mass-market works for
the sake of profit. As Margaret Rosenthal demonstrates through her analysis
of the differences between the original screenplay for the film *Dangerous
Beauty* and the actual Hollywood production, many authors who focus on
a particular person's life, like Veronica Franco's, commit themselves to the
project of enhancing autonomy, especially for traditionally disempowered
groups, but opposing forces thwart and subvert the authors' goal of empower-
ment. In the case of *Dangerous Beauty*, the feminist character found in the
original screenplay is converted in the film into a dependent female who
can only succeed through the intervention of males, a change made in order
to appeal to a broader Hollywood viewership.

Central to biofiction is the authorial commitment to foreground the
agential behavior of figures who have been strategically denied individual
autonomy, which, in part, explains why authors consistently gravitate toward
certain types of historical figures. For instance, the life of Sor Juana Inés de
la Cruz, specifically in relation to her poem *Primero sueño*, can be used to
enable readers "to think about political change," and as such, the Mexican
nun's life and work can be used in contemporary fiction "to inspire political
action," as Emilie Bergmann convincingly argues.

The focused analysis of biofictions about early modern women is valuable
for scholars because it can illuminate the nature and power of biofiction
more generally and specify the kinds of contributions the literary form
can make to contemporary culture as well as numerous fields of study. For
instance, Julia Dabbs shows how the early modern *paragone* debate, which

examines what medium (painting versus poetry) is best suited for visualizing a biographical subject, is enacted in a specific biofiction about Sofonisba Anguissola and can thus be used to better define and assess the merits of individual biofictions. Stephanie Russo argues that Joy McCullough, in her biofiction about Gentileschi, does not so much accurately represent the life of the Italian painter as mine her life for meanings that resonate for women in both the seventeenth and twenty-first centuries. Specifically, she uses the rape of Gentileschi and the portrayal of rape victims in her paintings to expose the patriarchal psychology underwriting rape culture and to portray female resistance and rage. Through her analysis of the novel's symbolism, Russo then clarifies how the biofictional art of converting a seventeenth-century story into a symbol can shed new and important light on the #MeToo Movement and the alleged sexual assault of Christine Blasey Ford by Brett Kavanaugh.

The contemporary ethos always inflects the representation of a particular life, whether in biography or biofiction, and in a marvelous essay about Lady Arbella Stuart biographies and biofictions from the nineteenth century until the present, Sara Jayne Steen shows how "new information and approaches" in each age alter "how we read and are read, how we interpret the past, and how we assess each other." But authors of biofiction, she argues, are different from biographers because they unapologetically privilege their own aesthetic vision over historical fact, which raises some needed ethical questions.

The volume wonderfully makes the case for doing an extensive study of biofiction by focusing on a single demographic. To be specific, the authors in this volume illustrate the value of knowing the lives of early modern women; at the same time, they better define how biofiction functions and signifies, and they clarify how the literary form can advance knowledge and justice about the past, in the present, and for the future.

About the Author

Distinguished McKnight University Professor at the University of Minnesota Morris, **Michael Lackey** is a scholar of twentieth- and twenty-first-century intellectual, political, and literary history. He has authored and edited eleven books, mostly about biofiction, including *Truthful Fictions* and *Conversations with Biographical Novelists*, which contain interviews with some of the world's most famous biographical novelists.

Index

Discussions of paintings, literature, and critical works are indexed under the author's name.